Autodesk® Combustion® 4 Fundamentals Courseware Manual

Autodosk Combuston A

levnet.

Autodesk® Combustion® 4

Fundamentals

Courseware

Manual

First published 2005 by Focal Press

2 Park Square, Milton Park, Abingdon, Oxon OX14 4RN 711 Third Avenue, New York, NY 10017, USA

Routledge is an imprint of the Taylor & Francis Group, an informa business

First issued in hardback 2017

Copyright © 2005, Autodesk, Inc. Published by Taylor & Francis. All rights reserved.

All rights reserved. No part of this book may be reprinted or reproduced or utilised in any form or by any electronic, mechanical, or other means, now known or hereafter invented, including photocopying and recording, or in any information storage or retrieval system, without permission in writing from the publishers.

Notice:

Product or corporate names may be trademarks or registered trademarks, and are used only for identification and explanation without intent to infringe.

No responsibility is assumed by the publisher for any injury and/or damage to persons or property as a matter of products liability, negligence or otherwise, or from any use or operation of any methods, products, instructions or ideas contained in the material herein

Library of Congress Cataloging in Publication Data

Application submitted

British Library Cataloguing-in-Publication Data

A catalogue record for this book is available from the British Library.

ISBN: 978-0-240-80785-0 (pbk) ISBN: 978-1-138-45632-7 (hbk)

Cover Design: Eric DeCicco

Interior Design: Autodesk Media and Entertainment

© 2005 Autodesk Canada Co./Autodesk, Inc. All rights reserved.

This publication, or parts thereof, may not be reproduced in any form, by any method, for any purpose.

AUTODESK CANADA CO./AUTODESK, INC. MAKES NO WARRANTY, EITHER EXPRESSED OR IMPLIED, INCLUDING BUT NOT LIMITED TO ANY IMPLIED WARRANTIES, OF MERCHANTABILITY OR FITNESS FOR A PARTICULAR PURPOSE, REGARDING THESE MATERIALS AND MAKES SUCH MATERIALS AVAILABLE SOLELY ON AN "AS-IS" BASIS.

IN NO EVENT SHALL AUTODESK CANADA CO./AUTODESK, INC. BE LIABLE TO ANYONE FOR SPECIAL, COLLATERAL, INCIDENTAL, OR CONSEQUENTIAL DAMAGES IN CONNECTION WITH OR ARISING OUT OF PURCHASE OR USE OF THESE MATERIALS. THE SOLE AND EXCLUSIVE LIABILITY TO AUTODESK CANADA CO./ AUTODESK, INC., REGARDLESS OF THE FORM OF ACTION, SHALL NOT EXCEED THE PURCHASE PRICE OF THE MATERIALS DESCRIBED HEREIN.

Autodesk Canada Co./Autodesk, Inc. reserves the right to revise and improve its products as it sees fit. This publication describes the state of this product at the time of its publication, and may not reflect the product at all times in the future.

Autodesk Canada Co./Autodesk, Inc. Trademarks

The following are registered trademarks of Autodesk Canada Co./Autodesk, Inc. in the USA and/or other countries: 3D Props, 3D Studio, 3D Studio MAX, 3D Studio VIZ, 3DSurfer, 3ds Max, ActiveShapes, ActiveShapes (logo), Actrix, ADI, AEC Authority (logo), AEC-X, Animator Pro, Animator Studio, ATC, AUGI, AutoCAD, AutoCAD LT, AutoCAD Map, Autodesk, Autodesk Inventor, Autodesk (logo), Autodesk MapGuide, Autodesk University (logo), Autodesk View, Autodesk WalkThrough, Autodesk World, AutoLISP, AutoSketch, backdraft, Biped, bringing information down to earth, CAD Overlay, Character Studio, Cinepak, Cinepak (logo), Cleaner, Codec Central, Combustion, Design Your World, Design Your World (logo), Discreet, EditDV, Education by Design, Fire, Flame, Flint, Flint RT, frost, glass, Gmax, Heidi, HOOPS, Hyperwire, i-drop, Inferno, Inside Track, Kinetix, Lustre, MaterialSpec, Mechanical Desktop, mountstone, NAAUG, ObjectARX, PeopleTracker, Physique, Planix, Powered with Autodesk Technology (logo), RadioRay, Revit, riot, river, Smoke, Softdesk, sparks, Stone, stream, Texture Universe, The AEC Authority, The Auto Architect, vapour, VISION*, Visual, Visual Construction, Visual Drainage, Visual Hydro, Visual Landscape, Visual Roads, Visual Survey, Visual Toolbox, Visual TugBoat, Visual LISP, Volo, WHIP!, and WHIP! (logo), Wire.

The following are trademarks of Autodesk, Inc., in the USA and/or other countries: AutoCAD Architectural Desktop, AutoCAD Learning Assistance, AutoCAD STREAM STREA

All other brand names, product names, or trademarks belong to their respective holders.

Government Use

The software and documentation is provided with RESTRICTED RIGHTS. Use, duplication, or disclosure by the United States Government or any agency, department or instrumentality thereof is subject to the restrictions set forth in the Commercial Computer Software—Restricted Rights clause at FAR 52.227-19 or the Commercial Computer Software—Licensing clause at NASA FAR Supplement 1852.227-86. Manufacturer is Autodesk Canada Co./Autodesk, Inc., 10, Duke Street, Montreal, Quebec, Canada, H3C 2L7.

Title: Autodesk® Combustion® 4 Fundamentals Courseware

Software version: 4

Date: June 3, 2005

Supplementary Resources Disclaimer

Additional resources were previously made available for this title on DVD. However, as DVD has become a less accessible format, all resources have been moved to a more convenient online download option.

You can find these resources available here: www.routledge.com/9781138456327

Please note: Where this title mentions the associated disc, please use the downloadable resources instead.

Table of Contents

	Welcome to Combustion	1
	Installing the Courseware Media	2
	Conventions and Terminology	2
	Setting the Preferences.	3
	Relinking Media	12
	Playing Movies	12
	Getting More Help	12
Part I	Fundamentals	13
1	Touring Combustion	15
	Overview	16
	Open a Workspace	16
	Play the Clip	18
	Explore the Scene	19
	Examine the Composite	21
	Make Changes to the Composite	24
	Explore the Schematic View	25
2	Creating Simple Composites	27
	Overview	28
	Create a Composite	28
	Scale and Position the Olympic Rings and Torch	
	Position and Animate the Hand	32
	Position and Change the Order of the Flame	33
	Hide the Black Background of the Flame	
	Add Text to the Clip	37
	Animate the Text	38

Part II	Using Paint	83
7	Learning Paint Basics	85
	Overview	86
	Create a Paint Branch	86
	Draw a Rectangle	88
	Change the Rectangle Into a Fish	90
	Animate the Fish	92
	Play the Clip	94
	Change the Color of the Fish	94
	Duplicate the Fish Object	96
	Make the Fish Appear to Jump out of the Bucket	98
8	Creating, Controlling, and Positioning Objects	101
	Overview	102
	Open the Starting Workspace	102
	Tint One of the Roofs of the First Landmark	103
	Animate the Salmon	105
	Position the Three Key Words	107
	Position the Three Landmark Images	108
9	Animating Text	111
	Overview	112
	Create a Composite Branch	112
	Add Text to the Clip	
	Change the Appearance of the Text	116
	Animate the Text Along a Path	
	Add a Timecode Generator to the Clip	
	Add Another Text Object	
	Animate a Text Roll	
10	Exploring Draw Modes in Text	127
0.00	Overview	
	Open the Workspace	
	Examine the Draw Modes.	
	Change the Draw Modes.	
		101

11	Wire Removal	135
	Overview	136
	Create a Composite	136
	Remove the Wire	
	Animate the Line Object	141
	Hide the Line Object's Red Color	
	Fix the Sidewalk	
12	Creating Text Gradients	147
	Overview	148
	Create a Text Branch	148
	Add Text	149
	Create a Text Gradient	152
	Add a Text Outline	154
	Edit a Text Object	155
	Animate the Text	157
13	Animating Gradients	159
	Overview	160
	Create a Paint Branch	160
	Create a Rounded-Corner Rectangle	161
	Apply a Gradient	162
	Change the Gradient Type	165
	Animate the Gradient	166
	Add a Text Object	169
	Apply a Gradient to the Outline.	171
14	Creating Custom Brushes	173
	Overview	174
	Open the Starting Workspace	174
	Create a Custom Brush from Particles	175
	Create a Lighting Effect	179
	Change the Appearance of the Background	
	Create a Custom Brush from an Image	
	Create the Wall Construction Animation	
	Animate the Wall Construction	183

15	Creating Flash Compatible Animations	18/
	Overview	188
	Create a Paint Branch	188
	Create the Background Rectangle	189
	Animate the Background Rectangle	190
	Create a Clone Box	191
	Create Copies of the Clone Box and Position Them	192
	Extend the Duration of the Clone Boxes	193
	Animate the Scale of the Clone Boxes	193
	Animate the Offset of the Clone Boxes	
	Create the mood_panoram Image Slide	
	Add a Text	
	Animate the Text Along a Path	
	Preview Macromedia Flash Output.	
	Export as Macromedia Flash Output	198
16	Combining Selections	100
10	To the second se	
	Overview	
	Create a Paint Branch	
	Select the Stars	
	Subtract the Circles	
	Change the Color of the Stars.	203
17	Animating Selections	207
	Overview	208
	Create a Paint Branch	208
	Select the Chair	208
	Adjust the Color Balance	212
	Animate the Selection	212
Part III	Transforming and Controlling Layers	215
18	Keyframing	217
	Overview	218
	Create a Composite	218
	Loop the Wasp Footage	
	Animate the Wasp	
	Create the Sting.	221
	11 1 22 1 21 1 0 1	222
	Adjust the Wasp's Flight Speed	223

19	Creating Expressions	227
	Overview	228
	Open the Starting Workspace	228
	Animate the Panels Layer	229
	Animate the Clouds Layer Using Channel Linking	230
	Animate the Electric Glow Layer	231
	Animate the Electron Layer with Multi-channel Expressions	233
	Adjust the Electron Layer's Position by Editing the Expressions	234
20	Cropping and Corner-Pinning	237
	Overview	238
	Create a Composite Branch	238
	Scale and Crop the Poster Image	
	Corner Pin the Poster Image	241
	Scale and Crop the Logo Image	243
	Corner-Pin the Logo Image	243
	Change the Appearance of the Logo	244
	Position a Layer from the Photoshop File	245
21	Aligning Objects to a Motion Path	247
	Overview	248
	Open a Workspace and Import Footage	248
	Animate the PCText	250
	Duplicate a Layer via the Schematic view	251
	Adjust the Opacity of the PcText Layers:	
	Import the Earth Footage	253
	Animate the Earth Image on the Z Axis	254
	Change the Playback Behavior of the Orb Footage	255
	Animate the Orb Footage Along the X Axis	256
	Customize the Motion Path Tangent Handles	257
Part IV	Changing Layer Surface Properties	26
22	Exploring Transfer Modes	263
	Overview	
	Create a Composite	
	Animate the Layers	
	Change the Layers' Transfer Mode	
	•	

23	Overview Create a Composite Branch Create the Displacement Source Add a Displace Operator. Animate the Displacement Source	274 274 275 276
Part V	Using Channels, Mattes, and Masks	281
24	Using Alpha Channels Overview Create a Composite Branch Create a Matte Animate the Matte Animate the Gradient Layer Create a Stencil Layer Animate the Birds Layer	284 284 285 289 289
25	Creating Channel Effects Overview Open a Workspace Add a Compound Alpha Arithmetic Operator Add a Compound RGB Arithmetic Operator Add a Turbulence Operator Add a Blend Operator	. 296 . 296 . 297 . 301 . 302
26	Using Masks Overview Create a Composite Make Dino Appear from Behind the Building Track the Mask Animate the Shape of the Mask	. 310 . 310 . 311

Part VI	Using Null Objects, Lights, and the Camera	321
27	Animating with a Null Object	323
	Overview	324
	Create a Composite Branch	324
	Arrange Three Layers to Form a Six-Sided Star	325
	Animate a Null Object	327
	Enhance the Clip's Appearance	
	Clean up the Workspace	331
28	Moving the Camera	333
	Overview	334
	Create a Composite	334
	Scale, Position, and Animate the Footage	335
	Set the Viewport Layout	336
	Animate the Camera	337
	Make an Image Travel with the Camera	342
29	Creating Shadows with Lights	343
	Overview	344
	Create a Composite Branch	344
	Animate the Film Roll	345
	Add Spotlights	
	Target the Spotlights	
	Adjust the Surface Properties of the Layers	350
Part VII	Tracking and Stabilizing	351
30	Four-Point Tracking	353
	Overview	354
	Create a Composite Branch	
	Change the Properties of the Actress Layer	355
	Track the Corner Points of the Actress Layer	356
	Apply a Mask Around the Actress	359
	Key Out the Blue-Screen Background	360

31	One-Point Stabilizing	63
	Overview	364
	Create a Composite Branch	364
	Stabilize the Woods Footage	365
	Analyze the Jitter in the Clip.	
	Remove the Black Borders in the Clip	
	Using Other Stabilizing Modes	
	Play the Clip in the RAM Player	370
32	Two-Point Stabilizing	375
	Overview	376
	Create a Composite Branch	376
	Apply the Stabilize Operator	377
	Track the Motion of the Two Points	380
	Examine the Stabilize Point Channels	382
Part VIII	Keying and Color Correcting	385
33	Using the Discreet Color Corrector	387
	Overview	
	Create a Composite Branch	
	Create a Composite Dranen	
	Adjust the Black and White	389
	Adjust the Black and White	389 391
	Adjust the Black and White	389 391 392
	Adjust the Black and White	389 391 392 393
34	Adjust the Black and White Add Saturation Adjust the Color Adjust the Shadows	389 391 392 393 393
34	Adjust the Black and White Add Saturation Adjust the Color Adjust the Shadows Compare the Color Correction Results	389 391 392 393 393
34	Adjust the Black and White Add Saturation Adjust the Color Adjust the Shadows Compare the Color Correction Results Using the Diamond Keyer	389 391 392 393 393 395 396
34	Adjust the Black and White Add Saturation Adjust the Color Adjust the Shadows Compare the Color Correction Results Using the Diamond Keyer Overview	389 391 392 393 393 395 396 396
34	Adjust the Black and White Add Saturation Adjust the Color Adjust the Shadows Compare the Color Correction Results Using the Diamond Keyer Overview Create a Composite Branch	389 391 392 393 393 395 396 396 397

35	Using the Discreet Keyer	405
	Overview	406
	Create a Composite Branch	406
	Generate a Matte Using the YUV Mode	407
	View the Matte	409
	Add Softness to the Matte	411
	Use the Histogram to Improve the Matte	414
	Adjust the Color Suppression Curves	
	Color Correct the Front Clip	418
Part IX	Nesting Composites	421
36	Basic Nesting	423
30	Overview	
	Create a Composite	
	Create a Lens Flare Effect for the Lamp	
	Animate the Crate	
	Add a Motion Blur Effect to the Woman and Crate	
	Clean up the Composite	
37	Creating a Motion Blur	435
	Overview	
	Open the Workspace	
	Nest the Composite	
	Add a Motion Blur Operator	
	Customize the Motion Blur	
	Color Correct the Clip	
Part X	Additional Topics	443
38	Applying and Tracking a Particle Emitter	445
	Overview	
	Open Footage into a Composite	
	Create a Smoke Effect	
	Track the Smoke to the Toaster	
	Change the Appearance and Behavior of the Smoke	
	Change the Appearance and Behavior of the Emitter	
	Add a Deflector to Produce a more Realistic Look	

39	Creating Particle Effects	453
	Overview	454
	Open the Workspace	454
	Add a Particle Operator	455
	Add a Particle Emitter to the Clip	455
	Track the White Dot	457
	Apply the Tracked Emitter to the Train Clip	458
	Import a Custom Shape for the Smoke Particle	459
	Edit the SmokePuff Particle Type	461
	Animate the Values for the Particles	463
	Adjust the Size Over Life Setting	464
40	Creating Capsules	467
	Overview	468
	Open the Workspace	
	Examine the Schematic and Encapsulate the Operators	
	Edit the Capsule	
	Adding and Creating Controllers	470
	Save the Capsule to the Library	471
	Reuse the Capsule on New Footage	472
41	Building G-Buffers	475
	Overview	476
	Open the Workspace	476
	Examine the Schematic and open the Paint Operator	476
	Paint the Train Trestle with a Gradient for Z-Depth	477
	Reorder and Enable the Remaining Paint Objects	480
	Apply a G-Buffer Builder, Use the Paint Operator for Z-Depth	
	Apply a 3D Fog Operator and Animate the Near Plane	481
42	Morphing	483
	Overview	484
	Open Footage into a Composite Branch	
	Create Picture Keys and In/Out Points for the Morph	
	Add Control Polygons to Morph Picture Keys	
	Animate the Polygons to Morph to the Next Picture Key	
	Fine-Tune the Morph	
	Index	491

A TOUR CONTRACTOR OF THE SECOND CONTRACTOR OF

A CONTROL OF THE CONT

gabre

Welcome to Combustion

Welcome to the courseware for Autodesk®

Combustion®. This instructional material is designed for use in a classroom environment with an authorized instructor.

Before starting the first lesson, read this introduction to install the courseware media, to set the required preferences, and to become familiar with the typographical conventions used in the text.

The only prerequisite for using this courseware is that you be familiar with the Windows® or Macintosh® operating system.

Installing the Courseware Media

All the media required to complete this courseware can be found on the *Courseware DVD* included in the Combustion *Courseware* package. Install the courseware media as follows:

1. Insert the *Courseware DVD* in your computer's DVD-ROM drive.

The Courseware DVD contains a single Courseware folder. Inside this folder are folders that contain the media required for each individual lesson, including the footage, the required workspace files, and the sample .mov or .avi files for each lesson.

2. Copy the Courseware folder to a location on a hard disk.

Note: Although you can work directly off the DVD, your interaction with the software is faster if you copy the Courseware folder to a location on a hard disk.

In the lessons, you are instructed to import footage from the *LessonXX* (where XX is the lesson number) folder. At this instruction, use the file browser in the Import Footage dialog to locate the *Courseware* folder that you copied to a local hard disk location.

Conventions and Terminology

The following conventions are used in this courseware.

Menu Selections

Menu selections, including context menu selections, are indicated by dividing vertical lines. For example, if you are instructed to choose Operators | Keying | Diamond Keyer, you can either click Operators on the main menu bar at the top of the screen, choose the Keying sub-menu, and finally choose Diamond Keyer or, right-click / CONTROL-click the context menu, choose the Keying sub-menu, and finally choose Diamond Keyer.

Hot Keys

Combustion uses a wide array of hot keys: keyboard shortcuts that accelerate operations. For a complete list of hot keys, see the Combustion *Hot Key Card* included in the product box. In this courseware, hot keys appear in **Bold, Caps** type. For example:

In the Toolbar (F2), click the Arrow tool (or press TAB).

In cases where there is a difference between hot key assignments on Windows and Macintosh operating systems, both are given. For example:

Choose File | Save or press CTRL+S (Windows) or ₩+S (Macintosh) to save the workspace.

Once this convention has been introduced in a lesson, it is shortened as follows:

Choose File | Save ($CTRL+S / \Re+S$) to save the workspace.

Tools

When you are instructed to click a tool, the tool is shown in the left margin. For example:

R

In the Toolbar, click the Arrow tool (TAB).

Setting the Preferences

The Combustion user interface can be customized. To ensure that the user interface elements and general behavior match those illustrated in this courseware, set the Combustion preferences according to the following instructions.

- 1. Launch the software:
 - If you are using Combustion on a PC, click the Start menu button and choose Programs | Autodesk | Combustion. (If you made a shortcut to the software on the desktop, double-click the Combustion icon.)
 - If you are using Combustion on a Macintosh, use the Finder to locate the Combustion icon and then doubleclick the icon to launch the software. (If you made an alias on the desktop or added Combustion to the Launcher items, double-click the Combustion icon.)

You can display the frames of a clip using frame numbers (starting from 0 or 1) or timecode. For the courseware lessons, use frame numbers starting from 1.

3. Under Host, click the Animation category.

When you build a composite, many properties can be animated. You can set the interpolation either to Constant, Linear, Cubic, Bezier, or Hermite/Flame. For the courseware lessons, use the default Bezier

keyframe interpolation. Bezier draws smooth curves, similar to cubic interpolation, except that you can adjust the slope of the curve at each keyframe.

The Speed channel enables you to adjust the speed of an object as it travels along a motion path. Although some of the courseware lessons use the Speed channel, make sure it is disabled in the Animation Preferences dialog so the channel is not used by default. Enable the Speed channel in the Timeline instead.

4. Under Footage, click the General category.

When you import a still image into a composite branch, it is automatically assigned a duration equal to the length of the clip. However, when you open a still image as a Paint, Edit, Keyer, or Color Corrector branch, the image is assigned a duration according to the Preferences dialog. For the courseware, make sure the Default Still Image Duration is set to 30.

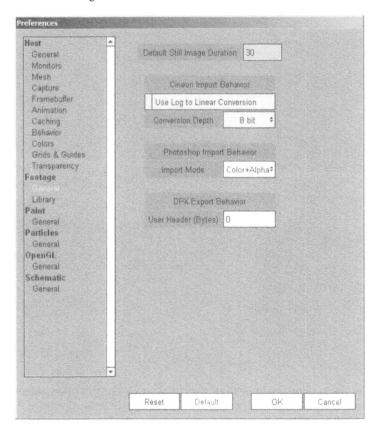

When you import footage, the bit depth is initially set to the bit depth of the footage in the Output controls of the Footage operator. For Cineon files, you can make Combustion automatically convert the files from logarithmic data to linear data and set the linear bit depth. You can leave the bit depth at 10 bits, or change it to 8 bit, 10 bit, 16 bit, or Float. When you import Cineon files, enable Use Log to Linear Conversion if you want the files to be automatically converted to linear format.

5. Under Footage, click the Library category.

By default, the Footage Library is set to display thumbnails on new nodes and to display an overview of the footage.

All footage used in the workspace appears in the Footage Library. You can see a listing of the footage in the Footage Library at the bottom of the Workspace panel or Timeline. For Footage operator nodes, you can show the footage details next to the thumbnail. The information is the same as the Footage details area of the Footage Controls panel.

To see the Footage operators as nodes with scrubbable thumbnails and footage information, make sure Display Thumbnails on New Nodes is enabled in the Library Footage.

6. Under Particles, click the General category.

The default setting for displaying particles is set to always display emitter shapes. When enabled, all emitter object icons and deflector icons are visible in the viewport. Make sure the default is set to always display emitter shapes.

7. Under OpenGL, click the General category.

Combustion support for OpenGL gives you the ability to interact with the composites in true 3D space with real-time feedback, speeding up the creative process and enabling the manipulation of images in 3D space.

Keep in mind that some OpenGL graphics accelerator cards include limited texture memory which may result in limited performance when using OpenGL in Combustion. If you have a limited OpenGL graphics card, it is recommended that you set your Combustion Preferences to Use Software OpenGL

Note: If you have no OpenGL hardware, software-based OpenGL is automatically used (regardless if Use Software OpenGL is enabled or not).

8. Under Schematic, click the General category.

As you can see, the Schematic preferences offer a wide range of options to facilitate the workflow when building complex workspaces in the Schematic view.

See the Combustion User's Guide for detailed information about working with the Schematic view.

9. Under Host, click the Colors category.

Combustion provides two color schemes: Charcoal and Platinum. Because the Charcoal interface (the default setting) is too dark for printing illustrations, the Platinum color scheme is used in these lessons. However, the Charcoal interface is recommended because it improves color perception of video content.

Hint: You can customize the User Interface (UI) colors in the color boxes in the Pen Colors group of controls.

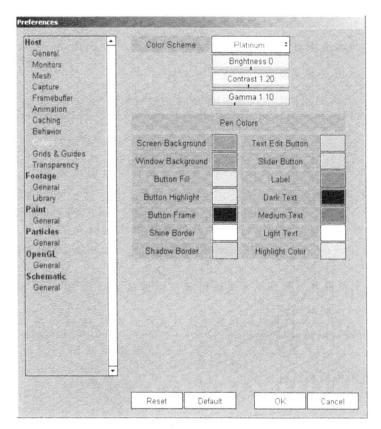

Note: The screenshots in this book are from Combustion on a PC running the Windows 2000 operating system. On a Macintosh, the Combustion user interface is the same. Also, monitors were set to 1280 x 1084. Monitor resolution affects the size of the clips in the viewports, so some screenshots may not match your screen exactly.

Relinking Media

Workspaces link to their footage using absolute path names. Depending on where you install the courseware media, Combustion may prompt you to relink footage it cannot find. For example, if you install the courseware media on a drive other than the C: drive, you may need to relink the footage in some lessons. To relink footage, use the following procedure on both Windows and Macintosh platforms.

If Combustion cannot locate the footage used by the workspace you try to open, a Replace Footage dialog appears requesting you if you would like to replace it.

- 1. Click Yes and use the file browser to locate the missing footage.
- 2. Use the file browser to locate the missing footage folder.

The files whose path names match those of the missing footage are automatically relinked. The workspace file is updated, so you do not have to save the workspace to keep the updated path. You may proceed with the lesson.

Playing Movies

The courseware media includes .mov or .avi files of the expected results for each lesson. If you do not have enough RAM to view the result clip in real time in the viewport, play the provided movie.

- If you are using a PC, double-click the .mov / .avi file in the lesson folder to view the movie using Windows MediaTM Player.
- If you are using a Macintosh, double-click the .avi /.mov file in the lesson folder to view the movie using the QuickTime® Movie Player.

Note: If you are using a Macintosh, you cannot view an .avi movie in Combustion. You need to view it outside of the Combustion application.

You are now ready to proceed with the first lesson.

Getting More Help

For more instructional material, see the Combustion *Tutorials* and new features media presentations. For a comprehensive reference to all of the software features, see the *Combustion User's Guide*. You can also use the Online Help system for topic-based information as well as reference information about the main interface elements.

For more training and tutorials materials, visit the learning and training page at **www.discreet.com/training**. For answers to FAQs, Technical News, and access to the Support Knowledge Base, visit the support and services page at **www.discreet.com/support**.

Fundamentals

Part I

1	Touring Combustion	. 15
2	Creating Simple Composites	. 27
3	Using Operators in a Composite	. 41
4	Timewarping	. 51
5	Editing Clips	. 59
6	Optimizing Workflow	. 73

aleba serkina (

Touring Combustion Lesson 1

In this lesson, take a tour of a workspace and get acquainted with the interface.

Overview

When you work in Combustion, you use workspace files. A workspace contains all the settings that define the result clip. You can use different viewport layouts to view the clip and you can play back the clip in real time. You can access a number of panels, including the Toolbar, the Workspace panel, the Timeline, and a number of Control panel, to display elements of a workspace in the viewport(s), and to make changes to the workspace. In this lesson, explore a workspace with a composite clip.

In this lesson:

- Open a workspace with a composite branch.
- Explore the viewport layout options.
- Play the clip in the viewport.
- Explore the scene using the Perspective view and Perspective tools.
- Examine the composite in the Workspace panel and the footage in the Footage Library view.
- · Position and rotate an object.
- Explore the Schematic view.

Open the 01_Touring.mov file in the 01_TouringCombustion folder and preview the result.

Note: Depending on the operating system and on the fonts installed on the workstation, workspaces containing text objects may differ slightly from one workstation to another.

Open a Workspace

A workspace file uses the extension .cws. Although you can have only one workspace open at a time, a workspace can contain as many branches as you require. In this lesson, explore a workspace file with a four-layer composite.

- 1. Check the Combustion preferences. For instructions, see "Setting the Preferences" on page 3.
- 2. Choose File | Open Workspace or press CTRL+SHIFT+O (Windows) or **%**+SHIFT+O (Macintosh) to access the Open Workspace dialog.

3. Open the workspace for this lesson:

a) Use the file browser in the Open Workspace dialog to locate the 01_TouringCombustion folder.

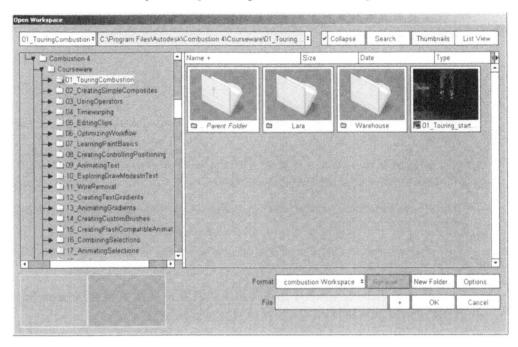

b) Select 01_Touring_start.cws and then click OK (ENTER / RETURN) to open the workspace file.

After a moment, the composite is displayed in the viewport(s).

You can select to display one, two, three, or four viewports, and show the Schematic view in any of the viewports. You can also select to display elements of a composite or the composite in each viewport independently. For instance, you can select to display the output of a layer in one viewport, the output of a Paint operator in another viewport, and the output of the composite in another viewport.

4. From the Viewport Layout list, select the single-viewport layout.

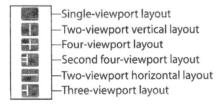

- 5. View the clip by zooming out, zooming in, and by panning the scene:
 - a) Click the Zoom Out button (CTRL+-/ 第+-), click and scrub (drag downward over) the Home button, or scroll with your mouse wheel in the viewport to zoom out.

Hint: You can also choose Window | Zoom Out or right-click (Windows) or **CONTROL**-click (Macintosh) the viewport and choose Zoom Out.

b) Click the Zoom In button (CTRL+=/ %+=), click and scrub (drag upward over) the Home button, or scroll with your mouse wheel in the viewport to zoom in.

Hint: You can also choose Window | Zoom In or right-click (Windows) or CONTROL-click (Macintosh) the viewport and choose Zoom In.

Pan

c) Click and scrub over the Pan button or hold down SPACEBAR and scrub the viewport to pan the composite.

Home

d) Click Home.

Clicking Home cycles the viewport display between a centered image with a 100% zoom factor, an image that fits the viewport, and the most recent custom zoom and pan settings.

Play the Clip

The viewports provide real-time playback of clips at each stage of their development. Play the clip in the viewport in real time using the Playback controls. The Playback controls are below the viewport.

1. Click the Go to Start button to go to the first frame of the clip.

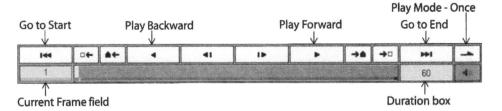

2. If Loop Play Mode is not selected, click the Play Mode button and select Loop Play Mode.

The Play Mode button cycles between Play Once , and Ping Pong .

3. Click the Play Forward button ____ to play the clip.

Hint: You can also press HOME to go to the first frame and press SPACEBAR to go play the clip.

The first time you play the clip, it does not play in real time. The clip plays slowly while each frame is rendered to RAM cache. Once it reaches the last frame and starts playing again, the playback rate increases to real time, using the RAM cached version.

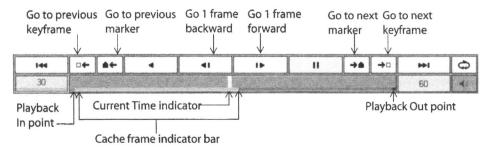

Note: Real-time playback of a clip is limited by the amount of RAM installed on your workstation. The more RAM your system has, the more frames can be cached and played back in real-time.

You can view how much RAM is available for real-time playback and how much RAM is used by the system at any moment by looking at the RAM gauge in the lower right corner of the screen.

4. Right-click / CONTROL-click the lower right corner of the Info Palette and choose Cache Meter.

When all the RAM is used up, the software overwrites the lower operators.

5. Change the viewport display quality to the right of the Playback controls to Medium.

This lowers the display quality in the viewport, but in turn uses much less memory to render to RAM cache, and allows you to cache more frames. It can be very useful for systems with limited resources.

- **6.** Click the Stop Playback button (SPACEBAR) to stop the clip.
- 7. Click the Go to Start button (HOME) to go to the first frame of the clip.

Explore the Scene

Explore the scene using the Toolbar tools. In addition to drawing tools, selection tools, mask tools, and tools used for editing and positioning objects, the Toolbar contains tools used for changing the viewing perspective of objects displayed in the viewport.

So far, you viewed the composite from a Camera view, much like a camera person views the scene on a movie set. In Perspective view, you can view the scene from a director's viewpoint, where you can see the actors (layers), the camera person (Camera) and the lighting people (Light).

1. In the Toolbar (F2), select Perspective View from the View list.

Hint: You can also right-click / **CONTROL**-click the viewport and choose Perspective to show the Perspective view.

In Perspective view, you can view the composite from any point, independently of the camera.

- 🕏 2. Scrub the Perspective Zoom tool and drag down or to the right to zoom out.
- **3.** Scrub the Perspective Rotate tool and drag the mouse in the viewport to arc rotate around the scene.

4. Reset the Perspective tools:

- a) Double-click the Perspective Zoom tool and then click Reset in the Zoom Factor dialog.
- b) Double-click the Perspective Rotate tool and then click Reset in the Direction dialog.
- 5. Select Camera View from the View list.

Hint: You can also right-click / CONTROL-click the viewport and choose Camera to switch to Camera view.

6. Choose Window | Fit in Window or right-click / CONTROL-click the viewport and choose Fit in Window. The zoom factor in the viewport is set to fit the whole frame in the window.

Examine the Composite

Examine the composite using the Workspace panel. The Workspace panel is a map of the workspace that enables you to navigate the operators, layers, and objects in the workspace branches.

1. Select the two-viewport vertical layout.

Notice the border of the left viewport is highlighted, indicating the left viewport is the active viewport (by default).

2. Show the Workspace panel (F3).

The Workspace panel displays the contents and structure of the workspace. A workspace contains one branch for every top-level operator. In this case, the top-level operator is a Composite operator. The Composite operator contains four layers: the Warehouse layer, Lara layer, Platform layer and City layer.

The layers in this workspace are based on footage made out of either stills or image sequences. Explore the contents of the layers via the Footage Library view.

3. Choose Window | Footage Library (SHIFT+F12 or SHIFT+~).

The Footage Library view is displayed in the left viewport.

4. Zoom in on the four footage thumbnails that make up the scene.

The thumbnails to the left (city and platform) do not have any duration and frame rate information because they are still images. The thumbnails to the right (Lara[####] and wareh[####]) have a duration and frame rate information because they are image sequences. Both image sequences are 60 frames and have a frame rate of 29.97 fps.

5. Preview the animation of the Lara footage directly in the thumbnail by scrubbing the top of the thumbnail.

6. Choose Window | Footage Library (SHIFT+F12 or SHIFT+~) to return to the composite display.

- 7. Click Home.
- 8. Examine the layers:
 - a) In the Workspace panel (F3), double-click the City layer.
 In the Workspace panel, the viewport icon is next to the City layer, indicating the output of City layer is displayed in the active viewport, the left viewport. The City layer is the background in the composite.
 - **b)** Double-click the Warehouse layer to display its output it in the active viewport.
 - c) Go to the last frame (END).

The Warehouse layer contains an alpha channel that allows you to see other layers through the layer. Since the right viewport displays the output of the composite, the layers behind the Warehouse layer are seen as the door is kicked down.

d) Right-click / CONTROL-click the left viewport and choose View Mode | Alpha (CTRL+SHIFT+8 / CONTROL+SHIFT+8).

The viewport displays the alpha channel of the Warehouse layer. The black pixels represent transparency and the white pixels represent opacity.

- 9. View the contents of the Warehouse layer:
 - a) In the Workspace panel (F3), CTRL-click / % -click the triangle next to the Warehouse layer.

The contents of the Warehouse layer are expanded.

Hint: To expand the current object, you can also select the object and press CTRL+RIGHT ARROW / %+RIGHT ARROW.

b) Expand the Workspace panel (**SHIFT+F10**).

The Workspace panel is expanded and shown at the top left of the viewport. The Warehouse layer contains a Text operator and a Footage operator. The Text operator contains a text object. The text object contains the word "caution".

Note: You can expand the Workspace width via the Monitors Host category in the Combustion Preferences dialog.

c) Press **SHIFT+F10** to show the Workspace panel next to the Toolbar.

Make Changes to the Composite

You can make changes to a composite or to elements of a composite via the control panels, the viewport or the Schematic view. Here, make changes to a text object using the control panels. First, play the clip.

1. Click the right viewport to make it active.

- 2. Select the single-viewport layout.
 - 3. Play the animation (SPACEBAR).

Notice the shake in the clip. Various techniques such as tracking, parenting or animating the position of elements in a clip can be used to simulate the shaking effect. In this lesson, the Warehouse layer was moved to match the shake caused by the falling door.

- **4.** Go to the first frame (**HOME**).
- **5.** In the Workspace panel (**F3**), select the text object.
- **6.** In the Text Controls panel (**F8**), click Transform.
- 7. Change the Y Position and the Rotation values of the text object:
 - a) Click the Y Position field and change the value from 179.86 to 256.
 - b) Click the Rotation field and change the value from 0° to 35°.

Hint: You can also change values in a field by scrubbing the field.

The word CAUTION is now centered on the crate at a 35° angle.

Hint: You can undo your last change by choosing Edit | Undo Rotation Change (CTRL+Z/ 架 +Z). Go to the same menu to undo as many changes as set in the General Host category in the Combustion Preferences dialog.

Explore the Schematic View

Although the Workspace panel provides powerful means for managing and building workspaces, the Schematic view enables you to manage, build, and process workspaces or elements of a workspace. Examine the composite and learn how to navigate via the Schematic view.

1. Choose Window | Schematic (F12 or ~) or click the Schematic View button.

The Schematic view is a flowchart style view of the workspace. It displays a series of nodes. Each operator in the Workspace panel is represented by a node in the Schematic view. The arrows (or edges) connect the nodes and show the hierarchy of the composite.

Notice that the Schematic view shows that the Lara node contains a Discreet Keyer operator node and a Draw Mask operator node.

- 2. Position the nodes in the Schematic view:
 - a) Click and drag a node in the Schematic view.
 - b) Right-click / CONTROL-click any node and choose Layout (L) to reposition all the nodes.
- 3. Click the Zoom In button (CTRL+= / %+=) and the Zoom Out button (CTRL+- / %+-) to zoom in and out the Schematic view.

4. Pan the Schematic view by scrubbing the Pan button or by scrubbing the Schematic overview at the upper right of the viewport.

Touring Combustion

- 5. Right-click / CONTROL-click the Schematic and choose Flow Direction | Flow Up (SHIFT+UP ARROW) to change the flow direction to Flow Up.
- **6.** Choose Window | Schematic (F12 or \sim) to display the composite in the viewport.
- 7. (Optional) Save the workspace:
 - a) Choose File | Save Workspace (CTRL+S / 幾+S) to open the Save Workspace dialog.
 - b) Set a filename and directory for the workspace, and then click OK (ENTER / RETURN).
- 8. Choose File | Close Workspace (CTRL+W / 第+W) to close the workspace.

Creating Simple Composites

Lesson 2

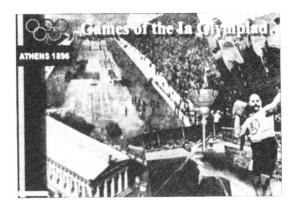

In this lesson, create a composite by importing footage and arranging the layers in the Workspace panel. Then, animate the layers, and add an animated title to the clip.

Overview

When you import images into a composite, they are added as layers. If you import an image with a pre-defined alpha channel, some areas of the image are transparent, allowing you to see other images behind it. If you import an image that does not contain an embedded alpha channel, you can still make areas of the image transparent by keying or masking part of the image.

For this lesson, import footage and create a simple composite. Scale, position, and animate the layers. Then, change the order of the layers in the composite. Since you import an image without alpha information, apply a matte channel to the image in the form of a grayscale image to define areas of transparency in the image. Finally, add some text to the composite.

In this lesson:

- Create a workspace with a composite branch.
- Import footage for the composite.
- Scale, position, and animate the layers.
- Rearrange the order of the layers in the Workspace panel.
- Add a Set Matte operator to a layer to define areas of transparency in the clip.
- · Create and animate text.

Open the 02_CreatingSimpleComposites.mov file in the 02_CreatingSimpleComposites folder and preview the result.

Need Help?

If you need help completing this lesson, save and close your workspace, and then open the 02_CreatingSimpleComposites.cws file as a reference.

Create a Composite

Create a composite branch and import footage to begin building the composite.

1. Check the Combustion preferences. For instructions, see "Setting the Preferences" on page 3.

2. Choose File | New or press CTRL+N (Windows) or 38+N (Macintosh) to open the New dialog and create a branch with the following properties:

• Type: Composite

· Name: CreatingSimpleComposites

· Format: NTSC DV · Duration: 45 frames

· Bit Depth: 8 Bit

· Mode: 2D

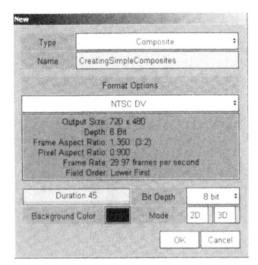

3. Select the single-viewport layout.

Notice the composite in the Workspace panel (F3) is empty. It contains no layers and no operators. The Footage Library is also empty. You need to import footage for the composite.

4. Choose File | Import Footage (CTRL+I / ₩+I) to open the Import Footage dialog.

Hint: You can also right-click / CONTROL-click the CreatingSimpleComposites composite in the Workspace panel and choose Import Footage.

- 5. In the Import Footage dialog, locate and open the 02_CreatingSimpleComposites folder.
- 6. Click Thumbnails to view the footage in the selected folder and enable Collapse to collapse the image sequences.

7. Import the images as follows:

- a) CTRL-click / 第-click the *Back.png* image and the *Olympic Torch.png* image.
- **b)** Double-click the *Flame* folder and click the *flame*[###].jpg image sequence.
- c) Double-click the Parent folder, double-click the Hand folder and click the hand [###].png image sequence.
- **d)** Double-click the *Parent* folder, double-click the *Rings* folder and click the *or*[####].png image sequence.

 The selected images are added in the import queue.

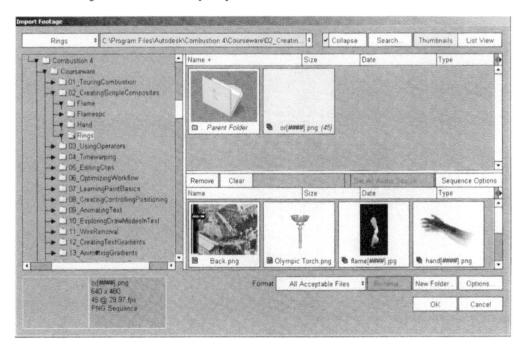

e) Click OK (ENTER / RETURN) to import the queued images into the composite.

Hint: Import footage in one import session by pressing CTRL-click / 第-click to add multiple still images and by double-clicking folders and clicking the image sequences.

The images are added to the composite in the order they are imported: the last file you select is the uppermost layer in the composite.

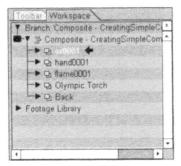

- **8.** Rename the layers in the Workspace panel:
 - a) Right-click / CONTROL-click the flame0001 layer, choose Rename and name the layer "Flame".
 - b) Rename the hand0001 layer "Hand".
 - c) Rename the or0001 layer "Olympic Rings".
- 9. Play the animation (SPACEBAR).

Playing the animation after importing the footage gives you a good idea of how the composite looks and what changes need to be done based on the 02_CreatingSimpleComposites.cws file.

Scale and Position the Olympic Rings and Torch

Now that you imported the footage for the composite, scale and position the Olympic rings and the Olympic torch.

- 1. Go to the last frame (END).
 - Since the Olympic rings have an animated fade-in effect, they are easier to see towards the end of the animation.
- 2. With the Olympic Rings layer still selected in the Workspace panel, click Transform in the Composite Controls panel (F8).
- 3. Scale the Olympic Rings layer:
 - a) Enable Proportional to keep X and Y Scale equal.
 - b) Set either of the Scale fields to 30%.

- 4. Position the Olympic Rings layer:
 - a) Set the X Position to -245.
 - b) Set the Y Position to 200.
- 5. Scale and position the Olympic Torch layer:
 - a) In the Workspace panel, select the Olympic Torch layer.
 - **b)** In the Composite Controls panel, disable Proportional.
 - c) Set the X Scale to 45% and the Y Scale to 70%.
 - d) Set the X Position to 130.
 - e) Set the Y Position to -60.
- 6. Play the animation (SPACEBAR).

The Olympic rings and torch are properly positioned and animated for the duration of the clip. However, since you moved the Olympic torch, you need to position and animate the hand.

Position and Animate the Hand

Make the hand move toward the Olympic torch at the beginning of the clip and end the animation with the hand taking the Olympic torch.

- 1. Go to the first frame (HOME).
- **2.** In the Workspace panel, select the Hand layer.
- 3. In the Composite Controls panel, enable Proportional and set either of the Scale fields to 90%.
- 4. Set the X Position to 250.
- 5. Set the Y Position to -175.
- **6.** Drag the animation slider bar in the Playback controls to frame 30.

- 7. Animate the Hand layer from frame 30 to the end of the clip:
 - a) Enable Animate (A).

- b) Set the X Position to 209.
- c) Set the Y Position to -125.
- d) Disable Animate (A).
- 8. Play the animation (SPACEBAR).

The hand moves toward the Olympic torch and takes the torch at frame 30.

Position and Change the Order of the Flame

The flame is slightly more complex to adjust since you need to remove the black background. Before removing the black background, position the flame and change the layer order in the Workspace panel.

- 1. Go to the first frame (HOME).
- 2. In the Workspace panel, select the Flame layer.
- 3. In the viewport, drag the flame image and position it on top of the Olympic torch.

- 4. Change the order of the layers in the composite:
 - a) In the Workspace panel, click the Flame layer and drag the cursor under the Olympic Torch layer.

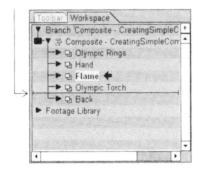

b) Release the cursor when a line appears under the Olympic Torch layer.

Notice in the viewport that the flame appears to be behind the Olympic torch.

Hide the Black Background of the Flame

The flame image sequence is a .JPG image sequence. This type of file cannot contain alpha information (defining transparency). Hide the black background by importing a grayscale image sequence into the Footage Library. Then, add a Set Matte operator to the Flame layer and use the grayscale image sequence as a matte for the Flame layer.

- 1. Choose File | Open (CTRL+O / %+O) to access the Open dialog.
- 2. Double-click the *Parent* folder, double-click the *Flameopc* folder, then select the *flameopc*[####].jpg image sequence and click OK (ENTER / RETURN).

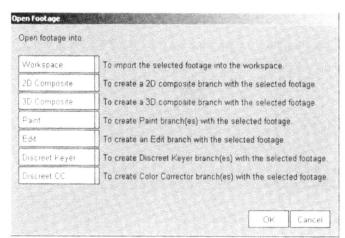

3. In the Open Footage dialog, select Workspace to import the selected footage into the Footage Library.

The viewport displays the grey scale image sequence you just imported. Opening footage in this manner does not create a layer for the footage but rather imports it into the Footage Library.

- 4. In the Workspace panel, click on the triangle next to the Footage Library to view its contents.
 - The *flameopc*[####].*jpg* image sequence is added to the Footage Library and is the current operator. You can use the footage as a stencil or a matte.
- 5. In the Workspace panel, double-click the CreatingSimpleComposites composite to make it the current operator.
- **6.** Add a Set Matte operator to the Flame layer:
 - a) In the Workspace panel, select the Flame layer.
 - **b)** Show the Operators panel **(F5)**.
 - **c)** In the Operators panel, click the Channel category.

d) CTRL-click / 38-click Set Matte.

A Set Matte operator is added to the Flame layer and the Set Matte Controls panel is displayed.

- 7. Set the flameopc[0000] footage as the matte for the Flame layer:
 - a) In the Workspace panel, select the Set Matte operator.
 - b) In the Set Matte Controls panel, click the Layer button to access the Layer dialog.
 - c) Scroll down to the Footage Library and select the flameopc[0000] footage.

d) Click OK (ENTER / RETURN).

Notice that the default selected Input channel for the matte is Luminance. This means that the Luminance channel of the flameopc [0000] footage sets the matte for the Flame layer.

Note: To achieve the same result, you could have just added a Set Matte operator to the Flame layer and then set the flameopc[0000] footage as the matte for the Flame layer by selecting Open Footage in the Layer dialog and importing the flameopc[0000] footage from the Import Footage dialog.

8. Play the animation (**SPACEBAR**).

Add Text to the Clip

Create a title for the clip.

- 1. Go to the first frame (HOME).
- 2. In the Workspace panel, right-click / CONTROL-click the Back layer and choose Operators | Text.

 A Text operator is added to the Back layer.
- 3. In the Text Controls panel (F8), click Text, then Basics.
- 4. Set the font for the text:
 - a) From the Font list, select Times New Roman.
 - **b)** From the Font Style, select Bold.
 - c) Set the Font Size to 50.
- 5. In the Text Editor, type "Games of the 1 Olympiad".

- 6. Set the attributes of the text:
 - a) In the Text Controls panel, click Attributes then double-click Face.

The Face option is enabled if its the gray box is yellow.

- b) Click the Color box and select white as the color in the Pick Color dialog.
- c) Double-click Outline to enable the text outline option.
- d) Click the Color box and select a medium blue color in the Pick Color dialog.

- e) Double-click Shadow to enable the text shadow option.
- f) Set the shadow Distance to 10.

Notice the text says "Games of the 1 Olympiad" instead of "Games of the I Olympiad". This can be easily corrected in a single step.

7. Go to the Text Editor and change "1" to "I".

Animate the Text

Now that you have a title for the clip, animate the text to make it move from right to left. Although you can animate the attributes of the text, here you only animate the position of the text.

- 1. Position the text for animation:
 - a) In the Workspace panel, select the text object under the Text operator.
 - b) Go to the last frame (END).
 - c) In the Text Controls panel, click Advanced.
 - d) From the Path Options Type, select Path.
 - e) In the Text Controls panel, click Transform.
 - f) Set the X Position to 419 and the Y Position to 45.
- **T 2.** In the Toolbar (**F2**), click the Text tool.

The text string appears on a line.

3. In the Text Controls panel, click Advanced.

4. Animate the text:

- a) Enable Animate (A).
- **b)** Click the Go to Start button in the Playback controls.
- c) In the Text Controls panel, set Path Offset to 130%.

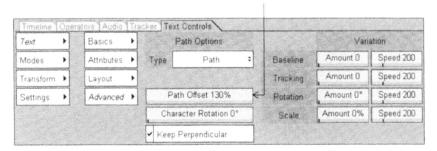

Path Offset sets where the text begins relative to the first point of the path.

- d) Go to frame 25.
- e) In the Text Controls panel, set Path Offset to 0%.

5. Preview the animation:

- a) In the Workspace panel (F3), double-click the CreatingSimpleComposites composite.
- **b)** Go to the first frame (**HOME**).
- c) Play the clip (SPACEBAR).
- **6.** (Optional) Save the workspace:
 - a) Choose File | Save Workspace (CTRL+S / ૠ+S) to open the Save Workspace dialog.
 - **b)** Set a filename and directory for the workspace, and then click OK (**ENTER** / **RETURN**).
- 7. Choose File | Close Workspace (CTRL+W / ૠ+W) to close the workspace.

of an one Managar

and the state of t

Alexander of the larger of the second restriction of the second restri

Using Operators in a Composite

Lesson 3

In this lesson, create a composite, then
create a matte for a layer, suppress a color in
an image and, improve the brightness and
contrast in the clip using various operators
to give the composite a more realistic look.

Overview

To change the appearance of a layer, add an operator. Operators enable you to create special effects to layers based on the footage and on any previously applied operators on that layer. Once added, operators can be turned on and off, and copied from one layer to another.

In this lesson:

- Add a Set Matte operator to a layer to define transparency areas in the clip.
- Extend the duration of a Footage operator.
- Scale and animate layers.
- Add a Brightness/Contrast operator to two layers to give the clip a more realistic look.
- Add a Linear Keyer operator to a layer to remove the layer's blue background.

Open the 03_UsingOperators.mov file in the 03_UsingOperators folder and preview the result.

Need Help?

If you need help completing this lesson, save and close your workspace, and then open the 03_UsingOperators.cws file as a reference.

Create a Composite

Create a composite branch and import footage to begin building the composite.

- 1. Check the Combustion preferences. For instructions, see "Setting the Preferences" on page 3.
- 2. Choose File | New or press CTRL+N (Windows) or %+N (Macintosh) to access the New dialog.
- 3. Create a branch with the following properties:
 - Type: Composite
 - Name: 03_UsingOperators
 - Format: NTSC
 - · Duration: 60 frames
 - Bit Depth: 8 Bit
 - Mode: 2D

- **4.** Select the single-viewport layout.
 - 5. In the Workspace panel (F3), right-click / CONTROL-click the 03_UsingOperators composite and choose Import Footage (or press $CTRL+1 / \Re +1$).

- **6.** In the Import Footage dialog, do one of the following to locate the *03_UsingOperators* folder:
 - · Navigate the file browser.
 - Edit the path at the top of the dialog.

• Click the browser menu button to the left of the path.

Hint: To select a recently used folder, click the menu button to the right of the path.

7. Scrub the *03_UsingOperators.mov* thumbnail to preview the result clip.

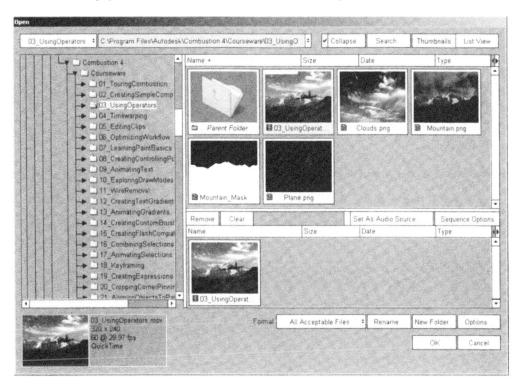

8. Click Clouds.png, CTRL-click / % -click Mountain.png and Plane.png (in this order), and click OK (ENTER / RETURN) to import the queued images into the composite.

The last image you selected—*Plane.png*—is the uppermost layer in the composite.

Change the Appearance of the Sky

There are several methods you can use to change the appearance of the sky in the mountain image, including masking and keying. In this lesson, use a method that is very popular in the motion picture industry called matte. A matte is a black and white image you add to an element in a clip to define ares of opacity and transparency. First, add a Set Matte operator to the Mountain layer, then use an image you import as the matte for the Mountain layer.

1. In the Workspace panel (F3), turn off the Plane layer by clicking the layer's icon.

- In the Workspace panel, right-click / CONTROL-click the Mountain layer and choose Operators | Channel | Set Matte.
- 3. Use the Mountain_Mask image as the matte for the Mountain layer:
 - a) In the Workspace panel, select the Set Matte operator.

- **b)** In the Set Matte Controls panel, click the Layer button.
- c) In the Layer dialog, click Open Footage.

In the Import Footage dialog, in the 03_UsingOperators folder, notice the Mountain_Mask.png image is a black and white image. The black area of the image represents complete transparency and the white area of the image represents complete opacity.

d) Select the Mountain_Mask.png and click OK (ENTER / RETURN).

The transparent area of the *Mountain_Mask.png* image reveals the underlying layer—the Clouds layer. The default Luminance Input Channel (in the Set Matte Controls panel) sets the alpha to zero.

e) Change the viewport display quality to the right of the Playback controls to Preview.

4. In the Workspace panel, expand the Footage Library.

Notice the Mountains_Mask footage is added to the Footage Library.

- 5. Select the Mountain_Mask Footage operator.
- **6.** In the Footage Controls panel, select Source.

The Mountain_Mask footage has a duration of 30 frames. Still images imported into the Footage Library are set to the default duration specified in the Combustion Preferences dialog, under the General Footage category.

7. In the footage details, change the duration of the Mountains_Mask footage from 30 to 60 frames to match the duration of the clip.

Scale and Animate the Clouds

Scale, position, and animate the Clouds layer to create a more realistic composite.

- 1. In the Workspace panel, select the Clouds layer.
- 2. In the Composite Controls panel (F8), click Transform.
- 3. Scale and position the Clouds layer:
 - a) Disable Proportional.
 - b) Set the X Scale to 120.

The yellow border indicates the frame size of the Clouds layer.

- c) Set the Y Scale to 75.
- d) Set the Y Position to 100.
- 4. Animate the Clouds layer:
 - a) Enable Animate (A).
 - b) Go to the last frame (END).
 - c) Set the X Position to -8.
 - d) Disable Animate (A).
- 5. Preview the result:
 - a) Go to the first frame (HOME).
 - **b)** Click in the workspace panel background to deselect the Clouds layer.
 - c) Play the clip (SPACEBAR).

The clouds appear to move slightly from right to left.

Note: If you do not have enough RAM to view the clip in real time, select Medium or Draft from the Display Quality list to the right of the Playback controls. This lowers the file resolution in the viewport and allows you to cache more frames.

Color Correct the Clouds and the Mountain

Create a more realistic-looking composite by adding Brightness/Contrast operators to the Clouds and Mountain layers.

- 1. Go to the first frame (HOME).
- 2. Add a Brightness/Contrast operator to the Clouds layer:
 - a) In the Workspace panel, click the Clouds layer.
 - b) In the Operators panel (F5), click the Color Correction operator category in the list of Operator categories.

Operators in the selected category

- c) CTRL-click / %-click the Brightness/Contrast operator in the list of Color Correction operators to access automatically the Brightness/Contrast Controls panel.
- $\textbf{d)} \ In the Brightness/Contrast \ Controls \ panel, set \ Brightness \ to \ 20\% \ and \ Contrast \ to \ -20\%.$

The clouds are brighter and the contrast with the mountains is greater. Now, improve the look of the mountains by adding the same operator to the Mountains layer.

- 3. Copy the Brightness/Contrast operator to the Mountain layer:
 - a) In the Workspace panel, right-click / CONTROL-click the Brightness/Contrast operator and choose Copy.
 - **b)** Right-click / **CONTROL**-click the Mountain layer and choose Paste.
- 4. In the Workspace panel, select the Brightness/Contrast operator under the Mountain layer.

Notice the Brightness is set to 20% and the Contrast is set to -20%. Although this operator is a copy of the original, you can change its brightness and contrast values.

5. In the Brightness/Contrast Controls panel, set Brightness to 10% and Contrast to 20%.

The improvement in the brightness and contrast of the mountain and clouds give the composite a more realistic look.

Reintroduce the Plane in the Scene

The only thing left to do is include an animated plane in the scene. Since you already imported the *Plane.png* image, you need to turn the layer on again and then remove the blue background from the image. One method of removing the blue background is by adding a Linear Keyer operator to the Plane layer. Keying is a very important part of compositing. It allows you to turn areas of your footage transparent based on pixel values, usually blue or green.

- In the Workspace panel, turn the Plane layer back on by clicking the layer's icon.
 The image of a plane appears on a blue background.
- 2. Remove the blue background using the Linear Keyer:
 - a) In the Workspace panel, right-click /CONTROL-click the Plane layer and choose Operators | Keying | Linear Keyer.

- **b)** In the Linear Keyer Controls panel, click the Key Color picker.
- c) In the viewport, click the blue background of the plane image.
 Most of the blue is removed from the layer. The only blue pixels remaining are around the edge plane.

- d) Zoom in (CTRL+= $/ \Re +=$) the viewport.
- **e)** In the Linear Keyer Controls panel, set Tolerance to 10% and Cleanup to 100%. The remaining blue is removed from the layer.

f) Zoom out (CTRL+-/ \cong +-) the viewport.

Animate the Plane

All that is left to do is animate the motion of the plane.

- 1. Position the plane for animation:
 - a) In the Workspace panel, select the Plane layer.
 - b) Make sure you are at frame 1.
 - c) In the Composite Controls panel, click Transform.
 - d) Set the X Position to 200.
- 2. Animate the plane:
 - a) Go to the last frame (END).
 - b) Enable Animate (A).
 - c) Set the X Position to -75 and the Y Position to -50.
 - d) Set the Z Rotation to 15°.
 - e) Enable Proportional and set either Scale fields to 65%.
 - f) Disable Animate (A).

The plane's motion path is displayed in the viewport.

3. Preview the result:

- a) Go to the first frame (HOME).
- b) Click in a gray area in the viewport to deselect the Plane layer.
- c) Play the clip (SPACEBAR).

The plane appears to fly toward the horizon.

- **4.** (Optional) Save the workspace:
 - a) Choose File | Save Workspace (CTRL+S / 38+S) to open the Save Workspace dialog.
 - **b)** Set a filename and directory for the workspace, and then click OK (**ENTER** / **RETURN**).
- 5. Choose File | Close Workspace (CTRL+W / ૠ+W) to close the workspace.

Timewarping Lesson 4

In this lesson, create a speed ramp with the
Timewarp to gradually change the action to
a speed slower than originally recorded and
then enhance the speed change with an
adaptive motion blur.

Overview

This lesson shows you how to use the Timewarp Operator to make the speed of the action taking place appear to go slower than originally recorded. A Timewarp can have timing, speed, or duration keyframes and can be enhanced by using a variety of frame interpolation controls. In this lesson, add a Variable Timewarp to the clip to change the speed of the action.

In this lesson:

- Add a Timewarp operator to the clip.
- Change the duration of the footage.
- Create two speed ramps for a slow motion effect.
- · Apply a frame interpolation to enhance the slow motion effect.

Open the 04_Timewarping.mov file in the 04_Timewarping folder and preview the result.

Need Help?

If you need help completing this lesson, save and close your workspace, and then open the 04_Timewarping.cws file as a reference.

Create a Composite

Create a composite branch and import footage to begin building the composite.

- 1. Check the Combustion preferences. For instructions, see "Setting the Preferences" on page 3.
- 2. Choose File | New or press CTRL+N (Windows) or %+N (Macintosh) to access the New dialog.
- 3. Create a branch with the following properties:
 - Type: Composite
 - · Name: 04_Timewarping
 - · Format: NTSC DV
 - · Duration: 120 frames
 - · Bit Depth: 8 Bit
 - · Mode: 2D

- **4.** Select the single-viewport layout.
 - 5. In the Workspace panel (F3), right-click / CONTROL-click the 04_Timewarping composite and choose Import Footage (or press CTRL+1 / 38+1).

- **6.** In the Import Footage dialog, do one of the following to locate the 04_Timewarping folder:
 - · Navigate the file browser.
 - Edit the path at the top of the Import Footage dialog.

• Click the browser menu button to the left of the path.

Hint: To select a recently used folder, click the menu button to the right of the path.

- 7. In the Import Footage dialog, enable Collapse and select Thumbnails.
- **8.** Double-click the *Moto* folder, then double-click the *moto_c###.png* image sequence. The image sequence is imported into the workspace.
- 9. Rename the moto_C0189 layer:
 - a) In the Workspace panel (F3), right-click / CONTROL-click the moto_C0189 and choose Rename.

- **b)** Enter "Moto" and press **ENTER** / **RETURN**.
- 10. Play the clip:
 - a) Choose Window | Fit in Window or click Home.
 - **b)** Play the clip (**SPACEBAR**).

The footage has a duration of 80 frames and the last 40 frames of the composite are black.

Extend the Duration of the Clip

There are several ways you can extend the duration of a clip. You can stretch the duration of a clip via the footage controls or by applying a Timewarp to the footage layer. Because the effect involves the slowing down of footage, extra frames are created. As a result, when you play back the clip, the black frames are replaced by the extra frames. If you extend the duration of a clip via the Footage Controls, the speed is constant. In this lesson, the speed of the action is not constant so you need to use the Timewarp operator to vary the speed of the action.

- 1. Extend the duration of the footage by applying a Timewarp operator to the Moto layer:
 - a) Go to (/) frame 1.
 - b) In the Operators panel (F5), click the Favorites category in the list of Operator categories.

Operators in the selected category

c) CTRL-click / 第-click the Timewarp to access automatically the Timewarp Controls panel.

Hint: You can also choose Operators | Timewarp or right-click / **CONTROL**-click the Moto layer in the Workspace panel and choose Operators | Timewarp.

d) In the Timewarp Basic Controls, extend the duration of the footage to 120 frames.

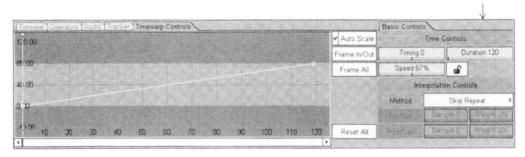

Extending the duration of the footage from 80 frames to 120 frames reduced the speed of the action from 100% to 67%.

Change the Speed of the Action

Build the speed ramp slow motion effect by keyframing the speed percentage. Slow down the speed of the action as the motorcycle comes closer to the camera, then gradually increase the speed (to the clip's original speed) as the motorcycle comes close to the camera. Before changing the speed, examine the Timewarp Curve Editor.

1. Examine the Timewarp Curve Editor.

The key elements in the Curve Editor are the timing curve (a solid line) and the speed curve (a broken line). The timing curve represents the mapping between frames of the source footage and frames of the output. The speed curve represents the speed at which the source footage is playing at any given point in time, relative to its original speed. The following image represents a Constant Timewarp—the speed is constant throughout the clip. By changing the duration to of the footage to 120 frames, the speed for the clip has been uniformly changed to 67%.

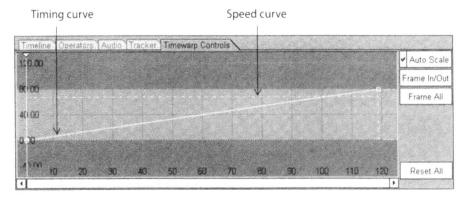

When the speed varies, the Timewarp is a Variable Timewarp.

2. At frame 1, in the Timewarp Time Controls, change the speed of the action to 100%.

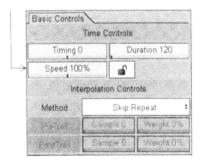

4 Timewarping

- 3. Change the speed at frame 30:
 - a) Go to (/) frame 30.
 - **b)** Set the speed to 100%.

For the first 30 frames, the clip plays at the original speed—100%.

- 4. Change the speed at frame 50:
 - a) Go to (/) frame 50.
 - **b)** Set the speed to 20%.

The speed gradually slows down to 20%

- 5. Change the speed at frame 80:
 - a) Go to (/) frame 80.
 - b) Set the speed to 20%.

The speed remains at 20% for a duration of 30 frames.

- **6.** Change the speed at frame 100:
 - a) Go to (/) frame 100.
 - **b)** Set the speed to 100%.
- **7.** Change the speed at frame 120:
 - a) Go to (/) frame 120.
 - b) Set the speed to 100%.

The clip finishes at its original speed—100%. The result of the changes are displayed in the following Timewarp Curve Editor image.

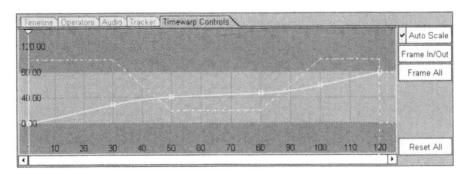

Note: You cannot manipulate the Speed Curve.

8. Play the clip (SPACEBAR) to view the result of your changes.

Notice that at 20% speed, frames 50 through 80 are jerky and appear to be strobing.

Improve the Quality of the Change in Speed

The Timewarp operator uses the Skip Repeat default Interpolation method to create the appearance of slower footage. In other words, in this lesson, it displays the same frame more than once. Frames 50 through 80 of the Timewarp Operator are "repeating" the same frame 3, 4 and sometimes 5 times. Change the frame Interpolation mode to improve the smoothness of the Timewarp.

- 1. Go to the Timewarp Time Controls.
- 2. In the Interpolation Controls, set the interpolation method to Adaptive.

Adaptive uses the Trail Method, blending multiple frames before and/or after the current frame, but automatically computes the trail length based on speed.

3. Play the clip (SPACEBAR).

The clip is no longer jerky and the change in speed is smoother.

- 4. (Optional) Save the workspace:
 - a) Choose File | Save Workspace (CTRL+S / 38+S) to open the Save Workspace dialog.
 - b) Set a filename and directory for the workspace, and then click OK (ENTER / RETURN).
- 5. Choose File | Close Workspace (CTRL+W / ૠ+W) to close the workspace.

and the state of t

ay to the following the standard philadelphic and the requestion as a second of the se

to each over the Challity of the Change in Speed

de de la lace de la compaña de la compaña de la compaña entre grande la lace de la compaña de la compaña de la La compaña de la compaña d La compaña de la compaña d

A STATE BANK A BANK

Andrew Control of the Control of the

ng paramatan na managan na managa Tanggan na managan na m

part of the second of the seco

ൂട്ടിനെയോടെ ടത്തുള്ള നിന്നും വിഷയില് പ്രവിഷ്ട്രം വിവിച്ചിട്ടുന്ന്

i king maka terak terpelagi ma

etag i transportation de la companya de la companya

Editing Clips Lesson 5

In this lesson, create an edited sequence of sports clips that you will composite over a scrolling grid background with an animated title sequence.

Overview

In this lesson, you learn to create an edited sequence of sports clips and that will be composited onto the Scrolling grid with an animated title sequence. You use the Edit Operator to import and sequentially arrange footage in time. The Edit operator enables you to easily rearrange edit segments at any time during the work in progress, and add a variety of transitions from one piece of footage to the next. It also enables you to determine which frames to show in the edit sequence.

In this lesson:

- · Create an Edit branch with the selected footage.
- · Set a fixed duration for the Edit sequence.
- Trim segments.
- Import additional footage and rearrange the Edit segments.
- · Import additional footage and overwrite frames.
- · Slip a segment.
- · Add various transitions effects.
- Merge the Edit sequence branch with the Title Sequence branch.

Open the 05_TitleSequence.mov file in the 05_EditingClips folder and preview the result.

Need Help?

If you need help completing this lesson, save and close your workspace, and then open the 05_TitleSequence.cws file as a reference.

Open the Starting Workspace

Start by opening a workspace. This workspace is the baseline for this lesson.

- 1. Check the Combustion preferences. For instructions, see "Setting the Preferences" on page 3.
- Choose File | Open Workspace or press CTRL+SHIFT+O (Windows) or %+SHIFT+O (Macinfosh) to access the Open Workspace dialog.
- 3. In the Open Workspace dialog, locate and open the 05_EditingClips folder by either navigating the file browser or editing the path at the top of the dialog.
- **4.** Double-click the 05_TitleSequence_start.cws file.
- 5. Select the single-viewport layout.
 - **6.** Play the clip (**SPACEBAR**).

The 240-frame composite shows an animated large blue scrolling grid background and an animated text.

Create an Edit Branch

Open footage to create an Edit branch with the selected footage. Then, adjust the output settings of the Edit sequence to a fixed duration.

- 1. Choose File | Open or press CTRL+O (Windows) or **%+O** (Macintosh) and use the file browser to locate and open the 05_EditingClips folder.
- 2. In the Open dialog, enable Collapse and select Thumbnails.
- 3. Import the footage as follows:
 - a) Double-click the BMX folder and then click the Bmx[###].png image sequence.
 - **b)** Double-click the *Parent* folder, double-click the *Inline* folder, and then double-click the *Inline*[####].png image sequence.

The Open Footage dialog appears.

c) Select Edit to create an Edit branch with the selected footage and click OK (ENTER / RETURN).

An Edit branch is added at the top of the composite branch and the Edit Controls are displayed. Opening footage this way allows the edit operator to automatically inherit the dimensions of the frame rate of the source footage. Notice the footage in the viewport is interlaced.

- 4. Change the footage settings to display the interlaced fields properly:
 - a) In the Workspace panel, click the triangle next to the Bmx layer to access its contents.
 - **b)** Select the Footage BMX[###] operator.
 - c) In the Footage Controls (F8), select Source.
 - d) In the Field Separation list, select Lower.
 - e) In the Workspace panel, click the triangle next to the the Inline layer to access its contents.
 - f) Select the Footage Inline[###] operator.
 - **g)** Perform steps c and d for the Inline footage.
- **5.** In the Workspace panel, select the Edit operator to access the Edit Controls.

5 Editing Clips

The Edit Controls show the Edit operator containing the BMX segment (sequence) and the Inline segment (sequence). The duration of the Edit operator is 180 frames.

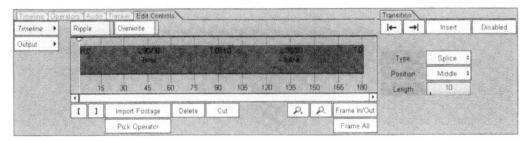

- **6.** Extend the duration of the Edit operator:
 - a) In the Edit Controls, click Output.
 - b) In The Duration field, enter 240.
 - c) Disable Auto Adjust Duration to set the duration of the Edit operator to the duration specified in the Duration field.

Frames in the Edit Timeline beyond 240 frames are ignored when Auto Adjust Duration is disabled.

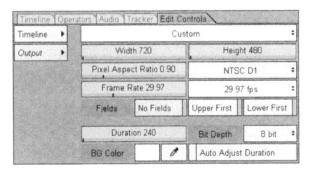

When enabled, Auto Adjust Duration enables the Edit operator duration to dynamically update to match the length of the edit segments.

7. Play the clip:

a) Go to the end of the clip (END) and choose Movie | Mark Out Point (SHIFT+O) to set the playback range to the end of the clip.

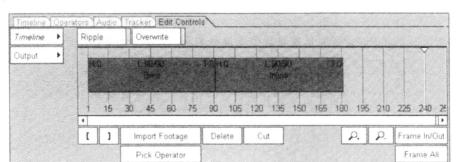

b) In the Edit Controls, click Timeline.

- c) Click Frame All.
- d) Go to frame 1.
- e) Play the clip (SPACEBAR).

The imported Bmx image sequence plays from frame 1 to frame 90, followed by the Inline image sequence from frame 91 to frame 180. As there is no segment past frame 180, the default white background fills the frames throughout the remainder of the Edit sequence.

Trim the Segments

A segment in the Edit Timeline represents a section of a clip that can be edited. The segment name, duration (L), and any available head (H) and tail (T) frames in the original source clip are displayed in the segments. Refine the Edit sequence by trimming the segments. Selecting which frames of each segments are played is an extremely important part of the editing process. Using various methods and tools to lengthen and shorten segments in the Edit Timeline is generally referred to as "trimming". It is also important to note that trimming segments is completely non-destructive leaving the original source footage untouched.

- 1. Go to (/) frame 1.
- **2.** In the Edit Timeline controls, ensure Ripple is selected.

When Ripple is enabled, the overall length of the Edit sequence either increases or decreases—ripples—when you add or remove segments in the Timeline.

5 Editing Clips

- **3.** Trim the tail of the Bmx segment:
 - a) Press CTRL / R and in the Edit Timeline controls, click and hold the Bmx segment.

The total length of the segment is displayed by a semi-transparent bar under the segment.

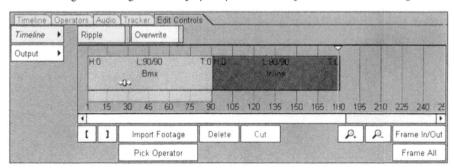

b) Release the mouse.

There are no head frames (H:0) and no tail frames (T:0) available. The segment and source duration is 90 frames (L:90/90).

c) Move the mouse over the tail (right) end of the Bmx segment and when the cursor changes to the Trim tool, click and drag to the left until the tail (T) value shows 12.

The last 12 frames of the Bmx segment, although still available in the footage, are not displayed in the Edit Timeline. Additionally, the Inline segment rippled to begin 12 frames earlier and the overall length of the Edit sequence decreased by 12 frames. The number of Bmx tail frames available is 12 and the segment duration is 78 frames.

- 4. Trim the head of the Inline segment:
 - a) Choose Editing | Go to Next Segment (.) or click the Go to Next Segment button in the Transition Controls.

The Current Time indicator is at frame 79. The first frame of the Inline segment is displayed in the viewport.

b) Move the mouse over the head (left) end of the Inline segment and when the cursor changes to the Trim tool _____, click and drag to the right until the head (H) value shows 12.

The number of Inline head frames available is 12 and the Inline segment duration is 78 frames out of 90 available frames. The overall length of the Edit sequence is 156 frames.

- 5. Play the sequence:
 - a) Go to (/) frame 1.
 - b) Play the sequence (SPACEBAR).

The BMX rider completes his jump and then the Inline skater segment plays. The skater completes his flip and the segment ends with the skater on the ramp. The remainder of the sequence from frame 157 is empty.

Import Footage and Rearrange the Sequence

Import footage and rearrange the order of the segments in the Edit Timeline. As every piece of source material may not be available at the beginning of the editing process, the ability to append segments to the sequence as well as the ability to rearrange segments is extremely important.

- 1. Go to (/) frame 1.
- 2. In the Edit Timeline controls, click Import Footage.
- 3. In the Import Footage dialog, click the Surfer folder in the 05_EditingClips folder.
- **4.** Double-click the *Surf[###].png* image sequence.

The Surf segment is added at the beginning of the Edit sequence.

- 5. Rearrange the sequence:
 - a) In the Edit Timeline controls, click and drag the Surf segment upward and slightly to the right.

The Bmx and Inline segments ripple.

5 Editing Clips

b) Hold the SHIFT key and drag the Surf segment to the right.

The SHIFT key allows precise editing via segment snapping. The Surf segment snaps to the nearest marker, cut point, transition head, transition tail, the current time indicator, or frame 0. In this case, it snaps to the splice point where the Bmx and Inline segments meet. As you drag the segment, the frame number appears under the cursor, indicating the start and end point of the segment.

- c) Release the mouse.
- 6. Play the sequence (SPACEBAR).

The Surf segment is now the second segment in the sequence; it starts at frame 79. The Inline segment is now the third segment and ends beyond the final frame (240). Since the duration of the Edit branch is set to 240 and Auto Adjust Duration is disabled, the Edit sequence end frames past frame 240 are not played back.

Overwrite a Range of Frames

Add a segment to the sequence without altering the overall duration. In some cases when building an edit, it is necessary to cover a portion of the exiting sequence without adjusting the timing of surrounding edits. Defining a range of frames to cover combined with overwrite editing allows this type of change to be accomplished quickly and easily.

- 1. Select the frames you want to edit:
 - a) Go to (/) frame 1.
 - b) Choose Editing | Go to Next Segment (.) or click the Go to Next Segment button ______ to position the Current Time indicator at the splice point between the Bmx and the Surf segments (at frame 79).
 - c) In the Edit Timeline controls, click the Mark In button \cite{t} (1).

This sets a mark in point to the Edit Timeline.

d) Go to frame 126 and click the Mark Out button 1 (I).

This sets a mark out point to the Edit Timeline and a frame range selection is created (indicated by the highlighted portion of the Surf segment in the Edit Timeline).

- **2.** Overwrite the Selected range with Imported Footage:
 - a) In the Edit Timeline controls, click Import Footage.
 - **b)** In the Import Footage dialog, click the *Skater* folder in the *05_EditingClips* folder.
 - c) Double-click the Skater[###].png image sequence.

The Skater segment is added however, only the first 47 frames of the 90 frames available in the source footage are used.

- 3. In the Edit Timeline controls, click the Mark In button and the Mark Out button to disable the frame range.
- 4. Play the Edit sequence:
 - a) Go to (/) frame 1.
 - b) Play the Edit sequence (SPACEBAR).

Notice the Skater image sequence appears somewhat incomplete as the action ends before the skater completes his slide along the ramp. This is adjusted in the next part of the lesson. Before you do this, change the footage settings to display the interlaced fields properly.

- 5. In the Workspace panel, click the triangle next to the Skater layer to access its contents.
- **6.** Select the Footage Skater[###] operator.

5 Editing Clips

- 7. In the Footage Controls (F8), select Source.
- **8.** In the Field Separation list, select Lower.

Slip a Segment

In many cases when building an Edit sequence, the change in the segment order and timing from one segment to the next may be right but the content of a segment may need to be altered to reveal a better portion of the underlying footage. The Edit operator enables you to easily slip segments to achieve the desired result.

- 1. Go to (/) frame 1.
- 2. In the Workspace panel, select the Edit operator.
- 3. In the Transition controls, click the Go to Next Segment button twice to position the Current Time indicator to the splice point between the Skater and Surf segments.
- **4.** Go to the previous frame to display the last frame of the Skater in the viewport.
- 5. Press CTRL / H and drag the Skater segment toward the left until the Skater segment shows H:17 and T:26.

 It is important to notice that during this process the segment and source duration value (L: 47/90) does not change. The timing of the overall sequence is not affected, only the content of the Skater segment.
- **6.** Go to (/) frame 1 and play the Edit sequence (**SPACEBAR**).

The Skater segment now shows the complete slide of the skater along the rim of the ramp.

Add Transitions

The default transition where one segment meets the next in the Edit Timeline is known as a splice. However, a splice is one of three types of transitions available in the Edit Operator. The different types of transitions can be used to take away from the monotony of using splices all the time. They are also used to soften what might normally be a jarring visual change. Add a transition between the Bmx and Skater segments and between the Skater and Surf segments.

1. Position the Current Time indicator at the splice point between the Bmx and Skater segments.

2. Insert a Dissolve transition:

a) In the Transition controls, change the Type to Dissolve, Position to Middle, and Length to 10 (expressed in frames).

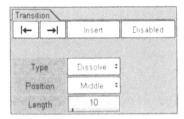

b) Click Insert.

A Dissolve icon is inserted at the splice point between the two segments on the Edit Timeline.

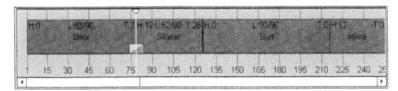

As the Dissolve uses hidden frames of the underlying source footage to create the effect, the Head, Tail and Length values of each segment change to reflect the frames exposed by the transition. However neither the physical lengths of the segments on the Edit Timeline nor the overall duration of the sequence have changed. The viewport now displays a frame equally mixed from both the Bmx and Skater segments.

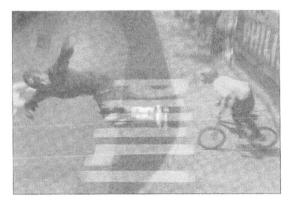

3. Position the cursor over the tail end of the Dissolve icon between the Bmx and Skater segments and when the cursor changes to the Trim tool , click and drag to the right until the length (indicated in the Transition controls) value is 17.

5 Editing Clips

4. Go to (/) frame 1 and play the Edit sequence (**SPACEBAR**).

The Dissolve transition uses a greater number of head frames from the Skater segment than tail frames from the Bmx segment.

- 5. Insert a Wipe transition at the splice point between the Skater and Surf segments:
 - a) Choose Editing | Go to Previous Segment (,) or choose Editing | Go to Next Segment (.) and position the Current Time indicator at the splice point between the Skater and Surf segments.
 - **b)** Choose Editing | Insert Wipe (**W**).

A Wipe transition icon is inserted at the splice point between the two segments on the Edit Timeline. Since the Surf segment has no available head frames (H:0), the default Length and Position of the Wipe transition is modified to the best available settings. The Wipe transition starts at the splice point due to the lack of available head frames in the Surf segment.

- **6.** Preview the result of the Wipe transition:
 - a) Press CTRL+PAGE UP / 98+PAGE UP twice to go back 10 frames.
 - b) Play the clip (SPACEBAR).

The viewport displays a Wipe transition traveling from right to left from frame 127 to frame 131.

- 7. Modify the Wipe transition:
 - a) In the Transition controls, click the Go to Next Segment button button and position the Current Time indicator at the splice point between the Skater and Surf segments.
 - **b)** In the Edit Timeline controls, click the Zoom tool ρ twice to zoom in on the Wipe icon.
 - c) Click the Wipe icon to see its attributes in the Transition controls.

The Wipe transition travels left to right and has a duration of five frames.

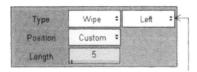

d) Click Left and choose Right from the Wipe direction list.

As the surfer in the Surfer segment is moving from left to right, it makes more sense for the wipe to travel in the same direction.

- **8.** Preview the result of the Wipe transition:
 - a) Press CTRL+PAGE UP / \#+PAGE UP twice to go back 10 frames.
 - b) Click Frame All to display the entire Edit sequence in the Edit Timeline controls.
 - c) Play the clip (SPACEBAR).

The viewport displays a Wipe transition traveling from left to right from frame 127 to frame 131.

- 9. Insert a Dissolve transition at the splice point between the Surf and Inline segments:
 - a) Position the Current Time indicator at the splice point between the Surf and Inline segments.
 - **b)** Choose Editing | Insert Dissolve (**D**).

A Dissolve transition icon is inserted at the splice point between the two segments on the Edit Timeline. Since the Surf segment has no available tail frames (T:0), the default Length and Position of the Dissolve transition is modified to the best available settings. The Dissolve transition must end at the splice point due to the lack of available tail frames in the Surf segment.

- **10.** Preview the result of the Dissolve transition:
 - a) Press CTRL+PAGE UP / \#+PAGE UP twice to go back 10 frames.
 - **b)** Click Frame All to display the entire Edit sequence in the Edit Timeline controls.
 - c) Play the clip (SPACEBAR).

The Dissolve transition from the Surf segment to the Inline segment begins five frames before the end of the Surf segment and ends at the splice point with the Inline segment.

Merge the Edit and Title Sequence Branches

Use the Edit Branch as the source operator of the Video Project Edit Layer in the Title Sequence Composite Branch to complete the composite effect.

- 1. Go to (/) frame 1.
- 2. Copy the Edit operator to the Video Projection Edit layer in the 05_TitleSequence composite branch:
 - a) In the 05_TitleSequence composite branch, expand the Video Projection Edit layer.

The layer contains a Resize filter and a Rectangular Mask operator. It does not contain any footage.

- b) In the Workspace panel, right-click / CONTROL-click the Edit operator and choose Copy (CTRL+C / 第+C).
- c) Right-click / CONTROL-click the Video Projection Edit layer and choose Paste (CTRL+V / 98+V).

The Edit operator is added to the Video Projection Edit layer, under the Rectangular Mask operator.

3. Preview the result:

- a) In the Workspace panel, double-click the 05_TitleSequence composite branch to see its output in the viewport.
- b) In the Workspace panel, click the icon next to the Video Projection Edit layer to show the output of the Video Projection Edit layer in the viewport.
- c) Play the clip (SPACEBAR).

The output of the edited sequence is masked, resized, and composited into the animation using perspective and a Colorize transfer mode, and appears to be projected onto the Scrolling Grid.

4. Clean up your Workspace:

- a) In the Workspace panel, select the Edit Branch.
- b) Choose Edit | Delete (**DELETE** / **DEL**).

Since the 05_TitleSequence composite branch is complete and includes the Edit sequence, you do not need to keep the Edit branch.

5. (Optional) Save the workspace:

- a) Choose File | Save Workspace (CTRL+S / 38+S) to open the Save Workspace dialog.
- b) Set a filename and directory for the workspace, and then click OK (ENTER / RETURN).
- 6. Choose File | Close Workspace (CTRL+W / ૠ+W) to close the workspace.

Optimizing Workflow

Lesson 6

In this lesson, familiarize yourself with

Workspace, viewport, Timeline, and File

Save features to save time, simplify

workflow, and increase productivity.

Overview

Composites can become quite deep and complex, from multiple operators and layers to intense keyframed animations. Using the Compare Tool, Timeline Filters and shortcut keys, you can find the information you are looking for in a composite faster and easier and move around the user interface with more confidence.

In this lesson:

- Expand and navigate the Workspace panel with hot keys.
- Compare frames with the Compare tool.
- · Navigate and filter channels in the Timeline with hot keys.
- · Create a custom channel filter.
- · Navigate viewports with hot keys.
- Save Incremental versions of the Workspace.
- · Render Incremental versions of the final output.

Open the 06_OptimizingWorkflow.mov file in the 06_OptimizingWorkflow folder and preview the result.

Need Help?

If you need help completing this lesson, save and close your workspace, and then open the 06_OptimizingWorkflow.cws file as a reference.

Open the Starting Workspace

Start by opening a workspace. This workspace is the baseline for this lesson.

- 1. Check the Combustion preferences. For instructions, see "Setting the Preferences" on page 3.
- Choose File | Open Workspace or press CTRL+SHIFT+O (Windows) or %+SHIFT+O (Macintosh) to access the Open Workspace dialog.
- **3.** In the Open Workspace dialog, locate and open the *08_CreatingControllingPositioning* folder by either navigating the file browser or editing the path at the top of the dialog.
- 4. Double-click the 06_Optimizing_start.cws file.
- 5. Select the single-viewport layout.
 - 6. Choose Window | Fit in Window or click the Home button Home |
 - 7. Play the clip (SPACEBAR).

The clip features numerous animated footage, included Paint objects, text, blurs, and transitions effects.

View the Contents of the Clip in the Workspace Panel

Because the composite has many layers, expanding the contents of just 1 layer causes the preceding and following layers to scroll off the top and bottom of the viewport. Expanding the Workspace gives you greater access to the contents of the composite.

1. In the Workspace panel (F3), CTRL- click/ %-click the arrow next to the workflow composite icon.

This expands the composite to the object level. To see more of the workspace requires scrolling up and down.

2. Press SHIFT+F10 to expand the Workspace panel.

The Workspace panel expands and docks to the upper left of the user interface. When the Workspace panel is expanded, you have simultaneous use of the Toolbar.

Note: The width of the Workspace panel can be customized via the combustion preferences dialog, in the Monitors Host category.

- 3. Navigate in the Workspace panel using hot keys:
 - a) In the Workspace panel, select the workflow composite.
 - b) Press CTRL+Down ARROW / 98+Down ARROW.

The next element (Text - SATURDAY NITE) in the Workspace panel is selected.

c) Press CTRL+UP ARROW / 98+UP ARROW.

The previous element in the Workspace panel (workflow composite) is selected.

d) Select the Text - SATURDAY NITE layer and press CTRL+RIGHT ARROW / ૠ+RIGHT ARROW.

The Text - SATURDAY NITE layer is expanded, displaying all its contents.

e) With the Text - SATURDAY NITE layer selected, press CTRL+LEFT ARROW / St-LEFT ARROW.

The Text - SATURDAY NITE layer is collapsed.

Compare Two Color Correctors to Match a Color

Use the Compare Tool to see the output of two operators side-by-side in the viewports.

- 1. In the Workspace panel, Expand the moto Lower Left layer.
- Double-click the Discreet Color Corrector in the moto LOWER LEFT layer.The output of the Discreet Color Corrector is displayed in the viewport.
- 3. Enable the Compare tool:

- a) In the Toolbar (F2), click-drag the Compare tool.
- AB
- **b)** From the context menu, select the Compare tool On.

The Toolbar displays the Compare options and the viewport displays a vertical comparison region.

Note: Other Compare tool options are Rectangle and Split Horizontally.

4. From the Compare list, select Operator to access the Operator Picker dialog.

Select Discreet Color Corrector in the moto LOWER RIGHT layer and click OK to compare the Discreet Color Corrector from the moto LOWER LEFT layer to the Discreet Color Corrector moto LOWER RIGHT layer.

The screen is split vertically, with the Discreet Color Corrector from the moto LOWER LEFT layer displayed to the left and the Discreet Color Corrector from the moto LOWER RIGHT layer displayed to the right.

- 6. In the viewport, click-drag the white region limit to move the vertical split left or right.
- 7. In the viewport ALT-click-drag/OPTION-click-drag to change to a horizontal Compare.
- 8. Click the viewport to return to a Vertical Split.

6 Optimizing Workflow

9. In the Color Corrector Controls panel (**F8**), click and drag the Master Color Settings (M) in the color wheel from green to red until it matches the color of the moto LOWER RIGHT layer displayed to the right.

10. In the Toolbar (F2), click-drag the Compare tool and choose Compare tool off.

Filter Animation and Channels in the Timeline

Use the Timeline menu and hot keys to isolate information in the Timeline with channel filters.

- 1. In the Workspace panel, double-click the workflow composite.
- 2. In the Timeline (F4), select the workflow composite.
- 3. At the composite level, filter all the layers for Position, Scale, and Rotation:
 - a) Press P to show only the Position channels of the layers.

- **b)** Press **S** to only the Scale channels of the layers.
- c) Press R to only the Rotation channels of the layers.

The Timeline shows only Rotation channels.

Note: Other hot keys for channel filtering are **H** for shear and **C** for opacity.

- **4.** Add channels to the Timeline filtering:
 - a) Press SHIFT+C to add the Opacity channel.

The Opacity channel is added to the Rotation channel in the Timeline.

b) Press SHIFT+P to add the Position channel.

The Position channel is added to the Rotation and Opacity channels.

c) Press R.

The Rotation channel is removed from the channel filtering.

- 5. Filter selected channels for expressions:
 - a) In the Timeline menu, click the right-arrow menu button ().

b) From the context menu, choose Show Only Channels with Expressions.

The Timeline was previously filtered to show only Position and Opacity. Only expressions on these channels are shown in the Timeline.

c))In the Timeline menu, disable Show Only Channels with Expressions.

The Timeline returns to the previously filtered channels.

- **6.** Filter only channels in a layer:
 - a) In the Timeline menu, select Reset All Object Specific Channels (**E**).

This returns the Timeline to an unfiltered state.

- b) Navigate to the Text SATURDAY NITE (press CTRL+DOWN ARROW / 98+DOWN ARROW twice).
- c) Press C.

The opacity channel for only the Text-SATURDAY NITE layer is shown in the Timeline, while the remaining layers still display all channels.

d) Press E.

The channel filtering is removed from the selected object.

Note: Hot keys for channel filtering layers are the same as hot keys at the composite level.

Create a Custom Channel Filter Preset

The Timeline menu and hot keys are the default methods of isolating and displaying specific channel information. Creating custom channel filter presets allows for even more precise channel filtering.

- In the Timeline collapse and then expand the workflow composite.
 All layers are collapsed.
- 2. Create a Blur Amount Filter Preset:
 - a) In the Timeline menu, enable Show Only Animated Channels. This displays only channels with keyframes.
 - b) In the Timeline, expand the moto UPPER LEFT layer, then expand the Dolly Blur.
 - c) In the Timeline, expand the moto UPPER RIGHT layer, then expand the Dolly Blur.
 - d) CTRL-click / OPTION-click the Dolly Blur Amount channel of the moto UPPER LEFT layer and the Dolly Blur Amount channel of the moto UPPER LEFT layer.
 - e) In the Timeline menu, select Add Channel Filter Preset.
 - f) Name the channel preset "Blurs".
 - g) In the Timeline menu, select Channel Filter Presets.

The Channel Filter Presets includes None and Blurs.

h) Select None.

Navigate Viewports

Instead of clicking in a viewport, use hot keys to designate the active viewport. A viewport with a white outline indicates it is the active viewport.

1. Select the four-viewport layout.

The active viewport is indicated by a white border,

- 2. Set all four viewport layouts to a smaller zoom factor:
 - a) Click Home.

The active viewport—the top left viewport—is set to a smaller zoom factor.

b) Press [to cycle to the next viewport and click Home.

The top right viewport is set to a smaller zoom factor.

c) Press [to cycle to the next viewport and click Home.

The bottom left viewport is set to a smaller zoom factor.

d) Press [to cycle to the next viewport and click Home.

The bottom right viewport is set to a smaller zoom factor.

- 3. Playback the clip in the bottom left viewport:
 - a) Press SHIFT+[to cycle to the previous viewport.
 - b) Play the clip (SPACEBAR).

Quickly Save an Incremental Version of a Workspace

Instead of renaming workspaces to save versions of workspaces, you can either append an increasing digit to the filename automatically or manually every time you save a workspace.

- 1. To save a version of a workspace:
 - a) Choose File | Save As (CTRL+SHIFT+S / 38+SHIFT+S).

b) At the bottom of the Save Workspace dialog, click the Increment Save button three times.

Each time the Increment Save button is clicked, the file name increases in increments of 1 digit, zero (0), one (1), two (2), three (3) etc.

c) CTRL-click / St-click the Increment Save button three times.

Each time you CTRL-click / ૠ-click the Increment Save button, the file name decreases in increments of 1 digit.

d) Choose File | Preferences, and in the General Host category, enable Increment on Save.

Every time you save a workspace, a new increment of the workspace is saved followed by a zero (0), one (1), two (2), three (3) etc.

Quickly Render an Incremental Version of the Workspace

Save time appending or renaming renders with the Incremental Render button.

- 1. Render a new version of the final output:
 - a) Choose File | Render (CTRL+R / ૠ+R).
 - b) Set the file destination and the file output as an image sequence.

c) Click the Incremental Render button at the end of the filename.

The filename increment digit increases by 1 every time you click the Increment Render button.

d) CTRL-click / %-click the Increment Render button.

Each time you CTRL-click / **%**-click the Increment Render button, the file name decreases in increments of 1 digit.

- e) Click Close to cancel the rendering process.
- 2. (Optional) Save the workspace:
 - a) Choose File | Save Workspace (CTRL+S / 策+S) to open the Save Workspace dialog.
 - b) Set a filename and directory for the workspace, and then click OK (ENTER / RETURN).
- 3. Choose File | Close Workspace (CTRL+W / ૠ+W) to close the workspace.

Using Paint Part II

7	Learning Paint Basics	85
8	Creating, Controlling, and Positioning Objects	101
9	Animating Text	111
10	Exploring Draw Modes in Text	127
11	Wire Removal	135
12	Creating Text Gradients	147
13	Animating Gradients	159
14	Creating Custom Brushes	173
15	Creating Flash Compatible Animations	187
16	Combining Selections	199
17	Animating Selections	207

Hist paid

Management of the second of th

Learning Paint Basics

Lesson 7

In this lesson, draw Paint objects on an image then, animate the objects.

Overview

Use Paint to create paint strokes, geometry, and selections, and to apply effects to areas of an image without affecting the rest of the image. When you paint in Combustion, you create vector graphics. Vector graphics are stored as mathematical descriptions of lines and curves, so you can resize them without affecting their quality. You can also animate the scale, position, and other attributes of Paint objects from frame to frame.

In this lesson:

- · Open an image as a Paint branch.
- Draw a filled rectangle and add control points to convert the rectangle into a fish shape, using the grid as a guideline for drawing.
- Animate the Paint object's position and motion path.
- Sample background image colors to change the Paint object's color to a gradient.
- Duplicate the Paint object and convert it to a stroked object to create an outline.
- Use the Bezier Selection tool to copy a portion of the image over a Paint object.

Open the 07_PaintBasics.mov file in the 07_LearningPaintBasics folder and preview the result.

Need Help?

If you need help completing this lesson, save and close your workspace, and then open the 07_PaintBasics.cws file as a reference.

Create a Paint Branch

Open the footage as a Paint branch.

- 1. Check the Combustion preferences. For instructions, see "Setting the Preferences" on page 3.
- 2. Choose File | Open or press CTRL+O (Windows) or ૠ+O (Macintosh) and use the file browser to locate and open the 07_LearningPaintBasics folder.
- **3.** In the Open dialog, click Thumbnails to view the footage in the selected folder.

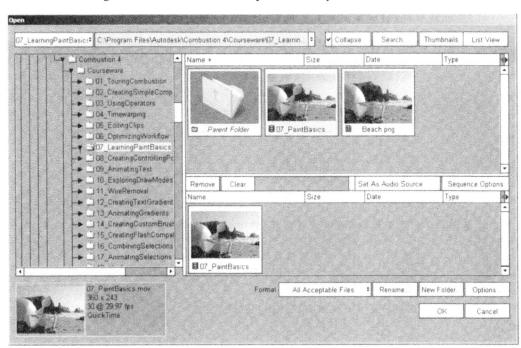

4. Scrub the *07_LearningPaintBasics.mov* thumbnail to preview the clip.

The clip shows a fish jumping out of a bucket.

5. Select the *Beach.png* image and click OK (ENTER/RETURN).

The Open Footage dialog appears.

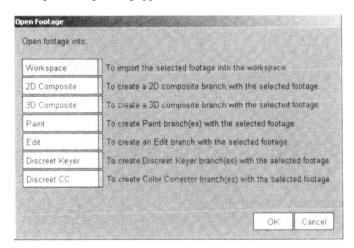

7 Learning Paint Basics

6. Select Paint to create a Paint branch with the selected footage and click OK (ENTER/ RETURN).

An image of a beach with beach toys appears in the viewport.

In this lesson, the Playback controls indicate that the duration of the clip is set to the default duration of 30 frames.

- =
- 7. From the Viewport Layout list, select the single-viewport layout.
- **8.** Choose Window | Fit in Window or right-click / **CONTROL**-click and choose Fit in Window.

The zoom factor in the viewport is set to fit the whole frame in the window.

Draw a Rectangle

Use the Filled Rectangle tool to draw a rectangle over the bucket.

1. Show the Toolbar (F2).

Some Paint tools have a black triangle at the lower right corner, indicating a context-menu for accessing additional Paint tools. These tools are the Compare tool, the stroked tools, the filled tools, the Text tools, the selection tools, and the mask tools.

The Freehand tool, Rectangle tool, Ellipse tool, Bezier tool and B-Spline tool have two modes: Stroked and Filled.

2. In the Toolbar, click the Filled Rectangle tool (SHIFT+R).

Note: If the Filled Rectangle tool is not shown in the Toolbar, click-drag the filled tool and choose the Filled Rectangle tool from the context menu, or press the tool's hot key.

The Rectangle tool enables you to set a corner radius to create a rectangle with rounded corners.

- 3. In the Paint Controls panel, set the options for drawing the rectangle:
 - a) Click Modes.

b) Click Reset to set the draw mode settings to default.

The Reset button in the Modes controls resets Draw mode, Opacity, Preserve Alpha, Anti-Alias, Foreground Color and Background Color, and Source mode to their default settings.

4. Choose Window | Grids, Guides and Ruler | Show All.

The grid and ruler are shown in the viewport. The guides are not shown as you need to create them first. For this exercise, you don't need guides.

5. In the viewport, draw a rectangle in the center of the sand bucket.

The default object duration is set from the current frame to the end of the clip. You can change the default object duration either via the Combustion Preferences dialog or the Paint Settings controls.

Change the Rectangle Into a Fish

Add and adjust control points to change the rectangle into a fish shape.

1. In the Toolbar, click the Arrow tool (TAB).

In the viewport, a bounding box with the pivot point in the centre appears around the rectangle object, indicating the object is selected and is in Edit mode.

2. In the Toolbar, click the Edit Control Points tool or press TAB.

A control point appears at each corner of the rectangle object.

- 3. Transform the rectangle into a fish shape by adding three control points:
 - a) Move the cursor to the top center of the rectangle and when the cursor changes to a green cross hair -t., click to add a control point.
 - b) Drag the new control point upward, approximately half the height of the rectangle to create a tip.

c) Add a control point on each side, between the bottom and top control point. Then, drag these control points towards the center of the object to create the fish tail.

d) Press CTRL / **%** and drag the top left control point up. Tangent handles appear and a bezier curve is created. Now do the right side.

A fish is created.

e) Refine the shape of the fish by dragging the control points and their tangent handles.

Hint: SHIFT and drag to constrain the movement of the tangent handles to horizontal, vertical or 45-degree angles.

4. Choose Window | Grids, Guides and Ruler | Hide All.

Animate the Fish

Rotate and move the fish, then adjust its motion path to create a curve.

1. Enable Animate (A).

Animate is red when enabled. When Animate is enabled, keyframes are created automatically when you change an object or layer.

2. Go to the last frame (END).

With Animate enabled, the changes you make on the last frame are interpolated from the original orientation of the object on the first frame.

3. In the Toolbar (F2), click the Edit Object tool.

Hint: Press TAB to cycle through the Arrow tool options: Edit Object tool and Edit Control Points tool.

4. Rotate the fish:

a) In the Paint Controls panel, click Transform.

b) Set Rotation to -90.00°.

Note: With the Edit Object tool selected, you can also rotate the object using the rotation handle of the pivot point.

5. With the cursor, click and drag the fish to position it in the upper right corner of the background image.

In the viewport, a linear motion path is displayed showing the distance and direction of the fish from the first frame to the last frame. Each end of the motion path has a keyframe.

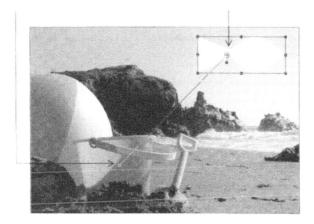

6. With the cursor, drag to adjust the green tangent handles extending from each end of the motion path to create a smooth, curved motion.

7. Disable Animate (A).

Play the Clip

Use the Playback controls to view the clip in the viewport in real time. The playback controls are below the viewport.

1. Click the Go to Start button to go to the first frame of the clip.

2. If Loop Play Mode is not selected, click the Play Mode button and select Loop Play Mode.

The Play Mode button cycles between Play Once → , Loop ← , and Ping Pong ⇒ .

3. Click the Play Forward button to play the clip.

Hint: You can also press HOME to go to the first frame and press SPACEBAR to play the clip.

The fish is in front of the bucket and appears to be jumping into the water. You need to have the fish appear to be jumping out of the bucket and into the water.

4. Click the Stop Playback button

Change the Color of the Fish

Change the source color of the fish object to a Gradient. Sample colors from the background image to create a custom Gradient Fill.

1. Go to the last frame (END).

In the viewport, notice a bounding box with the pivot point in the centre appears around the fish object, indicating the object is selected and is in Edit Object mode.

- 2. In the Paint Controls panel (F8), change the source color of the fish:
 - a) Click Modes.
- **b)** In the Modes controls, click the Color Picker tool.
 - c) Click Gradient to change the source of the fish from a Solid color to a Gradient.

d) Click the Gradient thumbnail preview.

The gradient controls are displayed.

e) Click the Linear Gradient button.

7 Learning Paint Basics

- 3. Sample the colors of the background image to define the color gradients of the fish:
 - a) Click the left side of the Color gradient bar to add a gradient tag.

b) In the right viewport, position the cursor (**) over the shovel.

At the bottom of the screen, the Info Palette displays the pixel.

c) Click to sample a pixel.

The Color gradient bar changes from white to the selected yellow color.

To create a gradient, you need at least two tags.

- d) Click the right side of the Color gradient bar to add a second gradient tag.
- e) Position the cursor (🥒) over a bright pink area of the beach ball then click to sample the pixel.

The color gradient appears in the Color gradient bar and the color gradient applied to the fish object is displayed in the viewport.

Duplicate the Fish Object

Add a second fish object to the clip by duplicating the fish object. Then, change the properties of the duplicated fish object.

1. Choose Edit | Duplicate (CTRL+ALT+D / %+OPTION+D).

A duplicate object appears in the viewport on top of the original object. Because the duplicate is created in the same position and has the same properties as the original object, it is not immediately obvious that there are now two identical objects.

Hint: You can also choose Edit | Copy (CTRL+C / \Re +C) and Edit | Paste (CTRL+V / \Re +V) to create a copy of the selected object.

2. Show the Workspace panel (F3).

The Paint operator has two Paint objects: Filled Rectangle, the first fish object, and Filled Rectangle(2), the copy of the first fish object.

- 3. Change the properties of the Filled Rectangle(2) object:
 - a) In the Paint Controls panel, click Modes.
 - b) In the Modes controls, click Solid to change the Gradient source to a Solid color.

The solid color is the last pixel sampled.

c) From the Object Mode list, select Stroked.

- d) From the Brushes palette, select a small brush size.
- e) From the Swatches panel select black for the outline.

The duplicated fish object has a solid black outline.

Hint: You can also click the Swap Foreground and Background Colors button () in the Paint Modes controls or press X.

4. Play the clip (**SPACEBAR**) to view the result.

Make the Fish Appear to Jump out of the Bucket

To have the fish appear to be jumping out of the bucket and into the water, isolate the bucket from the rest of the image by adding a Selection object.

- 1. Go to the first frame (HOME).
- 2. Create a selection around the bucket:

- a) In the Toolbar (F2), click-drag the Selection tool and choose the Bezier Selection tool (OPTION+P).
- b) In the viewport, draw a 4-point polygon outlining the bucket. To complete the polygon, press ENTER / RETURN after adding the last control point, or position the cursor over the first control point and when the cursor changes to -1/20, click.

- c) Adjust the control points by dragging them to the desired position.
- d) In the Paint Controls panel, enable Invert to invert the selection.

The order in which selections and Paint objects are stacked in the Workspace panel affects how they influence each other. Since Selections only affect (or limit) objects and effects above them in the Workspace panel, you need to change the order of the objects in the Workspace panel.

- **3.** In the Workspace panel (**F3**), drag the Polygon Selection(=) object under the Filled Rectangle object. The fish object appears to be inside the bucket.
- **4.** Choose Edit | Select None (CTRL+D / ૠ+D) to deselect the object.
- Play the animation (SPACEBAR).The fish appears to be jumping out of the bucket and into the water.
- **6.** (Optional) Save the workspace:
 - a) Choose File | Save Workspace (CTRL+S / 98+S) to open the Save Workspace dialog.
 b) Set a filename and directory for the workspace, and then click OK (ENTER/ RETURN).
- 7. Choose File | Close Workspace (CTRL+W / ૠ+W) to close the workspace.

to the first and the second of the second

The special of the second problem is a second

The MT of an obtained a second fitting

and include confingues, in a confinction

그래얼하다는 그리고 생활을 마친다. 왕은 학생은 사람들이 가는 그 것으로 그린다.

Creating, Controlling, and Positioning Objects Lesson 8

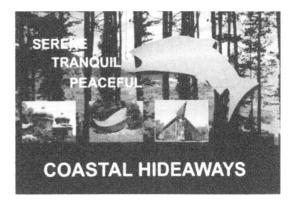

In this lesson, finish a composite and familiarize yourself with paint features such as B-splines, point grouping, and grids, guides, and ruler.

Overview

This lesson shows you how to create a polygon using the B-spline, how to manipulate a portion of an object without affecting the rest of the object by grouping control points, and how to precisely position objects and snap objects to the grid.

B-Splines function differently than Bezier splines. They allow for a smoother control when rotoscoping and creating shapes. With B-Splines, you control the curves using control points and a weight handle. The advantage of B-Splines over Bezier curves is that it takes less point manipulations (control points and tangent handles) to achieve the same curve.

Control point grouping enables you to select a subset of object control points and group them into a single entity that you can animate independently from the rest of the object. This feature makes it easier to rotoscope and create simple to complex shape animations.

Visual tools such as Grids, Guides and Rulers provide you with customizable visual cues for creating precisely aligned composite or paint elements.

In this lesson:

- Create a B-Spline polygon to tint a portion of a still image.
- Group points of a polygon and animate the shear.
- · Modify a grid to align text.
- Use guides to position images in a composite.

Open the 08_CreatingControllingPositioning.mov file in the 08_CreatingControllingPositioning folder and preview the result.

Need Help?

If you need help completing this lesson, save and close your workspace, and then open the 08_CreatingControllingPositioning.cws file as a reference.

Open the Starting Workspace

Start by opening a workspace. This workspace is the baseline for this lesson.

- 1. Check the Combustion preferences. For instructions, see "Setting the Preferences" on page 3.
- Choose File | Open Workspace or press CTRL+SHIFT+O (Windows) or %+SHIFT+O (Macintosh) to access the Open Workspace dialog.
- **3.** In the Open Workspace dialog, locate and open the *08_CreatingControllingPositioning* folder by either navigating the file browser or editing the path at the top of the dialog .
- **4.** Double-click the 08_CreatControlPosit_start.cws file.

- 5. Select the single-viewport layout.
- 6. Play the clip (SPACEBAR).

The clip features a coastal hideaway vacation advertisement. The first objective of this lesson is to touch up the lower image to the left.

Tint One of the Roofs of the First Landmark

Three images of coastal landmarks were scaled down. In the first image (to the left), one of the two roofs is color-corrected with a B-spline Paint object set to "Tint". Use this B-Spline object as your guide to create an object to color correct the second roof.

- 1. Go to the first frame (HOME).
- 2. In the Workspace panel (F3), click the triangle next to the landmark_A layer to access its contents.
- 3. Double-click the Paint operator to make it the current operator and see its output in the viewport.
- 4. Click the triangle next to the Paint operator to expand it.

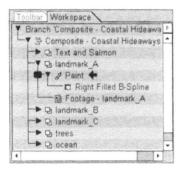

- 5. Examine the Right Filled B-Spline used to tint the roof on the right:
 - a) In the viewport, click the roof to the right.

In the viewport, a bounding box with the pivot point in the centre appears around the object, indicating the object is selected and is in Edit mode.

- **b)** In the Toolbar, click the Edit Control Points tool (**TAB**).
- c) In the viewport, drag a selection box around all the control points.

All the weight handles of the B-Spline object are now visible.

B-Splines have only 3 properties to manage: X position, Y position, and weight, which can be thought of as tension. B-Spline points make up an outer "box" that contains a polygon shape. The closer points are placed together, the sharper the curve. Weight handles will fall on either inside or outside of the polygon, depending on the direction of the curve. Pushing the weight handle in (decreased tension) creates a relaxed curve, pulling the weight handle out (increased tension) creates a sharp corner.

6. Create a B-Spline object to tint the roof to the right:

a) In the Toolbar, click the Filled B-Spline tool.

Note: If the Filled B-Spline is not shown in the Toolbar, click-drag the filled tool and choose the Filled B-Spline tool from the context menu.

b) In the Paint Controls panel, (F8), click Modes and select Tint from the Draw modes.

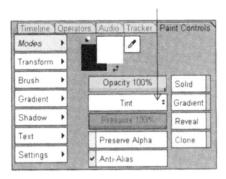

c) Pick a red color from the Swatches panel.

d) In the viewport, click to add control points for drawing the B-Spline object around the roof on the left, using the following image as a guideline.

- e) Close the B-Spline by positioning the cursor over the first control point and when the cursor changes to -ig, click, or by pressing ENTER / RETURN after adding the last control point.
- f) In the viewport, select individual points to adjust the weight and position until they fit the contour of the roof.

Animate the Salmon

Animate the tail of the salmon, then, animate the position of the salmon.

- 1. In the Workspace panel (F3), double-click the Coastal Hideaways composite.
- 2. Show the salmon in the viewport:
 - a) In the Workspace panel, click the triangle next to the Text and Salmon layer to access its contents.
 - b) Double-click the Text and Salmon Paint operator to view its output in the viewport.
 - c) Expand the contents of the Text and Salmon Paint operator.
 - d) Select the Salmon Paint object.

In the viewport, a bounding box with the pivot point in the centre appears around the salmon, indicating the object is selected and is in Edit mode.

3. Play the clip (SPACEBAR).

Notice that the tail of the salmon is not animated.

- 4. Go to frame 1 (HOME).
- 5. Group the control points that make up the tail of the salmon:
- ♦
- a) In the Toolbar, click the Edit Control Points tool (TAB).

b) In the viewport, drag a selection box to select the six control points of the salmon's tail.

c) Choose Group | Object Group (CTRL+G / ૠ+G).

A bounding box with the pivot point in the centre defines the grouped points.

d) In the viewport, click and drag the group pivot point to the upper left of the tail group.

- e) In the Workspace panel (F3), expand the Salmon object.
- f) Rename the Group object "Tail".

6. Animate the tail:

- a) Enable Animate (A).
- **b)** Go to (/) frame 30.
- c) In the Paint Controls panel (F8), click Transform.
- d) Set Y Shear to 22.
- e) Go to the last frame (END).
- f) Set Y Shear to -15.
- 7. Play the clip (SPACEBAR).

- 8. Animate the position of the salmon:
 - a) Go to (/) frame 30.
 - b) In the Workspace panel, select the Salmon object.
 - c) In the viewport, position the salmon so that the mouth is about to bite the hook.
 - d) Go to the first frame (HOME).
 - e) Click and drag the Salmon to the right, outside of the viewport.
- 9. Play the clip (SPACEBAR).

Position the Three Key Words

Use the Grid to position the three key words. Using a grid with the "snap to" function enabled helps in positioning objects at precise distances from each other.

- 1. Disable Animate (A).
- 2. Choose Window | Grid, Guides and Ruler | Show Grid (SHIFT+G).
- 3. Change the preferences:
 - a) Chose File | Preferences (CTRL+;) or choose combustion | Preferences (\mathbb{H}+;).
 - b) In the Grids & Guides Host category, enable Grid Linked and set the Vertical Subdivision to 1.

- c) Click OK (ENTER / RETURN).
- 4. Position the three key words:
 - a) Go to the last frame (END).
 - **b)** In the viewport, click and drag the keyword SERENE so that the first letter is positioned in square 2 at the top and left of the frame.
 - c) The text object snaps to the edges of the grid because the snap to grid is enabled.

Hint: You can disable or enable snap to grid via Window | Grid, Guides and Ruler | Snap To Grid (CTRL+SHIFT+G / CONTROL+SHIFT+G).

- d) Click and drag the keyword TRANQUIL so that the first letter is positioned in square 3 at the top and left of the frame.
- e) Click and drag the keyword PEACEFUL so that the first letter is positioned in square 4 at the top and left of the frame.

Position the Three Landmark Images

Guides are very helpful when it comes to positioning objects in the viewport. Guides are not linked to each other. You can create as many guides as you need and you can position them anywhere in the viewport. Use guides to position the three landmark images to finalize your composite. This time, show your composite in the viewport so you can see all the elements that make up your composite before positioning your images.

- 1. Go to the first frame (HOME).
- In the Workspace panel (F3), double-click the Coastal Hideaways composite to view its output in the viewport.
- 3. Create three guides to define the area where you want to position all three landmark images:
 - a) Choose Window | Grid, Guides and Ruler | Show Ruler (SHIFT+L).

The Ruler appears at the top and left edge of the viewport.

Note: You cannot create guides without showing the Ruler.

- b) Position the cursor at the top edge of the viewport, over the ruler area.
 - The cursor changes to \$\(\xi\).
- c) Click and drag the (white) guide below the keyword PEACEFUL. A red guide is created.

- d) Repeat step a and then click and drag the (white) guide above Coastal Hideaways.
- e) Position the cursor at the left edge of the viewport, over the ruler area.
- f) Click and drag the (white) guide just in front of the salmon's tail.

Note: If required, click and drag the guide(s) in the ruler area to precisely position the guide(s).

- 4. Position all three landmark images:
 - a) Choose Window | Grid, Guides and Ruler | Show Grid (SHIFT+G) to hide the grid.
 - b) In the viewport, click the left landmark image and drag the image between the top and bottom guides, near the left edge of the frame.
 - c) Click the centre landmark image and drag the image between the top and bottom guides.
 - d) Click the right landmark image and drag the image between the top and bottom guides.

5. Play the clip (SPACEBAR).

Without seeing all the objects positions on the final frame, the

The Guides enable you to precisely position objects in the viewport without having to see the position of all the objects throughout the animation.objects in the workspace viYou can use guides to Guides provide an indication of the area that can be used for other elements without interfering with the following animation.

- **6.** Without seeing object positions on the final frame, the Guides have provided an indication of the area that can be used for other elements without interfering with the following animation
- 7. (Optional) Save the workspace:
 - a) Choose File | Save Workspace (CTRL+S / 38+S) to open the Save Workspace dialog.
 - b) Set a filename and directory for the workspace, and then click OK (ENTER/ RETURN).
- 8. Choose File | Close Workspace (CTRL+W / ૠ+W) to close the workspace.

ാന് വരുന്നുള്ള വരുന്നുള്ള വരുന്നു വരുന്നു. വരുന്നുള്ള വരുന്നുള്ള വരുന്നുള്ള വരുന്നുള്ള വരുന്നുള്ള വരുന്നുള്ള വ വരുന്നുള്ള വരുന്നുള്ള

en de la composition de designation de la composition della compos

ing the west of the superior o

and the second s

de la companya di Maria. Per antara di mandra di mandra di mandra del mandra del mandra del mandra del mandra d La grafia del mandra d La companya del mandra del mandra

and the second of the second o

en facilità de la companya della companya della companya de la companya della com

e Mark State Comment for the engineer of the comment of the commen

and the state of the second of

Animating Text Lesson 9

In this lesson, create text animations by setting text on a path, using the timecode, and creating a text roll.

Overview

Text objects, like Paint objects, are vector-based and do not degrade when scaled. Unlike other objects, the text objects have highly diverse set of attributes, such as face, outline and shadow. Once a text object is created and animated, the text features can be edited. Create and animate text objects on a path, add a Timecode generator, and create a text roll similar to movie credits.

In this lesson:

- Loop footage so it plays for the entire clip.
- Add a text operator to the composite.
- Adjust the text attributes and animate the text along a path.
- Add a glowing timecode generator.
- Create a Text layer and import text from a text file.
- · Create a text roll.

Open the 09_AnimatingText.mov file in the 09_AnimatingText folder and preview the result.

Note: Depending on the operating system and on the fonts installed on the workstation, workspaces containing text objects may differ slightly from one workstation to another.

Need Help?

If you need help completing this lesson, save and close your workspace, and then open the 09_AnimatingText.cws file as a reference.

Create a Composite Branch

Create a composite branch to make a transparent clip of 60 frames.

- 1. Check the Combustion preferences. For instructions, see "Setting the Preferences" on page 3.
- 2. Choose File | New or press CTRL+N (Windows) or %+N (Macintosh) to open the New dialog and create a branch with the following properties:
 - Type: Composite
 - Name: 09_AnimatingText
 - · Format: NTSC D1
 - · Duration: 120 frames
 - Bit Depth: 8 Bit
 - · Mode: 2D

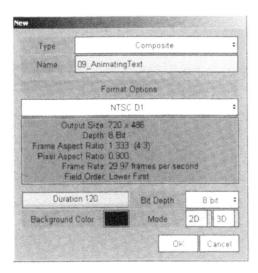

- 3. Select the single-viewport layout.
 - 4. In the Workspace panel (F3), right-click / CONTROL-click the 09_AnimatingText composite and choose Import Footage (or press CTRL+I / ₩+I).
 - 5. In the Import Footage dialog, do one of the following to locate and open the 09_AnimatingText folder:
 - a) Navigate the file browser.
 - b) Edit the path at the top of the dialog.

c) Click the browser menu button to the left of the path.

Hint: To select a recently used folder, click the menu button to the right of the path.

- **6.** Import the footage as follows:
 - a) Double-click the *Rollers* folder, then click the *rollers*[####].png image sequence.
 - b) Double-click the Parent folder, click the tunnel.png image, and click OK (ENTER/ RETURN) to import the queued images into the composite.

The images are added to the composite in the order they are imported: the last file you select is the uppermost layer in the composite.

- 7. Rename the rollers0000 layer:
 - a) In the Workspace panel, right-click / CONTROL-click the rollers0000 layer, and choose Rename.
 - b) Rename the rollers0000 layer "rollers".
- **8.** Play the clip (**SPACEBAR**).

The rollers disappear after frame 15 because the rollers footage is an image sequence of 15 frames. To extend the animation of the rollers to the end of the clip, you can either stretch the duration of the footage or change the playback behavior.

- 9. Loop the footage so it plays from start to end, then returns to the start frame and plays again:
 - a) In the Workspace panel, click the triangle next to the rollers layer to view its contents (or press CTRL+RIGHT ARROW / %+RIGHT ARROW).
 - **b)** Select the rollers[###] Footage operator.
 - c) In the Footage Controls panel (F8), click Output.

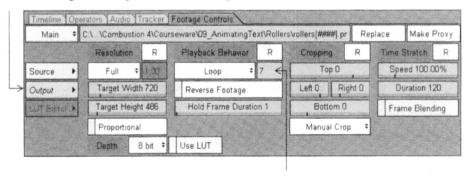

d) Set the Playback Behavior to Loop and enter a value of 7 for the 15-frame image sequence.

The 15-frame image sequence plays once, and then loops 7 times to match the length of the 120-frame composite.

10. Play the clip (SPACEBAR).

The rollers footage plays for the entire 120 frames.

Add Text to the Clip

Start building your composite by adding text to the rollers. To add a text object to the clip, you need to add a Text operator first. Then, you create a text object. Once a text object is created and animated, you can edit the object at any time, including changing the text, the font, and the font attributes. You can also add new characters to the text block.

- 1. Go to frame 1 (HOME).
- 2. In the Workspace panel, select the rollers layer.
- 3. Choose Operators | Text.

In the Workspace panel, a Text operator is added to the rollers layer.

Hint: There are several ways you can add a Text operator to the rollers layer. You can right-click / CONTROL-click the rollers layer in the Workspace panel and choose Operators | Text. You can also select the rollers layer in the Workspace panel, and click Text in the Operators Favorites category.

- 4. Set the text default object duration:
 - a) In the Text Controls panel, click Settings.
 - **b)** From the Default Object Duration option list, select Current To End Frame.
- 5. In the Text Editor, type "play that funky music".

The text appears in the viewport and a text object is added to the Workspace panel.

115

9 Animating Text

6. In the Text Controls panel (F8), click Modes.

7. Click Reset to set the text draw mode settings to default.

Change the Appearance of the Text

Set the font size, color, and apppearance for the text. Use the Basics controls to set the font type and size, and use the Attributes controls to change the color and appearance of the text.

- 1. In the Workspace panel, select the text object.
- 2. In the Text Controls panel, click Text, then click Basics.
- **3.** Select the font from the Font Browser dialog:
 - a) In the Text Controls panel, click Font.

b) Move the Font Browser dialog so the image and type are visible in the viewport.

c) In the Font Browser dialog, enable Preview.

Note: The Font Browser displays the fonts installed on your workstation. The default font is always the first font in the list.

d) Click the Arial font thumbnail and click OK (ENTER / RETURN).

Since Preview is enabled, the font selected in the Font Browser dialog is displayed in the viewport.

Note: You can also select a font type and style using the Text Basics controls.

- 4. In the Text Controls panel, set the Font Size to 60.
- 5. Enable Small Caps.

6. Set Tracking to 20 to add space between the characters in the text.

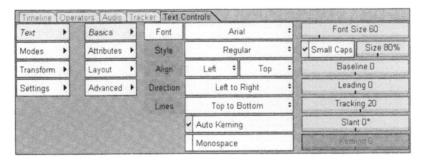

7. Set the Text Attributes:

a) In the Text Controls panel, click Attributes, then click Face.

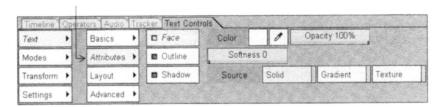

Note: Ensure Face is enabled.

- b) Click the Color Picker.
- c) Sample a light color from the rollers image in the viewport.

The color of the text object is changed to the color sampled.

- d) Click the gray box on the Outline button or double-click the Outline button to enable the text outline.
- e) Click the Color Box next to the Color Picker.
- f) In the Pick Color dialog, enter values in the Red, Green, and Blue fields to select a dark color.

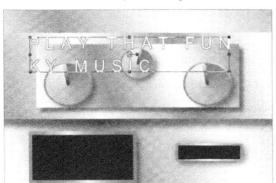

The outline of the text object is changed to the color selected in the Pick Color dialog.

Animate the Text Along a Path

Use the Path Options to select the type of path for the text object and to edit the text on a path property.

- 1. Set the Path for the text object:
- T a) In the Toolbar (F2), click the Text tool.
 - **b)** In the Text Controls panel, click Advanced.

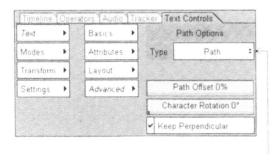

c) From the Path Options Type list, select Path.

The text string appears on a line.

- 2. Adjust the path:
 - a) In the Text Controls panel, click Transform.
 - **b)** Set the Y Position to 200.

The word "THAT" is centered just under the middle roller.

- c) Click and drag the path's left control point to the top center of the left roller.
- d) Click and drag the path's right control point to the top center of the right roller.
- e) CTRL-click / 第-click the path's left control point and drag inward.

 Green tangent handles extend from the control point, allowing you to change the shape of the curve.
- f) CTRL-click / % -click the path's right control point and drag inward.

 The text flows smoothly between the rollers.

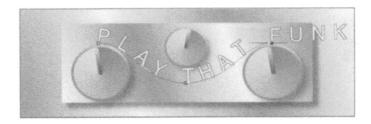

- 3. In the Toolbar, click the Arrow tool.
 - 4. Enable Animate (A).
 - 5. Set the start and finish positions for the text on the path:

Note: Make sure you are at frame 1 (**HOME**).

- a) In the Text Controls panel, click Text, then click Advanced.
- **b)** In the Advanced controls, set Path Offset to 123%.

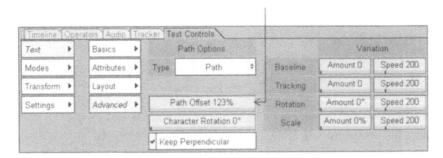

Path Offset sets where the text begins relative to the first point of the path.

- c) Go to the last frame (END).
- d) Set Path Offset to -230%.
- e) Disable Animate (A).

- **6.** In the Workspace panel (**F3**), double-click the 09_AnimatingText composite.
- 7. Play the clip (SPACEBAR).

The text flows smoothly from right to left, between the rollers.

Add a Timecode Generator to the Clip

Add a second text object to the Text operator. This time, add a Timecode generator to represent the frame number as the clip plays. A generator is like a variable that you can program to show a changing value.

- 1. Go to frame 1 (HOME).
- 2. In the Workspace panel, double-click the Text operator.

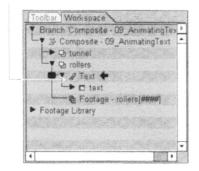

3. Add a timecode generator text object:

- a) In the Toolbar (F2), click the Text tool.
- b) Click Timecode.

The Text Editor shows [TC], which represents the timecode generator.

c) In the Playback controls, click the duration field to display timecode.

Note: You can also set the timecode in the Display Time As list, in the Preferences dialog.

d) In the Text Controls panel, enable Use Current Timecode.

- **4.** Set the font for the timecode generator:
 - a) In the Text Controls panel, click Basics.
 - b) From the Font list, select Arial.
 - c) Set the Font Size to 30.
- 5. Change the timecode text color and add an outline:
 - a) In the Text Controls panel, click Attributes.
 - **b)** Click the Face color box, and choose a bright red color.
 - c) Double-click Outline to enable it.
 - d) Click the Outline color box, and choose a bright red color.
- 6. Add a soft glow to the timecode text:
 - a) In the Text Attributes controls, set Softness to 10.
 - b) Set Opacity to 70%.
 - c) Set Size to 3.
- 7. Disable Shadow if enabled.
- 8. Move the timecode text into the small "window" in the rollers layer.
- k
- a) In the Toolbar, click the Arrow tool (TAB).

A bounding box with the pivot point in the centre appears around the timecode text object.

b) In the viewport, click and drag the timecode text object into the small "window" in the lower right corner.

- 9. In the Workspace panel (F3), double-click the 05_AnimatingText composite.
- **10.** Play the result (**SPACEBAR**).

The current timecode is displayed as the clip plays.

Add Another Text Object

Add a third text object to the clip. This time, create a Text layer, then copy and paste text from a text file to Combustion in the Text Editor, and adjust the text properties.

1. Go to the beginning of the clip (HOME).

- **2.** Select the two-viewport horizontal layout.
 - 3. Choose Object | New Layer (CTRL+Y / 38+Y) to create a layer with the following properties:
 - · Type: Text
 - · Name: Roll
 - · Format: NTSC D1
 - Duration: 4:00
 - Bit depth: 8 Bit
 - Background Color: Black
 - Enable Transparent

The top viewport displays the new Text operator.

- **4.** Copy the contents of the *lyrics.txt* file in the Text Editor:
 - a) Minimize / Hide the Combustion application.
 - b) From the desktop, go to the default path for the courseware media and open the 09_AnimatingText folder.
 - c) Open the lyrics.txt file.
 - d) Select and copy the content of the file (CTRL+A+CTRL+C / #+A+ #+C).
 - e) Press ALT+TAB / ₩+TAB and go back to the Combustion application.
 - f) In the Text Controls panel, click in the Text Editor panel and paste (CTRL+V / \(\mathbb{H} + V \)) the contents of the lvrics.txt file.
- **5.** Right-click / **CONTROL**-click the bottom viewport and choose Fit in Window.
- **6.** Right-click / **CONTROL**-click the top viewport and choose Fit in Window.
- 7. Change the text Font:
 - a) In the Text Controls panel, click Text, then click Basics.
 - a) From the Font list, select Arial.
 - b) Change the Font Size to 20.
- **8.** Change the text color:
 - a) In the Text Controls panel, click Attributes, then click Face.
 - **b)** Click the Face color box, and choose a bright blue color.

Animate a Text Roll

Adjust the margins of the text object, change the text layout to a roll, and set start and end positions of the roll.

- 1. Adjust the margins of the text object:
 - a) In the Text Controls panel, click Layout.
 - b) Set the left margin to 90.
 - c) Set the right margin to 330.

The text bounding box should be roughly the width of the large "window" in the lower left of the rollers layer.

- d) Enable Word Wrap so words that extend beyond the margins are not broken.
- 2. Make the text object roll, and set the start and end positions:
 - a) Click Animate (A) to enable Animate.
 - b) In the Text Controls panel, from the Type list, select Roll Up.
 - c) Set Completion to 5%, or just before the text enters the bottom of the black area of the window.

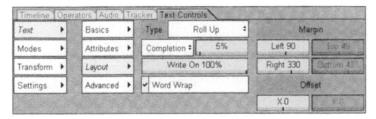

- d) Click the Go to End button
- e) Set Completion to 45%, or just as the text leaves the top of the black area of the window.

- f) Disable Animate (A).
- 3. In the Workspace panel, double-click the triangle next to the 09 AnimatingText composite.
- 4. Select the Text Roll layer and drag it under the rollers layer.

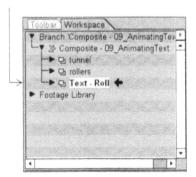

Because the rollers footage has an alpha channel, the roll text will only show through the window.

5. Click the bottom viewport or press [to cycle to the next viewport.

- 6. Select the single-viewport layout.
 - 7. Choose Window | Fit in Window.
 - **8.** Play the result (**SPACEBAR**).
 - 9. (Optional) Save the workspace:
 - a) Choose File | Save Workspace (CTRL+S / 28+S) to open the Save Workspace dialog.
 - b) Set a filename and directory for the workspace, and then click OK (ENTER / RETURN).
 - 10. Choose File | Close Workspace (CTRL+W / 发 + W) to close the workspace.

en de la compansión de la compansión

Exploring Draw Modes in Text

Lesson 10

In this lesson, use draw modes to change the appearance of animated Text.

Overview

You can change the look of a Paint object by setting its draw mode. A draw mode defines how the Paint object interacts with objects behind it. For example, you can use the Overlay draw mode with an animated text object in a motion graphics project to give the text an interesting look.

Note: The Text operator contains most of the text controls found in the Paint operator. The result of this lesson can be achieved by using the Text tools in the Paint operator.

In this lesson:

- Change the draw modes of text objects to learn how these modes affect their appearance.
- Examine the Timeline to see the draw modes of different text objects.

Open the 10_ExploringDrawModes.mov file in the 10_ExploringDrawModesInText folder and preview the result.

Need Help?

If you need help completing this lesson, save and close your workspace, and then open the 10_DrawModes.cws file as a reference.

Note: Depending on the operating system and on the fonts installed on the workstation, workspaces containing text objects may differ slightly from one workstation to another.

Open the Workspace

Open the starting workspace for this lesson.

- 1. Check the Combustion preferences. For instructions, see "Setting the Preferences" on page 3.
- 2. Choose File | Open or press CTRL+ SHIFT+O (Windows) or \#+SHIFT+O (Macintosh) to access the Open Workspace dialog.
- 3. In the Open Workspace dialog, use the file browser to locate and open the 10_ExploringDrawModes folder.
- 4. Select 10_DrawModes_start.cws and click OK (ENTER / RETURN) to open the file.

5. Select the single-viewport layout.

Home 6. Click the Home button until the viewport displays a zoom factor of 100%.

Clicking Home cycles the viewport display between a centered image with a 100% zoom factor, an image that fits the viewport, and the most recent custom zoom and pan settings.

7. Play the clip (**SPACEBAR**).

The clip features moving text objects over a background image.

Examine the Draw Modes

Use the Modes list in the Text Controls panel and the Draw Mode channel in the Workspace panel to examine the draw modes used in the clip. Next, examine the draw modes of the Text operator objects.

- 1. Go to the first frame (HOME).
- 2. Change the display of the Workspace panel:
 - a) Show the Workspace panel (F3).
 - **b)** Click the right-arrow menu button () and choose Show Operators and Properties.

The operators and their properties are displayed in the Workspace panel.

c) Click the triangle next to the Blue layer to view the layer's contents.

Note: To expand an object, you can also select the object and press CTRL+RIGHT ARROW / % +RIGHT ARROW.

- d) Click the triangle next to the Operators category to view the operators applied to the clip.
- e) Click the triangle next to the Text operator to view the text objects in the clip.
 All the objects in the Workspace panel (as in the Timeline) can be expanded to show their categories and properties.

3. Expand the Workspace panel (SHIFT+F10).

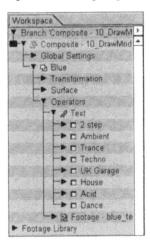

The Workspace panel is expanded and shown to the left of the viewport. When there are many elements in the Workspace panel, you can either scroll in the Workspace panel or expand the Workspace panel to access the elements.

- 4. Examine a text object's draw mode in the Text Controls panel:
 - a) In the Workspace panel, double-click the Text operator to access the Text Controls panel.
 - b) Select the Trance text object.

The Trance object bounding box is displayed in the viewport, indicating the object is in Edit Object mode.

c) In the Text Controls panel (F8), click Modes to view the Modes controls.

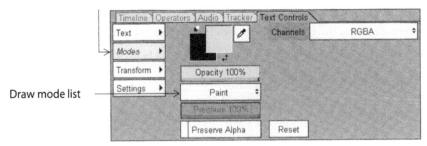

The Trance text object uses the Paint draw mode.

- 5. Examine a text object's draw mode in the Workspace panel:
 - a) In the Workspace panel, select the next text object (or press CTRL+DOWN ARROW / %+DOWN ARROW)—the Techno object.
 - b) Click the triangle next to Techno object (or press CTRL+RIGHT ARROW / %+RIGHT ARROW) to expand the object.

Notice that the Draw Mode property (channel) in the Workspace panel (as in the Text Controls panel) is set to Paint.

expanded Workspace panel

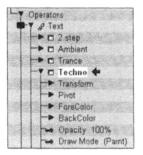

6. Examine the draw modes for other objects using the methods outlined in step 4 or 5.

All the text objects use the Paint draw mode. This is the default for new Text (and Paint) objects.

Change the Draw Modes

Apply different draw modes to the text objects to see their effects in the clip.

1. Ensure Animate (A) is disabled.

When Animate is disabled, you can change the property at any frame without creating keyframes.

- 2. Set the draw mode for the Techno object:
 - a) In the Workspace panel, select the Techno object.
 - b) In the Modes controls, select Overlay from the Draw Mode list.

The white text object is combined with the colors of the blue background image and creates new tints based on these results. The contrast and color saturation are increased.

Note: Draw modes can be animated. However, the transition between the draw modes is instantaneous rather than the gradual transition found in most other channels.

- 3. (Optional) Examine a text object's Draw Mode channel in the Timeline:
 - a) In the Workspace panel, select the Techno object.
 - **b)** Show the Timeline (**F4**).
 - c) In the Timeline, ensure Context is enabled.

When Context is enabled, the Timeline displays the properties of the object selected in the Workspace panel.

d) In the Workspace panel, select the Techno object Draw Mode to display it in the Timeline.

Note: You can also press CTRL+Down ARROW / 第+DOWN ARROW to navigate down a branch.

The highlighted key icons next to the object property channels in the Workspace panel and Timeline indicate that these properties can be animated. They are enabled by default. When disabled, the properties cannot be animated (even when Animate is enabled).

e) Click the Draw Mode key icon.

The key icon turns gray and the keyframe set at frame 1 in the Timeline is no longer displayed.

- f) Click the Draw Mode key icon to enable animation.
- **4.** Apply draw modes to the following text objects by first selecting them in the Workspace panel and then selecting the draw mode from the Draw Mode list in the Text Controls panel (**F8**).

Note: You can change Draw Mode in the Timeline by scrubbing the property name.

Text Object	Draw Mode	Description
2 step	Dodge Midtones	The Dodge Midtones mode lightens the midlevels or midtones of both color and grayscale images.
		The name "dodging" comes from the traditional darkroom technique of using a small, circular paddle to block (or dodge) the amount of light received by a print, thereby lightening the areas of the print which have been dodged. These dodging tools do not take into account the current color when applying their effects. However, if the Pressure slider is active, the Pressure setting affects the amount of dodging (or lightening) that occurs with one application. Repeated application increases the amount of lightening that occurs.
Ambient	Dodge Shadows	The Dodge Shadows mode lightens the darkest areas of the image.
Trance	Luminance	The Luminance mode replaces the brightness of the image's color in the selected area with the luminance value from the current color. This is most effectively done by using a shade of gray as the current color so that the portion of the image being affected takes on a uniform level of luminance. Luminance mode can be used to match brightness levels in different areas of an image.
		The Pressure slider is not available in Luminance mode.
Techno	Overlay	The Overlay mode applies a gel of the current color onto your image. It combines the colors of the image with those of the current color to create new tints based on these results. It boosts contrast and color saturation at the same time.
		The Pressure slider is not available in Overlay mode.
UK Garage	Burn Shadows	The Burn Shadows mode darkens the darkest sections of the image.
		This mode is the opposite of the dodging technique described earlier. "burning" a print in a darkroom is achieved by holding your hand in sort of an "O", focusing the light and allowing more light to reach some areas of a print more than others. Burning an image thus darkens the selected area. These burning tools do not take into account the current color when applying their effects. However, if the Pressure slider is active, the Pressure setting affects the amount of burning (or darkening) that occurs with one application. Repeated application increases the amount of darkening that occurs.

Text Object	Draw Mode	Description
House	Soft Light	The Soft Light mode applies a soft, diffuse light of the current color onto your image. It does not completely affect areas of detail, but does reduce the contrast levels in the image. It takes into account the brightness levels of the current color and can actually reduce the brightness level of areas if the current color is a dark one. Using this mode with black produces a very dark effect, with white a very bright one.
		The Pressure slider is not available in Soft Light mode.
Acid	Brightness	The Brightness mode adjusts the overall brightness or darkness level of all pixels in the area being processed. Use this as you would the brightness control on a television set. A Pressure slider setting of 50% produces no effect, while values of more than 50% increase brightness and those of less than 50% cause a reduction in the brightness level.
Dance	Overlay	Refer to Techno.

- 5. Choose Edit | Select None (CTRL+D / ૠ+D) to deselect the Dance object.
- **6.** Play the clip (**SPACEBAR**) to view the result.
- **7.** (Optional) Save the workspace:
 - a) Choose File | Save Workspace (CTRL+S / %+S) to open the Save Workspace dialog.
 - **b)** Set a filename and directory for the workspace, and then click OK (**ENTER** / **RETURN**).
- 8. Choose File | Close Workspace (CTRL+W / ૠ+W) to close the workspace.

Wire Removal

Lesson 11

In this lesson, retouch a clip by drawing on a single frame and then animating the paint stroke to follow the action.

Overview

In this lesson, use the Paint tools to retouch a clip. Remove an unwanted wire by painting over it and revealing footage underneath then, cover a crack in the sidewalk by painting over it with cloned pixels from another area of the sidewalk.

In this lesson:

- Draw a line over a wire attached to the person's back using the Paint tools.
- Animate the line frame by frame to follow the wire throughout the clip.
- Hide the line and the wire using the Reveal method.
- Draw a brush stroke over a crack in the sidewalk.
- Hide the crack in the sidewalk using the Clone method.

Open the 11_WireRemoval.mov file in the 11_WireRemoval folder and preview the result.

Need Help?

If you need help completing this lesson, save and close your workspace, and then open the 11_WireRemoval.cws file as a reference.

Create a Composite

Create a composite branch and import the footage for the composite.

- 1. Check the Combustion preferences. For instructions, see "Setting the Preferences" on page 3.
- 2. Choose File | New or press CTRL+N (Windows) or 96+N (Macintosh) to open the New dialog and create a branch with the following properties:
 - Type: Composite
 - Name: 11_WireRemoval
 - · Format: NTSC DV
 - · Duration: 30 frames
 - Bit Depth: 8 Bit
 - Mode: 2D

- **3.** Select the single-viewport layout.
 - In the Workspace panel (F3), right-click / CONTROL-click the 11_WireRemoval composite and choose Import Footage (or press $CTRL+1 / \Re +1$).

- 5. In the Import Footage dialog, do one of the following to locate and open the 11_WireRemoval folder:
 - · Navigate the file browser.
 - Edit the path at the top of the dialog.

• Click the browser menu button to the left of the path.

Hint: To select a recently used folder, click the menu button to the right of the path.

- 6. Import the footage:
 - a) Double-click the Man folder, and click the man[###].jpg image sequence.
 - **b)** Double-click the *Parent* folder, double-click the *Car* folder, then click the *car*[####].png image sequence and click OK (ENTER/ RETURN) to import the queued images into the composite.

The images are added to the composite in the order they are imported: the last file you select is the uppermost layer in the composite.

- 7. Rename the layers:
 - a) In the Workspace panel (F3), right-click / CONTROL-click the car0015 layer, and choose Rename.
 - b) Rename the car0015 layer "Car".
 - c) Right-click/ CONTROL-click the man0015 layer, and choose Rename.
 - d) Rename the man0015 layer "Man".
- 8. View the animation layer by layer:
 - a) In the Workspace panel, double-click the Man layer to display it in the viewport.
 - b) Play the animation (SPACEBAR).

Notice the white wire attached to the man's back. The wire is used to snap the man back, giving the impression the man is hit by the car.

- c) In the Workspace panel, double-click the Car layer to display it in the viewport.
- **d)** Play the animation (**SPACEBAR**).

The car was filmed from exactly the same camera position. The car layer is masked to show only the area that you need in the final composite.

Note: For more information on using masks, see Lesson 26, "Using Masks."

9. In the Workspace panel, double-click the 11_WireRemoval composite to see the entire composite in the viewport.

Remove the Wire

When removing wires, you use Paint tools to take pixel information from one area and duplicate that information on top of the unwanted wires. First, add a Paint operator to the Man layer then, draw a line over the wire to cover the wire.

- 1. Go to the first frame (HOME).
- 2. Add a Paint operator to the Man layer:
 - a) In the Workspace panel, select the Man layer.
 - b) In the Operators panel (F5), click the Favorites category.

- c) CTRL-click / %-click Paint in the list of Favorites operator to access automatically the Paint Controls panel.
- d) In the Workspace panel, double-click the Paint operator to display its output in the viewport.
- The viewport icon next to the Paint operator indicates the output of the Paint operator is displayed in the viewport.

- 3. Set the Draw mode preferences:
 - a) In the Paint Controls panel, click Modes.

- b) Click Reset to set the draw mode settings to default.
- c) From the Brushes palette, select a soft brush slightly wider than the wire.
 To hide the wire, you need a brush slightly wider than the wire to achieve a good result.

The selected brush is shown next to the color picker.

- d) Click the Swatches tab.
- e) From the Swatches panel, click a red color to contrast with the color of the sidewalk.

The default (white) foreground color is changed to the selected color.

4. Show the Toolbar (F2).

The Toolbar is context sensitive. Since the operator is a Paint operator, the Toolbar shows the Paint tools.

Notice some Paint tools have a black triangle at the lower right corner, indicating a context-menu for accessing additional Paint tools. These tools are the Compare tool, the stroked tools, the filled tools, the Text tools, the selection tools, and the mask tools.

- 5. Click and scrub the Magnify tool to zoom in on the line in the viewport.
- 6. Scrub the Grab tool to pan the viewport.

simple vector graphic for the object.

a) Select the Line tool (L).

- 7. Draw a line:
- Note: Before you draw an object, determine where you want the object to appear in the clip. Then, draw a

b) Make sure you are at frame 1, then drag the cursor over the wire.

Note: You can begin drawing the line outside the left border.

8. Play the animation (SPACEBAR).

The Line object is visible throughout the clip but does not follow the animation of the clip.

Animate the Line Object

Animate the Line object so it hides the wire throughout the duration of the clip.

- 1. Go to the first frame (HOME).
- 2. Ensure the Line tool in the Toolbar is still selected.
- 3. Go to the Edit Controls Points mode by doing one of the following:
 - In the Toolbar (**F2**), click the Arrow tool 🕟 and then click the Edit Control Points tool 💠
 - Press TAB twice to access the Edit Controls Points mode.
- 4. Choose Window | Outlines Only to display the background footage and only the wireframe of the Line object.

 The Outlines Only option enables you to position objects more accurately.
- 5. Animate the Line object:
 - a) Enable Animate (A).
 - b) Press PAGE DOWN to go to the next frame.
 - c) Reposition the Line object to hide the wire by dragging its control points.

- d) Go to the next frame and reposition the Line object.
- e) Repeat step d to the end of the clip.

Note: This process may seem tedious but it becomes easier as you get used to it. Alternatively, you could try and use the tracker to do most of the work for you.

- f) Disable Animate (A).
- 6. Preview the result:
 - a) Go to the first frame (HOME).
 - b) Choose Window | Outlines Only to disable Outlines Only.
 - c) In the Workspace panel, deselect the Line object by clicking in the background.
 - d) Play the clip (SPACEBAR).

The wire is hidden throughout the clip by the Line object. Now you need to remove the Line object's red color.

Hide the Line Object's Red Color

There are various methods to hide the Line object's color. While the Clone source mode works well to disguise the wire, use the Reveal source mode. Revealing is similar to using an eraser on a layer. It allows you to see the layer beneath the object.

- 1. Go to the first frame (HOME).
- 2. In the Workspace panel (F3), select the Line object.
- **3.** Reveal the background:
 - a) In the Paint Controls panel, click Reveal in the Modes controls.

b) From the Source list, select Pick Operator.

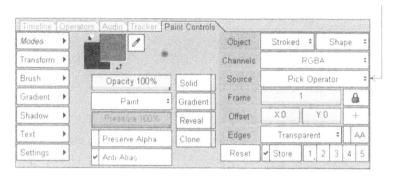

- c) In the Select Source dialog, click Open Footage.
- d) In the Import Footage dialog, double-click the *Parent* folder, click *street.jpg* and then click OK (ENTER / RETURN).

The footage is imported into the Footage Library.

Note: The imported image is a still image of the same scene taken from the same camera position, but without the actor present.

- **4.** In the Workspace panel, double-click the 11_WireRemoval composite.
- 5. Play the animation (SPACEBAR) to view the result.

Notice that both— the wire and the Line object—are no longer visible. Instead, the Line object reveals the footage you imported into the Footage Library.

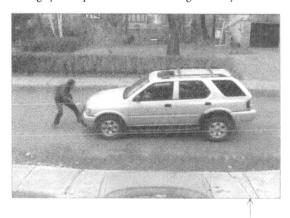

Notice the crack in the sidewalk. This time, use a more sophisticated technique to retouch a clip.

Fix the Sidewalk

Remove the crack in the sidewalk using the Cloning method. Clone pixels from one area of the sidewalk onto the crack in the sidewalk to cover the crack.

- 1. Go to the first frame (**HOME**).
- 2. In the Workspace panel, double-click the Paint operator.
- 3. Create a brush stroke:

a) In the Toolbar (F2), click the Stroked Freehand tool (F) or click-drag the Filled Freehand tool and choose the Stroked Freehand tool.

The Freehand tool, Rectangle tool, Ellipse tool, Bezier tool and B-Spline tool have two modes: Stroked and Filled.

Note: To access the control points of a Brush Stroke object, Filled Stroke object, or Lasso Selection object, enable the Make curve option before creating the object or choose | Make Curve once the object is created.

- b) Choose Window | Outlines Only.
- c) Draw a brush stroke over the crack in the sidewalk.
- d) Choose Window | Outlines Only to see your actual brush stroke.
- 4. Clone an area of the sidewalk:

a) Select the Line object via the Workspace panel (F3) or by clicking the Arrow tool (TAB).

The Line object bounding box with the pivot point in the center is displayed in the viewport, indicating the object is in Edit Object mode.

b) In the Paint Controls panel, click Clone.

The source mode of the Brush Stroke Paint object changes from a solid red source to a clone source. The values in the X and Y Position fields reflect the offset values of the first control point created. Therefore, your result may be different than the result shown in the following image, depending on which control point was created first and depending on its offset values. This examples shows the result of the brush stroke created from top to bottom.

c) Click the clone Set Position button.

d) Click in the viewport to the left of the crack in the sidewalk.

The brush stroke is cloned using pixels from the sidewalk. As a result, the crack is no longer visible.

5. If you still see the crack (refer to the following image to the left, at the lower right of the bounding box), drag the cursor in the X and Y Position fields or over the Set Position button to adjust the clone source.

The crack in the sidewalk is no longer visible (refer to the following image to the right).

- **6.** View the end result:
 - a) In the Workspace panel (F3), double-click the 11_WireRemoval composite to view the composite in the viewport.
 - b) Play the clip (SPACEBAR) to view the result.
- 7. (Optional) Save the workspace:
 - a) Choose File | Save Workspace (CTRL+S / 策+S) to open the Save Workspace dialog.
 - b) Set a filename and directory for the workspace, and then click OK (ENTER / RETURN).
- 8. Choose File | Close Workspace (CTRL+W / ૠ+W) to close the workspace.

The state of the s

albert of the second of the se

and the state of t

Creating Text Gradients

Lesson 12

In this lesson, apply a gradient to text, then apply a source image as an outline, and animate the text.

Overview

You can use gradients to create smooth transitions between colors in text objects. With gradients, you can create colorful, eye-catching graphics or text in motion graphics projects.

In this lesson:

- Create a Text branch and replace the background with an image sequence.
- Add text to the clip and apply a three-color gradient.
- Create a text outline and use a source image for texture.
- · Animate the Text.

Open the 12_CreatingTextGradients.mov file in the 12_CreatingTextGradients folder and preview the result.

Need Help?

If you need help completing this lesson, save and close your workspace, and then open the 12_CreatingTextGradients.cws file as a reference.

Note: Depending on the operating system and on the fonts installed on the workstation, workspaces containing text objects may differ slightly from one workstation to another.

Create a Text Branch

Create a Text branch.

- 1. Check the Combustion preferences. For instructions, see "Setting the Preferences" on page 3.
- 2. Choose File | New or press CTRL+N (Windows) or ℜ+N (Macintosh) to create a branch with the following properties:
 - Type: Text
 - Name: 12_CreatingTextGradients
 - Format: NTSC D1Duration: 30 frames
 - Bit Depth: 8 Bit

- 4. Replace the solid background with animated footage:
 - a) In the Workspace panel (F3), select the Footage operator.

b) In the Footage Controls panels (F8), click Replace.

c) In the Replace Footage dialog, open the 12_CreatingTextGradients folder, double-click the Background folder, and then double-click the Background[#####].png image sequence.

The footage is displayed in the viewport.

5. Play the animation (**SPACEBAR**).

A forest image is blurred as the clip plays.

Add Text

Add some text to the clip. First set the text characteristics, and then create the Text object.

1. Go to (/) frame 1.

12 Creating Text Gradients

2. In the Workspace panel, select the Text operator.

- 3. In the Text Controls panel (F8), click Modes, and then click Reset to return to the default settings.
- 4. Set the Text characteristics:
 - a) Click Text and then Basics.

- b) From the Font list, select Verdana.
- c) In the Font Size field, enter 100.
- d) Enable Small Caps.
- e) Set Size to 60%.
- f) Set Tracking to 8.
- g) Set Slant to 6°.

5. Create a text object:

- T
- a) In the Toolbar (F2), click the Text tool (T).
- **b)** Draw a wide box in the viewport.

The box edge represents the margins of the text area.

Hint: You can click Layout in the Text Controls to see the four margin values.

c) Type "In a Time".

The text appears in the viewport.

- R
- d) In the Toolbar, click the Arrow tool.

In the viewport, a bounding box, with a pivot point in the center, appears around the text, indicating the object is in Edit Object mode.

- **6.** Position the text object:
 - a) Choose Window | Sow Safe Zones (') to display the Action and Title safe zones.

b) In the viewport, position the cursor over the Text object and when the cursor changes to $\frac{1}{2}$, drag the Text object to the lower right corner of the Title safe zone.

Hint: You can also use the Transform controls to move the Text object.

Create a Text Gradient

Change the text face from solid white to a three-color gradient.

1. In the Text Controls panel, click Attributes.

- 2. In the Source area, click Gradient to access the Color and Opacity gradient bars.
- 3. Create the gradient:
 - a) Click the left side of the Color gradient bar to add a gradient tag.

b) Click the center of the gradient bar, and again at the right end of the gradient bar to add another gradient tag.

You should have three gradient tags.

c) Double-click the gradient tag at the far left.

The Pick Color dialog is displayed.

d) Choose a light orange color, and click OK (ENTER / RETURN).

- e) Double-click the middle gradient tag and choose a yellow color.
- f) Double-click the last gradient tag and choose a dark yellow color.

Hint: You can also right-click / **CONTROL**-click the gradient tag to open a color palette, and choose your colors.

4. Set Angle to 45°.

In the viewport, the text object displays the three-color gradient set at an angle.

Add a Text Outline

Create an outline for the text and use a source image for the outline texture.

1. In the Text Controls panel, click Outline, and make sure Outline is enabled.

Note: When enabled, the little box next to Outline is yellow.

The text has a white outline.

- 2. Set the outline size to 3.
- 3. Open an image file for the outline texture:
 - a) Select Texture as the Source.

- b) From the Source list, select Pick Operator.
- c) In the Select Source dialog, click Open Footage.
- d) Open the 12_CreatingTextGradients folder and double-click Camouflage.jpg.

The camouflage footage appears in the Texture Source preview.

4. Scrub the Texture Source preview to adjust the texture starting point and change the look of the outline.

As you scrub, the outline in the viewport changes. If you scrub to the edge of the footage, the outline disappears.

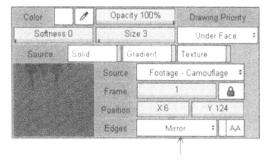

5. From the Edges list, select Mirror to avoid having any visible edges in the outline.

Edit a Text Object

Change the look of the gradient, and then edit and reposition the text.

- 1. Change the gradient color placement:
 - a) In the Text Controls panel, click Face.
 - b) In the Color gradient, click the gradient tag on the left side.
 - c) Drag the handle to expand the range of the gradient color.

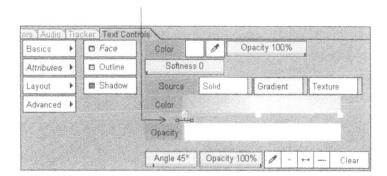

- d) Repeat step c for the gradient tag on the right side.
- 2. In the Text Editor, select the text and type "In a World".

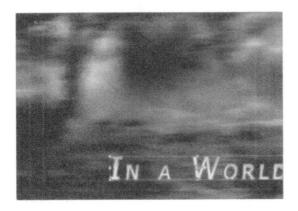

Notice the text object no longer fits in the Title safe zone properly.

- 3. Reposition the text object in the viewport:
 - a) Click Basics.
 - b) Set Align Right.

In the viewport, the text aligns to the right margin. However the right margin is too far right, and the text still does not display properly.

T c) In the Toolbar (F2), click the Text tool (T).

In the viewport, the margins appear showing the text aligned right.

d) Click the Arrow tool and drag the text object left, so it fits in the Title safe Zone properly.

Now the text position will be correct even if you edit the text again.

4. Disable Safe Zones (').

Note: If you enter text in the Text Editor, the margins are automatically at the Title safe zone. You can set this value in the Preferences.

Animate the Text

- 1. In the Text Controls panel, click Layout.
- 2. Enable Animate (A).
- 3. Set Write On to 0%.

- 4. Go to frame 30 (END).
- 5. Set Write On to 100%.
- Play the animation (SPACEBAR).The letters appear in the viewport one by one, as if they are being typed.
- 7. (Optional) Save the workspace:
 - a) Choose File | Save Workspace (CTRL+S / 策+S) to open the Save Workspace dialog.
 - b) Set a filename and directory for the workspace, and then click OK (ENTER / RETURN).
- 8. Choose File | Close Workspace (CTRL+W / ૠ+W) to close the workspace.

the fire feet

in the manner of the second for the

t lævulmint udern

report to see

gregorio en por en 11. eusan resistante e que en entre en establista.

poleno qui la la capati de la c

Animating Gradients

Lesson 13

In this lesson, animate a gradient so it appears to wash over a rectangle. Add text to the rectangle, and set the text outline to gradient.

Overview

You can create and animate four types of gradients: linear, radial, radial sweep, and spiral. Each gradient has a vector that defines its length and direction. You can animate this vector to change the gradient throughout the clip.

In this lesson:

- Draw a Paint object.
- Apply a three-color gradient to the object.
- Examine the four types of gradients.
- Animate the gradient by changing its vector.
- Add a text object with a gradient outline.

Open the 13_AnimatingGradients.mov file in the 13_AnimatingGradients folder and preview the result.

Note: Depending on the operating system and on the fonts installed on the workstation, workspaces containing text objects may differ slightly from one workstation to another.

Need Help?

If you need help completing this lesson, save and close your workspace, and then open the 13_AnimatingGradients.cws file as a reference.

Create a Paint Branch

Create a Paint branch.

- 1. Check the Combustion preferences. For instructions, see "Setting the Preferences" on page 3.
- 2. Choose File | New or press CTRL+N (Windows) or \$\mathbb{H}+N (Macintosh) to create a branch with the following properties:
 - Type: Paint
 - Name: 13_AnimatingGradients
 - Format: NTSC D1
 - Duration: 30 frames
 - Bit depth: 8 Bit

- **3.** Select the single-viewport layout.
 - 4. Choose Window | Fit in Window, or right-click / CONTROL-click the viewport and choose Fit in Window.
 - **5.** Make sure you are at frame 1.

Create a Rounded-Corner Rectangle

Use the Filled Rectangle tool to draw a rounded-corner rectangle.

1. Show the Toolbar (F2).

Some Paint tools have a black triangle at the lower right corner, indicating a context-menu for accessing additional Paint tools. These tools are the Compare tool, the stroked tools, the filled tools, the Text tools, the selection tools, and the mask tools.

The Freehand tool, Rectangle tool, Ellipse tool, Bezier tool and B-Spline tool have two modes: Stroked and Filled.

2. In the Toolbar, click the Filled Rectangle tool (SHIFT+R).

Note: If the Filled Rectangle tool is not shown, in the Toolbar, click-drag the filled tool and choose the Filled Rectangle tool from the context menu, or press the tool's hot key.

The Rectangle tool enables you to set a corner radius to create a rectangle with rounded corners.

Note: Corner Radius is not a channel and cannot be animated. It is used only at the time you create the rectangle object.

3. Set the corner radius to 20%.

- 4. In the Paint Controls panel (F8), set the options for drawing the rectangle:
 - a) Click Modes.

b) Click the Default Foreground and Background Colors button.

Hint: To reset the colors to their default, you can also press D.

c) Click Reset to set the draw mode settings to default.

The Reset button in the Modes controls resets Draw mode, Opacity, Preserve Alpha, Anti-Alias, Foreground Color and Background Color, and Source mode to their default settings.

5. Choose Window | Grids, Guides and Ruler | Show Grid (**SHIFT+G**).

The Grid is helpful for drawing and positioning objects in the viewport.

6. Click the viewport and drag diagonally to draw a large rectangle.

The default object duration is set from the current frame to the end of the clip. You can change the default object duration either via the Combustion Preferences dialog or the Paint Settings controls.

7. Choose Window | Grids, Guides and Ruler | Show Grid (SHIFT+G) to hide the grid.

Apply a Gradient

Apply a gradient to the rectangle using the three primary colors in the RGB color system.

- 1. Apply a gradient to the rectangle:
 - a) In the Workspace panel (F3), select the Filled Rectangle.

b) In the Paint Modes controls, click Gradient to change the source of the object from a solid color to a gradient.

The Gradient thumbnail preview is displayed to the right of the Gradient button.

- 2. Select the gradient's first color:
 - a) In the Paint Controls panel, click Gradient to access the Gradient controls.

Hint: You can also click the Gradient thumbnail preview in the Modes controls to access the Gradient controls.

b) Click the left side of the Color gradient bar to add a gradient tag.

A tag indicates where a particular color appears in the gradient.

c) Show the Sliders panel to the right of the Brushes palette.

d) Click RGB% to define colors in percentages of Red, Green, and Blue.

Hint: You can also choose colors in the Sliders panel by their RGB or HSV (Hue Saturation Value) values.

e) Make the gradient's first color green by setting the fields in the Sliders panel to R=0%, G=100%, and B=0%.

Hint: You can also double-click a gradient tag to select a color using the Pick Color dialog, or right-click / **CONTROL**-click the tag to pick from a color palette.

- 3. Select the gradient's second color:
 - a) Click the right side of the gradient Color bar to add a second gradient tag.
 - **b)** Make the gradient's second color red by setting the fields in the Sliders panel to R=100%, G=0%, and B=0%.

The gradient shown in both the rectangle and the gradient Color bar fades from green to red.

Hint: You can animate gradient tags in a clip by changing their color or opacity over time.

- **4.** Select the gradient's third color:
 - a) Click the middle of the gradient Color bar to add a third gradient tag.
 - **b)** Make the gradient's third color yellow by setting the fields in the Sliders panel to R=100%, G=100%, and B=0%.

Both the gradient Color bar and the rectangle now show a three-color gradient.

Hint: To remove a Gradient tag, select the tag(s) you want to remove, and then click the Remove Tags button [-].

Change the Gradient Type

Change the look of the rectangle's gradient by changing the gradient type.

1. In the Gradient controls, click the Radial Gradient button

A circular gradient appears with the colors radiating outwards from the center of the ellipse. Notice that the direction control box also shows a preview of the new gradient type.

13 Animating Gradients

The colors are swept around in a counter-clockwise direction.

3. Click the Spiral Gradient button .

The colors turn into a spiral of colors originating from the center.

4. Click the Linear Gradient button **1** to restore the default gradient type.

Animate the Gradient

Animate the rectangle's gradient by using the Edit Gradient tool.

1. In the Toolbar (F2), click the Edit Gradient tool to display the Gradient vector.

Hint: Press TAB to cycle through the Arrow tool's options (Edit Object, Edit Control Points, Edit Gradient).

Note: The Gradient option is only available if a Paint object's source is set to Gradient.

The gradient vector is displayed in the viewport.

- 2. Change the gradient's direction to a preset direction:
 - a) In the Gradient controls, click the left arrow button in the direction control box to reverse the direction of the gradient.

b) Click the lower right arrow to apply a diagonal gradient.

Notice that the gradient vector matches the preset direction selected. The start point of the diagonal gradient moves to the upper left while its end point moves to the lower right.

c) Click the right arrow to restore the gradient to its original direction.

Although you can animate gradients using the presets in the direction control box, manipulating the gradient vector itself allows you to fine-tune the animation.

3. Make sure you are at frame 1.

- 4. Enable Animate (A).
- **5.** Position the gradient at the first frame:
 - a) Drag the start point of the gradient vector so it is outside the left side of the rectangle. Notice that the gradient changes because its start point lies off of the rectangle's surface.
 - b) Drag the end point of the gradient vector so it also lies just outside the left side of the rectangle.
 The rectangle turns blue because the gradient vector is now completely outside the rectangle.
 - c) Drag the vector above and to the left of the rectangle.

- 6. Position the gradient at the last frame:
 - a) Go to the last frame (END).
 - b) Drag the end point of the vector until it is just beyond the lower right corner of the rectangle.

By extending the gradient vector across the rectangle at the last frame, the colors will appear to wash over the rectangle.

- 7. Disable Animate (A).
- **8.** Go to the first frame (**HOME**).

9. Play the clip (SPACEBAR) to view the result.

The gradient extends diagonally across the rectangle, changing its color from solid red at the beginning to the three-color gradient at the end.

Add a Text Object

Create a text object over the rectangle object. Then add a drop shadow and outline.

- 1. Go to (/) frame 1.
- 2. Add a text object:
 - a) In the Paint Controls panel, click Text, and then make sure Basics is selected.

- b) Click Font to access the Font Browser dialog.
- c) Select a sans serif font, and click OK (ENTER / RETURN).
- d) Set the Font Size to 98.
- e) In the Text Editor, enter the word "Gradients".
- **3.** In the viewport, position the cursor anywhere inside the object, and then click and drag the text object and position it over the center of the rectangle object.

Note: If the object is so small that the pivot point prevents you from selecting the shape, CTRL-click (Windows) or COMMAND-click (Macintosh) and drag.

4. Set the Face attributes:

a) In the Text controls, click Attributes, and make sure Face is turned on and selected.

- b) Set Opacity to 50%.
- c) Set Color to black.

5. Add a drop shadow:

a) Double-click Shadow to select it and enable it.

- b) Set Opacity to 45%.
- c) Set Softness to 4.
- d) Set Scale to 85%.
- e) Set Distance to 20.
- f) Set Direction to 315°.

- **6.** Add an outline to the text:
 - a) Double-click Outline to select it and enable it.

In the viewport, an outline is added to the text object.

- b) Make sure Opacity is set to 100%.
- c) Set Softness to 1.
- d) Set Size to 2.
- e) Set Drawing Priority to Under Face.

Apply a Gradient to the Outline

Apply a gradient to the text outline using the same primary colors as before.

1. In the Outline settings, click Gradient.

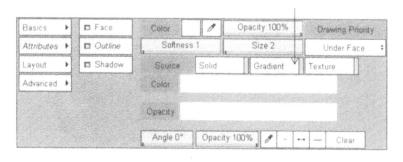

- 2. Click the left side of the gradient Color bar to add a gradient tag.
- 3. Set the gradient's first color:
 - a) Double-click the Gradient tag to open the Pick Color dialog.
 - b) Set the color sliders to 100% for Red, Green, and Blue.
- 4. Add a second gradient tag to the right side of the Color bar and set Red to 2%, Green to 85%, and Blue to 9%.
- 5. Add a final gradient tag to the middle of the Color bar and set Red to 4%, Green to 26%, and Blue to 61%.
- **6.** Set Angle to 100°.

13 Animating Gradients

- 7. In the viewport, click away from the rectangle to deselect the objects.
- 8. Play the clip (SPACEBAR).
- 9. (Optional) Save the workspace:
 - a) Choose File | Save Workspace (CTRL+S / 98+S) to open the Save Workspace dialog.
 - **b)** Set a filename and directory for the workspace, and then click OK (${\sf ENTER}$ / ${\sf RETURN}$).
- **10.** Choose File | Close Workspace ($\mathsf{CTRL} + \mathsf{W} \ / \ \Re + \mathsf{W}$) to close the workspace.

Creating Custom Brushes

Lesson 14

In this lesson, you create custom brushes from particles and source material, make changes to the custom brushes, and animate the brushes.

Overview

Custom brushes extend the Combustion paint capabilities allowing a high degree of flexibility and control over the size shape, size, and individual marks that make up the brushes. Used creatively, custom brushes can be used for everything from custom clip art to specialized brush types for rotoscoping and design.

In this lesson, you enhance the background with a tile texture created with custom brushes and enhance a sign to mimic flashing lights using custom brushes.

In this lesson:

- Create custom brushes from images and particles.
- Use paint tools to modify the custom brush.
- · Create animations based on custom brush objects.

Open the 14_CreatingCustomBrushes.swf file in the 14_CreatingCustomBrushes folder and preview the result.

Need Help?

If you need help completing this lesson, save and close your workspace, and then open the 14_CreatingCustomBrushes.cws file as a reference.

Open the Starting Workspace

Due to the amount of viewport configuration changes in this lesson, it is necessary to change how Combustion responds to viewport selection. First, set the Combustion Behavior preferences, then open the starting workspace. This workspace is the baseline for this lesson.

- 1. Set the Combustion preferences:
 - a) Refer to "Setting the Preferences" on page 3.
 - b) In the Combustion Behavior Host category, enable Switch Operator with View and click OK (ENTER / RETURN).
- Choose File | Open Workspace or press CTRL+SHIFT+O (Windows) or ℜ+SHIFT+O (Macintosh) to access the Open Workspace dialog.
- **3.** In the Open Workspace dialog, locate and open the 14_CreatingCustomBrushes folder by either navigating the file browser or editing the path at the top of the dialog.
- 4. Double-click the 14_CustomBrushes_start.cws file.

6. Choose Window | Fit in Window or click the Home button Home |

7. Play the clip (SPACEBAR).

The clip features a custom resolution of 590 width x 699height. The background wall layer appears blank grey until frame 62. At frame 62, the "Now Showing" enters from the top of the frame. At frame 88 the Poster layer begins to appear and settles into place at frame 114. It holds it's position for the remainder of the composition.

Create a Custom Brush from Particles

All custom brushes are created from and applied with Combustion paint operator. In this exercise, add the Paint operator to the layer and create a New Brush Set. Creating a brush set helps separate brushes you create into logical groups, leaving default brushes unmodified. Brushes can be organized in any manner. Organizing by brush type or project are often good methods. Then, create a custom brush from a customized particle system that is to be used to lighten the "Now Showing" Text.

- 1. In the Workspace Panel (F3), expand the Now Showing layer.
- 2. Add a Paint operator to the Now Showing layer:
 - a) In the Workspace panel, select the Now Showing layer.
 - **b)** In the Operators panel (**F5**), click the Favorites category.

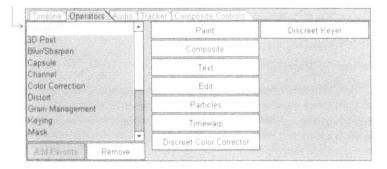

- c) CTRL-click / %-click Paint in the list of Favorites operator to access automatically the Paint Controls panel.
- 3. Double-click the Paint operator to make it the current operator.

4. Create a brush set:

- a) In the Paint Controls (F8), click Modes.
- **b)** Click the Brushes palette menu button () and choose New Brush Set.
- c) Name the new brush set Attack Brushes and click OK.

A default Brush set is created with 3 elliptical basic brushes displayed in the Brushes palette.

- 5. Create a custom brush from particles:
 - a) In the Paint Controls panel (F8), select Brush controls.
 - b) Choose Custom from the Shape list.

The Brush Source controls appear.

c) Choose New Particle from the Brush Source controls.

The viewport layout changes to two-viewport layout. The current Paint branch is displayed in the right viewport, and a blank particle operator is displayed in the left viewport. The Particles controls (**F8**) are displayed and the Toolbar displays the particles toolset. In the Workspace Panel (**F3**), a new branch Particles- Custom Brush is added to the Workspace. This is the actual branch that is supplying the image to the custom brush entry in the Paint operator's brush palette.

- **d)** In the Particle Controls panel (**F8**), scroll down the Library list to the *Demo Group 1* folder and click the Star Trail 2 emitter.
- e) In the Toolbar (F2), click the Point Emitter tool and click in the center of the frame of the left viewport.

.

An instance of the Start Trail emitter is created in the viewport.

6. Test the custom brush:

- a) Select the right viewport.
- b) Click the Home button Home to fit the "Now Showing" text in the viewport.
- c) In the Toolbar (F2) choose the Line Tool (L).
- d) In the Paint Controls panel (**F8**), click Brush, set Brush size to approximately 120, and enable Update in the Brush Source controls.

This automatically updates the brush palette in real time as changes are made to the source brush image.

e) In the right viewport, click and drag to create a straight line across the "Now Showing" text.

Custom brushes can be dynamically updated by modifying the source image (or particle) as well as changing the brush parameters in the Paint Controls.

7. Update the custom brush:

- a) Click the left viewport.
- b) In the Workspace panel (F3), in the CustomBrush Particles branch, select the Star Trail 2 object.
- c) In the Particles Controls (F8) select Emitter.
- d) Click the Tint color box and select a light yellow color from the Pick Color dialog.
- e) Set Tint Strength to 100%.

The particle in the left viewport is now yellow.

f) Select the right viewport.

The Paint Controls panel is displayed. In the Brushes palette, the particle is updated to reflect the new selected yellow color.

- g) When brushes are updated in the palette, objects previously created with the brush are not automatically updated. This allows you to pick and choose which instances to change and allows you to create a variety of stroke types without creating a custom brush type for each one.
- 8. Update the line with the updated custom brush:
 - a) In the Workspace Panel (F3) select the Paint Line object.

The Line is selected in the right viewport.

9. In the Paint Controls (F8), select the updated yellow particle brush in the Brushes Palette.

The Line updates to reflect the new yellow color.

- 10. In the Brush Options, modify the brush settings:
 - a) Set Brush Size to 63.
 - **b)** Set Spacing to 42%.

The continuous line is changed to segmented line, simulating a strand of lights.

Create a Lighting Effect

Use the Line to create a lighting effect for the Now Showing Text. Use a different Paint mode and an expression to create a flashing light effect. Duplicate and reposition the line object to fill in the "Now Showing" text.

- 1. Change the Paint Draw mode of the Line object:
 - a) In the Paint Controls panel (F8), select Modes to access the Modes controls.
 - b) In the Modes controls, choose Color Dodge from the Draw mode list.

The line is now visible only thru the Opaque areas of the "Now Showing" text. The Color Dodge mode allows the underlying shading of the Now Showing text to be maintained even thru the color changes caused by the light effect.

- 2. Create the Flashing Effect:
 - a) In the Timeline (F4), select the Opacity channel of the Line Object.
 - b) Click the Expression Browser Button to access the Expression Browser dialog.

- c) In the Expression Browser dialog, click the Sine Expression picon.
- d) set the Minimum Y Value to 0, the Maximum Y Value to 100, and Frequency to 10.

Note: All other parameters should be 0. (Ignore the Picon Frame Range Channel as it has no effect on the expression.)

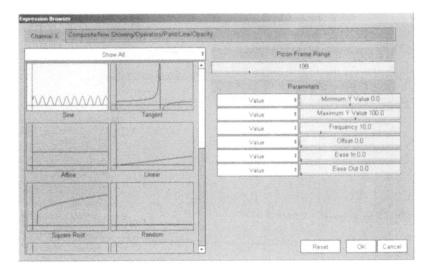

- e) Click OK (ENTER / RETURN) to apply the expression to the Opacity channel.
- f) Play the clip (SPACEBAR).

The Dotted line appears to oscillate or flash on and off.

- **3.** Reposition and copy the line to fill the text.
 - a) Go to frame 1 (HOME).
 - b) In the Workspace panel, select the Line object.
 - c) In the Paint controls (F8), select the Transform options and set the line Y Position to 165.
 - d) Choose Edit | Copy then Edit | Paste.

In the Workspace panel, a duplicate line object—Line(2)—is created in the Paint Operator.

- e) In the Workspace panel, select the Line(2) object, and in the Paint Transform controls, set Y Position to 186 and X Position to 637.
- **f)** In the Workspace panel, select the Line object and create another copy.
- g) In the Workspace panel, select the Line(3) object and in the Paint Transform controls, set Y Position to 206.

 The advantage of working this way is that you only have to adjust the Y position of the object and it will line up properly.
- **h)** In the Workspace panel, select the Line(2) object and create a copy.
- i) In the Workspace panel, select the Line(4) object and in the Paint Transform controls, set Y Position to 225.

j) Play the clip (SPACEBAR).

The "Now Showing" text is filled with flashing lights.

Change the Appearance of the Background

Add a paint operator to the wall layer in preparation to create an animated brick wall construction from a custom image brush.

- 1. In the Workspace Panel (F3), expand the Wall layer.
- 2. Right-click/ control-click (Macintosh) the Footage (4) footage and choose Add Operator | Paint.
- 3. Double-click the Paint operator.
- 4. In the Paint Controls panel, set the draw mode to Paint.

Create a Custom Brush from an Image

Create a custom brush by importing footage into a Paint branch and use the masking tools to select the area to to be used as the brush. Used as clip art libraries for fast access to commonly used still images and multi point, multi color textures for rotoscoping and design work, image brushes greatly extend the Combustion painting capabilities.

- 1. Open Footage into a Brush:
 - a) In the Paint Controls panel (F8), click Brush to access the brush controls.
 - b) Choose the second (unmodified) brush from the brushes palette.
 - c) Select Custom from the Shape list.
 - d) In the Brush Source, select Open footage into Paint.
 - e) In the Import Footage dialog, locate and open the 14_CreatingCustomBrushes folder.
 - f) Select Tile.png and click OK (ENTER / RETURN).

In this instance, the New Custom brush branch appears in the right viewport.

2. Select the single-viewport layout from the viewport layout list.

The Paint Custom Brush (2) is displayed in the viewport.

- 3. Click Home to scale the image fit the viewport.
- 4. Mask the tile:

- a) In the Toolbar, click the Bezier Mask tool (P).
- **b)** In the Viewport, add a mask around the perimeter of the red tile by single clicking at each corner to add a control point.

The custom brush in the brushes palette is updated to reflect the changes made by the mask. The transparency created by the mask is now reflected in the brush palette as the grey area surrounding the custom brush image

Create the Wall Construction Animation

Modify the parameters of the custom brush to create a tiled image. Use the tiled image to create an animation simulating the construction of a wall. This effect could be created by using an imported image in combination with a series of operators and a multi layer composite. However, using custom brushes, allows the entire effect to be created and contained within a single operator. This approach uses less memory and reduces rendering times on the final result

- 1. In the Workspace Panel (F3), double click the Paint operator applied to the Wall Layer.
- 2. Create a Tiled Line from the custom brush
 - a) If required, zoom out to see the entire frame in the viewport.
 - **b)** In the Toolbar (**F3**), select the Line Tool (**L**).
 - c) To constrain the Line tool, hold SHIFT, click and drag to draw a line from outside the top of the viewport to outside the bottom of the viewport.

d) In the Toolbar (F3), select the Arrow tool (TAB).

e) In the Paint Controls (F8), select Brush, and set the brush Size to 160 and brush Spacing 98%.

The brush now tiles seamless end to end creating a column of tiles.

3. Play the clip (SPACEBAR).

The custom brush is not animated.

Animate the Wall Construction

To simulate the construction of the wall, you need to animate the object.

- 1. Enable Animate (A).
- 2. Go to the first frame (Home).
- 3. In the Paint Controls panel (F8), click Transform.
- 4. Set the X Position to 700.

The Line is repositioned outside the right edge of the frame.

- 5. Go to frame 10 and set the X Position to 62.
 - The line is aligned inside the left edge of the frame and the animation and the animation path is created.
- **6.** In the Timeline (**F4**) choose Graph Mode (\) from the Timeline view list to view the channel information as a graph.

7. Select the Line's X Position channel.

- **8.** Right-click / CONTROL-click (Macintosh) on the second keyframe and choose Ease In from the context menu. This creates a smoother animation curve where the line object will slow as it approaches the second keyframe resting position.
- 9. Disable Animate (A).
- 10. Go to the first frame (HOME).
- **11.** Play the animation (**SPACEBAR**).

The line moves quickly from right to left, landing softly.

- 12. Complete the wall construction:
 - a) Go to frame 10.
 - b) Choose Overview Mode (\) from the Timeline view button to view the channel information in an overview.
 - c)) Choose Edit | Copy and then Edit | Paste.

The line is copied as line(2) in the Workspace panel and in Timeline and is the currently selected object.

- 13. In the Paint Controls (F8), set the X Position 147 and the Y Position to 449.
 - Line(2) and its entire animation curve is offset to the left and down fitting seamless into the Line Object.
- **14.** In the Workspace panel, hold **SHIFT** and click the line object. Both lines are selected in the Workspace and viewport.
- 15. Choose Edit | Copy (CTRL+C / %+C).
- 16. Choose Edit | Paste (CTRL+V / ૠ+V) three times.

There are now eight line objects in the Workspace panel.

- 17. In the Workspace Panel (F3), hold SHIFT and select Line(3) and Line(4).
- **18.** In the Paint Controls (**F8**), set the X Position to 236.

Both line objects are offset fitting seamles into the previous line object.

- **19.** In the Workspace Panel (**F3**), hold **SHIFT** and select Line(5) and Line(6).
- **20.** In the Paint Controls (**F8**), set the X Position to 401.
- 21. In the Workspace Panel (F3), hold SHIFT and select Line(7) and Line(8).
- 22. In the Paint Controls (F8), set the X Position to 568.

Both line objects are offset fitting seamless into the previous line object. The entire frame is now seamless filled with tiles.

23. Go to frame 1 and play the animation (**SPACEBAR**).

All tiles slide into frame filling the frame over the first 10 frames.

- **24.** Offset the Line Animation:
 - a) Go to the Timeline (F4).
 - b) Choose Overview mode.
 - c) In the Workspace panel, select the Paint operator.
 - **d)** In the Timeline (${\bf F4}$), collapse and expand the Paint operator.

All paint objects and their time bars are now visible in the Timeline.

- e) Go to frame 10.
- f) In the Timeline, click and drag to slide Line(2) duration bar to begin at frame 10.
- g) Repeat this process sliding each successive line an additional 10 frames. Line(8) begins at frame 70.

25. Review the complete animation:

- a) In the Workspace Panel (F3), double-click the Composite Operator.
- b) Go to frame 1 (HOME).
- c) Play the clip (SPACEBAR).

The tile background is built beginning at frame 0 and is complete by frame 80. The "Now Showing" Sign enters at frame 62 with the letters flashing. The Poster enters at frame 88, settles by frame 114 and holds for the rest of the animation.

Some features of this workspace have been disabled for the purposes of tutorial. Enable them to improve the final animation and appearance of the Composition.

26. Enable Enhancements (Optional):

- a) In the Workspace Panel (F3), expand the Now Showing layer.
- b) Enable the Glow Operator on the Now Showing layer.

This operator enhances the lighting effect introduced by our custom particle brush in the first part of the lesson.

- c) In the Workspace Panel (F3), expand the Wall layer.
- d) Enable the Timewarp operator on the Wall layer.

The Timewarp accelerates the construction of the wall. As each line was offset by the same distance and number of frames, the addition of this Timewarp operator allows each line to fall into place progressively faster than the last without having to alter each line's keyframes independently.

- e) In the Workspace Panel (F3), select the Composite Operator.
- f) In the Composite controls, choose settings and Enable Shading and shadows.

An animated spot light adds dramatic shading to the composite for a more stylized result.

Play the animation (SPACEBAR).

27. (Optional) Save the workspace:

- a) Choose File | Save Workspace (CTRL+S / \cong +S) to open the Save Workspace dialog.
- b) Set a filename and directory for the workspace, and then click OK (ENTER / RETURN).
- 28. Choose File | Close Workspace (CTRL+W / ૠ+W) to close the workspace.

Creating Flash Compatible Animations

Lesson 15

In this lesson, export a Combustion

workspaces as a Macromedia® Flash™

file—a .swf file format designed to deliver

graphics and animation over the Internet.

Overview

The Export to Flash feature of the Paint Operator enables paint objects and animations to be saved as Macromedia® Flash™ files (.swf format) for use in multimedia applications and delivery of graphics and animation over the Internet. Create a motion graphic project and export it as a Macromedia® Flash™ file.

In this lesson:

- Use Combustion Paint Operator to create flash compatible animation suitable for internet or multimedia delivery.
- Use the vector drawing tools as well as clone and reveal functions to create animation based on both shapes and bitmap images.
- Export the workspace as a .swf file format.

Open the 15_CreatingFlashAnimations.swf file or .html file in the 15_CreatingFlashAnimations folder and preview the result.

Need Help?

If you need help completing this lesson, save and close your workspace, and then open the 15_CreatingFlashAnimations.cws file as a reference.

Create a Paint Branch

Create a Paint branch and set up your workspace for creating projects to output as .swf file formats.

- 1. Check the Combustion preferences. For instructions, see "Setting the Preferences" on page 3.
- 2. Choose File | New or press CTRL+N (Windows) or ℜ+N (Macintosh) to access the New dialog.

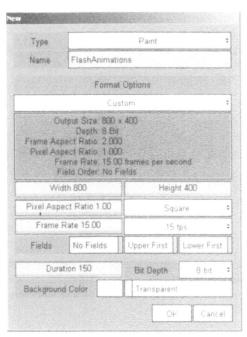

3. Create a branch with the following properties:

- **4.** Select the single-viewport layout.
 - 5. Make sure Animate is disabled (A).
 - 6. In the Toolbar (F2), enable Flash Mode.

When enabled, the Flash mode shows the tools supported for creating objects for export to .swf file format.

Create the Background Rectangle

Create a filled gray rectangle to cover the entire background.

- 1. Choose Window | Grid, Guides and Ruler | Show Grids (SHIFT+G). The grid is useful as tool to align objects.
- 2. Choose Window | Grid, Guides and Rulers | Show Ruler (SHIFT+L). Rulers are useful in precise positioning of objects in the viewport.
- 3. In the Paint Controls panel, pick a gray swatch from the swatches panel to the left.

4. In the Toolbar (**F2**), click the Filled Rectangle tool (**SHIFT+R**).

Note: If the Filled Rectangle tool is not shown in the Toolbar, click-drag the filled tool and choose the Rectangle tool from the context menu, or press the tool's hot key (SHIFT+R).

5. Change the shape Mode to Fixed and set the dimensions as W: 900 and H: 500.

- 6. Using the 0 mark on the X and Y rulers and the grid overlay as reference, click in the center of the viewport to create a filled gray rectangle covering the entire background. Based on the fixed dimensions (W: 900 & H: 500) the gray rectangle object that is added to the paint branch in the workspace panel is large enough to completely cover the background in the viewport.
- 7. Choose Window | Grid, Guides and Ruler | Show Grids (SHIFT+G) to hide the grid.
- 8. Choose Window | Grid, Guides and Rulers | Show Ruler (SHIFT+L) to hide the ruler.

Animate the Background Rectangle

Use the Transform controls to create, position, and scale animation for the background rectangle.

- 1. In the Workspace panel, select the Filled Rectangle.
- 2. Enable Animate (A).
- 3. In the Paint Controls panel (F8), select Transform.
- Set X Position to 1300.
 Setting X position to 1300 positions the object completely off the right edge of the frame.
- 5. Go to (/) frame 10.

6. Set X Position to 393.

This repositions the filled rectangle back in the frame, covering the entire white background. A linear motion path is created with a keyframe at each end.

7. Set Y Scale to 110%.

Although the gray rectangle covered the entire viewport already, this creates an initial keyframe for the Y Scale animation.

- 8. Go to frame 15.
- 9. Set Y Scale to 64%

This reveals a portion of the white background along the upper and lower portion of the frame.

10. Disable Animate (A).

11. Play the animation (**SPACEBAR**).

From frame 1 to frame 10, the gray rectangle moves into view from the right edge covering the entire background. From 10 to 15, it scales vertically to reveal the white background along the upper and lower edges of the viewport after which it holds through the last frame of the animation.

Create a Clone Box

Create a stylized box to display a mood_panoramic bitmap graphics. Although the Combustion Paint tools are primarily vector based, the clone and reveal options allow the introduction of bitmap imagery into the project which can be exported to flash.

- 1. Go to (/) frame 15.
- 2. In the Paint Controls panel (F8), select Modes to access the Modes Controls.

3. In the Modes Controls, click Clone from the Source type.

- **4.** From the Source list, select Pick Operator and choose *mood_panoram.png* located in the *15_CreatingFlashAnimations* folder.
- 5. In the Toolbar, (F2), click the Filled Rectangle tool (SHIFT+R).
 - 6. Change the shape Mode to Fixed, set the dimensions to W: 155 and H: 130, and set the Corner Radius to 32.
 - 7. Click in the left half of the viewport.

A filled, rounded corner rectangle is created, using a portion of the mood_panoram image as its fill source.

This rectangle is repositioned later in the exercise.

- **8.** Go to frame 1 (**HOME**) and press the **SPACEBAR** to review the animation.
- **9.** In the Workspace panel (**F3**), rename the Filled Rectangle(2) object Clone Box.

Create Copies of the Clone Box and Position Them

Create three copies of the Clone Box and align them.

1. In the Paint Controls panel (F8), select Transform.

- 2. Set X Position to 118 and set Y Position to 167.
- 3. Create three copies of the Clone Box:
 - a) Choose Edit | Copy (CTRL+C / %+C).
 - b) Choose Edit | Paste (CTRL+V / 98+V).
 - c) Choose Edit | Paste (CTRL+V / 98+V).
 - d) Choose Edit | Paste (CTRL+V / %+V).
- 4. Position the Clone Boxes:
 - a) In the Workspace panel, select the Clone Box(2) and in the Transform controls, set X Position to 305.
 - b) In the Workspace panel, select the Clone Box(3) and in the Transform controls, set X Position to 497.
 - c) In the Workspace panel, select the Clone Box(4) and in the Transform controls, set X Position to 684.
- **5.** Play the animation (**SPACEBAR**).

The Clone Boxes appear at frame 15 and have a duration of one frame. Unlike other Paint objects, cloned Paint objects have a duration of one frame.

Extend the Duration of the Clone Boxes

Adjust the duration of the Clone Boxes to show from frame 15 though the end of the Paint branch.

- 1. In the Workspace panel, drag a selection box around all four Clone Boxes.
- 2. Go to the last frame (END).

The bounding boxes for the Clone Boxes are still be displayed in the viewport although the objects themselves are not visible. The object duration must be lengthened.

- 3. Press the period key (.) to extend the duration to the end of the clip.
- 4. Press I to go back to frame 15.

Animate the Scale of the Clone Boxes

Animate the scale of all four Clone Boxes from 0% to 100% over a 10 frame duration.

- 1. Enable Animate (A).
- 2. In the Paint Transform controls, enable proportional scale.

3. Set X Scale to 0%.

As all the Clone Boxes are still selected from the previous part of the lesson, adjusting the scale field will affect all selected objects.

- 4. Go to (/) frame 25.
- 5. Set X Scale to 100%.
- 6. Press I to go back to frame 15.
- 7. Play the animation (SPACEBAR).

The Clone Boxes scale from 0% to 100% from frame 15 to frame 25.

8. Go to the end of the clip.

Animate the Offset of the Clone Boxes

Animate the Clone offset of the Clone Box revealing a portion of the mood_panoram image over time.

- 1. In the Paint Controls panel, click the Modes to access the Modes controls.
- 2. In the Clone Controls, set the clone Offset X Position to 640.
- 3. Go to frame 35.
- 4. In the Clone Controls, set the clone Offset X Position to 0.
- 5. Play the animation (SPACEBAR).

From frame 35 though frame 150 this animation horizontally adjusts the clone offset to show the same portion of the mood_panoram image on each of the clone boxes. The mood_panoram image travels from right to left on each box.

6. Go to frame 35.

Create the mood_panoram Image Slide

Adjust the animation curve of the clone offset of each Clone Box to create the illusion of the mood_panoram image sliding from one Clone Box to the next.

- 1. Disable Animate (A).
- 2. In the Workspace panel, select Clone Box(2).

3. In the Clone controls, change the clone offset X Position to 162 revealing the pointing finger with the purple background.

With Animate disabled, this adjustment offsets all key frames of the animation equally. The result is an animation that starts on the purple portion of the mood_panoram image but moves at the same rate as the rest of the Clone Box offset animations.

- **4.** In the Workspace panel, select Clone Box(3).
- **5.** In the Clone controls, change the clone offset X Position to 318 revealing the 2 finger image with the green background.
- **6.** In the Workspace panel, select only Clone Box(4).
- **7.** In the Clone controls, change the clone offset X Position to 478 revealing the thumbs up image with the blue background.
- 8. Play the animation (SPACEBAR).

Each Clone Box now displays a separate portion of the mood_panoram image. The mood_panoram image travels from right to left on each Clone Box, across all four Clone Boxes, creating the illusion of the image passing from one Clone Box to the next.

Add a Text

Add a text object to the Paint branch.

- 1. Go to (/) frame 35.
- 2. In the Paint Controls panel, click Modes and click Solid Source button.

T

3. In the Toolbar select the Text Tool (**T**).

In the viewport, click and drag to draw a text box over the gray area beneath the Clone Boxes.

- 4. In the Paint Controls panel, click Attributes, to access the text attributes controls.
- 5. Click the Color box and choose white from the pick color dialog.
- 6. Click in the Text editor and type, "A gesture for every mood".
- 7. Set the font properties:
 - a) In the Basics Controls, click Font to display the Font Browser.
 - b) In the Font Browser window, click the Arial font thumbnail and click OK (ENTER / RETURN).
 - c) n the Basics Controls change the font size to 65.

Animate the Text Along a Path

Use the Path Options to select the type of path for the text object and edit the text on a path property.

- 1. In the Paint Controls panel (F8), click the Advanced button to show the Advanced text controls.
- 2. From the Path options Type list, select Path.

The text string appears on a line with 3 default control points.

3. Click on the path line half way between the left and center control points creating a new control point. Drag this point straight down to the border where the gray background and lower white edge.

4. Click on the path line half way between the center and right control points creating a new control point. Drag this point straight down to the border where the gray background and lower white edge meet.

- 5. Enable Animate (A).
- 6. In the Advanced text controls, set Path Offset to 110%.
- 7. Go to (/) frame 120.
- 8. Set Path Offset to 0%.

Starting at frame 35, the text scrolls across the curved path entering from the right edge of the frame. The text animation ends at frame 120 and then holds through the last frame of the clip.

Preview Macromedia Flash Output

As you create and animate your Paint object(s), you can preview your work in the Macromedia Flash Player view within Combustion before outputting your object(s) to .swf file format.

1. Choose Window | Flash View.

Hint: You can also right-click / CONTROL-click and choose Flash View.

The viewport switches to display the Macromedia Flash Player.

Export as Macromedia Flash Output

The Export to Flash feature generates two output formats: .swf format and .html format. You can view your Paint output in both formats.

- 1. In the Paint Controls panel (F8), select Settings.
- 2. In the Settings controls, click Export.
- 3. In the Export Flash File dialog, choose a directory and a file name.
- **4.** To review the work in a web browser, open the HTML file. For multimedia authoring purposes or create your own web page, use the .swf file.
- 5. (Optional) Save the workspace:
 - a) Choose File | Save Workspace (CTRL+S / 38+S) to open the Save Workspace dialog.
 - b) Set a filename and directory for the workspace, and then click OK (ENTER / RETURN).
- 6. Choose File | Close Workspace (CTRL+W / ૠ+W) to close the workspace.

Combining Selections

Lesson 16

In this lesson, combine selections to apply an effect to specific areas without affecting the rest of the image.

Overview

Use selections to isolate areas of an image for painting and applying effects. For greater flexibility, selections can also be combined. For example, when working on several parts of an image with complex shapes, you can add, subtract, or intersect any number of selections to isolate the specific areas required.

In this lesson:

- Select areas of an image using the Bezier Selection tool.
- Subtract elliptical selections from the Bezier selections, so the Bezier selection appear to have a hole in them.
- Apply a tint to the selected areas to change their color.

Need Help?

If you need help completing this lesson, save and close your workspace, and then open 16_CombiningSelections.cws file as a reference.

Create a Paint Branch

Open the footage as a Paint branch.

- 1. Check the Combustion preferences. For instructions, see "Setting the Preferences" on page 3.
- 2. Choose File | Open or press CTRL+O (Windows) or #+O (Macintosh), select Stars.png from the 16_CombiningSelections folder and click OK (ENTER / RETURN) to open the image.

The Open Footage dialog appears.

3. Select Paint and click OK (ENTER / RETURN) to create a Paint branch with the selected footage.

4. Select the single-viewport layout.

An image of a sidewalk with "walk of fame" stars appears in the viewport. Notice the Stars.png image is a still image and the default Still Image Duration is set to 30 frames.

- 5. Change the default Still Image Duration to 1 frame via the Footage Controls panel:
 - a) In the Workspace panel (F3), select the Stars Footage operator.
 - b) In the Footage Controls panel (F8), click Source and change the Source Frames End to 1.

Select the Stars

Draw a selection around each of the stars on the sidewalk.

1. In the Workspace panel, select the Paint operator.

2. In the Toolbar (F2), click the Bezier Selection tool (OPTION+P).

Note: If the Bezier Selection tool is not shown in the Toolbar, click-drag the Selection tool and choose the Bezier Selection tool from the context menu, or press the tool's hot key (OPTION+P).

- 3. Set the options for the tool:
 - a) In the Paint Controls panel (F8), click Modes.
 - b) Click Reset to set the Modes controls to their default settings.

The Replace (=) mode removes the effect of any previous selections there may be, and replaces them with the current selection.

- 4. Zoom in on the right star:
 - a) Click the Zoom In button three times to zoom in on the image.

b) Scrub the Pan button to pan across the image until the right star is centered in the viewport.

Hint: You can also scrub Home to zoom in on the star.

- 5. Draw a selection around the star:
 - a) Click a point on the star.

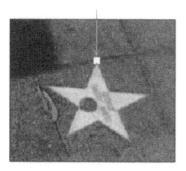

b) Click around the shape of the star to draw the selection and press ENTER / RETURN or position the cursor over the first control point and when the cursor changes to $\begin{pmatrix} -\frac{1}{10} \end{pmatrix}$ click to close the polygon selection.

When you close a Polygon selection, the Toolbar switches to the Arrow tool, with the Edit Control Points tool selected.

- c) With the Edit Control Points tool selected, reshape the Polygon selection to fit tightly around the star.
- **6.** Draw a selection around the middle star:

a) Scrub the Pan button until the middle star is centered in the viewport.

b) In the Toolbar, click the Bezier Selection tool (**OPTION+P**).

c) In the Modes controls, select Add from the Mode list.

The Add (+) combination mode adds new selections without removing previous selections.

Hint: You can use hot keys to set the combination mode of a selection. To set the mode to Add, press **SHIFT** while clicking the first point.

- d) Click around the shape of the middle star to draw the selection.
- e) Press ENTER / RETURN, or position the cursor over the first control point and when the cursor changes to (-'15) click to close the polygon selection.

Both stars are selected.

- f) With the Edit Control Points tool selected, reshape the selection to fit tightly around the star.
- 7. Copy a selection and move it over the left star:
 - a) Scrub the Pan button until both the middle star and the left star are visible in the viewport.

- **b)** In the Toolbar, click the Edit Object tool (**TAB**).
- c) Position the cursor over the selection (of the middle star), press ALT / OPTION and click drag the selection on top of the left star.

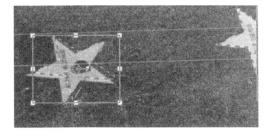

A copy of the second selection is created. The selection may not match the shape of the star exactly.

d) Click the Edit Control Points tool, (TAB) and reshape the selection to fit tightly around the star.

- 8. Draw selections around the two partial stars at the left and right edges of the image:
 - a) In the Modes controls, select Add from the Mode list.

- b) In the Toolbar, click the Bezier Selection tool (OPTION+P) to draw selections around the two partial stars at the left and right edges of the image.
- 9. Click Home or choose Window | Fit in Window) to view the entire image in the viewport.

 All the stars in the image are selected.

Subtract the Circles

Use the Subtract combination mode to subtract the dark blue circles inside the stars so they are not affected when you tint the image later.

- 1. In the Toolbar, click the Magnify tool, then click the right star to zoom in on it.
- 0
- 2. In the Toolbar, click-drag the Bezier Selection tool and choose the Elliptical Selection tool (OPTION+C) to draw selections around the circles.
 - 3. In the Modes controls, select Subtract from the Mode list.

The Subtract (-) combination mode subtracts the new selection from any previous selection.

Hint: To set the selection combination mode to Subtract, you can also press CTRL / 署 while clicking the first point.

4. Click in the center of the circle and drag out to fit the circle inside the elliptical selection.

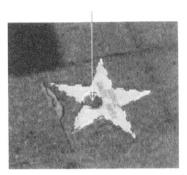

Because the combination mode is set to Subtract, this selection removes the dark blue circle from the polygon selection around the star.

5. Click the Arrow tool (TAB).

- 6. Click the Edit Object tool, or press TAB twice and edit the selection object to fit around the circle.
- 7. Use a copy of the selection to select the circle in the middle star:
 - a) Scrub the Pan button until both the right star and the middle star are visible in the viewport.
 - b) Press ALT / OPTION and drag a copy of the elliptical selection on top of the circle in the middle star.
 - c) Adjust the shape of the ellipse if necessary.
- 8. Repeat step 7 to select the remaining dark blue circle in the image.

All the circles are subtracted out of the star selections.

Change the Color of the Stars

Use a Tint effect to make the stars yellow.

- 1. Click Home to view the entire image in the viewport.
- 2. Choose Effects | Color Correction | Tint.

The Tint Controls panel appears.

- **3**. Select a yellow color for the tint:
 - a) Click the Color box to open the Pick Color dialog.

b) In the Pick Color dialog, set Red to 100% and green to 100%.

The color becomes yellow.

- c) Click OK (ENTER / RETURN) to close the Pick Color dialog.
- 4. In the Tint Controls, set Amount to 40%.

The stars are tinted yellow. The sidewalk and the circles within the stars are not affected.

- **5.** (Optional) Save the workspace:
 - a) Choose File | Save Workspace (CTRL+S / 策+S) to open the Save Workspace dialog.
 - b) Set a filename and directory for the workspace, and then click OK (ENTER / RETURN).
- 6. Choose File | Close Workspace (CTRL+W / ૠ+W) to close the workspace.

Animating Selections

Lesson 17

In this lesson, isolate a moving element in a clip by animating the shape and position of a selection, and then apply color correction.

Overview

The shape and position of selection objects can be animated. By using animated selections, you can isolate elements in a clip that change shape and/or position, and apply effects to them.

In this lesson:

- Create a polygon selection to select the sofa chair.
- Feather the selection to create a more realistic-looking effect.
- · Adjust the color balance to make the sofa chair yellow.
- Animate the selection to compensate for camera pan.

Open the 17 AnimatingSelections.mov file in the 17 AnimatingSelections folder and preview the result.

Need Help?

If you need help completing this lesson, save and close your workspace, and then open the *17 AnimatingSelections.cws* file as a reference.

Create a Paint Branch

Open an image sequence as a new Paint branch.

- 1. Check the Combustion preferences. For instructions, see "Setting the Preferences" on page 3.
- 2. Choose File | Open, or press CTRL+O (Windows) or **%+O** (Macintosh).
- 3. In the Open dialog, use the file browser to locate and open the 17_AnimatingSelections folder.
- **4.** Click Thumbnails to view the footage in the selected folder and enable Collapse to collapse the image sequence.
- **5.** Double-click the *Sofa* folder and then double-click the *Sofa*[##].png image sequence.
- 6. In the Open Footage dialog, click Paint, and then click OK (ENTER / RETURN).

- 8. Choose Window | Fit in Window, or right-click / CONTROL-click the viewport and select Fit in Window.
- 9. Play the clip (SPACEBAR).

Select the Chair

Draw a selection around the shape of the chair.

1. Go to the first frame (HOME).

2. In the Toolbar (**F2**), click the Bezier Selection tool (**OPTION+P**).

Note: If the Bezier Selection tool is not shown in the Toolbar, click-drag the Selection tool and choose the Bezier Selection tool from the context menu, or press the tool's hot key (OPTION+P).

- 3. Set the options for the selection:
 - a) In the Paint Controls panel (F8), click Modes.
 - b) Click Reset to set the Modes controls to their default settings.

The (default) Replace (=) mode removes the effect of any previous selections there may be, and replaces them with the current selection.

c) Set Feather to 2 to feather the selection by 2 pixels.

Effects applied to a feathered selection fade gradually at the edge, creating a softer look. The feather radius spans en equal distance inside and outside the selection.

Hint: To feather the edge of a selection *after* creating the selection, choose Selection | Feather. You can also use this method to feather a combination of several selections.

- 4. Draw a selection around the sofa chair:
 - a) Click a point on the sofa chair to begin drawing the selection.

b) Click around the sofa chair to roughly draw the shape and press ENTER / RETURN or position the cursor over the first control point and when the cursor changes to (-js) click to close the polygon selection.

When you close a Polygon selection, the Toolbar switches to the Arrow tool, with the Edit Control Points tool selected.

- 5. Fine-tune the shape of the selection by adding and adjusting control points as needed:
 - To adjust a control point, position the cursor 🚁 over a control point then click and drag the control point.
 - To slightly nudge a control point, select it with the cursor and use the arrow keys on the keyboard to adjust its position.

• To add a control point, position the cursor over the selection marquee and when the cursor changes to -to click.

- 6. Use tangent handles to create curved lines:
 - a) Press CTRL / **%** and drag a point to view the tangent handles.

b) Drag the tangent handles to create curved lines to match the chair's outline.

Note: To break a handle from the other handle, press CTRL / % and drag it. To rejoin broken handles, press CTRL / % and drag one of the handles. To make both handles the same length again, press CTRL / % and click the control point to hide the handles, and then press CTRL / % and drag the handles out again. To adjust the length of both sides of an unbroken tangent handle, press ALT / OPTION and drag the control point. To hide the handles, press CTRL / % and click a point.

Adjust the Color Balance

Add aColor Correction filter to change the color of the chair to yellow.

1. Choose Effects | Color Correction | Balance.

The Balance Controls panel appears.

Hint: You can also right-click / **CONTROL**-click the Polygon Selection in the Workspace panel, and choose Color Correction | Balance.

- 2. Adjust the individual Red, Green, and Blue channels:
 - a) Set Red to 7.
 - b) Set Green to 3.
 - c) Set Blue to -10.

The color is modified within the selection, making the sofa chair yellow.

3. Play the clip (SPACEBAR).

As a result of a camera pan, the selection does not stay on the chair during the clip.

Animate the Selection

Animate the selection to match the movement of the camera.

- 1. Go to (/) frame 1.
- 2. Enable Animate (A).
- 3. Move the selection to match the position of the sofa chair:
 - a) In the Workspace panel (F3), select the Polygon Selection (=) object.

The bounding box of the polygon selection object is displayed in the viewport, indicating the object is in Edit Object mode.

- **b)** Click and drag the polygon selection to reposition, if required, the selection over the sofa chair.
- c) Go to the next frame (press / or PAGE DOWN), click and drag the polygon selection to reposition the selection over the sofa chair.

- d) Repeat step c to the end of the clip.
- 4. Play the clip to view the result:
 - a) In the viewport, click away from the sofa chair to deselect it.
 - **b)** Choose Window | Show Marquee to disable Show Marquee, or right-click / **CONTROL**-click the viewport, and choose Show Marquee.
 - c) Go to the first frame (HOME).
 - d) Play the clip (SPACEBAR).

The polygon selection moves as the camera pans, making the sofa chair appear yellow throughout the clip.

- 5. (Optional) Save the workspace:
 - a) Choose File | Save Workspace (CTRL+S / Se+S) to open the Save Workspace dialog.
 - b) Set a filename and directory for the workspace, and then click OK (ENTER / RETURN).
- 6. Choose File | Close Workspace (CTRL+W / 第+W) to close the workspace.

after the ball of the graph Sight in

aprilia e mante el adales el en el el

ramoštija proces i stala ništija

and the company of the property of the contract of the contrac

g pour a seguente de la compaña de la co La compaña de la compaña d

Transforming and Controlling Layers Part III

18	Keyframing	217
19	Creating Expressions	227
20	Cropping and Corner-Pinning	237
21	Aligning Objects to a Motion Path	247

rest til elleranolt bas enimalensif

Keyframing Lesson 18

In this lesson, import footage and create an animation by keyframing a layer's position, rotation and scale.

Overview

There are several ways to animate objects, including creating expressions and adding keyframes. This lesson shows you how to animate objects by adding keyframes. A keyframe is a point in time that records changes to an object, such as its position, color or intensity, as well as other changes depending on the type of object.

When you create keyframes that span over a period of time, Combustion automatically uses interpolation to determine the values for the "in-between" frames to make your work easier. For example, if a layer takes one second to move from point A to point B, you need only to define point A and point B. Combustion calculates where the layer should be at any time between these two points.

In this lesson:

- Loop the footage so it plays for the entire clip.
- Animate a layer's position, rotation, and scale.
- Use the Speed channel to control the speed of an object along its motion path.
- Add a Blur operator to a layer.

Open the 18_Keyframing.mov file in the 18_Keyframing folder and preview the result.

Need Help?

If you need help completing this lesson, save and close your workspace, and then open the 18_Keyframing.cws file as a reference.

Create a Composite

Create a composite branch and import the footage for the composite.

- 1. Check the Combustion preferences. For instructions, see "Setting the Preferences" on page 3.
- Choose File | New or press CTRL+N (Windows) or ₩+N (Macintosh) to open the New dialog and create a branch with the following properties:
 - Type: Composite
 - Name: 18_Keyframing
 - · Format: NTSC DV
 - Duration: 60 frames
 - Bit Depth: 8 Bit
 - · Mode: 2D

- **3.** Select the single-viewport layout.
 - 4. In the Workspace panel (F3), right-click / CONTROL-click the 18_AnimatingKeyframes composite and choose Import Footage (or press CTRL+I / ૠ+I).

- 5. In the Import Footage dialog, use the file browser to locate and open the 18_AnimatingKeyframes folder.
- 6. Import the footage:
 - a) Double-click the *Hand* folder and then click hand[###].jpg to add it to the import queue.
 - **b)** Double click the *Parent* folder, double-click the *Wasp* folder, click *WASP[####].PNG*, and then click OK (ENTER / RETURN).
- **7.** Rename the layers in the Workspace panel:
 - a) Right-click / CONTROL-click the hand0000 layer and choose Rename.
 - b) Name the hand0000 layer "Hand".
 - c) Select the WASP0000 layer, select the layer again and name the layer "Wasp".
- **8.** Play the clip (**SPACEBAR**).

Notice the wasp disappears after frame 5. This is because the wasp footage is an image sequence of 5 frames.

Loop the Wasp Footage

To extend the animation of the wasp to the end of the clip, you can either stretch the duration of the footage or change the playback behavior. You can also stretch the footage using the Timewarp. However, since the first and last frames are identical, you can just loop the footage so it plays from start to end, then returns to the start frame and plays again.

- In the Workspace panel (F3), click the triangle next to the Wasp layer to view its contents (CTRL+RIGHT ARROW)
 % +RIGHT ARROW).
- 2. Select the WASP[###] Footage operator.
- 3. In the Footage Controls panel (F8), click Output.
- 4. Set the Playback Behavior to Loop.

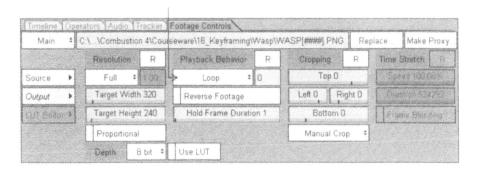

5. Play the clip (SPACEBAR).

The wasp flaps its wings to the end of the clip.

Animate the Wasp

Animate the wasp to make it land on the hand.

- 1. In the Workspace panel, select the Wasp layer.
- 2. Go to frame 1 (HOME).
- 3. Scale and position the wasp:
 - a) In the Composite Controls panel, click Transform.
 - **b)** Enable Proportional to keep X and Y Scale equal.
 - c) Set either of the Scale fields to 75%.
 - d) Set the X Position to -240.
- 4. Enable Animate (A).
- 5. Go to frame 20.
- **6.** Scale, position, and rotate the wasp:
 - a) In the Composite Controls panel, set either of the Scale fields to 33%.
 - b) In the viewport, position the wasp so it is centered on the left hand.
 - c) Drag the green tangent handles to give the wasp a slightly curved flight trajectory.
 - d) In the Composite Controls panel, set Z Rotation to approximately 19°.

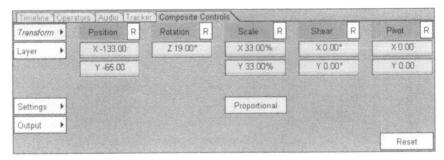

The following images show the wasp's flight trajectory from frame 1 to frame 20.

Frame 1

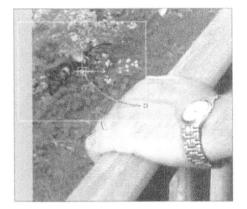

Frame 20

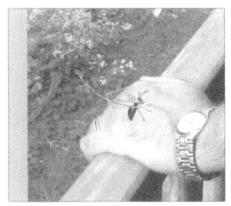

7. Set the playback out point:

- a) Make sure you are at frame 20.
- b) Choose Movie | Mark Out Point (SHIFT+O).

The clip will play back from frame 1 to frame 20.

- **8.** Preview the result:
 - a) Go to frame 1 (HOME).
 - b) Play the animation (SPACEBAR).

Create the Sting

Continue animating the wasp to create the sting by defining the wasp's position at various frames. With Animate enabled, changing the position of the wasps at various frames adds keyframes.

- 1. Position the wasp at frame 27:
 - a) Go to (/) frame 27.
 - b) In the viewport, drag the wasp a little above the hand (to approximately -30 in the Y position).

A new keyframe is added at frame 27.

- 2. Position the wasp at frame 34:
 - a) Go to frame 34.
 - **b)** Drag the wasp back to where it was at frame 20 (to approximately -133 in X and -65 in Y).

- 3. Position the wasp at frame 35:
 - a) Go to frame 35.
 - **b)** Drag the wasp down a little further (to approximately -112 in X and -80 in Y).
- 4. Position the wasp at frame 36:
 - a) Go to frame 36.
 - b) Drag the wasp back up to approximately 0 in the Y position.

Note that steps 3 and 4 last only a frame each. A sting happens quite fast. This is why you are animating the wasp's sting in three frames.

- **5.** Position the wasp at frame 49:
 - a) Go to frame 49.
 - **b)** Drag the wasp away from the hand to give it a chance to escape (to approximately -263 in X and 123 in Y). Depending on where you positioned the wasp, you may need to adjust the control points on the tangent handles.

Note: If you cannot see the ends of the tangent handles, zoom out and adjust the control points or the tangent handles.

- **6.** Position the wasp at frame 60:
 - a) Go to the last frame (END).
 - **b)** Drag the wasp a bit farther up and away from the hand (to approximately -234 in X and 215 in Y).

Frame 49

Frame 60

7. Disable Animate (A).

- 8. Set the playback out point:
 - a) Go to (/) frame 60.
 - b) Choose Movie | Mark Out Point (SHIFT+O).
- 9. Preview the result:
 - a) Go to frame 1 (HOME).
 - b) Play the animation (SPACEBAR).

Adjust the Wasp's Flight Speed

Make the wasp slow down as it approaches the hand and speed up as the hand swipes it away. Use the Speed channel in the Timeline to control the speed of the wasp along its motion path. Note that adjustments to Speed do not affect the overall motion path.

- 1. Go to frame 1 (HOME).
- **2.** Make sure the Wasp layer is still selected in the Workspace panel.
- 3. Show the Timeline (F4).

Notice in the Timeline list that the Speed channel category is disabled by default.

Note: To enable Speed channel by default, choose File | Preferences or press CTRL+; % (on Windows) or choose combustion | Preferences or press 樂+; (on Macintosh) and under Host, click the Animation category and enable Use Speed Channel by Default.

4. Click Graph and Frame All.

The Graph mode shows the value of a category's channel over time and Frame All displays the entire selected curve in the graph area of the Timeline.

5. In the Timeline list, select the Speed channel.

18 Keyframing

6. Click the square icon next to the Speed channel to enable the channel.

- 7. Make the wasp slow down when it reaches frame 20 and start flying faster at frame 36 (just after the sting):
 - a) Drag the tangent handles of the keyframe at frame 20, as shown in the following image.

b) Drag the tangent handles of the keyframe at frame 36, as shown in the following image.

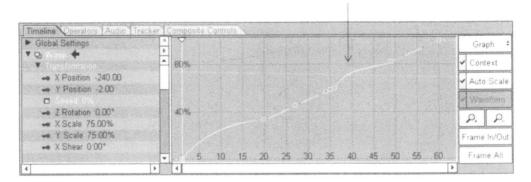

8. Click anywhere in the Timeline to deselect all the keyframes.

9. Select the keyframe at frame 49 and press **DELETE**.

Deleting a keyframe from the Speed channel does not delete the original Position keyframe. The Position keyframe at frame 49 still exists.

10. Test the result:

- a) Play the clip (SPACEBAR).
- b) If you are not satisfied with the result, adjust the tangent handles in the Speed channel as the clip plays.

Note: If you have problems selecting the tangent handles in the Timeline, select the keyframe and then click Reset Tngts.

Blur the Wasp

Blur the wasp layer so it blends with the composite. 3D objects have a tendency to appear too perfect when composited with real life footage.

- 1. Go to the frame 1(HOME).
- 2. Select the Wasp layer in the Workspace panel.
- 3. In the Operators panel (F5), click the Blur/Sharpen category.

18 Keyframing

- 4. CTRL-click / % -click Box Blur.
- **5.** In the Workspace panel, select the Box Blur operator.
- **6.** In the Box Blur Controls panel, set radius to 0.5.

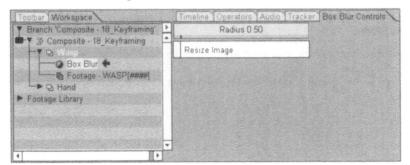

The Box Blur changes the color value of each pixel based on the pixels next to it in the vertical and horizontal directions. It is fairly close to the look achieved using Gaussian Blur, but renders much faster.

- 7. Play the animation (SPACEBAR).
- **8.** (Optional) Save the workspace:
 - a) Choose File | Save Workspace (CTRL+S / %+S) to open the Save Workspace dialog.
 - b) Set a filename and directory for the workspace, and then click OK (ENTER / RETURN).
- 9. Choose File | Close Workspace (CTRL+W / ૠ+W) to close the workspace.

Creating Expressions

Lesson 19

In this lesson, learn how to quickly animate by applying preset expressions and how to edit expressions.

Overview

Expressions offer a dynamic way to quickly apply simple or elaborate animation curves to any available channel(s) in a workspace. Combustion offers a variety of options for applying and working with expressions ranging from the high level Expression Browser and channel linking features to direct and editing and script manipulation. This lesson offers insight to the steps necessary to apply expression based animation emphasizing their application as creative tools and workflow enhancements.

In this lesson:

- · Use the Expression Browser to apply expression presets to various channels to quickly animate of various workspace parameters.
- Edit expressions and use channel linking methods to allow layers to influence each other.

Open the 19_CreatingExpressions.mov file in the 19_CreatingExpressions folder and preview the result.

Need Help?

If you need help completing this lesson, save and close your workspace, and then open the 19_CreatingExpressions.cws file as a reference. Additional intermediate workspaces are provided as well.

Open the Starting Workspace

Start by opening a workspace. This workspace is the baseline for this lesson.

- 1. Check the Combustion preferences. For instructions, see "Setting the Preferences" on page 3.
- 2. Choose File | Open Workspace or press CTRL+SHIFT+O (Windows) or **%**+SHIFT+O (Macintosh) to access the Open Workspace dialog.
- 3. In the Open Workspace dialog, locate and open the 19_CreatingExpressions folder by either navigating the file browser or editing the path at the top of the dialog.
- **4.** Double-click the 19_CreatingExpression_start.cws file.

- **5.** Select the single-viewport layout.
 - 6. Play the clip (SPACEBAR).

The animation is currently 300 frames long, but completely lacks motion except for large orange Nucleus layer that enters from the right edge of the frame and lands behind the A in the Atomix logo. The following exercises uses expressions in various ways to give motion to various elements in the composite.

Animate the Panels Layer

The Atomix Background layer is actually a nested composite made up of several graphic layers including the Panels layer. Add a Shift operator to the Panels layer, then animate the Shift operator using the Expression Browser. The shift operator is extremely well suited to this task as it will give the panels the appearance of motion without having to actually move the layer. Combining this operator with expressions works well because the motion can be extend indefinitely without the need for keyframe editing.

- In the Workspace panel, expand the Atomix Background layer, and its nested composite operator to reveal
 the layers it contains.
 - As a nested composite, all the layers of the Atomix Background layer are treated as a single image by the Atomix composite, but have the advantage of still being access individually for direct manipulation.
- 2. Double click the Panels layer to view its output in the viewport.
- 3. Add a Shift operator to the Panels layer:
 - a) In the Operators panel (F5), click the Distort category.
 - b) CTRL-click / 38 -click Shift.
- 4. In the Shift Controls, choose Wrap Image from the Undef. Areas list.
 - This allows the the source image's pixels to wrap around to their opposing edge when shifted beyond the original extents of the image.
- 5. Show the Timeline (F4).
- **6.** Add an Expression to the Shift Operator's Y channel to animate it:
 - a) In the Timeline, expand the Shift Operators Shift Amount category to expose the X and Y Channels.
 - b)) Select the Y channel.
 - c) Click on the Expression Browser button located to the right of the Timeline to invoke the Expression Browser window and choose an expression preset.
 - Because it requires no scripting, the Expression Browser is the easiest way to begin working with expressions in Combustion. The Expression Browser takes its context from the channel specification and number of channels selected. As Shift Amount Y is a single channel selection, the channel label is displayed at the top of the Expression Browser window to indicate it as the destination of the selected preset and the types of preset curves are those that apply only to single channel selections.

- d) In the left pane of the Expression Browser, click the Picon representing the Linear Expression. The preset parameters appear in the right pane.
- e) Set Slope to 4, and Offset to 0 and click OK.

The Expression Browser closes, the Timeline exposes the first portion of the expression script on the Shift Amount Y channel, and the key icon is changed to an 'e' icon, denoting the channel is controlled by expression.

7. Play the clip (SPACEBAR).

The images in the panel shift from top to bottom in a continuous move.

Animate the Clouds Layer Using Channel Linking

Add a shift operator to the Clouds layer, then create channel animation by linking channels of the Shift operators. Linking the animation of channels creates channel dependencies that allow the control of many parameters from a single channel. As such making a change to the source channel updates all the dependent channels without further editing saving time.

- 1. Go to frame 1 (HOME).
- 2. In the Workspace panel, double click the Clouds layer.

The Clouds layer is displayed in the viewport.

- 3. Add a Shift operator to the Clouds layer:
 - a) Show the Operators panel (F5).
 - **b)** In the Operators panel, click the Distort category.
 - c) CTRL-click / 38-click Shift.

A Shift operator is added to the Clouds layer and the Shift Controls panel is displayed.

- 4. In the Shift Controls, choose Wrap Image from the Undef. Areas list.
- **5.** Show the Timeline (**F4**).
- 6. Link the Clouds layer's Shift Operator's X amount channel to the Panel layer's Shift Operator's Y amount.
 - a) In the Timeline, expand the Shift Operator's Shift Amount category to expose the X and Y Channels.
 - b) Select the X Channel.
 - c) Click the absolute link button (Link(/)) located just right of the Expression Browser button. The enabled Link (/) button shows green to indicate it is waiting for a channel selection.

- d) In the Workspace panel click the Panel layer's Shift operator to display it's channels in the Timeline.
- e) Select the Shift Amount Y channel. The Timeline context reverts to the Clouds layers Shift Operator channels.

The first portion of the applied link expression is applied to the Clouds layer Shift Amount X Channel and the Link(/) button is now disabled (gray).

Combustion creates the link between channels using a method (a type of JavaScript command) called CB.GetChannelValue. The values generated by the Panel's layer's Shift Y Amount channel on any given frame is now also the value of the Cloud's Shift X Amount channel.

- 7. Play the clip to view the result (SPACEBAR).
 - a) In the Workspace panel double click the Atomix Background layer.
 - b) Play the clip (SPACEBAR) to view the result.

The Clouds appear to shift from left to right in a continuous move at the same rate of speed as the images in the Panel layer shift from top to bottom. Linking the Clouds layer's Shift Amount X channel to the Panel's Shift Amount Y channel has created a dynamic and direct relationship between the two channels. Any change made to the Panels' Y shift will automatically update the Clouds' X shift in constant synchronization. Based on this example, one channel can be used to directly control an infinite number of channels in your Combustion workspace, giving you massive control over complex changes from a single channel.

Animate the Electric Glow Layer

Add Crumple and Glow filter to the Electric Glow layer, then use the Expression Browser to animate their channels. In some cases it is more effective to animate by applying a style of motion than to work in detail, particularly in cases of very dynamic motion changes. Using expressions saves time from having to edit the details of a motion curve, but still allow the desired look to be created quickly. Here the Electric Glow layer will be transformed from a simple still to electrifying with just a few steps.

- 1. Go to frame 1 (HOME).
- 2. In the Workspace panel, double click the Electric Glow layer.

The layer is displayed in the viewport.

- **3.** Add a Crumple Operator filter to the Electric Glow layer:
 - a) Show the Operators Panel (F5).
 - b) Select the Distort Category.
 - c) CTRL-click / 38-click Crumple.

A Crumple operator is added to the Electric Glow layer and the Crumple Controls panel is displayed.

19 Creating Expressions

- 4. Set the Crumple Controls (F8) to create the basic distortion:
 - a) Set amplitude to 5%.
 - b) Set Octaves to 2.00.
 - c) Horizontal Scale 5%.
 - d) Vertical Scale 12%.
- 5. Animate the Crumple's Time Slice channel with the Expression Browser:
 - a) Show the Timeline (F4).
 - b) Select the Timeslice Channel of the Crumple filter.
 - c) Click the Expression Browser Button.
 - d) In the left pane of the Expression Browser, click the Picon representing the Linear Expression. The preset parameters appear in the right pane.
 - e) In the right pane of the Expression Browser, change the Slope value to 0.5 and click OK (Offset should be at 0).
- **6.** Play the clip (**SPACEBAR**) to view the result.

The edges of image are rapidly crumpling, but remain legible. The linear expression applied to the Timeslice channel takes the place a minimum of two keyframes saving time in designing the look of the animation. It also offers additional flexibility in that its value will extrapolate infinitely. Therefore, the overall composition length can also be altered without the need to edit keyframe positions or values in the Timeline manually.

- 7. Add a Glow filter to the Electric Glow layer to create random flicker effect:
 - a) Select the Crumple filter in the Workspace Panel.
 - b) Show the Operators Panel (F5).
 - c) Select the Stylize Category.
 - d) CTRL-click / 38-click Glow.

A Glow operator is added to the Electric Glow layer and the Glow Controls panel is displayed

8. Set the Glow Controls (**F8**) Radius to 5.00.

- 9. Animate the Glow's Strength channel with the Expression Browser:
 - a) Show the Timeline (F4).
 - **b)** Select the Strength of the Glow operator.
 - c) Click the Expression Browser Button.
 - d) In the left pane of the Expression Browser, click the preset Picon representing the Random Expression. The preset's parameters appear in the right pane.
 - e) Set Minimum Value Y: 0.5 Set maximum to 1.5 and click OK. (ENTER / RETURN).
- 10. Play the clip (Spacebar) to view the result.

The Glow operator is flickering rapidly changing on every frame. The Random preset chosen in the Expression Browser saved a considerable amount of creative time over adding and manipulating the number of keyframes it would take to create the glow effect manually.

Animate the Electron Layer with Multi-channel Expressions

Create a circular motion path for the Electron layer using a multiple channel selection and the Expression Browser.

- In the Workspace Panel, double click the Composite Atomix Operator.
 The composite is displayed in the viewport.
- 2. Go to frame 1 (HOME).
- 3. In the Workspace Panel, select the Electron layer, the small yellow sphere in the center of the O of the Atomix logo.
- 4. In the Timeline (F4), CTRL-click / ૠ-click-click the Electron layer's X Position and Z Position channels.
- **5.** Click the Expression Browser button.
 - Notice that the selection of two channels in the Timeline prior to opening the browser causes a variety of two channel presets to be offered.
- 6. In the left pane of the Expression Browser, click the preset Picon representing the Circle Expression.
 - The preset parameters appear in the right pane. Set X Offset to -46.25, Y Offset 0, X Scale 164, Y Scale 164, and Frame Cycle to 50. Click OK (ENTER / RETURN). An independent expression is applied to each of the two previously selected channels. The first line of each expression is displayed in the Timeline.

7. Play the clip (SPACEBAR) to view the result.

The Electron layer is animating on a circular path. The path takes the Electron layer both left and right along the layer's X Position channel, as well as near and far based on the second expression applied to the layer's Z channel. The center of the layer's circular path needs to be adjusted to follow the Nucleus layer which is the focus of the next section of this exercise.

Adjust the Electron Layer's Position by Editing the Expressions

Edit the expressions applied to the Electron layer's position channel's by linking the Nucleus layer's position as its center. This is another excellent example of using channel linking. The animation created in this exercise would be nearly impossible if based on keyframe editing alone. This example uses the power of channel linking working within the context of an existing expression. Combustion expression editor features in context linking allowing creative decisions without a lot of typing.

- 1. Go to frame 1 (HOME).
- 2. In the Timeline (F4), right-click / CONTROL-click the Electron layer's X position channel and choose Edit Expression from the context menu.
 - Combustion opens the multi-line editor displaying the expression applied to the channel.
- **3.** Insert an absolute channel link into the X position expression:
 - a) In the first line of the expression, double click the text "-46.25" (make sure to include the semicolon) and delete it leaving the first line as: "XOffset=". Make sure the blinking cursor for text entry is positioned directly after the "=" symbol.

Note: Note that one of the two link buttons should be selected (green). The "=" sign is one of several special characters in the Combustion multiline editor that allows interactive editing of the expression utilizing using the link function.

- b) Make sure the Link absolute mode (Link(/)) is enabled. If not, press F1 to toggle between link modes.
- c) In the Workspace panel, select the Nucleus layer.

The Nucleus layer's animation channels are now visible in the Timeline.

d) In the Timeline, select the Nucleus layer's X position channel.

The method and path to that channel is now inserted into the edited expression (again utilizing the CB.GetChannelValue method).

- e) Press SHIFT+ENTER to close the multi-line editor and commit the edits to the expression.
- **4.** In the Timeline (**F4**), right-click/**CONTROL**-click the Electron layer's Z position channel and choose Edit Expression from the context menu.

Combustion opens the multi-line editor displaying the expression applied to the channel.

- 5. Insert an absolute channel link into the Z position expression:
 - a) In the first line of the expression, select the text "0.00;" (make sure the semicolon is selected) and delete it leaving the first line as: "YOffset=". Make sure the blinking cursor for text entry is positioned directly after the "=" symbol.
 - b) Make sure the Link absolute mode (Link(/)) is enabled. If not, press F1 to toggle between link modes.
 - c) In the Workspace panel, select the Nucleus layer.

The Nucleus layer's animation channels are now visible in the Timeline.

d) In the Timeline, select the Nucleus layer's Z position channel.

The method and path to that channel is now inserted into the edited expression. (Note: although the expression variable is "YOffset" as the expression is actually applied the Electron layer's Z position channel, it is correct to select Nucleus layer's Z channel.

e) Press SHIFT+ENTER / SHIFT+RETURN to close the multi-line editor and commit the edits to the expression.

The Center of the Electron's orbit is now linked directly to and will follow the Nucleus Position. Only the Y channel remains to be linked.

- 6. Link the Electron and Nucleus layers' Y Position:
 - a) In the Timeline, select the Electron layer's Y position channel.
 - **b)** Click the Link(/) (Link Absolute) button.
 - c) In the Workspace panel, select the Nucleus layer.

It's channels are displayed in the Timeline.

d) In the Timeline, select the Nucleus layer's Y position channel.

The linking expression method (CB.GetChannelValue) method and corresponding channel path are inserted into the Electron's Y Channel and is partially visible in the Timeline.

7. Play back the result (**SPACEBAR**).

The Electron layer now orbits the Nucleus as it moves though the composite. The use of expressions allows the Electron's animation to become dependent on the animation of other layers. Once the relationship is created, it never has be updated offering flexibility and control.

- 8. (Optional) Save the workspace:
 - a) Choose File | Save Workspace (CTRL+S / ૠ+S) to open the Save Workspace dialog.
 - b) Set a filename and directory for the workspace, and then click OK (ENTER / RETURN).
- 9. Choose File | Close Workspace (CTRL+W / ૠ+W) to close the workspace.

ang kan sa atau ng kanalaga ng kalaway ng kanalaga na atau na

er a comprese de la comprese del comprese de la comprese del comprese de la comprese del comprese della compres

and the contraction of the contr

Taglet a first growth american american american and american and american american and american ameri

en de la conseguir de la companya d La companya de la co

in a second of the second of t

s segan nar se de conting

The state of the s

Cropping and Corner-Pinning Lesson 20

In this lesson, place images into a movie poster frame and on the side of a truck using cropping and corner-pinning.

Overview

You use cropping and corner-pinning to composite images or video onto a background. With cropping, you remove pixels from the sides of an image. With corner-pinning, you shape the image by positioning each of the image's corners to fit a specific area.

In this lesson:

- Import a movie poster, an Adobe® Photoshop® file, and a background image.
- Crop the images to resize them for the background image.
- Change the properties of two layers to enable four-corner pinning.
- Size and shape the images by pinning their corners onto the background image.
- Change the transfer mode of a layer to integrate it into the background.
- Position a layer from the imported Photoshop file within a corner-pinned image.

Need Help?

If you need help completing this lesson, save and close your workspace, and then open the 20_CroppingCornerPinning.cws file as a reference.

Create a Composite Branch

Create a composite branch and import the images.

- 1. Check the Combustion preferences. For instructions, see "Setting the Preferences" on page 3.
- 2. Choose File | New or press CTRL+N (Windows) or %+N (Macintosh) to create a branch with the following properties:
 - Type: Composite
 - Name: 20_CroppingCornerPinning
 - Format: NTSC D1 Duration: 1 frame Bit Depth: 8 Bit
 - · Mode: 3D

Note: When corner-pinning, you need to work in 3D mode.

- **3.** Select the single-viewport layout.
 - **4.** Choose File | Import Footage (CTRL+I / SE+I) and open the 20_CroppingCornerPinning folder.

5. CTRL-click / %-click store.png, poster.png, and logo.psd (in this order), and then click OK (ENTER / RETURN).

An Import Options dialog opens asking what import mode to use for the *logo.psd* file.

When importing a multi-layer file, the Merged Image option imports the file as a single layer, the Grouped option imports the file as separate layers parented to a null object in a composite, and the Nested option imports the file as separate layers parented to a null object in a nested composite. The Nested options allows for control over the layers independently and/or as a group.

6. In the Import Options dialog, select Nested and then click OK (**ENTER / RETURN**).

The first footage imported is the lowest layer in the Workspace panel.

The order that footage is imported is important because it also defines the initial order of the layers in the Workspace panel.

Hint: Drag the layers in the Workspace panel to reorder them.

7. Choose Window | Fit in Window, or click the Home button.

Scale and Crop the Poster Image

Scale and crop the poster image to fit it inside the empty frame in the store image background. The empty frame in the store image is a 27 by 40 inch frame. The poster image is 32 by 40 inches, which is 5 inches wider than the empty frame.

- 1. In the Workspace panel (**F3**), turn the logo layer off by clicking its icon.
- **2.** Scale the poster image:
 - a) In the Workspace panel, select the poster layer.
 - **b)** In the Composite Controls panel (**F8**), click Transform.
 - c) Enable Proportional under Scale and set any of the Scale fields to 30%.

Hint: When Proportional is enabled, changing one of the Scale fields changes the others to the same value.

- 3. In the Workspace panel, click the triangle next to the poster layer (CTRL+RIGHT ARROW / %+RIGHT ARROW).
- 4. Select the poster Footage operator.

In the Footage Controls panel, note the dimensions of the poster image in the Footage Details. The poster is 400 pixels wide by 500 pixels high.

You only need to change the poster width. Compare the width-to-height ratios of the poster versus the empty frame on the store image to calculate the new width. You can represent this relationship as:

$$\frac{Frame\ Width}{Frame\ Height} = \frac{Target\ Poster\ Height}{Actual\ Poster\ Height}$$

5. Calculate the target poster width by replacing the fields in the ratio with the actual values from the composite.

The empty frame on the store image is 27 inches wide by 40 inches high. The poster image is 400 pixels wide by 500 pixels high.

The calculation is:
$$\frac{27}{40} = \frac{Target \ Poster \ Width}{500}$$

This translates into making the target poster width 338 pixels, rounded-up from 337.5. This is a difference of 62 pixels from the original width of the poster.

Hint: You can double-click any of the fields under Cropping in the the Footage Output controls to display a calculator to help you with this formula.

- 6. Crop both sides of the poster image:
 - a) In the Workspace panel, double-click the poster Footage operator under the poster layer.
- b) In the Toolbar, click the Crop tool.

In the viewport, a dotted line appears around the poster image to show the cropping.

- c) In the Footage Controls panel, click Output.
- d) In the Cropping fields, set Left to 31 and Right to 31.

Positive values always crop inwards on all sliders, while negative values crop outwards.

Hint: To manually crop, you can drag the dotted line in the viewport.

Corner Pin the Poster Image

Pin the corners of the poster image to mount it in the poster frame.

- 1. Change the viewport display:
 - a) In the Workspace panel (F3), double-click the 15_CroppingCornerPinning composite.
- b) Select the two-viewport vertical layout.
 - The active viewport—the left viewport— is indicated by a white border.
- c) In the Toolbar (F2), scrub Magnify tool to zoom in (CTRL+= / 98+=) the left viewport.
 - d) Scrub the Grab tool to focus on the lower-left corner of the empty frame of the store background.
 - 2. In the Workspace panel (F3), select the poster layer.
 - 3. In the Composite Controls panel, click Layer to access the Layer controls.

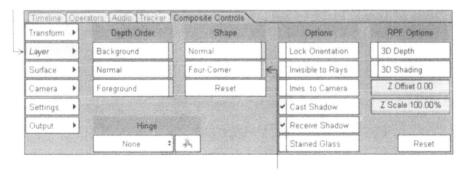

4. Enable Four-Corner to convert the layer's shape to four-corner.

A control point appears at each corner of the poster image.

Hint: Change the Display Quality to Best so that the poster displays a clean anti-aliased image.

- 5. Corner-pin the poster image into the empty frame on the store image:
 - a) In the left viewport, position the poster image over the empty frame.
 - **b)** Position the cursor over a corner control point. When the cursor changes to an arrow, click and drag the corner control point to its corresponding corner of the empty frame.
 - c) In the Composite Controls panel, enable Invis. to Camera.

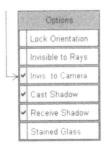

To aid in precise placement, you may find it helpful to temporarily make the poster image Invisible to Camera and work with only the outline. You can also temporarily turn off the layer's footage by clicking on its icon in the Workspace panel.

d) Repeat step b) with each of the remaining corners to corner-pin the poster image in the empty frame.

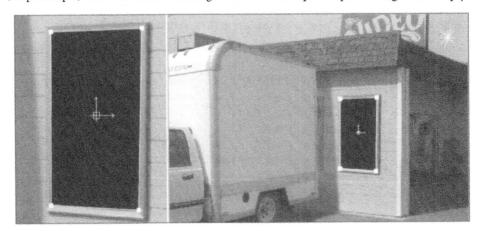

e) In the Composite Controls panel, disable Invis. to Camera.

Note: Remember to turn on the Footage Operator for the poster layer if you made the layer invisible or turned off the footage for corner-pinning.

Scale and Crop the Logo Image

Scale and crop the logo image by scaling the logo layer and cropping the Nested Composite.

- 1. Click the right viewport.
- 2. Select the single-viewport layout.
 - **3.** Scale the logo layer:
 - a) In the Workspace Panel (F3), select the logo layer.
 - b) Turn on the layer by clicking its icon.
 - c) In the Composite Controls panel, click Transform.
 - d) With Proportional enabled, set any of the fields to 30%.
 - 4. Crop the Nested Composite:
 - a) Click the triangle next to the logo layer to access its contents (CTRL+RIGHT ARROW / %+RIGHT ARROW).
 - b) Select the Composite nested within the logo layer.

The truck is 7 feet long by 7 feet high. The logo is designed for a 12-foot long truck. We do not need to change the height of the logo, just the length. Leave the height at 600 pixels and set the length at 600 pixels.

c) In the Composite Controls panel, click Output and change the Width to 600.

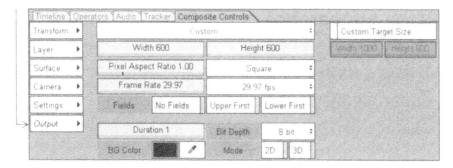

Corner-Pin the Logo Image

Pin the corners of the logo to the truck.

1. Change the viewport display:

- a) Select the two-viewport layout.
- **b)** Choose Window | Fit in Window, or right-click / **CONTROL**-click the left viewport and choose Fit in Window to view the entire composite in the viewport.

- 2. In the Workspace panel, select the logo layer.
- 3. Change the layer's properties to move its corner points independently:
 - a) In the Composite Controls panel, click Layer.
 - b) Enable Four-Corner to convert the layer's shape to four-corner.

A control point appears at each corner of the logo image.

4. Corner-pin the logo on the side of the truck:

Note: Notice the upper left corner of the truck is rounded. Position the logo under the round corner.

- a) In the left viewport, move the logo to the side of the truck.
- b) Click a logo's corner control point and drag it to its corresponding corner of the truck.
- c) Repeat step b) with each of the remaining corners to place the logo image on the side of the truck.
- 5. Click the right viewport.

- **6.** Scrub the Pan button to see all four corners of the logo.
- 7. Zoom in (CTRL+= / \Re +=) and fine-tune the corner-pinning of the logo.

Change the Appearance of the Logo

Add Blur and Noise Operators to the logo and change the logo's transfer mode to blend it with the background.

- 1. Select the single-viewport layout.
 - 2. Change the transfer mode of the logo layer:
 - a) In the Composite Controls panel, click Surface.

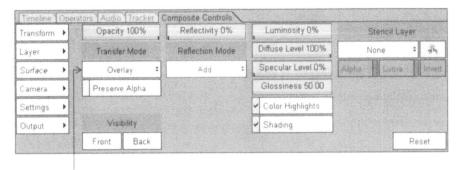

b) From the Transfer Mode list, select Overlay.

- 3. Add a Gaussian Blur Operator to the logo layer:
 - a) In the Operator Controls panel (F5), click the Blur/Sharpen category.
 - b) CTRL-click/ St-click Gaussian Blur.
 - c) In the Gaussian Blur Controls panel, set Radius to 2.
- 4. Add a Noise Operator to the logo layer:
 - a) In the Operator Controls panel, click the Noise category.
 - b) CTRL-click/ St-click Add Noise.
 - c) In the Add Noise Controls panel, set Amount to 15% and enable Monochrome.

This creates the Noise in the same color as the logo image.

Position a Layer from the Photoshop File

The *logo.psd* image you imported at the beginning of the lesson is a Photoshop file. The Photoshop file contains two layers: Popcorn layer and Background layer. Since you selected nested as the import option, you imported the file as layers in a nested composite. This enables you to manipulate the layers independently. Move one of the two layers in the nested Photoshop file. The Background layer contains the filmstrip and text, and the Popcorn layer contains a graphic of a single piece of popcorn.

- 1. Change the position of the Popcorn layer:
 - a) Click the triangle next to the Composite nested in the logo layer.

This Nested Composite is the Photoshop file imported at the beginning of the lesson.

- b) Select the Popcorn layer.
- c) In the Composite Controls panel (F8), click Transform.
- d) Set the X Position to -25 and the Y Position to -80.
- 2. Choose Window | Fit in Window or right-click / CONTROL-click the viewport and choose Fit in Window to view the entire composite in the viewport.
- 3. (Optional) Save the workspace:
 - a) Choose File | Save Workspace (CTRL+S / 38+S) to open the Save Workspace dialog.
 - b) Set a filename and directory for the workspace, and then click OK (ENTER / RETURN).
- 4. Choose File | Close Workspace (CTRL+W / ₩+W) to close the workspace.

ew. gen in the confidence of the

Lings of the state of the state

the state of the s

on the state of th

en de la composition La composition de la

The state of the s

, and an experience of the contract of the con

And the second of the second o

range survey of the state of th

e de la composition La composition de la

Aligning Objects to a Motion Path

Lesson 21

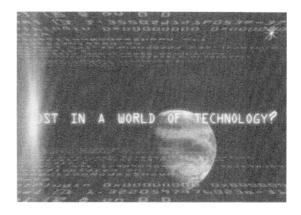

In this lesson, align the axes of different motion graphics elements to their motion paths to complete this commercial spot.

Overview

You can use the Align tool to align the X, Y or Z axis of a layer to its motion path. You can also adjust the motion path of an animated layer in the viewport to refine its motion.

In this lesson:

- · Animate the position of a layer by moving it in the viewport.
- Duplicate layers in the Schematic view.
- · Loop footage to match timeline length.
- Create 3 object motion paths for specific, X, Y, and Z axes.
- Refine aligned object motion paths for smoother animation.

Open the 21_AligningObjectsToPath.mov file in the 21_AligningObjectsToPath folder and preview the result.

Need Help?

If you need help completing this lesson, save and close your workspace, and then open the 21_AligningObjectsToPath.cws file as a reference.

Open a Workspace and Import Footage

Open the 21_Aligning_start.cws file and then import the footage for the composite via the Schematic view.

- 1. Check the Combustion preferences. For instructions, see "Setting the Preferences" on page 3.
- 2. Choose File | Open Workspace, or press CTRL+SHIFT+O (Windows) or %+SHIFT+O (Macintosh).
- 3. In the Open Workspace dialog, use the file browser to locate and open the 21_AligningObjectsToPath folder.
- 4. Click the 21_Aligning_start.cws from the 21_AligningObjectsToPath folder and then click OK (ENTER / RETURN).

The 21_Aligning_start.cws contains a single composite branch.

5. Play the animation (SPACEBAR).

The text "Lost in a World of Technology?" forms on a space background.

- **6.** Show the Schematic view by selecting one of the following options:
 - Press F12 or ~.

- · Click the Schematic view button.
- Choose Window | Schematic.
- Right-click / CONTROL-click the viewport and choose Schematic.

The Schematic view is a visual representation of all of the layers and operators in a workspace (via a process tree). In the Schematic view, you can easily add, remove, disconnect or connect layers or operators in your composite.

Hint: To change the flow direction of the process tree in Schematic view, right-click /CONTROL-click the viewport and choose Flow Direction, press SHIFT+DOWN ARROW to direct the flow downward, or press SHIFT+RIGHT ARROW to direct the flow to the right. Press L at any time to automatically layout the Schematic.

- 7. Zoom in (CTRL+= / 38+=) and zoom out (CTRL+= / 38+-) the Schematic view.
- 8. Import the footage for your composite:
 - a) In the Schematic view, select the Composite node.
 - A selected node in the Schematic is highlighted (like a selected item in the Workspace panel).
 - **b)** Right-click / **CONTROL**-click the Composite node and choose Import Footage.
 - c) From the 21_AligningObjectsToPath folder, import the PcText.png image.
 - **Hint:** You can also choose File | Import Footage (CTRL+I / \Re +I) to import footage.
 - d) Press L to arrange the nodes.

In the Schematic view, the PcText footage and layer nodes appear. In the Workspace panel, the layer appears, and the footage is added to the Footage library.

Hint: To rearrange nodes, you can also right-click / CONTROL-click on a selected node and choose Layout.

9. Preview the animation:

- a) Click the Schematic view button. (F12 or ~) to show the Composite view.
- b) Play the clip (SPACEBAR).

The PcText layer appears in the clip.

Hint: You can return to the Composite view by triple-clicking the Composite node (in the Schematic view), or double-clicking the Composite branch (in the Workspace panel).

Animate the PCText

Animate the PcText layer so it appears to fly off into space by moving the PcText layer to create keyframes, and by aligning the layer to the Y axis.

- 1. In the Workspace Panel (**F3**), select the PcText layer.
- 2. Go to frame 1 (HOME).
- **3.** In the Composite Controls panel (**F8**), click Transform.
- 4. Set the X Position to 143, the Y Position to -65, and the Z Position to -682.

The image is no longer visible in the viewport because it is behind the camera. To see the proper result, add the final position keyframe and align the object to an axis.

5. Enable Animate (A).

- 6. Go to the last frame (END).
- 7. Enable the Align Y option.

8. Set the Z Position to -393.

- 9. Preview the result:
 - a) Go to frame 1 (HOME).
 - b) Play the animation (SPACEBAR).

Because the layer's Z position is animated and the layer is aligned to the Y axis, it appears to move in 3D space.

Duplicate a Layer via the Schematic view

Use the Schematic view to duplicate the PcText layer. Change the Y Position of the duplicated layer so it mirrors the animation of the original layer.

- 1. Show the Schematic view (F12 or ~).
- 2. Set the viewport layout:
- =

a) Select the two-viewport horizontal layout.

The top viewport shows the Schematic view, and the bottom viewport shows the Camera view.

- **b)** Right-click / **CONTROL**-click the bottom viewport and choose Fit in Window.
- 3. In the Schematic view, right-click / click and CONTROL-click the PcText layer node and choose Duplicate.
- **4.** Press **L** to arrange the nodes.

The layer is duplicated and the footage is instanced. In this case, "instancing" means the same footage is the source for two different layers.

Note: Use copy and paste to create a copy of a layer.

- **5.** In the Workspace Panel (**F3**), select the PcText(2) layer.
- 6. Go to frame 1 (HOME).
- 7. Disable Animate (A).
- **8.** In the Composite Controls panel (**F8**), click Transform.
- 9. Set the Y Position to 65 (leave the X Position set to 143 and the Z Position set to -682). Since the Y Position of the PcText(2) layer is set to the opposite of the PcText layer (and Animate is disabled) the animation of the PcText(2) layer mirrors the PcText layer.
- 10. Click the Composite viewport (or press [to cycle viewports) and play the clip (SPACEBAR) to view the result.

Adjust the Opacity of the PcText Layers:

- 1. In the Composite Controls panel (F8), click Surface.
- 2. Go to the last frame (END).
- 3. Enable Animate (A).
- 4. In the Workspace panel (F3), SHIFT-click the PcText and PcText(2) layers to select both layers.
- 5. Set the Opacity to 25%.

6. Play the clip (SPACEBAR) to view the result.

Since Animate is enabled and the opacity of the layers is animated at frame 60, the layers fade from 100% opacity at the first frame to 25% opacity at the last frame. When Animate is enabled, a keyframe is automatically created at the first frame. The PcText moves in the top and bottom of the viewport (on the Y axis) and fades out toward the background.

7. Select the single-viewport layout.

Choose Window | Fit in Window.

Import the Earth Footage

Import the Earth image into the 21_AligningToMotionPath composite via the Workspace panel.

- 1. Go to frame 1 (HOME).
- 2. In the Workspace panel (F3), select the 21_AligningToMotionPath composite.
- 3. Choose File | Import Footage (CTRL+1/ ₩+1).
- **4.** From the 21_AligningObjectsToPath folder, import the Earth.png image.

Animate the Earth Image on the Z Axis

Animate the Earth image along the Z axis to warp the perspective of the image so it matches the original composite. Then, refine the motion path of the Earth layer.

- 1. In the Workspace panel (**F3**), select the Earth layer.
- 2. In the Composite Controls panel (F8), click Transform.
- 3. Set the Z Position to 1378, the X Position to -442, and the Y Position to -91. The image moves back in space and to the left of the viewport.
- 4. Go to the last frame (END).
- 5. Set the X Position to 166, the Y Position to –362, and the Z Position to -66.

 The image moves forward in Z space and toward the bottom of the viewport.
- **6.** Enable the Align Z option.

7. Go to frame 1 (HOME).

8. Using the following illustration as a guide, adjust the tangent handles of the Earth image motion path (in the viewport) to smooth out the animation.

9. Play the clip (SPACEBAR) to view the result.

The Earth image slides along the Z axis of the motion path, creating an angular change in the perspective of the object as it reaches the last keyframe.

Change the Playback Behavior of the Orb Footage

Import, then extend the length of the orb footage to match the length of the composite.

- 1. Import the orb footage:
 - a) Go to frame 1 (HOME).
 - b) In the Workspace panel (F3), select the 21_AligningToMotionPath composite.
 - c) Choose File | Import Footage (CTRL+1 / 38+1).
 - **d)** From the 21_AligningObjectsToPath folder, double-click the Orb folder and import the orb[###].png image sequence.
- 2. In the Workspace panel (F3), double-click the orb001 layer.

The Layer view is displayed.

3. Expand the orb001 layer (CTRL+RIGHT ARROW / %+RIGHT ARROW).

The orb Footage operator is visible in the Workspace panel.

- 4. In the Workspace panel (F3), select the orb[###] Footage to access the Footage Controls panel.
- 5. In the Footage Controls panel, click Output.
- 6. From the Playback Behavior list, select Loop and enter a value of 5 for the 10-frame image sequence.

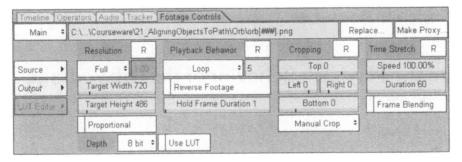

The 10-frame image sequence plays once, and then loops 5 times to match the length of the 60-frame composite.

Note: You can leave the Loop value at 0 to loop for an infinite value.

7. In the Toolbar (F2), select Camera View.

Animate the Orb Footage Along the X Axis

Animate the orb footage along the Aligned X axis of a motion path.

- 1. In the Workspace panel (F3), select the orb001 layer.
- 2. In the Composite Controls panel (F8), click Transform.

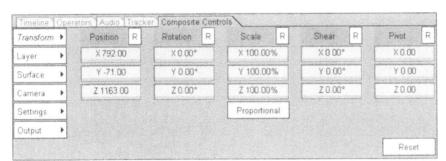

3. Set the Z Position to 1163, the Y Position to -71, and the X Position to 792.

The orb image moves back and to the right in the viewport.

- 4. Enable Proportional Scale, and enter 155 in either the X, Y, or Z scale fields.
- 5. Go to frame (/) 22.
- **6.** Enable the Align X option.
- 7. Animate the orb footage:
 - a) Set the X Position to -265 and the Z Position to 1121 (and leave the Y Position set to -71).
 - **b)** Go to frame (/) 37.
 - c) Set the X Position to -130, the Y Position to -13, and the Z Position to -372.
 - d) Go to frame (/) 54.
 - e) Set the X Position to -4, the Y Position to 0, and the Z Position to -632.
- 8. Play the clip (SPACEBAR) to view the result.

The orb travels from the right of the viewport, behind the globe, around the left and in front of the viewport.

Customize the Motion Path Tangent Handles

Adjust the motion path of the orb footage to smooth its animation along the X axis.

- 1. Go to frame 1 (HOME).
- 2. Disable Animate (A).
- 3. Select the two-viewport vertical layout.

- 4. Set the viewports:
 - a) Click the left viewport.

Note: If the Schematic appears in one of the viewports, exit the Schematic by pressing F12 or ~.

b) In the Toolbar (F2), select Top View from View list.

- c) Click the right viewport (or press [).
- d) In the Toolbar (F2), ensure Camera View is selected from the View list.
- e) Zoom out the left viewport.
- 5. In the Workspace panel (F3), select the orb001 layer.

The selected layer is represented by the yellow line, and its motion path is displayed.

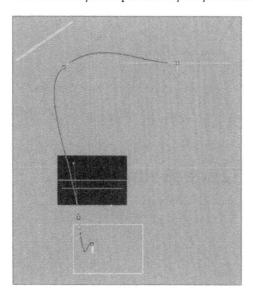

6. (Optional) Go forward in the clip and notice how the orb layer stays aligned to the X axis.

7. Using the following image as a guide, adjust the tangent handles of the motion path to smooth the animation.

- 8. Click the Camera view, and then select the single-viewport layout.
 - 9. Zoom in and then play the clip (SPACEBAR). The orb animation is more fluid.
 - 10. (Optional) Save the workspace:
 - a) Choose File | Save Workspace (CTRL+S / %+S) to open the Save Workspace dialog.
 - **b)** Set a filename and directory for the workspace, and then click OK (ENTER / RETURN).
 - 11. Choose File | Close Workspace (CTRL+W / ૠ+W) to close the workspace.

Changing Layer Surface Properties Part IV

22	Exploring Transfer Modes	263
23	Displacing a Layer	273

Changing Layor Surface Coperdes

Exploring Transfer Modes

Lesson 22

In this lesson, change how four moving text images appear against a background.

Overview

A transfer mode changes the appearance of a layer when another layer passes underneath it. As a result, the colors in the top layer can be blended, mixed, or even reversed. Unlike other transformations, changing a layer's transfer mode can cause abrupt changes in its appearance. Use transfer modes to create unique visual effects in the composite.

In this lesson:

- · Animate the xfer layers in the composite.
- Use the Speed channel in combination with the Ping Pong Extrapolation to cycle the xfer layers back to their start positions.
- Enable keyframing for the Transfer Mode channel.
- · Assign several transfer modes to the xfer layers.
- Examine a layer's Transfer Mode channel in the Timeline.

Open the 22_ExploringTransferModes.mov file in the 22_ExploringTransferModes folder and preview the result.

Need Help?

If you need help completing this lesson, save and close your workspace, and then open the 22_ExploringTransferModes.cws file as a reference.

Create a Composite

Create a composite branch and import the images.

- 1. Check the Combustion preferences. For instructions, see "Setting the Preferences" on page 3.
- 2. Choose File | New, or press CTRL+N (Windows) or %+N (Macintosh), to open the New dialog and create a branch with the following properties:
 - · Type: Composite
 - · Name: ExploringTransferModes
 - Format: NTSC D1
 - · Duration: 90 frames
 - Bit depth: 8 Bit
 - · Mode: 2D
- 3. Select the single-viewport layout.

- 4. Import the footage:
 - a) In the Workspace panel (F3), right-click / CONTROL-click the ExploringTransferModes composite and choose Import Footage (CTRL+I / %+I).
 - b) In the Import Footage dialog, use the file browser to locate and open the 22_ExploringTransferModes folder.
 - c) CTRL-click / % -click background.png, xfer_four.png, xfer_three.png, xfer_two.png, and xfer_one.png (in this order), then click OK (ENTER / RETURN).
- 5. Choose Window | Fit In Window, or right-click / CONTROL-click and choose Fit in Window.

Animate the Layers

Position and animate the layers so they move horizontally across the background. Use the Speed channel in combination with the Ping Pong Extrapolation to cycle the layers back to their starting positions.

- 1. Go to the first frame (HOME).
- 2. Position of all four xfer layers:
 - a) In the Workspace panel (F3), select the xfer_one layer.
 - b) In the Composite Controls panel (F8), click Transform and set the Y Position to 182.
 - c) Select the xfer_two layer and set its Y Position to 60.
 - d) Select the xfer_three layer and set its Y Position to -60.
 - e) Select the xfer_four layer and set its Y Position to -182.

All four xfer layers are visible in the viewport.

- 3. Go to frame 10 (/).
- 4. Enable Animate (A).
- 5. Add a keyframe at frame 10 for all four xfer layers to create 10-frame pause in the animation:
 - a) In the Workspace panel, select the xfer_one layer.
 - b) In the Timeline (F4), click Graph.

The Graph mode shows the value of a category's channel over time.

c) Click Add Key.

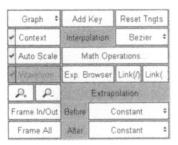

- d) Select the xfer_two layer in the Workspace panel and click Add Key in the Timeline.
- e) Select the xfer_three layer and click Add Key.
- f) Select the xfer_four layer and click Add Key.
- **6.** Animate the position of all four xfer layers:
 - a) Go to frame 50 (/).
 - b) In the Workspace panel, select the xfer_one layer.
 - c) In the Composite Controls panel (F8), click Transform and set the Y position to 60.
 - d) Select the xfer_two layer and set its Y position to 182.
 - e) Select the xfer_three layer and set its Y position to -182.
 - f) Select the xfer_four layer and set its Y position to -60.
- **7.** Set the animation behavior of all four xfer layers using the Speed channel in combination with the Extrapolation method:
 - a) In the Workspace panel, select the xfer_one layer.
 - b) Show the Timeline (F4).

The Timeline shows the Transformation category of the xfer_one layer.

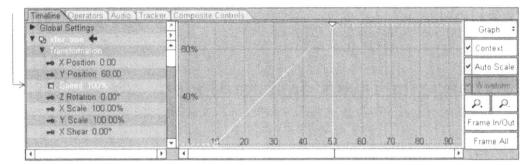

d) From the Extrapolation After list, select Ping Pong.

Ping Pong After Extrapolation reverses the Speed curve so the layer travels back to its original position at the end of the clip.

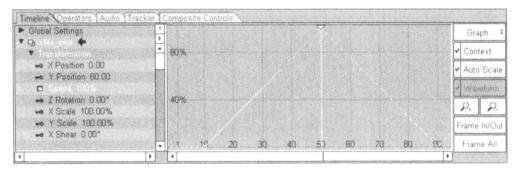

- e) In the Workspace panel, select the xfer_two layer.
- f) In the Timeline, select the Speed channel and enable it by clicking on its icon.
- g) From the Extrapolation After list, select Ping Pong.
- h) Repeat steps f and g for the xfer_three layer and the xfer_four layer.
- 8. In the playback controls, select Loop Play Mode.

 The Play Mode button cycles between Play Once , Loop , and Ping Pong =

9. Play the clip (SPACE BAR) to view the result.

The four xfer layers start traveling horizontally across the background layer at frame 10, then reverse and return to their starting position along the same path.

Change the Layers' Transfer Mode

Transfer modes control how a layer's surface blends with the layers behind it. Select a transfer mode for each xfer layer.

- 1. Go to the first frame (HOME).
- 2. Enable Transfer Mode keyframing for all four xfer layers:
 - a) In the Timeline list, expand the Surface category to view its content.
 - b) Click the Transfer Mode key icon to enable keyframing.

Note: Keyframing for Transfer Modes is disabled by default.

- c) Select the xfer_three layer, expand the Surface category, and click the Transfer Mode key icon.
- d) Select the xfer_two layer, expand the Surface category, and click the Transfer Mode key icon.
- e) Select the xfer_one layer, expand the Surface category and click the Transfer Mode key icon.
- **3.** Go to frame 10 (/).

- **4.** Change the Transfer mode of the four xfer layers as follows:
 - a) In the Workspace panel, select the xfer_one layer.
 - b) In the Composite Controls panel (F8), click Layer.
 - c) From the Transfer Mode list, select Overlay.

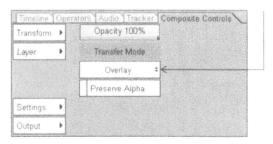

- d) Select the xfer_two layer and change its transfer mode to Multiply.
- e) Select the xfer_three layer and change its transfer mode to Exclusion.
- f) Select the xfer_four layer and change its transfer mode to Colorize.

The transfer modes affects the layers' surfaces as follows.

Layer	Transfer Mode	Description
xfer_one	Overlay	Combines the colors of the xfer_one layer with those of the layers behind it to create new tints. Overlay boosts contrast and color saturation.
xfer_two	Multiply	Multiplies the pixel values of the xfer_two layer with the pixels of the layers behind it, and clips all RGB values at 255.
xfer_three	Exclusion	Changes the white pixels of the xfer_three layer to invert the pixels of the layers behind it.
xfer_four	Colorize	Changes the hue and saturation of the xfer_four layer to the hue and saturation values of the layers behind it.

- **5.** Go to the frame 50 (/).
- **6.** Change the transfer mode of the four xfer layers as follows:
 - a) Select the xfer_one layer, and from Transfer Mode list, select Subtract.
 - **b)** Select the xfer_two layer, and from Transfer Mode list, select Difference.
 - c) Select the xfer_three layer, and from Transfer Mode list, select Saturation.
 - d) Select the xfer_four layer, and from Transfer Mode list, select Luminance.

The transfer modes affects the layers' surfaces as follows.

Layer	Transfer Mode	Description
xfer_one	Subtract	Subtracts the RGB values of the xfer_one layer's pixels from the layers behind it. The resulting composite can make the layer's pixels appear very dark.
xfer_two	Difference	Subtracts the RGB values of the xfer_two layer's pixels from the pixels of the layers behind it. If the result is a negative number, the inverse value is used.
xfer_three	Saturate	Changes the saturation of the xfer_three layer to the saturation values of the layers behind it.
xfer_four	Luminance	Changes the luminance of the layers in the background to the luminance value of the xfer_four layer.

- 7. Examine a layer's Transfer Mode channel in the Timeline:
 - a) In the Workspace panel, select the xfer_one layer.
 - b) In the Timeline (F4), scroll down to the Surface category.
 - c) Select Transfer Mode to view the keyframes for the channel.

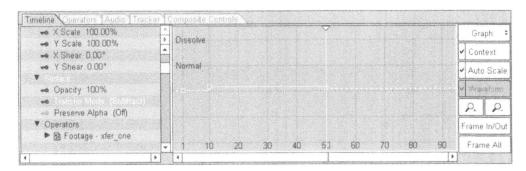

The Transfer Mode channel contains three keyframes: a keyframe at frame 1 for the Normal transfer mode, a keyframe at frame 10 for the Overlay transfer mode, and a keyframe at frame 50 for the Subtract transfer mode.

Hint: Change transfer modes by scrubbing the Transfer Mode channel in the Timeline.

- 8. Play the clip (SPACEBAR).
- 9. (Optional) Save the workspace:
 - a) Choose File | Save Workspace (CTRL+S / 策+S) to open the Save Workspace dialog.
 - b) Set a filename and directory for the workspace, and then click OK (ENTER / RETURN).
- **10.** Choose File Close Workspace (**CTRL+W** / **%+W**) to close the workspace.

erressa udju Ali Šepratijum i militini militini programa pr

പൂട് പെട്ടിയുന്നു

The state of the s

Displacing a Layer Lesson 23

In this lesson, displace a layer to simulate a flag flapping in the wind.

Overview

You can distort a layer by displacing its pixels along the X and Y axes. This changes the appearance of a layer, making some parts of it seem closer to the camera than others. The displacement of each pixel is determined by the color value of the corresponding pixel in the displacement source, which can be another image.

In this lesson:

- Create a displacement source to the composite by adding a solid layer with a Fractal Noise operator.
- Use the luminance channel of the displacement source to apply a Displace operator to the layer you are modifying.
- Add a Bump Map operator to emphasize the 3D effect.
- Animate the Fractal Noise operator to make the layer appear to flap.

Open the 23_DisplacingALayer.mov file in the 23_DisplacingALayer folder and preview the result.

Need Help?

If you need help completing this lesson, save and close your workspace, and then open the 23_DisplacingALayer.cws file as a reference.

Create a Composite Branch

Create a composite branch and import the flag image.

- 1. Check the Combustion preferences. For instructions, see "Setting the Preferences" on page 3.
- 2. Choose File New, or press CTRL+N (Windows) or %+N (Macintosh), to create a branch with the following properties:
 - Type: Composite
 - Name: DisplacingALayer
 - · Format: NTSC D1
 - Duration: 30 frames
 - Bit Depth: 8 Bit
 - · Mode: 3D
- 3. Choose File | Import Footage (CTRL+1 / \mathbb{H} +1) and import Flag.png from the 23_DisplacingALayer folder.

- 4. Select the single-viewport layout.
 - 5. Choose Window | Fit in Window, or right-click / CONTROL-click the viewport and choose Fit in Window.

Create the Displacement Source

Create a new layer to be the displacement source, and then apply a Fractal Noise operator to it.

- 1. Choose Object | New Layer, or press CTRL+Y / ૠ+Y to open the New dialog.
- 2. Set the following properties for the new layer:
 - · Type: Solid
 - Name: Displacement Source
 - Format: NTSC D1
 - Bit Depth: 8 Bit
 - · Background Color: white
 - Transparent: Disabled

Hint: The layer's duration will default to the length of the composite.

Because the solid layer will only be used as a source for the Displace operator, it does not matter how big you make it—the source is scaled to fit the layer to which the Displace operator is added. However, by setting it at the same size as the composite, you get a better idea of the effect the displacement source will have on the displaced layer.

- 3. In the Workspace panel (F3), rename the new layer "Displacement Source".
- 4. Add a Fractal Noise operator to the Displacement Source layer:
 - a) In the Operators panel (F5), select the Noise category.

b) CTRL-click/ \ -click Fractal Noise.

5. In the Fractal Noise Controls panel, set Amount to 100% and Horizontal Scale to 20%.

The lower you set Horizontal Scale, the more ripples in the displacement source. View the ripple effect in the viewport, or the Preview window on the controls panel.

6. In the Workspace panel, turn off the Displacement Source layer by clicking its icon.

You no longer need to see this layer because it is only used as the displacement source.

Note: Be sure to leave the layer's operator on.

Add a Displace Operator

Add a Displace operator to the Flag layer and then select the displacement source.

- 1. In the Workspace panel, select the Flag layer.
- Choose Operators | Distort | Displace, or open the Operators panel (F5), select Distort, and then CTRL-click / 98-click Displace.
- **3.** Set the displacement source:
 - a) In the Displace Controls panel (F8), click the Layer button to open the Layer dialog.

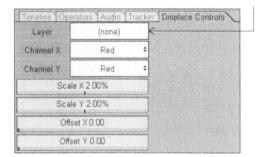

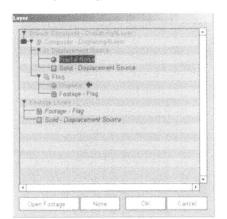

b) In the Layer dialog, select the Fractal Noise operator and click OK (ENTER / RETURN).

Hint: You can also displace a layer with its own Footage operator, or any other operator belonging to it.

c) Select Luminance from the Channel X and Channel Y lists.

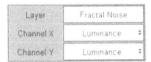

The Flag layer is displaced based on the luminance channel of the Fractal Noise operator. Flag pixels that correspond to lighter pixels in the Displacement Source layer look as though they are closer to the camera. Part of the displaced flag is cut off because the displaced pixels exceed the boundaries of the footage settings for the Flag layer.

Note: Because the displacement source is a grayscale image in this case, using the Luminance channel has the same effect as using the Red channel.

- 4. Enlarge the Flag footage by adjusting its cropping settings:
 - a) In the Workspace panel, select the Footage operator in the Flag layer.
 - **b)** In the Footage Controls panel (**F8**), click Output.
 - c) Set the Top, Left, Right, and Bottom Cropping fields to -25.

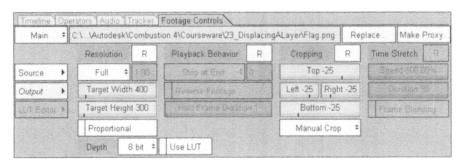

Now you can see the entire flag.

Animate the Displacement Source

Although the flag looks rippled, it remains motionless throughout the clip. First add a Bump Map to enhance the flag's 3D look. Next, animate the Fractal Noise operator to make the flag flap.

- 1. In the Workspace panel, select the Flag layer.
- 2. In the Operators panel (F5), select the Stylize category and then CTRL-click/ % -click Bump Map.

 Like Displacement, the bump map effect is generated using an image channel of a source.
- **3.** Set the source for the Bump Map operator:
 - a) Click the Layer button to open the Layer dialog.
 - **b)** Select the Fractal Noise operator and click OK (**ENTER** / **RETURN**).

Using the same source for both the Bump Map and the Displace operators emphasizes the displacement.

4. Adjust the Bump Map settings:

a) Set Height to 20% to shade the flag based on the Luminance channel of the displacement source.

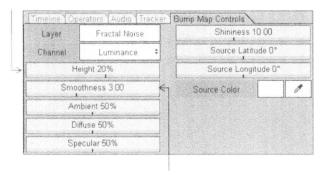

- b) Set Smoothness to 3 to eliminate the relief artifacts.
- c) Set Ambient, Diffuse, and Specular to 30% to darken the flag.
- **d)** Set Shininess to 7 to give the flag a nylon-like sheen.
- **5.** Animate the Fractal Noise operator to simulate the flag flapping in the wind:
 - a) In the Workspace panel, select the Fractal Noise operator.

Hint: The Fractal Noise operator appears in italics in the Workspace panel because it is used as the source of another operator.

- b) Enable Animate (A) to enable automatic keyframing.
- c) Go to the last frame (END).
- d) In the Fractal Noise Controls panel (F8), set Origin X to 720.

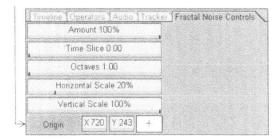

Because the Luminance channel of the Fractal Noise operator is the source for both the Displace and Bump Map operators, both effects are animated.

6. Play the clip (**SPACEBAR**) to view the result.

- 7. (Optional) Save the workspace:
 - a) Choose File | Save Workspace (CTRL+S / 幾+S) to open the Save Workspace dialog.
 - **b)** Set a filename and directory for the workspace, and then click OK (**ENTER** / **RETURN**).
- 8. Choose File | Close Workspace (CTRL+W / ૠ+W) to close the workspace.

Using Channels, Mattes, and Masks Part V

24	Using Alpha Channels	283
25	Creating Channel Effects	295
26	Using Masks	309

ales Maro, coasta labras d'alei de la U

Using Alpha Channels

Lesson 24

In this lesson, use alpha channels to define which parts of footage are visible through the use of mattes and stencils.

Overview

An alpha channel is a grayscale version of an image that defines its transparency. This channel allows you to see the layers behind a particular layer in a composite. You can apply an alpha channel to a layer in four ways: by using the Set Matte operator, by creating a Stencil Layer, by preserving the alpha channel for the layer or by using masks.

In this lesson:

- Create a matte for a layer using the alpha channel of an image.
- Animate a matte's position and texture.
- Create a matte using a stencil layer.
- · Animate a layer with a custom wipe.

Open the 24_UsingAlphaChannels.mov file in the 24_UsingAlphaChannels folder and preview the result.

Need Help?

If you need help completing this lesson, save and close your workspace, and then open the 24_UsingAlphaChannels.cws file as a reference.

Create a Composite Branch

Create a composite branch and import the images.

- 1. Check the Combustion preferences. For instructions, see "Setting the Preferences" on page 3.
- 2. Choose File New, or press CTRL+N (Windows) or \$\mathbb{H}\$+N (Macintosh), to create a branch with the following properties:
 - Type: Composite
 - · Name: UsingAlphaChannels
 - Format: NTSC D1
 - · Duration: 60 frames
 - Bit Depth: 8 Bit
 - · Mode: 3D

- **3.** Select the single-viewport layout.
 - 4. In the Workspace panel (F3), right-click / CONTROL-click the UsingAlphaChannels composite and choose Import Footage (or press CTRL+I / ૠ+I).
 - 5. In the Import Footage dialog, locate and open the 24_UsingAlphaChannels folder.

- 6. Import the footage:
 - a) Double-click the Birds folder and click the birds[###].png image sequence.
 - b) Double-click the *Parent* folder, CTRL-click / % -click Forecast.png, Gradient.png, and Sunset.png (in this order), and then click OK (ENTER / RETURN) to import the queued images into the composite.
- 7. In the Workspace panel (F3), right-click / CONTROL-click the birds0000 layer and name it "Birds."
- 8. Choose Window | Fit in Window, or right-click / CONTROL-click the viewport and choose Fit in Window.

Create a Matte

Add a Set Matte operator to the Sunset layer, then use an image you import as the matte for the layer.

- 1. Add a Set Matte operator to the Sunset layer:
 - a) In the Workspace Panel (F3), select the Sunset layer.
 - b) In the Operators panel (F5), select the Channel category.

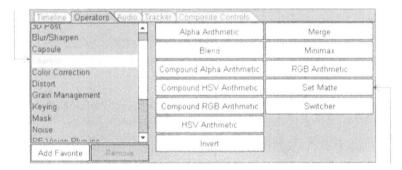

c) CTRL-click/ 98-click Set Matte.

In the viewport, the sunset image remains the same. You need to select the matte's source footage to see it applied to the image.

- 2. Select the source footage for the matte:
 - a) In the Set Matte Controls panel (F8), click the Layer button.

The Layer dialog is normally used to select the matte's source footage from the workspace. However, this dialog can also be used to import footage into the workspace to be used as the source of the matte.

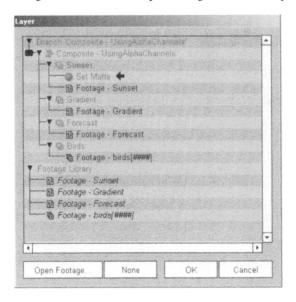

- b) In the Layer dialog, click Open Footage.
- c) In the Import Footage dialog, locate the 24_UsingAlphaChannels folder.
- d) Select the TV_Logo.png and click OK (ENTER / RETURN).

TV_Logo.png image is used as the matte for the Sunset layer. By default, the Luminance channel from the TV logo image is applied to the Sunset, causing the Sunset to fade around the logo.

3. In the Set Matte Controls panel, select Alpha from the Input channel list.

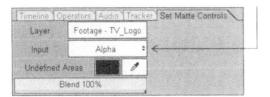

The alpha channel of the TV logo image is used to make the logo area of the Sunset layer transparent so you can see the gradient.

Note: The Set Matte operator is a simplified version of the Compound Alpha Arithmetic operator, also found in the Channel menu. If you need more control over the matte source, use the Compound Alpha Arithmetic operator.

4. Expand the Workspace (**SHIFT+F10**).

5. Expand the Footage Library.

The Footage Library contains the *TV_Logo* footage. An advantage of using Set Matte is that the matte's source does not have to be a layer in the composite.

Note: The Set Matte operator also creates an "embedded" alpha on the image, the alpha layer cannot be moved independently from the footage layer, and vice versa. To move the alpha and the footage separately, use the Stencil layer option.

6. Play the clip (**SPACEBAR**).

The *TV_Logo* footage only plays for half the clip. This is because the Default Still Duration is set to 30 in the Preferences dialog.

- **7.** Extend the *TV_Logo* footage to 60 frames.
 - a) In the Footage Library, select the TV_Logo footage.
 - **b)** In the Footage Controls panel (**F8**), click Source.

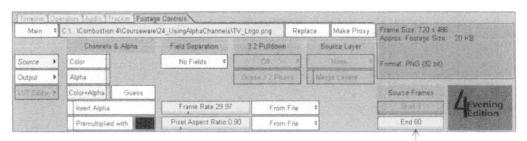

c) Set the Source Frames End to 60.

Animate the Matte

Animate the Sunset layer's position to see how it affects the matte.

- 1. Go to frame 1 (HOME).
- 2. Enable Animate (A).
- 3. Position the Sunset layer at the beginning of the clip:
 - a) In the Workspace panel, select the Sunset layer.
 - b) In the Composite Controls panel (F8), click Transform.
 - c) Enable Proportional and set the any of the Scale fields to 110%.
 - d) Set the X Position to -30.
- **4.** Position the Sunset layer at the end of the clip:
 - a) Go to the last frame (END).
 - b) Set X Position to 30.
- 5. Play the clip (SPACEBAR).

Since the source of the Set Matte operator is not a layer, the TV logo image moves with its target layer throughout the clip. Later, you create an effect using a stencil layer which moves independently of the target layer.

Animate the Gradient Layer

Change the Gradient layer's position to animate the texture of the matte.

- 1. Position the Gradient layer at the end of the clip:
 - a) Go to the last frame (END).
 - **b)** In the Workspace panel, select the Gradient layer.
 - c) In the Transform controls, set the Y Position to 120.
- 2. Disable Animate (A).
- 3. Play the clip (SPACEBAR).

Create a Stencil Layer

A stencil layer can be used as a matte for another layer. Create a stencil layer by applying the alpha channel of the Birds layer as a matte for the Sunset and Gradient layers.

- 1. Go to the first frame (HOME).
- 2. Set the Birds as the stencil layer for the Sunset and Gradient layers:
 - a) In the Workspace panel, select the Sunset layer.
 - b) In the Composite Controls panel, click Surface to view the Surface controls.
 - c) In the Stencil Layer list, select Birds.

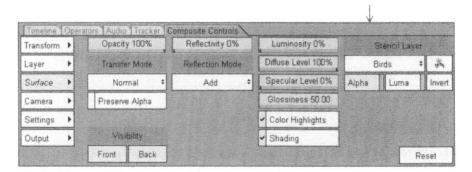

Notice the Birds layer in the Workspace panel is automatically turned off.

- d) In the Workspace panel, select the Gradient layer.
- e) In the Stencil Layer list, select Birds.

The Sunset and Gradient layers appear only in the birds pattern. While the result is similar to the TV logo in the Set Matter operator, the stencil layer can move independently of its target layer because it is a separate layer.

Note: You can only use one layer as the stencil layer. To create a stencil layer from several layers, use Preserve Alpha. You can also create a separate composite in the workspace and nest it as a layer. Also, several layers that have Stencil layers can be nested and the nested layers can be used as a stencil layer on another layer in the composite.

- 3. View the Layer controls for the Birds layer:
 - a) In the Workspace panel, select the Birds layer.
 - b) In the Composite Controls panel, click Layer.

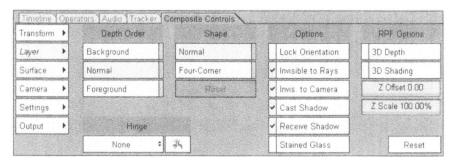

Notice that both the Invisible to Rays and Invisible to Camera options are enabled. The stencil layer uses the alpha channel of the Birds layer and ignores the color channels.

Note: In 2D compositing, these options do not apply, although the visibility of the stencil layer is still turned off.

4. Play the clip (SPACEBAR).

The birds footage has a duration of 20 frames. The footage needs to be looped to cover the 60- frame composite.

5. Extend the birds footage:

a) In the Workspace panel, expand the Birds layer and select the birds[###] Footage.

b) In the Footage Controls panel (F8), select Output.

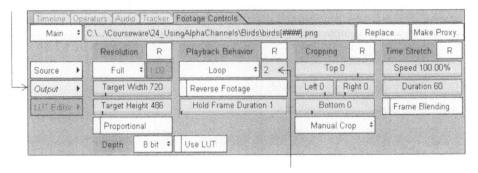

- c) From the Playback Behavior list, select Loop and enter a value of 2 for the 20-frame image sequence.
- **6.** Play the clip (**SPACEBAR**).

The 20-frame birds footage plays once, and then loops 2 times to match the length of the 60-frame composite.

Animate the Birds Layer

Animate the scale of the Birds layer to create a custom wipe.

- 1. Go to the first frame (HOME).
- 2. Enable Animate (A).
- **3.** Scale the Birds layer at the beginning of the clip:
 - a) In the Workspace panel, select the Birds layer.
 - b) In the Composite Controls panel, click Transform.
 - c) With Proportional enabled, set any of the Scale fields to 1000%.
 - d) Set the X Position to 35 so the first frame does not show the forecast layer.
 - e) Go to the last frame (END).
 - f) Set any of the Scale fields to 10%.
 - g) Disable Animate (A).

- **4.** Adjust the interpolation of the Birds layer scale:
 - a) In the Timeline (F4), click Graph and Frame All.

The Graph mode shows the value of a category's channel over time and Frame All displays the entire selected curve in the graph area of the Timeline.

b) Click the X Scale and CTRL-click / % -click Y Scale to select both channels.

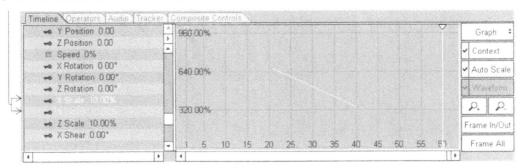

c) Right-click / CONTROL-click the last keyframe and choose Ease In to quickly smooth the animation.

Note: You can also manually drag the tangent handles to change the shape of the curve.

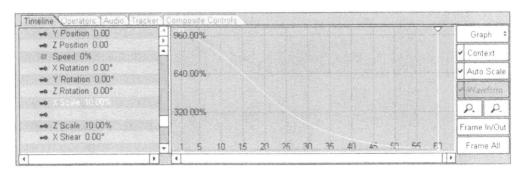

- **5.** Play the result (**SPACEBAR**).
- **6.** (Optional) Save the workspace:
 - a) Choose File | Save Workspace (CTRL+S / 38+S) to open the Save Workspace dialog.
 - b) Set a filename and directory for the workspace, and then click OK (ENTER / RETURN).
- 7. Choose File | Close Workspace (CTRL+W / ૠ+W) to close the workspace.

ring of the second of the BA

the state of the s

Creating Channel Effects

Lesson 25

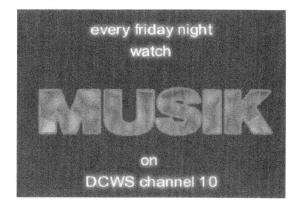

In this lesson, use channel effects to change the color and alpha channels in an image or a clip.

Overview

In this lesson, create a TV Promo by using various Channel effects and by merging Alpha and Color channels with specific mathematical operations.

In this lesson:

- Add a Compound Alpha Arithmetic operator to merge the luminance values of one layer to another layer.
- Add a Compound RGB Arithmetic operator to a layer to change the color channel inputs using another operator as a source.
- Add a Turbulence operator to create an animated liquid texture within the "Musik" word.
- Add a Blend operator to cross fade one source with another.

Open the 25_CreatingChannelEffects.mov file in the 25_CreatingChannelEffects folder and preview the result.

Need Help?

If you need help completing this lesson, save and close your workspace, and then open the 25_CreatingChannelEffects.cws file as a reference.

Open a Workspace

Open the 25_CreatingChannelEffects_start.cws file and set up the Schematic view preferences for the lesson.

- 1. Check the Combustion preferences. For instructions, see "Setting the Preferences" on page 3.
- Choose File | Open Workspace, or press CTRL+SHIFT+O (Windows) or %+SHIFT+O (Macintosh) to access the Open Workspace dialog.
- **3.** Locate and open the 25_CreatingChannelEffects folder, then double-click the 25_CreatingChannelEffects_start.cws.
- 4. Select the single-viewport layout.
 - 5. Play the clip (SPACEBAR).
- **6.** Select the two-viewport layout.
 - 7. Show the Schematic view by selecting one of the following options:
 - Press F12 or ~.
- Click the Schematic view button.
 - Choose Window | Schematic.
 - Right-click / CONTROL-click the viewport and choose Schematic.

The Schematic view displays nodes and edges. The nodes represent the layers and operators in the workspace, and the edges indicate the flow of image data between them. The output of one node is the source of the next node.

8. Choose Window | Fit in Window, or right-click / CONTROL-click and choose Fit in Window.

The process tree includes the CreatingChannelEffects composite operator node with all its layer nodes, Footage operator nodes, and its Paint operator node. Notice there is a Footage operator node that is not connected to the composite operator node. This orphan node is used later on in the lesson.

Add a Compound Alpha Arithmetic Operator

Begin building your composite by adding a Compound Alpha Arithmetic operator to the Paint Background layer.

- 1. Go to frame 1 (HOME).
- 2. In the Workspace panel (F3), select the Paint Background layer.
- **3.** In the Operators panel (**F5**), click the Channel category.

- 4. CTRL-click / ૠ-click Compound Alpha Arithmetic.
- 5. Press L to arrange the nodes.
- Choose Window | Fit in Window, or right-click / CONTROL-click the Schematic view and choose Fit in Window.

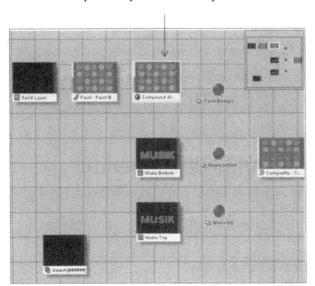

Notice the Compound Alpha Arithmetic operator node is added to the Paint Background layer node.

- 7. In the Workspace panel, select the Compound Alpha Arithmetic operator.
- **8.** Set the Paint Background layer to use the Luminance channel associated with the *blob[####].png* image sequence:
 - a) In the Compound Alpha Arithmetic Controls panel (F8), click the Layer button (None) to access the Layer dialog.

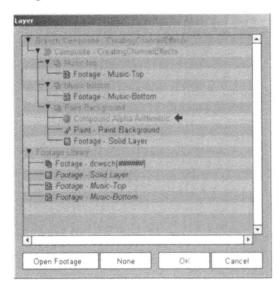

- b) In the Layer dialog, click Open Footage.
- c) In the Import Footage dialog, locate and open the 25_CreatingChannelEffects folder.
- **d)** Double-click the *Blob* folder, then double-click the *blob*[###].png image sequence.
- e) In the Image Sequence Detected dialog, click Load Image Sequence and then click OK (ENTER / RETURN).

Notice the blob Footage operator node is connected to the secondary input of the Compound Alpha Arithmetic Operator. The blob footage is used as a matte for the Paint Background layer node.

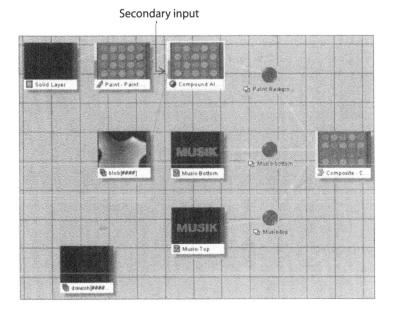

f) In the Compound Alpha Arithmetic Controls panel, from the Operator list, select Hard Light.

25 Creating Channel Effects

- g) From the Input list, select Luminance.
 - Luminance is chosen because the *blob[####].png* image sequence has no alpha channel.
- h) Change the Blend value to 88%.

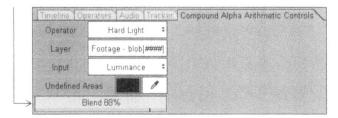

The luminance of the blob footage affects the Paint Background layer's visibility and creates an effect similar to stencilling a Matte.

9. Preview the Compound Alpha Arithmetic operator node:

Home

a) Scrub the Home button or use your mouse scroll wheel to zoom in (CTRL+= / 第+=) on the Compound Alpha Arithmetic operator node.

Pan

- **b)** Pan the viewport by scrubbing the Pan button or by holding down the **SPACEBAR** while dragging in the viewport.
- c) Scrub in the upper third of the node to view the clip.

Clip scrub indicator

The luminance of the blob image sequence masks part of the Paint background.

Hint: To preview all the nodes, click the Play button in the Playback controls or press the **SPACEBAR**.

- 10. Preview the result:
 - a) Click the right viewport or press [to cycle to the next viewport.
 - **b)** Play the clip (**SPACEBAR**).

Add a Compound RGB Arithmetic Operator

Add a Compound RGB Arithmetic operator to the Music-top layer node to change the color channel inputs using another operator as a source.

- 1. Go to frame 1 (HOME).
- 2. Right-click / CONTROL-click the Schematic view and choose Fit in Window.
- **3.** Right-click / **CONTROL**-click the Music-Top Footage operator node and choose Add Operator | Channel | Compound RGB Arithmetic.
- 4. Press L to rearrange the nodes.
- 5. Click the output connection point of the Paint Background Paint operator node.

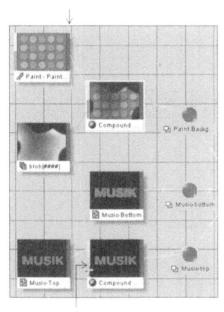

Secondary input connection point

6. Drag an edge to the secondary input connection point of the Compound RGB Arithmetic operator node and choose R Layer as the input.

The Paint Background Paint operator node is now used as the input for the red channel.

- 7. In the Workspace panel, select the Compound RGB Arithmetic operator.
- 8. In the Compound RGB Arithmetic Controls panel (F8), from the R Operator list, select Hard Light.

The Paint Background layer is revealed in the red channel of the Musik-top layer based on the luminance of the Paint operator.

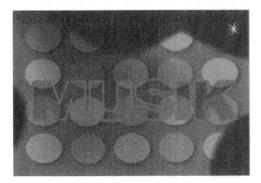

9. Click the right viewport ([) and play the clip (**SPACEBAR**) to preview the result.

Add a Turbulence Operator

Create an animated liquid texture within the "Musik" word. Add a Turbulence operator and apply it to the Blue and green channels of the Compound RGB operator. Since you only want the effect of the Turbulence operator applied to the Green and Blue channels of the word "Musik", create a new layer for the operator so the operator it is not attached to the composite.

- 1. Go to frame 1 (HOME).
- 2. Choose File | New (CTRL+N / ૠ+N).
- 3. Create a Solid layer with the following properties:
 - Type: Solid
 - · Name: Turbulence
 - · Format: NTSC D1
 - Duration: 30
 - Bit Depth: 8 Bit

A Turbulence Solid layer node is added to the workspace but is not connected to any of the nodes.

- **4.** Right-click / **CONTROL**-click the Schematic view and choose Fit in Window.
- 5. Press L to rearrange the nodes.
- 6. Right-click / CONTROL-click the Turbulence Solid layer node and choose Add Operator | Noise | Turbulence.

7. Double-click the Turbulence operator node to access the Turbulence Controls panel (F8).

8. In the Turbulence Controls panel, set Amount to 100%, Horizontal Scale to 6%, and Vertical Scale to 10%.

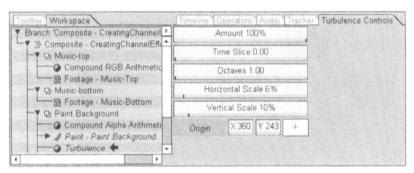

- 9. Animate the Turbulence operator:
 - a) Enable Animate (A).
 - b) Go to the last frame (END).
 - c) In the Turbulence Controls panel, set Time Slice to 3.0.
 - d) Disable Animate (A).
- **10.** Play the clip (**SPACEBAR**) and preview the result in the Schematic view.

The clip plays slowly at first while each frame is rendered to RAM, then plays back full speed.

- **11.** Connect the Turbulence operator node to the Green and Blue channels of the Compound RGB Arithmetic operator node:
 - a) Click the output connection point of the Turbulence operator node.
 - **b)** Drag an edge to the secondary input connection point of the Compound RGB Arithmetic operator node and choose G Layer as the input.

The following image shows the result.

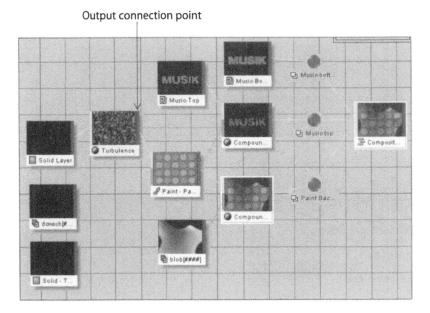

- c) Repeat steps a and b and choose B Layer as the input.
- **d)** Double-click the Compound RGB Arithmetic operator node.

e) In the Compound RGB Arithmetic Controls panel, change the G and B Operator transfer modes to Add, and the G and B Input channels to Luminance (if not already selected).

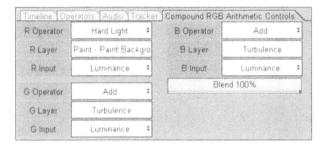

The turbulence is only shown within the Green and Blue channels of the Compound RGB Arithmetic operator.

12. Click the right viewport ([) and play the clip (SPACEBAR) to preview the result.

Changing the Transfer mode to Add combined the luminance of Green and Blue channels to create a white turbulence effect.

Add a Blend Operator

To add the TV text that appears at the end of the original piece and blend it with the composite, we need a Blend Operator.

- 1. Go to frame 1 (HOME).
- 2. In the Schematic view, select the edge connecting the Compound Alpha Arithmetic operator node and the Paint Background layer node.

- 3. Right-click / CONTROL-click the edge and choose Add Operator | Channel | Blend.
- **4.** Double-click the Blend operator node.
- 5. In the Blend Controls panel, click the Layer button to access the Layer dialog.
- Select the dcwsch[######] Footage operator in the Footage Library and click OK (ENTER / RETURN).

The Schematic view shows the dcwsch[#####] Footage operator node connected to the Blend operator node.

Note: You could have also connected the orphan dcwsch[#####] Footage operator node to the Blend operator node via the Schematic view.

- 7. From the Method list, select Crossfade.
- **8.** Animate the Blend operator:
 - a) Enable Animate (A) and go to frame 10.
 - **b)** In the Blend Controls panel, set Amount to 10%.
 - c) Go to the last frame (END) and set Amount to 100%.
 - d) Disable Animate (A).
- **9.** Click the right viewport ([) and play the clip (**SPACEBAR**).

As the clip plays, the dcwsch footage blends and fades over time.

- **10.** (Optional) Save the workspace:
 - a) Choose File | Save Workspace (CTRL+S / Se+S) to open the Save Workspace dialog.
 - **b)** Set a filename and directory for the workspace, and then click OK (${\sf ENTER}$ / ${\sf RETURN}$).
- 11. Choose File | Close Workspace (CTRL+W / ૠ+W) to close the workspace.

and some fire and the second of the con-

a finds of the control of the control of the section of the control of the contro

Using Masks Lesson 26

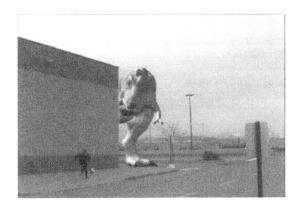

In this lesson, create a mask to make a dinosaur appear from behind a building.

Overview

Used as an effect operator or as part of a Paint operator, masks are valuable for hiding parts of an image and for rotoscoping purposes. The advanced features of the vector-based masks allow greater control over mask feathering and animation. In this lesson, import two image sequences and add a mask to reveal different areas in the clip.

Note: Masks are compatible with other Autodesk products such as Discreet® Inferno®, Discreet Flame®, and Discreet Flint®, enabling a parallel creative workflow.

In this lesson:

- · Make a copy of the background clip.
- Create a mask to hide part of the scene.
- Track the mask's control points to follow the camera movement.
- · Refine the mask.
- Control the visibility of the mask's control points on a range of frames.

Open the 26_UsingMasks.mov file in the 26_UsingMasks folder and preview the result.

Need Help?

If you need help completing this lesson, save and close your workspace, and then open the 26_UsingMasks.cws file as a reference.

Create a Composite

Create a composite branch and import footage for the composite.

- 1. Check the Combustion preferences. For instructions, see "Setting the Preferences" on page 3.
- 2. Choose File | New or press CTRL+N (Windows) or ૠ+N (Macintosh) to open the New dialog and create a branch with the following properties:
 - Type: Composite
 - · Name: UsingMasks
 - Format: NTSC DV
 - · Duration: 60 frames
 - · Bit Depth: 8 Bit
 - · Mode: 2D
- **3.** Select the single-viewport layout.

- 4. In the Workspace panel (F3), right-click / CONTROL-click the UsingMasks composite and choose Import Footage, (or press CTRL+1 / 元 +1) to access the Import Footage dialog.
- 5. In the Import Footage dialog, locate and open the 26_UsingMasks folder.
- 6. Import the footage:
 - a) Double-click the *Building* folder and click the *trus[###].png* image sequence.
 - **b)** Double-click the *Parent* folder, double-click the *Dino* folder, and double-click the *dino*[####].png image sequence.
- 7. Play the clip (SPACEBAR).

Note: If you do not have enough RAM to view the clip in real time, select Medium or Draft from the Display Quality list to the right of the playback controls. This lowers the file resolution in the viewport and allows you to cache more frames.

Make Dino Appear from Behind the Building

To make the dinosaur appear from behind the building, make a copy of the *trus*[###].*png* image sequence then mask part of the copy to hide an area of the footage. First, rename the layers and position the dinosaur.

- 1. Rename the layers in the Workspace panel:
 - a) In the Workspace panel (F3), right-click / CONTROL-click the dino0034 layer and choose Rename.
 - b) Enter "Dino" and press ENTER / RETURN.
 - c) Right-click / CONTROL-click the trus0035 layer and choose Rename.
 - d) Enter "Building Background" and press ENTER / RETURN.
- **2.** Position the Dino layer for the animation:
 - a) Go to the first frame (HOME).
 - b) In the Workspace panel, select the Dino layer.
 - c) In the Composite Controls panel, click Transform.
 - d) Set the X Position to -100.
 - e) Set the Y Position to -35.
- 3. Create a copy of the Building Background layer:
 - a) In the Workspace panel, select the Building Background layer.
 - b) Choose Edit | Copy (CTRL+C/ \mathbb{H}+C).

c) Choose Edit | Paste (CTRL+V/ 98+V).

The dinosaur is no longer visible in the viewport because the copy of the Building Background layer—Building Background(2) layer— is the top layer in the composite.

4. Rename the Building Background(2) layer "Building Foreground".

Since the Building Foreground layer and the Building Background layer use the same footage, you can delete one of the Footage operator via the Schematic view to maximize workflow efficiency.

5. Delete the copy of the trus[####].png footage operator node and connect the Building Foreground layer node to the trus[####] footage operator node via the Schematic view:

B04-10

a) Choose Window | Schematic or click the Schematic View button to display the Schematic view.

Hint: You can also press either F12 or ~ to show the Schematic view.

- b) Click the trus[###](2) footage operator node and press DELETE / DEL.
- c) Click the output connection point of the *trus[####].png* footage operator node, drag the edge to the Building Foreground layer node.

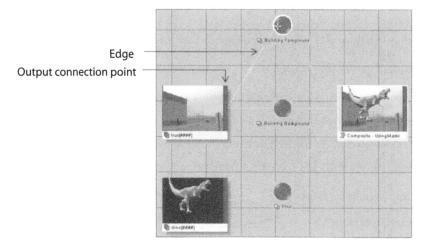

d) Release.

The Building Background and the Building Foreground layer nodes uses the same footage operator node.

Hint: To rearrange all the nodes, right-click any node and choose Layout (L), or click any node and press L.

- **6.** Set the viewport layout:
 - a) Choose Window | Schematic (**F12** or ~) to return to the viewport display.
- **b)** Select the two-viewport layout.

To see the effect of the mask in relation to the entire composite, you need to display two viewports.

- 7. Add a mask object to the Building Foreground layer to hide part of the background:
 - a) In the Workspace panel, select the Building Foreground layer.
 - b) In the Operators panel (F5), select the Mask category to access the mask operators.

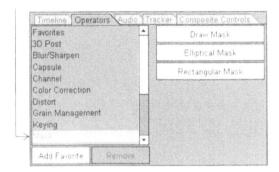

- c) CTRL-click / %-click Draw Mask.
- **8.** In the Workspace panel, double-click the Draw Mask operator to view the output of the mask in the active viewport.

In the Workspace panel, the viewport icon is next to the Draw Mask operator, indicating the Draw Mask operator is the current operator.

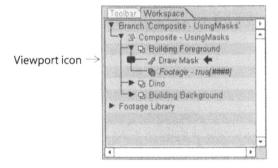

The active viewport switches to display the output of the current operator. The right viewport displays the result composite.

- **9.** In the Toolbar, click the Bezier Mask tool (**P**).
- 10. Draw a mask in the left viewport to hide the building, the sidewalk, and the road next to the sidewalk:
 - a) Start the mask by clicking the upper left area near the building's roof, outside the left border of the frame.
 - b) Click the upper right edge of the roof to add a second control point.

Note: You can reposition a control point at any time by dragging the control point with the cursor.

c) Click the lower right edge of the building to add a third control point.

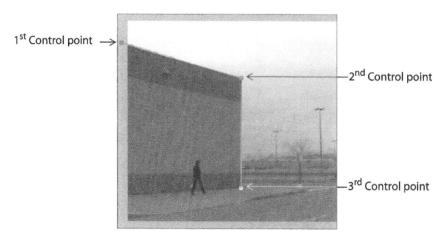

- d) Follow the sidewalk to the right and click outside the right border of the frame.
- e) Click outside the lower right border of the frame.
- f) Click outside the lower left border of the frame.

g) Close the mask by pressing Enter / Return after adding the last control point, or by clicking the first control point when the cursor changes to -io.

In the right viewport, the mask reveals the dinosaur.

Hint: Choose Window | Outlines Only, or right-click / CONTROL-click the left viewport and choose Outlines Only to display only the wireframe of the polygon mask.

Note: If necessary, adjust the mask by dragging the control points.

- 11. Feather the edges of the mask:
 - a) In the Mask Controls panel (F8), click Modes to access the mask Modes controls.
 - b) Set Feather to 2.

The feathering option softens the edge of the mask.

Hint: You can also feather the edges of the mask using the Edge Gradient option. The Edge Gradient option enables you to set independent edge gradients for each control point of the mask. Offset scales the overall shape of the mask to set its inner or outer boundaries. The Edge Gradient In/Out option softens the mask from the inside/outside.

- **12.** Preview the result in the right viewport:
 - a) Click the right viewport ([).
 - **b)** Play the clip (**SPACEBAR**).

Notice the little glitch between the mask and the right edge of the building. This is because there is a slight camera movement in the clip and the mask is stationary. You need to make the mask follow the edge of the building throughout the clip.

Track the Mask

Track the mask so it follows the camera movement throughout the clip. Select two control points of the polygon mask to track.

- 1. Go to the first frame (HOME).
- 2. Click the left viewport to make it active (or press [).
- **3.** In the Workspace panel, select the Polygon Mask (+) object.

4. In the left viewport, drag a selection box to select the two control points at the right edge of the building.

5. Show the Tracker panel (**F7**).

The Tracker is context sensitive. Because two control points are selected, the Tracker is set to track two control points.

6. In the Tracker panel, click Position to activate the Tracker for two control points.

7. Select All Trackers.

The Trackers appear in the left viewport. Usually, you position the Tracker over a reference area that is easy to track. However, since the Trackers are already positioned on the upper and lower corners of the building, over reference areas that are easy to track, all you need to do is analyze the clip.

- **8.** Click the Analyze Forward > button to analyze the clip.
- 9. When the Analysis is completed, click Off to turn the Trackers off.
- 10. Preview the result:
 - a) Click the right viewport ([).
 - b) Play the clip (SPACEBAR).

The mask follows the movement of the camera throughout the clip. However, toward the end of the clip, as the dinosaur comes from behind the building, its right cheek seems to be cut off.

Animate the Shape of the Mask

Adjust the mask to follow the contour of the dinosaur's cheek as the dinosaur comes from behind the building and turns its head toward a man running for his life. Add three control points to the mask and make them active over a span of four frames and inactive for the rest of the animation using the Active control point option.

- **Q** 1. In the Toolbar (**F2**), click the Magnify tool (or press **Z**) and scrub the right viewport to zoom in on the dinosaur's head.
 - 2. Scrub the animation slider bar between frames 55 and 58.
 - 3. Go to frame 55.
 - 4. Click the mask in the left viewport.

A bounding box appears around the mask in the viewport.

5. Zoom in on the mask.

6. In the Toolbar, click the Edit Control Points tool (**TAB**).

Hint: Press TAB to cycle through the Arrow tool options: the Edit Control Points tool, and the Edit Object tool that includes the pivot tool.

- 7. Enable Animate (A).
- 8. Add three control points to the right edge of the building as shown in the following image:
 - a) Position the cursor over the area between two control points. When the cursor changes to -t-, click to add a control point.
 - b) Add two additional control points.

Hint: To delete an unwanted control point, click the control point and press DELETE.

- 9. Adjust the position of the three controls points to follow the contour of the dinosaur's cheek from frame 55 to frame 58:
 - a) At frame 55, drag the control points to the desired position.

Hint: As you adjust the position of the control points in the left viewport, preview your changes in the right viewport.

- **b)** Go to frame 56 and repeat step a).
- c) Repeat step a) at frames 57 and 58.

Hint: Press CTRL / # and drag a control point to access its tangent handles then, drag the tangent handles to create a smooth curve. This changes the linear control point to a Bezier control point.

The mask and its result should look similar to the following image at frame 58.

At this point, the three control points you created are active throughout the animation. However, you only need them between frames 55 and 58.

- 10. Make the three control points active only from frame 55 to frame 58:
 - a) Select all three control points in the left viewport.
 - b) Go to the first frame (HOME).
 - c) In the Toolbar, disable the Active button to make the control points inactive.

- d) The Active button is gray when disabled.
- e) Go to frame 55 and enable the Active button.
- f) Go to frame 59 and disable Active and disable Animate (A).
- g) Scrub the animation slider bar.

Notice the control points are active from frame 55 to frame 58.

- 11. Preview the result:
 - a) Set the right viewport as the active viewport ([) and zoom out.

- b) Select the single-viewport layout.
- c) Go to the first frame (HOME) and play the clip (SPACEBAR).
- **12.** (Optional) Save the workspace:
 - a) Choose File | Save Workspace (CTRL+S / 2+S) to open the Save Workspace dialog.
 - b) Set a filename and directory for the workspace, and then click OK (ENTER / RETURN).
- **13.** Choose File | Close Workspace (CTRL+W / ૠ+W) to close the workspace.

and the second of the second o

Using Null Objects, Lights, and the Camera Part VI

27	Animating with a Null Object	323
28	Moving the Camera	333
29	Creating Shadows with Lights	343

Sind New Chjests, lipinis see den kan eerd

Animating with a Null Object

Lesson 27

In this lesson, make several layers appear to spin by using a null object to control the camera's position.

Overview

You can use a null object to animate other objects in a composite. Although the null object itself is an invisible object with no dimensions, other objects can be linked to it to follow its movement. For example, you can link the camera to a rotating null object to have the camera rotate around the composite.

In this lesson:

- Arrange three layers to intersect in a star formation.
- Add a null object to the composite, and then animate its rotation.
- Animate the camera by parenting it to the rotating null object.
- Apply a Glow operator to the layers to enhance their appearance.

Open the 27_AnimatingWithANullObject.mov file in the 27_AnimatingWithANullObject folder and preview the result.

Need Help?

If you need help completing this lesson, save and close your workspace, and then open the 27_AnimatingWithANullObject.cws file as a reference.

Create a Composite Branch

Create a composite branch and import the image.

- 1. Check the Combustion preferences. For instructions, see "Setting the Preferences" on page 3.
- 2. Choose File | New or press CTRL+N (Windows) or \$\mathbb{H}\$+N (Macintosh) to create a branch with the following properties:
 - Type: Composite
 - Name: BackClip
 - Format: NTSC D1
 - · Duration: 60 frames
 - · Bit Depth: 8 Bit
 - Mode: 3D
- 3. Choose File | Import Footage (CTRL+I / \mathbb{H}+I) and import Market.png from the 27_AnimatingWithANullObject folder.

- 4. Select the single-viewport layout.
 - 5. Choose Window | Fit in Window, or right-click / CONTROL-click the viewport and choose Fit in Window.

Arrange Three Layers to Form a Six-Sided Star

Create two copies of the Market layer and rotate the layers into a star formation.

- 1. In the Workspace panel (F3), select the Market layer.
- 2. Duplicate the Market layer:
 - a) Choose Edit | Duplicate (CTRL+ALT+D / OPTION+ ₩+D).
 - A Market(2) layer is added to the Workspace panel.
 - b) Choose Edit | Duplicate (CTRL+ALT+D / OPTION+ %+D).

A Market(3) layer is added to the Workspace panel. When you duplicate a layer, both layers use the same footage—point to the same footage. When you copy a layer, you also copy the footage.

- 3. Change the transfer mode to enhance the layer's appearance:
 - a) In the Workspace panel, select the Market(3) layer.
 - **b)** In the Composite Controls panel (**F8**), click Surface to view the Surface controls.
 - c) Select Add from the Transfer Mode list.

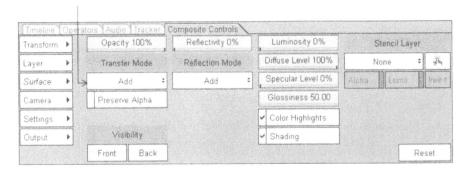

The Add transfer mode adds the color values from the two background layers, brightening the Market(3) layer substantially.

- **4.** Repeat step 3 to apply the Add transfer mode to the Market(2) and Market layers.
- 5. Rotate the Market(2) layer:
 - a) In the Workspace panel, select the Market(2) layer.
 - b) In the Composite Controls panel, click Transform to access the Transform controls.
 - c) Set Y Rotation to 60 degrees to rotate the layer.

6. Rotate the Market(3) layer:

- a) In the Workspace panel, select the Market(3) layer.
- b) In the Transform controls, set Y Rotation to -60 degrees to rotate the layer in the opposite direction.

7. View the layers from above:

- a) With Market(3) still selected, choose Edit | Select All (CTRL+A / 缎+A) to select the other items in the composite.
- **b)** In the Toolbar (**F2**), select Top View from the View list.

You now see the composite from above. Notice that the layers intersect at a 60 degree angle, forming a six-point star.

c) In the Toolbar, select Camera View from the Views list.

Hint: To change the view, you can also right-click / **CONTROL**-click in the viewport and choose a view from the context menu.

Animate a Null Object

Add a null object to the composite and animate its rotation. Then create a spinning text effect by parenting the camera to the null object so that the camera rotates around the three Market layers.

- 1. Go to the first frame (HOME).
- 2. Choose Object | New Null Object to add a null object to the composite.

By default, the null object is added at the origin (0,0,0). This point lies along the intersection line of the three Market layers.

Hint: You can move a null object like any other object by using the Arrow tool or by changing its Transform controls in the Composite Controls panel.

- 3. Enable Animate (A).
- 4. Rotate the null object in the clip:
 - a) In the Workspace panel (F3), select the Null Object.
 - b) Go to the last frame (END).
 - c) In the Transform controls, set Y Rotation to 360 degrees to rotate the null object once in the clip.

- 5. Make the Null Object the parent of the camera:
 - a) In the Composite Controls panel, select Camera from the Current list.

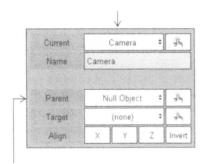

b) Select Null Object from the Parent list.

The camera is linked to the null object using a parent link. In a parent link, animating the parent object animates the child object the same way. In this case, the camera rotates around the layers as it follows the rotation of its parent—the null object.

- 6. Switch to Perspective view to see the result of this link.
 - a) In the Toolbar, select Perspective View from the Views list.

The viewport switches to Perspective view, so you can look at the composite from different viewpoints.

*

- **b)** Scrub the Perspective Zoom tool (**SHIFT+Z**) until you can see the camera in the viewport.
- c) In the Playback controls, scrub the Current Time indicator.

Notice that the camera rotates around the Market layers in the viewport, matching the rotation of the null object.

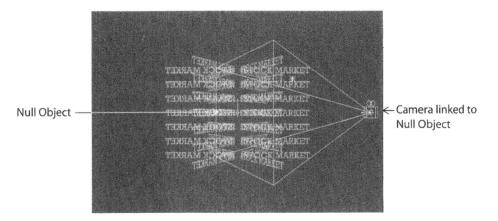

- d) In the Toolbar, select Camera View from the Views list.
- **7.** Loop the clip after the first 10 frames:
 - **a)** Go to (/) frame 10.
 - **b)** Choose Movie | Mark Out Point (**SHIFT+O**).

Hint: You can also drag the Playback out point in the Playback controls to frame 10.

c) Set the play mode to Loop

This 10-frame loop is a realistic simulation of the rotation of the star in the clip. This is because each side is identical and rotates 60 degrees in 10 frames (60 degrees \times 6 sides = 360 degrees).

- d) Go to the first frame (HOME).
- e) Play the clip (SPACEBAR) to view the result.

The spinning effect is created by the rotation of the camera around the stationary Market layers. Although you could spin the three layers in front of a stationary camera, this requires more effort.

Enhance the Clip's Appearance

Add a slight glow to the three Market layers and make the text fill the frame.

- 1. Go to the first frame (HOME).
- 2. Add a glow to the Market layer:
 - a) In the Workspace panel (F3), click in a blank space to deselect the layers and then select the Market layer.
 - b) In the Operators panel (F5), choose Stylize, and CTRL-click / 第-click Glow.
 - c) In the Glow Controls panel (F8), set Radius to 5 and Strength to 1.5.

The text appears to glow.

- **3.** Copy the Glow operator to the Market(2) layer:
 - a) In the Workspace panel, select the Glow operator under Market.
 - b) Choose Edit | Copy (CTRL+C / \mathbb{H}+C) to copy the operator.
 - c) Select the Market(2) layer.
 - d) Choose Edit | Paste (CTRL+V / 幾+V) to paste the Glow operator on the Market(2) layer.

 When you copy the Glow operator, it uses the same settings as the original operator.
- **4.** Repeat step 3 to copy the Glow operator to the Market(3) layer as well.

- **5.** Expand the Back Clip composite to see all layers and operators:
 - a) In the Workspace panel, collapse the Back Clip composite operator by clicking its triangle.
 - b) CTRL-click / 38-click the composite operator triangle to view all its contents.

The Glow operator is applied to all three Market layers.

- 6. Move the camera forward to extend the text to the edges of the frame:
 - a) In the Workspace panel, select the Camera.
 - **b)** In the Transform controls, set Z Position to -640 to move the camera toward the layers.

The text now extends to the edges of the frame.

7. Play the clip (SPACEBAR) to view the result.

Clean up the Workspace

Since all three Market layers use the same Glow operator (with identical settings), you can delete the Glow operator copies via the Schematic view to maximize workflow efficiency.

- 1. Choose Window | Schematic or click the Schematic View button (F12) to show the Schematic view.
- 2. Click the edge connecting the Glow(2) operator node to the Market layer node, drag the edge away from the nodes and release.

The Glow(2) operator node is disconnected from the Market layer node.

3. Click the edge connecting the Glow operator node to the Market layer node and press DELETE / DEL.

The Glow operator node is disconnected from the Market(2) layer node.

Hint: To delete an edge, you can also right-click / click and CONTROL-click an edge and choose Delete.

- **4.** Delete the edge connecting the Market footage operator node to the Glow(2) operator node.
- **5.** Delete the edge connecting the Market footage operator node to the Glow operator node (of the Market(2) layer node).

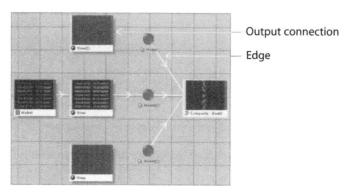

- Click the Market layer node, drag to the Glow output connection and release.The Market layer node is connected to the Glow operator node (containing the Market footage).
- 7. Repeat step 6 for the Market(2) layer node.
- 8. Click the orphan Glow operator nodes and press DELETE.

Before cleanup

End result

- **9.** (Optional) Save the workspace:
 - a) Choose File | Save Workspace (CTRL+S / 38+S) to open the Save Workspace dialog.
 - **b)** Set a filename and directory for the workspace, and then click OK (**ENTER / RETURN**).
- 10. Choose File | Close Workspace (CTRL+W / ૠ+W) to close the workspace.

Moving the Camera Lesson 28

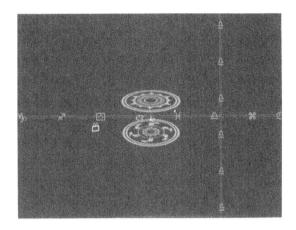

In this lesson, animate the camera to move among layers in 3D space.

Overview

When you work in 3D space, in addition to animating layers and operators, you can also animate the camera motion to make the camera travel among layers and other objects in the scene. You can also create relationships between the camera and the various objects. For example, you can have the camera follow one object while it keeps looking at another.

In this lesson:

- Scale, position, and animate the imported footage.
- Create and position a null object.
- Use the null object as the parent and target for the Camera.
- · Set a layer to always look at the camera.
- Lock a layer so it remains static in the scene as the camera is moves.

Open the 28_MovingTheCamera.mov file in the 28_MovingTheCamera folder and preview the result.

Need Help?

If you need help completing this lesson, save and close your workspace, and then open the 28_MovingTheCamera.cws file as a reference.

Create a Composite

Create a composite branch and import the footage for the composite.

- 1. Check the Combustion preferences. For instructions, see "Setting the Preferences" on page 3.
- 2. Choose File | New or press CTRL+N (Windows) or ℜ+N (Macintosh) to open the New dialog and create a branch with the following properties:
 - Type: Composite
 - · Name: MovingTheCamera
 - · Format: NTSC
 - Duration: 60 frames
 - Bit Depth: 8 Bit
 - · Mode: 3D
 - · Background: Black

 In the Workspace panel (F3), right-click / CONTROL-click the MovingTheCamera composite and choose Import Footage (CTRL+I / %+I).

- **5.** In the Import Footage dialog, locate and open the *28_MovingTheCamera* folder.
- 6. Import the footage as follows:
 - **a)** Double-click the *Bottom* folder and click the *bottom*[####].png image sequence.
 - b) Double-click the *Parent* folder, double-click the *Top* folder, and click the *top[####].png* image sequence.
 - c) Double-click the *Parent* folder, double-click the *Globe* folder, click the *globe*[####].png image sequence, and then click OK (ENTER / RETURN).
- 7. Rename the layers:
 - a) In the Workspace panel (F3), right-click / CONTROL-click the bottom0000 layer, choose Rename and name the layer "Bottom Rings".
 - b) Rename the top0000 layer "Top Rings".
 - c) Rename the globe00001 layer "Globe".
- **8.** Play the animation (SPACEBAR).

Scale, Position, and Animate the Footage

Scale, position, and animate the globe, then scale, position and rotate the rings.

- 1. Go to frame 1 (HOME).
- 2. In the Workspace panel, select the Globe layer.
- **3.** In the Composite Controls panel (**F8**), click Transform.
- 4. Scale and position the Globe layer:
 - a) Enable Proportional.
 - b) Set any of the Scale fields to 80%.
 - c) Set the Y Position to -300.
- 5. Animate the Globe layer:
 - a) Enable Animate (A).
 - b) Go to frame 20.
 - c) Set the Y Position to -90.
 - d) Disable Animate (A).

- **6.** Scale, position and rotate the Top Rings layer:
 - a) In the Workspace panel, select the Top Rings layer.
 - **b)** In the Composite Controls panel, set any of the Scale fields to 180%.
 - c) Set the Y Position to 200.
 - d) Set the X Rotation to 90°.
- 7. Scale, position and rotate the Bottom Rings layer:
 - a) In the Workspace panel, select the Bottom Rings layer.
 - **b)** In the Composite Controls panel, set either of the Scale fields to 180%.
 - c) Set the Y Position to -200.
 - d) Set the X Rotation to 90°.
- **8.** Preview the result:
 - a) Go to frame 1 (HOME).
 - **b)** Play the animation (**SPACEBAR**).

Set the Viewport Layout

Before animating the camera motion, you might find it useful to select the two-viewport layout: one viewport to show the Camera view and the other viewport to show the Perspective view. Camera view shows what the camera person sees on a movie set. Perspective view is what the Director sees (namely everything and everyone).

- 1. Go to frame 1 (HOME).
- 2. Select the two-viewport layout.
 - 3. Enable Feedback.

4. Right-click / **CONTROL**-click the right viewport and choose Perspective.

Perspective view enables you look at the composite from different viewpoints.

5. Examine the composite in Perspective view:

a) In the Toolbar (F2), scrub the Perspective Zoom tool to zoom out until all the layer edges are visible in the viewport.

b) Scrub the Perspective Rotate tool to view the composite from all sides.

Since Feedback is enabled, the objects are redrawn as you scrub with the Perspective tools. When Feedback is disabled, the layer outlines are visible as you scrub, and the objects are redrawn after a move is completed and the selected tool is disabled.

Notice that the right viewport set to Camera view remains static, no matter how much you rotate around the scene in Perspective view. While Perspective view cannot be animated, you can adjust Camera view to match Perspective view by using the camera's Transform controls.

Hint: To reset the zoom (or rotation), double-click the Perspective Zoom (or Perspective Rotate) tool in the Toolbar and click Reset in the dialog.

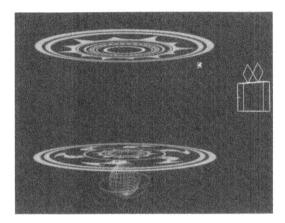

Animate the Camera

Animate the camera so it is positioned above the rings at the beginning of the clip and dives to its default position (X:0, Y:0, Z:-680) at the end of the clip. Create a "target" for the camera to look at. The target can be any object in the scene, such as a layer or a light. It can also be a non-renderable object called a null object. When the camera has a target, you can move the camera around without worrying about its rotation. The camera automatically rotates to keep looking at its target.

28 Moving the Camera

 In the Workspace panel (F3), right-click / CONTROL-click the MovingTheCamera composite and choose New Null Object.

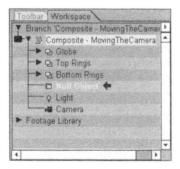

A null object is added at coordinates 0, 0, 0. A null object is an invisible object. It has no pixel information and cannot be rendered.

- 2. Position the Null Object:
 - a) In the Workspace panel, select the Null Object.
 - **b)** In the Composite Controls panel, click Transform.
 - c) Set the Y Position to -50.
- 3. Change the Camera parameters:
 - a) In the Workspace panel, select the Camera.
 - b) In the Composite Controls panel, click Camera.
 - c) In the Stock Lenses group, click 15mm.

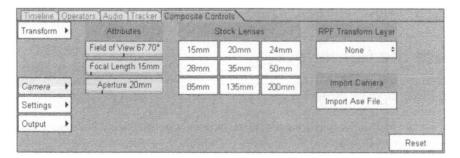

Setting the camera with a wide-angle lens enables you to see more of the scene, albeit with a slight perspective distortion.

- **4.** Use the Null Object as the parent and target for the Camera:
 - a) In the Composite Controls panel, select Null Object from the Parent list.

When layers or objects are parented, changes applied to the parent, such as position and rotation values, are also applied to the child. In this case, the Camera is the child of the Null Object. This enables you to create secondary camera motion by animating the parent object, the Null Object.

b) Select Null Object from the Target list.

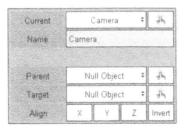

When an object or layer targets another, it rotates so that its Z-axis is always pointed at the pivot point of the other object or layer.

5. Animate the Camera:

Note: Make sure you are still at frame 1.

- a) Enable Animate (A).
- **b)** In the Composite Controls panel, click Transform.
- c) Set the Y Position to 1000 and the Z Position to 0.

Note: If you scrub the Y or Z Position fields, the camera remains focused on the null object.

- d) Go to the last frame (END).
- e) Set the Y Position to 0 and the Z Position to -680.
- f) Go to frame 30.
- g) Set the Y Position to 700 and the Z Position to -650.
- h) Disable Animate (A).
- 6. Preview the result:
 - a) Go to frame 1 (HOME).
- ❖
- **b)** In the Toolbar (**F2**), scrub the Perspective Zoom tool to zoom out until all the layer edges and camera are visible in the viewport.
- @
- c) Scrub the Perspective Rotate tool to view the composite from all sides.

d) Play the clip (SPACEBAR).

Note: If you do not have enough RAM to view the clip in real time, select Medium or Draft from the Display Quality list to the right of the playback controls. This lowers the file resolution in the viewport and allows you to cache more frames.

The camera is animated, starting from a position looking down at the scene and ending in a position parallel to the rings.

Frame 1

Frame 60

7. Animate the Null Object:

- a) In the Workspace panel (F3), select the Null Object.
- b) Go to the last frame (END).
- c) Enable Animate (A).
- d) In the Composite Controls panel, set the Y Rotation to 90°.
- e) In the Timeline (F4), click Overview.

f) Drag the Y Rotation keyframe to frame 40.

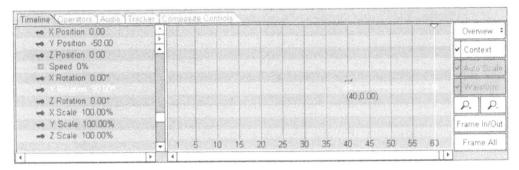

- g) Disable Animate (A).
- 8. Preview the result:
 - a) Scrub the animation slider bar to see how the camera moves.
 - b) Go to frame 1 (HOME).
 - c) Play the clip (SPACEBAR).

The null object rotates between frames 40 and 60, rotating the camera with it.

As the clip plays, notice the globe is not parallel to the camera viewpoint. Set the camera as the target to the globe so it "looks" at the camera throughout the animation.

- 9. Make the Camera target to the Globe:
 - a) In the Workspace panel, select the Globe layer.
 - b) In the Composite Controls panel (F8), select Camera from the Target list.

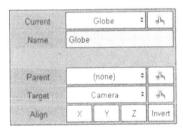

- 10. Preview the result:
 - a) Go to frame 1 (HOME).
 - **b)** Play the clip (**SPACEBAR**).

The globe follows the camera and is perpendicular to an invisible axis running from the layer to the camera.

Make an Image Travel with the Camera

Make an image "fixed" to the camera as the camera moves in the scene.

- 1. Go to frame 1 (HOME).
- 2. Choose File | Import Footage (CTRL+I / 98+I) and browse to the 28_MovingTheCamera folder.
- **3.** Double-click the *Letters* folder, then double-click the *Letters*[###].png image sequence.
- **4.** In the Workspace panel (**F3**), select the Letters0001 layer.
- 5. In the Composite Controls panel, click Layer.
- **6.** In the Options group, enable Lock Orientation.

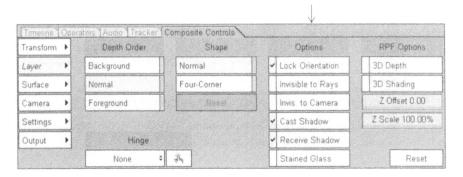

This option locks the layer to the viewport. If you change the Perspective view or move or rotate the camera, the layer maintains the same orientation in the viewport.

7. Play the clip (SPACEBAR).

Notice the layer's orientation changes because the camera looks at it from different perspectives.

- **8.** (Optional) Save the workspace:
 - a) Choose File | Save Workspace (CTRL+S / ૠ+S) to open the Save Workspace dialog.
 - b) Set a filename and directory for the workspace, and then click OK (ENTER / RETURN).
- 9. Choose File Close Workspace (CTRL+W / ૠ+W) to close the workspace.

Creating Shadows with Lights

Lesson 29

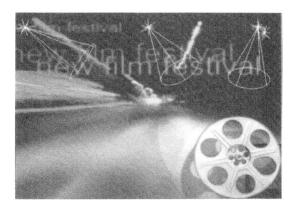

In this lesson, light an animated film roll with colored spotlights so the film roll casts shadows as it moves across the background.

Overview

Since the layers in a 3D composite can be arranged in 3D space, lights can cast shadows from one layer onto another. To make a shadow follow a moving layer, target the light to the layer.

In this lesson:

- Animate the position of a layer.
- Add three spotlights to the composite so a layer casts shadows onto a background.
- Change the color of the spotlights.
- Target the spotlights to follow a moving layer.
- Adjust the surface properties of the layers using the Surface controls.

Open the 29_CreatingShadowsWithLights.mov file in the 29_CreatingShadowsWithLights folder and preview the result.

Need Help?

If you need help completing this lesson, save and close your workspace, and then open the 29_CreatingShadowsWithLights.cws file as a reference.

Create a Composite Branch

Create a new composite branch and import the image sequences.

- 1. Check the Combustion preferences. For instructions, see "Setting the Preferences" on page 3.
- 2. Choose File | New or press CTRL+N (Windows) or #+N (Macintosh) to create a branch with the following properties:
 - Type: Composite
 - Name: ShadowsAndLights
 - · Format: NTSC D1
 - Duration: 30 frames
 - Bit Depth: 8 Bit
 - · Mode: 3D

- **3.** Select the single-viewport layout.
 - 4. Choose File | Import Footage (CTRL+1 / ૠ+1).
 - 5. In the Import Footage dialog, locate and open the 29_CreatingShadowsWithLights folder.

- 6. Import the footage as follows:
 - a) Double-click the *Film* folder and click the *FilmBG*[##].png image sequence.
 - b) Double-click the *Parent* folder, double-click the *Roll* folder, click the *Roll[##].png* image sequence and then click OK (ENTER / RETURN).
- 7. Rename the layers:
 - a) In the Workspace panel (F3), rename the Roll00 layer "Roll".
 - b) Rename the FilmBG00 layer "FilmBG".
- 8. Choose Window | Fit in Window, or right-click / CONTROL-click the viewport and choose Fit in Window.

Animate the Film Roll

Animate the Roll layer so it moves across the background layer.

- 1. Enable Animate (A).
- **2.** Make sure you are at the first frame (**HOME**).
- **3.** Shrink the film roll:
 - a) In the Workspace panel, select the Roll layer.

- **b)** In the Toolbar (**F2**), click the Scale tool.
- c) Press SHIFT and drag up (or to the left) in the viewport to proportionally scale the film roll to approximately 60%. Use the Scale X and Scale Y values in the Info bar below the Composite Controls panel as guides.

Hint: You can shrink the film roll via the Transform controls in the Composite Controls panel by entering 60% in the X and Y Scale fields.

- **4.** Position the film roll at the beginning of the clip:
 - a) In the Composite Controls panel (F8), click Transform.
 - b) Set Z Position to -55.

This increases the distance between the two layers and provides more space for the Roll layer to cast a shadow on the background layer.

- c) Set X Position to 192.
- d) Set Y Position to -111.

Hint: Make sure Feedback is enabled, below the Display Quality list, so you can see the position of the film roll change in the viewport.

- 5. Position the film roll at the end of the clip:
 - a) Go to the last frame (END).
 - b) In the Composite Controls panel, scrub the X Position field to show X -207.

Hint: You can also drag the Roll in the viewport to change the position.

As you move the film roll across the background, its motion path appears. This path shows the interpolation of the layer's position between the first and last frames.

- 6. Disable Animate (A).
- 7. Play the clip (SPACEBAR) to view the result.

The film roll moves across the background.

Add Spotlights

The composite is currently lit by the default point light, which shines light in all directions but fades over distance. Enable shadows and shading for the composite, then add three new spotlights of different colors.

- 1. Go to the first frame (HOME).
- 2. Add realistic shading and shadows to the composite:
 - a) In the Composite Controls panel (F8), click Settings.
 - b) Enable Shading and Shadows.

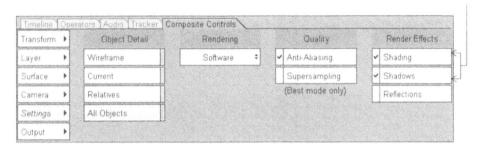

- c) Select Best from the Display Quality list.
- d) Enable Supersampling to smooth the shadow cast by the film roll.

Note: The Anti-Aliasing and Supersampling options only affect the result if the viewport display quality is set to Best.

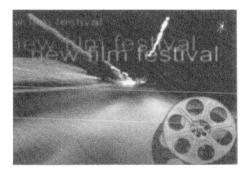

The Roll layer now casts a realistic shadow on the background.

- 3. Add a spotlight to illuminate the film roll:
 - a) Choose Object | New Light to add a new light.

Notice that Light(2) is automatically selected in the Current list.

b) In the Composite Controls panel, click Light to view the Light controls.

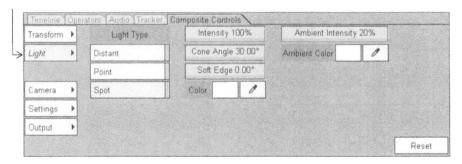

c) Click Spot under Light Type to change the light into a spotlight.

Spotlights shine a circle of light in a specific direction.

Note: The two other types of lights are distant lights and point lights. Distant lights are non-directional and shine with equal intensity everywhere in the composite. Point lights also shine in all directions, but their intensity falls over distance.

- **4.** Adjust the spotlight's settings:
 - a) Reduce the Intensity to 80 percent.
 - **b)** Increase Cone Angle to 40 degrees to widen the circle of light cast by the spotlight.
 - c) Set Soft Edge to 13 degrees to soften the spotlight's edge.

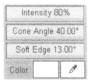

- **5.** Create two duplicates of the spotlight:
 - a) In the Workspace panel (F3), select Light(2).
 - b) Choose Edit | Copy, or press CTRL+C / \mathbb{H}+C to copy the object.
 - c) Choose Edit | Paste, or press CTRL+V / 第+V twice to create two duplicate spotlights.

 Light(4) and Light(6) are added to the composite and have the same settings as Light(2).

- **6.** Position Light(6):
 - a) Select Light(6).
 - b) Click Transform to access the Transform controls.
 - c) Set the X Position to -190.
- **7.** Position Light(4):
 - a) In the Workspace panel, select Light(4).
 - b) In the Transform controls, change the X Position to 0 and the Y Position to 130.
- 8. Change the spotlight colors:
 - a) With Light(4) still selected, click Light to access the Light controls.
 - b) Click the Color box to open the Pick Color dialog.
 - c) Set the color to 0% Red, 0% Green, 100% Blue and click OK.
- 9. Repeat step 8 to set the Light (6) color to 0% Red, 100% Green, 0% Blue, and the Light (2) color to 100% Red, 0% Green, and 0% Blue.

Target the Spotlights

Set the Roll layer as the target of the spotlights so they follow the film roll as it moves across the background.

1. With Light(2) still selected, choose Roll from the Target list.

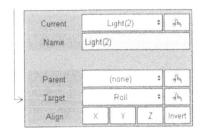

Light(2) changes its orientation to illuminate the film roll.

- 2. Select Light(4) from the Current list to make it the current object.
- 3. Select Roll from the Target list.
- 4. Repeat steps 2 and 3 to set Roll as the target for Light (6).

The three spotlights now target the Roll layer.

Note: The colors in the RGB system are additive, which means the combination of any two primary colors results in a brighter color. This is shown by the intersection of the light beams. For example, green + red = yellow, while white is the sum of all three colors.

5. Play the clip (SPACEBAR) to view the result.

The spotlights follows the moving film roll. As the colored lights overlap, they create new colors.

Adjust the Surface Properties of the Layers

Brighten the composite by changing the way the film roll and background layers react to light.

- 1. Go to the first frame (HOME).
- **2.** Adjust the surface properties of the background layer:
 - a) In the Workspace panel, select the FilmBG layer.
 - b) In the Composite Controls panel, click Surface to access the Surface controls.
 - c) Increase Luminosity to 19% to make the background brighter.

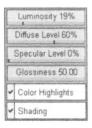

d) Set Diffuse Level to 60% to reduce the spread of light on the background's surface.

This darkens the outside edges of the layer, which receive the least light.

- 3. Adjust the surface properties for the Roll layer:
 - a) In the Workspace panel, select the Roll layer.
 - b) In the Surface controls, increase Luminosity to 17% and set Diffuse Level to 70%.
- **4.** Play the clip (**SPACEBAR**) to view the result.

The spotlights brighten both the film roll and the background while casting realistic shadows as the roll moves.

- **5.** (Optional) Save the workspace:
 - a) Choose File | Save Workspace (CTRL+S / 38+S) to open the Save Workspace dialog.
 - b) Set a filename and directory for the workspace, and then click OK (ENTER / RETURN).
- 6. Choose File | Close Workspace (CTRL+W / ૠ+W) to close the workspace.

Tracking and Stabilizing Part VII

30	Four-Point Tracking	353
31	One-Point Stabilizing	363
32	Two-Point Stabilizing	375

Four-Point Tracking Lesson 30

In this lesson, use four-point tracking to composite footage of an actress onto a computer screen that moves.

Overview

You can use four-point tracking to pin the corners of a foreground clip to a background clip. The result of this lesson is similar to the corner-pinning result from Lesson 20. However, in this lesson you use the Tracker to track a computer screen in the background layer that moves as the camera pans. With motion tracking, the foreground actress layer is automatically pinned to the monitor layer using the tracking data.

In this lesson:

- Change the properties of a layer to select its four corners.
- Pin the clip by tracking its corners onto the moving background.
- Apply a mask to the clip.
- Key out the blue-screen background from the clip.

Open the 30_FourPointTracking.mov file in the 30_FourPointTracking folder and preview the result.

Need Help?

If you need help completing this lesson, save and close your workspace, and then open the 30_FourPointTracking.cws file as a reference.

Create a Composite Branch

Create a composite branch and import two clips.

- 1. Check the Combustion preferences. For instructions, see "Setting the Preferences" on page 3.
- 2. Choose File New or press CTRL+N (Windows) or \$\mathbb{H}+N (Macintosh)\$ to create a branch with the following properties:
 - Type: Composite
 - Name: FourPointTracking
 - Format: NTSC D1
 - Duration: 45 frames
 - Bit depth: 8 Bit
 - Mode: 3D

- 3. Select the single-viewport layout.
 - **4.** Choose File | Import Footage (CTRL+1 / ₩+1).
 - 5. In the Import Footage dialog, use the file browser to locate and open the 30_FourPointTracking folder.

- 6. Import the footage as follows:
 - a) Double-click the *Monitor* folder and click the *Monitor*[##].png image sequence.
 - b) Double-click the *Parent* folder, double-click the *Actress* folder, click the *Actress[##].png* image sequence, and then click OK (ENTER / RETURN).
- 7. Rename the layers:
 - a) In the Workspace panel (F3), rename the Actress00 layer "Actress".
 - b) Rename the Monitor00 layer "Monitor".

Note: To rename a layer, select the layer in the Workspace panel (**F3**) and then click once, or right-click / **CONTROL**-click the layer and select Rename. (Double clicking a layer switches the viewport to layer view.)

8. Choose Window | Fit in Window, or right-click / CONTROL-click the viewport and choose Fit in Window.

Change the Properties of the Actress Layer

Change the properties of the Actress layer so you can move its corners independently.

- 1. Go to the first frame (HOME).
- 2. Enable Animate (A).
- 3. Change the Actress layer's properties to move its corner points independently:
 - a) In the Workspace panel, select the Actress layer.
 - **b)** In the Composite Controls panel (**F8**), click Layer to access the Layer controls.
 - c) Enable Four-Corner to convert the layer's shape to four-corner.

A corner point appears at each of the Actress layer's corners.

d) Press **SHIFT** and select each of the layer's four corner points.

courtesy of BehaviorCcommunications

Track the Corner Points of the Actress Layer

Put the actress inside the computer screen by pinning the corner points of the Actress layer to the Monitor layer. Then use the Tracker to follow these points as the camera pans and the computer screen moves in the clip.

1. Show the Tracker panel (**F7**).

The Tracker is context sensitive. Notice the Tracker panel label says "Nothing Selected". This is because the Tracker source has not been selected yet.

- 2. Set the Tracker to follow the Monitor layer:
 - a) Select Monitor from the Source list to set it as the tracked layer.

Because the four corner points of the Actress layer are selected, the Tracker panel label changes to say "Track 4 Control Points". The Tracker is ready to track four points.

b) Click Position to follow the position of all four corner points throughout the clip.

The Actress layer turns off in the Workspace panel. This enables you view the Monitor layer and the Tracker and Reference boxes in the viewport corners.

- **3.** Position a tracker on the screen:
 - a) Place the cursor over the upper left tracker and click when the cursor changes to \div .

 The cursor becomes a magnified preview of the tracked point.
 - b) Drag the tracker to the upper left corner of the computer screen, using the magnified preview as the guide.

High-contrast areas like the corners of the screen produce good tracking results.

4. Repeat step 3 to position the three remaining Trackers at their corresponding corners of the computer screen.

Note: If you accidentally resize the reference box of the selected Tracker, click Reset Trackers and move it again.

- **5.** Configure the Trackers:
 - a) In the Tracker panel, click Select All Trackers.

Hint: Another way of selecting multiple Trackers is to press SHIFT as you select the Trackers in the viewport.

b) Enable Absolute mode to match the corners of the Actress layer with the corners of the screen and avoid any offset.

- c) Select Roaming from the Reference list to resample the reference area at each frame.
- **6.** Track the corner points:
 - a) Click Analyze Forward > button to analyze the clip.

The Tracker follows the four corners of the computer monitor as they move in each frame.

b) Click Off when the analysis of the clip is complete.

The Tracker transfers the tracking data to the corner points of the Actress layer.

7. (Optional) Play the clip (SPACEBAR) to view the result.

The actress now appears inside the computer screen.

Apply a Mask Around the Actress

Remove the lighting equipment in the Actress layer by drawing a mask around the actress, so only she appears in the computer.

- 1. Go to the first frame (HOME).
- 2. In the Workspace panel, make sure the Actress layer is selected.
- 3. In the Operators panel (F5), click Mask, and then CTRL-click / %-click Draw Mask to add a mask to the Actress layer.

Note: You can also right-click / CONTROL-click the Actress layer and choose Operators I Mask I Draw Mask.

4. Double click the Draw Mask operator in the Workspace panel to make it the current operator.

Hint: To see which operator is being displayed, look at the text in the upper left corner of a viewport or look for the Current Operator indicator in the Workspace panel.

5. Draw a mask around the actress to remove the lighting equipment from the image:

- a) In the Toolbar (F2), select the Bezier Mask tool (P).
- b) In the viewport, click around the actress. Leave enough space for the movement of the actress in the clip.

Hint: To remove an unwanted control point while you are drawing the mask, press DELETE or BACKSPACE.

- c) Close the mask by clicking the first control point again or press ENTER / RETURN.
 - The actress is visible inside the polygon mask, while the lighting equipment is masked out.
- **6.** Play the clip (**SPACEBAR**) to view the result.

Check that the mask leaves enough room for the head and arms of the actress as she moves.

- 7. (Optional) If the mask is not big enough to fit the actress in all frames, modify the mask:
 - a) Go to the first frame that the actress is clipped by the mask.
 - b) Move the mask's control points so the actress is no longer clipped.
 - c) Adjust the mask at other frames where the actress is clipped by the mask.

Hint: To remove unwanted control points, select the controls point and then press DELETE.

8. In the Workspace panel (**F3**), double-click the composite to make it current.

The viewport shows the output of the composite and the lighting equipment no longer appears on the computer screen. However, you can still see the blue-screen background behind the actress.

Key Out the Blue-Screen Background

Key out the blue screen behind the actress using the Linear Keyer, so she appears more realistically in the computer.

- 1. Go to the first frame (HOME).
- 2. In the Workspace panel, select the Actress layer.
- 3. In the Operator's panel (F5), click Keying, and then CTRL-click / ૠ-click Linear Keyer.

- 4. Remove the blue-screen background:
 - a) In the Linear Keyer Controls panel, enable the Key color picker.

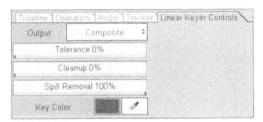

- b) In the viewport, click beside the actress to sample the blue screen with the color picker.
 Notice that the Key Color box shows the shade of blue of the pixel sampled with the color picker.
- c) Increase the key color Tolerance to between 12% and 15% to remove most of the blue screen.
- d) Set Cleanup to 100% to finish the key.

Cleanup removes semitransparent areas in the key and improves the edge. With the blue screen removed, only the actress appears in the screen.

Hint: To learn more about keying, see Lesson 34 "Using the Diamond Keyer" and Lesson 35 "Using the Discreet Keyer".

- 5. In the Workspace panel (F3), select the Composite and play the clip (SPACEBAR) to view the result.
- **6.** (Optional) Because of the curvature of the computer screen, there is a gap between the actress and the bottom of the screen. Remove the gap by adjusting the Y Position and Y Scale of the Actress layer through the clip.
- 7. (Optional) Save the workspace:
 - a) Choose File | Save Workspace (CTRL+S / ₩+S) to open the Save Workspace dialog.
 - b) Set a filename and directory for the workspace, and then click OK (ENTER / RETURN).
- 8. Choose File | Close Workspace (CTRL+W / ૠ+W) to close the workspace.

and the second of the second o

i de la companya de Independente la companya de la comp

and the second control of the contro

One-Point Stabilizing

Lesson 31

In this lesson, stabilize a clip by removing unwanted camera motion using the Stabilize 1 Point operator.

Overview

In Combustion, you can stabilize one or two points. Use one-point stabilizing to eliminate horizontal and vertical jitter. Use two-point stabilizing to eliminate jitter and unwanted camera pan and tilt. In this lesson, remove unwanted horizontal and vertical camera motion (called jitter) from a layer using the Stabilize 1 Point operator. Once you set a stabilize point in the jittery shot, use the Tracker to generate tracking data based on the motion of the stabilize point from frame to frame.

In this lesson:

- Examine a clip for jitter.
- Add a Stabilize 1 Point operator to a layer and set the stabilize point.
- Use the Tracker to track the stabilize point.
- Apply different stabilization modes to a clip.
- Render a stabilized clip to the RAM Player and compare it to the original footage.

Open the 31_1PointStabilizing.mov file in the 31_1PointStabilizing folder and preview the result.

Need Help?

If you need help completing this lesson, save and close your workspace, and then open the 31_1PointStabilizing.cws file as a reference.

Create a Composite Branch

Create a composite branch and import footage for the composite.

- 1. Check the Combustion preferences. For instructions, see "Setting the Preferences" on page 3.
- 2. Choose File | New, or press CTRL+N (Windows) or ૠ+N (Macintosh), to open the New dialog and create a branch with the following properties:
 - Type: Composite
 - Name: 1PointStabilizing
 - Format: NTSC DV
 - Duration: 48 frames
 - Bit Depth: 8 Bit
 - · Mode: 2D

- 3. Select the single-viewport layout.
 - 4. Choose File | Import Footage (CTRL+I / %+I), open the 31_1PointStabilizing folder, double-click the Woods folder, click the woods[####].png image sequence, and click OK (ENTER / RETURN).

5. Play the clip (SPACEBAR).

Notice the exaggerated jitter in the camera motion. The camera moves both horizontally and vertically but it has very little roll, which is why you can use the Stabilize 1 Point operator to remove the vertical and horizontal jitter.

Hint: In cases where you want to remove camera roll or zoom, use the Stabilize 2 Points operator. Learn more about two-point stabilizing in Lesson 32, "Two-Point Stabilizing."

- **6.** Go to the first frame (**HOME**).
- In the Workspace panel (F3), right-click / CONTROL-click the 1PointStabilizing composite and choose Import Footage.
- **8.** In the Import Footage dialog, double-click the *Parent* folder, double-click the *Dino* folder, click the *dino*[####].png image sequence, and click OK (ENTER / RETURN).
- **9.** Rename the layers in the Workspace panel:
 - a) Right-click / CONTROL-click the dino0001 layer and choose Rename.
 - b) Name the dino0001 layer "Dino".
 - c) Name the woods0000 layer "Woods".
- 10. Play the clip:
 - a) In the Workspace panel (F3), turn off the Woods layer by clicking the layer's icon.
 - b) Play the animation (SPACEBAR).

There is no camera motion in the dino image sequence.

c) Turn the Woods layer back on by clicking the layer's icon.

When composited over the Woods layer, the Dino character seems to float over the background because the woods image sequence has camera motion.

Stabilize the Woods Footage

Add a Stabilize 1 Point operator to the Woods layer and then set the stabilize point. As with motion tracking, you must locate a good reference area for setting the stabilize point.

- 1. Go to the first frame (HOME).
- 2. Add a Stabilize 1 Point operator to the Woods layer:
 - a) In the Workspace panel, select the Woods layer.

b) In the Operators panel (F5), select the Stabilize category.

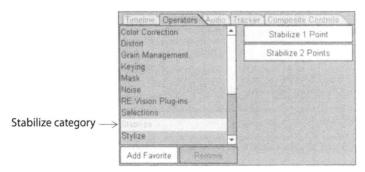

c) CTRL-click / % -click Stabilize 1 Point.

The Stabilize 1 Point operator uses the tracking data to shift the footage in the layer so the stabilize point is always in the exact same position in each frame

- 3. Set the stabilize point for the shot:
 - a) In the Stabilize 1 Point Controls panel, click the Stabilize Point picker.

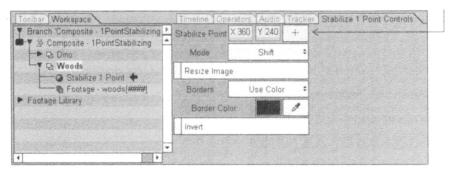

At the center of the viewport, a target appears over the default pivot point.

You use this target to set the stabilize point in the image. When setting a stabilize point, try to find a feature in the image that contains high contrast so it is easily identified, and remains consistent from frame to frame.

b) In the Workspace panel, turn off the Dino layer by clicking the layer's icon.

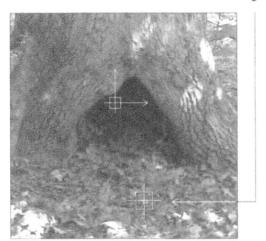

c) Click the leaf in front of the tree hole that is catching the sunlight.

The leaf provides an easy pattern for clip analysis because of its high contrast.

In the Stabilize 1 Point Controls panel, the Stabilize Point X and Y fields display the position of the target.

Hint: You can also set and adjust the position of the stabilize point by entering values in the Stabilize Point X and Y fields.

Analyze the Jitter in the Clip

Now that you set the stabilize point for the Stabilize 1 Point operator, use the Tracker to analyze the jitter in the clip. The Stabilize 1 Point operator uses the shift data generated by the Tracker to stabilize the clip. The tracking data is used to create keyframes for the stabilize point's X and Y channels. These keyframes are generated automatically, so it does not matter if Animate is enabled.

1. Show the Tracker panel (F7).

The Tracker is context sensitive. Because you just set the stabilize point for the Stabilize 1 Point operator, the Tracker is set to track the stabilize point—the Track 1 Effect Point.

31 One-Point Stabilizing

2. In the Tracker panel, click Position to activate the Tracker for for one-point tracking.

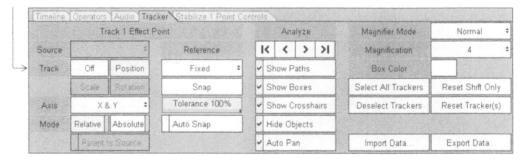

One-point tracking tracks the position of a sampled element as it moves from frame to frame.

The Tracker appears in the viewport. The Tracker consists of a reference box and a tracker box:

- The tracker box follows the frame-to-frame movement of the reference area.
- The reference box contains the reference area—the group of pixels whose motion is tracked.

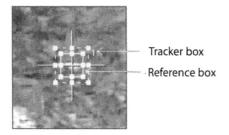

Hint: You can resize the reference and tracker boxes by dragging their corner handles.

3. Click the Analyze Forward button to analyze the clip.

The green path represents the motion path of the reference area from frame to frame.

4. When the analysis is completed, click Off to turn the Tracker off.

Note: Do not click the viewport. If you move the stabilize point after it has been tracked, the anchoring point for the stabilized clip moves, and the overall position of the footage in the layer is changed.

- 5. In the Stabilize 1 Point Controls panel (**F8**), click the Stabilize Point picker to avoid accidentally moving the stabilize point target in the viewport.
- 6. Preview the result:
 - a) Go to the first frame (HOME).
 - b) Play the animation (SPACEBAR).

The absolute position of the Woods layer is unchanged. However, the relative position of the layer's footage is modified by the Stabilize 1 Point operator to produce a steady shot. A black border appears where the footage is shifted.

Remove the Black Borders in the Clip

Keep in mind that the jitter motion in the camera was purposely exaggerated to show how efficient the Stabilize 1 Point operator is in Combustion. Generally, there is less camera jitter than in this woods image sequence and the black borders are significantly smaller. Since the black borders are within the safe action zone, you need to correct the problem.

- 1. Go to the last frame (END).
- 2. Choose Window | Show Safe Zones or right-click / CONTROL-click the viewport and choose Show Safe Zones (or press ').

Because broadcast video usually crops the edges of a frame, the Safe Zones define safe areas for action and titles.

- 3. In the Workspace panel, select the Woods layer.
- 4. In the Composite Controls panel, click Transform.
- 5. Enable Proportional and set either of the Scale fields to 107%.
- **6.** Preview the result (**SPACEBAR**).

Notice that the black borders remain outside the safe zone. You lose some resolution by scaling the clip up, but remember that in most cases, there is less jitter and chances are you may not need to scale the clip at all if the borders are already outside the safe zone.

Using Other Stabilizing Modes

There are three stabilizing modes: Shift, Fit, and Wrap. The Shift default mode leaves a border where the clip is shifted. The Fit mode scales the image sequence to fit the original layer size without changing its aspect ratio. Of course, if the clip is scaled too much, it may cause some unwanted distortion. The Wrap mode wraps the pixels around the opposite side to fill the border. It works well only when the top/bottom and left/right edges of an image are identical, making a tiled background

Although you used the default Shift mode and manually scaled the image sequence, you could have used the Fit mode that scales the image sequence automatically. Now try the Fit Stabilizing mode.

- 1. Go to the first frame (HOME).
- 2. In the Workspace panel, turn on the Dino layer by clicking the layer's icon.
- 3. Stabilize the Woods layer using the Fit Stabilizing mode:
 - a) In the Composite Controls panel, reset either of the Scale fields to 100%.
 - b) In the Workspace panel, select the Stabilize 1 Point operator.
 - c) In the Stabilize 1 Point Controls panel, from the Mode list, select Fit.
 - d) Play the clip (SPACEBAR).

Notice how the Woods clip appears bigger. Notice also that you did not have to reanalyze the clip using the Tracker because the Stabilize 1 Point operator used the existing tracking data to apply new stabilization modes to the clip.

4. Choose Window | Show Safe Zones (or press ') to turn the safe zones off.

Play the Clip in the RAM Player

Play the clip to compare your result with the original clip, before it was stabilized.

- 1. In the Workspace panel, turn off the Dino layer by clicking the layer's icon.
- 2. Go to the first frame (HOME).
- 3. Choose File | Render to RAM (CTRL+SHIFT+R / %+SHIFT+R) to open the Render to RAM dialog.

When you render an operator (such as a composite) to RAM, you can compare the result of this operator with the output of another operator. In this case, compare the stabilized Woods layer—the output of the composite—with the unstabilized Footage operator.

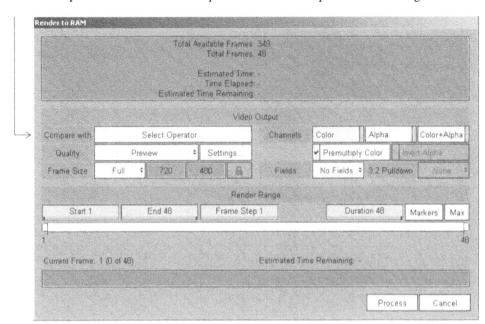

4. In the Compare with field, click Select Operator to access the Operator Picker dialog.

5. In the Operator Picker dialog, select the woods[####] Footage operator in the Woods layer and then click OK (**ENTER** / **RETURN**) to return to the Render to RAM dialog.

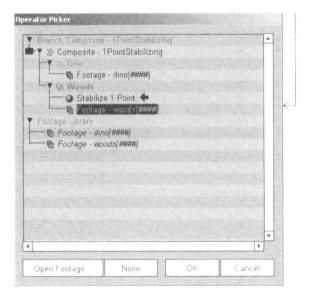

In the Render to RAM dialog, the Compare with field shows the woods[####] Footage, the jittery clip that is set to be compared with the output of the composite, the stabilized clip.

6. Process the clip:

a) From the Quality list, select Best.

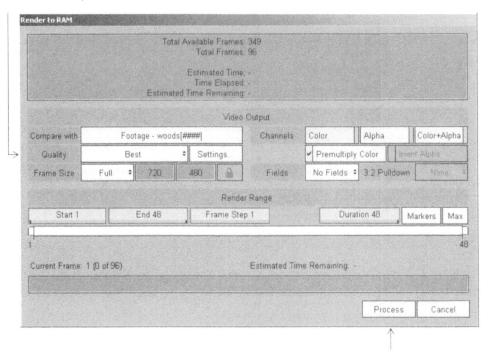

b) Click Process to render the clip to RAM.

After a few moments, the rendered result appears in the RAM Player. The RAM Player is a real-time player that plays in the viewport.

By rendering the clip to RAM with an operator for comparison, you can view both clips in the RAM Player simultaneously.

7. View both clips in the viewport:

- a) Zoom in once (CTRL+= $/ \Re +=$).
 - **b)** Show the Toolbar (**F2**).
 - c) Click the Compare tool.

d) Select Split Vertically from the Compare Region list.

e) In the viewport, click near the point on the leaf that you used as the stabilize point.

Note: If you do not see the vertical split, zoom in again.

A vertical split divides the two outputs in the RAM Player. The stabilized clip appears to the left of the split and the unstabilized footage appears to the right.

f) Play the clip (SPACEBAR).

In the viewport, the jitter is removed from the clip to the left of the vertical split.

- **8.** Right-click / **CONTROL**-click the viewport and choose Close to close the RAM Player.
- 9. In the Workspace panel, turn the Dino layer on by clicking the layer's icon.
- 10. (Optional) Save the workspace:
 - a) Choose File | Save Workspace (CTRL+S / ૠ+S) to open the Save Workspace dialog.
 - **b)** Set a filename and directory for the workspace, and then click OK (**ENTER** / **RETURN**).
- 11. Choose File | Close Workspace (CTRL+W / ૠ+W) to close the workspace.

g and accept to the profession of the contract of the contract

Two-Point Stabilizing

Lesson 32

In this lesson, remove unwanted camera

pan and roll in a clip by using the Stabilize 2

Points operator and the Tracker.

Overview

Like the Stabilize 1 Point operator, the Stabilize 2 Points operator uses the Tracker to analyze motion in a clip. With two-point stabilizing, the Tracker finds the position changes for two reference points. The Stabilize 2 Points operator translates this tracking data into position, scaling, and rotation values, and then inverts these values to stabilize the clip.

In this lesson:

- Apply a Stabilize 2 Points operator.
- Use the Tracker to analyze the motion in a clip.
- View the Stabilize Point channels in the Timeline.

Open the 32_2PointStabilizing.mov file in the 32_2PointStabilizing folder and preview the result.

Need Help?

If you need help completing this lesson, save and close your workspace, and then open the 32_2PointStabilizing.cws file as a reference.

Create a Composite Branch

Create a composite branch and import the footage.

- 1. Check the Combustion preferences. For instructions, see "Setting the Preferences" on page 3.
- 2. Choose File | New or press CTRL+N (Windows) or %+N (Macintosh) to create a branch with the following properties:
 - Type: Composite
 - Format: NTSC D1
 - · Duration: 40 frames
 - Bit Depth: 8 Bit
 - · Mode: 3D

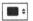

- **3.** Select the single-viewport layout.
 - 4. Choose File | Import Footage (CTRL+1 / 9€+1).
 - **5.** In the Import Footage dialog, locate and open the *32_2PointStabilizing* folder.
 - **6.** Double-click the *Street* folder, click the *Street(##).png* image sequence, and click OK (**ENTER / RETURN**).
 - 7. In the Workspace panel (F3), rename the Street01 layer "Street".

- 8. Choose Window | Fit in Window, or right-click / CONTROL-click the viewport and choose Fit in Window.
- 9. Change the footage settings to display the interlaced fields properly:
 - a) In the Workspace panel (F3), expand the Street layer.
 - b) Select the Footage operator in the Street layer.
 - c) In the Footage Controls panel (F8), click Source.

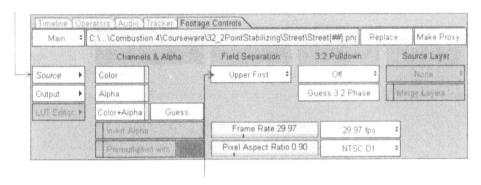

- d) Select Upper First from the Field Separation list.
- 10. Play the clip (SPACEBAR).

Notice how the camera moves around during the clip.

Apply the Stabilize Operator

Apply the Stabilize 2 Points operator and then set the stabilize points in the clip. The stabilize points should target areas in the shot that are high contrast, easily identifiable, and appear in every frame.

- 1. Go to the first frame (HOME).
- 2. In the Workspace panel, select the Street layer.
- Choose Operators | Stabilize | Stabilize 2 Points, or right-click / CONTROL-click the Street layer and choose Operator | Stabilize | Stabilize 2 Points.

4. In the Stabilize 2 Points Controls panel (**F8**), enable Position and Rotation to calculate and stabilize position and rotation changes.

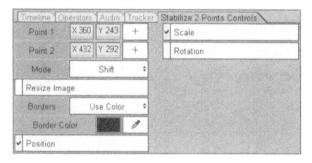

Hint: To remove scaling motion from a clip, enable Scale as well. Scaling corrections are not required for this clip.

- 5. Set the first stabilize point:
 - a) Click the Stabilize Point 1 picker to view the first crosshair in the center of the viewport.

This crosshair marks the first stabilize point. The Stabilize operator uses the motion tracking data generated from this point to anchor the clip.

b) Drag over the viewport to place the crosshair above the tail light of the green van parked on the left (X = 155, Y = 212).

- **6.** Position the second stabilize point:
 - a) Click the Stabilize Point 2 picker to show the second crosshair in the viewport.

This crosshair marks the second stabilize point. The Stabilize operator uses the motion tracking data generated from this point to remove camera roll from the shot.

Hint: Always try to place a rotation stabilize point far away from the anchoring stabilize point. The further the rotation stabilize point is from the anchoring stabilize point, the more precise the rotation corrections.

b) In the viewport, place the crosshair directly over the tail light on the blue car parked to the right of the man (X = 410, Y = 216).

7. From the Mode list, select Fit.

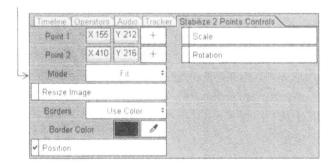

With Fit selected, the stabilized clip is automatically scaled and positioned to fit the frame.

Track the Motion of the Two Points

Use the Tracker to analyze the motion of the two stabilize points.

1. In the Tracker panel (**F7**), click Position to enable the Trackers.

Tracker boxes appear over the first crosshairs you positioned on the clip.

Note: When you click Position, the Stabilize 2 Points operator turns off in the Workspace panel. It turns on once the Tracker has generated the data it needs to stabilize the clip.

Notice the "Track 2 Effect Points" label in the Tracker panel. The Tracker is context-sensitive: because two stabilize points are active, the Tracker is set to track two points.

2. Select Roaming from the Reference list.

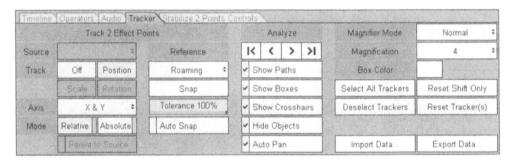

With Roaming selected, the stabilize points are resampled at every frame. It is a slower process, but resampling accounts for rotation and scale changes in the Tracker's reference box from frame to frame. Because the features around both stabilize points rotate and change in size, Roaming produces a better result.

3. Click Select All Trackers to analyze both stabilize points at the same time.

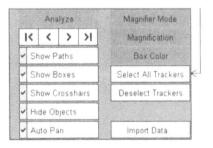

4. Click the Analyze Forward **>** button to analyze the clip.

As the clip is analyzed, watch the preview window to monitor the sampled reference area from frame to frame. It should stay consistent.

Once the analysis is complete, you can see the tracking paths generated for each stabilize point in the viewport.

5. Click Off to commit the tracking data to the Stabilize 2 Points operator.

Note: Notice the Stabilize 2 Points operator in the Workspace panel turns on again.

- **6.** Review the stabilized results:
 - a) Show the Stabilize 2 Points Controls panel (F8).

The Stabilize Point 2 picker is still enabled, you still see the crosshairs in the viewport. Use the crosshairs as reference points to view the stabilized clip.

Note: Do not click inside the viewport. If you move a stabilize point after it has been tracked, the anchoring point (or rotation point) for the stabilized clip moves and the overall position of the footage in the layer changes.

- b) Go to the first frame (HOME).
- c) Play the clip (SPACEBAR).

As the clip plays, notice that it is anchored to the first stabilize point (the crosshair on the left). The second stabilize point (the crosshair on the right) remains level with the first point at all times.

The absolute position and rotation of the Street layer is unchanged. However, the relative position and rotation of the footage inside the layer is shifted by the Stabilize 2 Points operator to produce a smooth camera shot.

7. To avoid accidentally moving the stabilize points, disable the Stabilize Point 2 picker.

The crosshairs are no longer visible in the viewport.

Examine the Stabilize Point Channels

In the Timeline, view how the tracking data is applied to the Stabilize Point channels.

- 1. Go to the first frame (**HOME**).
- 2. In the Workspace panel, select the Stabilize 2 Points operator to view its channels and categories in the Timeline list.
- 3. Show the Timeline (F4), and change the following display settings:
 - a) Click Graph to view channel information as a graph.
 - b) Make sure Context is enabled.
 - c) Click Frame All to show the entire duration of the clip in the Timeline.
 - d) Click the right-arrow menu button () to access the channel filtering menu.

- e) Choose Show Only Animated Channels.
- f) CTRL-click / \(\mathbb{H}\)-click the triangle next to the Stabilize 2 Points.

- 4. View the Stabilize Point channels for both stabilize points:
 - a) Select the Point 1 category to view both the X and Y channels at the same time.

The shift values used to anchor the clip to the first stabilize point are applied to both the X and Y axes.

- b) Expand the Point 2 category in the Timeline.
- c) Select the Point 2 category to view its X and Y channels at the same time.

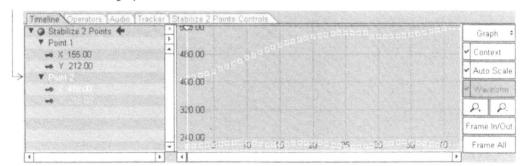

- 5. (Optional) Save the workspace:
 - a) Choose File | Save Workspace (CTRL+S / 策+S) to open the Save Workspace dialog.
 - b) Set a filename and directory for the workspace, and then click OK (ENTER / RETURN).
- **6.** Choose File | Close Workspace (CTRL+W / ૠ+W) to close the workspace.

Keying and Color Correcting Part VIII

33	Using the Discreet Color Corrector	387
34	Using the Diamond Keyer	395
35	Using the Discreet Keyer	405

pains and action are only all

Using the Discreet Color Corrector

Lesson 33

In this lesson, use the Discreet Color

Corrector to match the colors in two layers

of a composite for a more realistic result.

Overview

Use the Discreet Color Corrector to fix color problems, match colors between layers in a composite, and achieve artistic results.

In this lesson:

- Create a composite with a keyed image of a woman and an image of a building.
- Adjust black and white levels to increase the contrast and brightness of a layer.
- Increase the saturation of a layer and make gamma adjustments.
- · Adjust the hue of the front layer to match the colors in the background.
- Fine-tune gamma for the shadows in an image.
- Compare the color corrected layer with the original footage.

Need Help?

If you need help completing this lesson, save and close your workspace, and then open the 33_UsingDiscreetColorCorrector.cws file as a reference.

Create a Composite Branch

Open the footage as a composite branch and apply a Color Corrector operator to the foreground layer.

- 1. Check the Combustion preferences. For instructions, see "Setting the Preferences" on page 3.
- Choose File | Open or press CTRL+O (Windows) or 第+O (Macintosh) and open the 33_UsingDiscreetColorCorrector folder.
- 3. CTRL-click / % -click Woman.png and Building.png (in this order), and then click OK.

 The Open Footage dialog appears.
- 4. Click 2D Composite and click OK to create a 2D composite branch with the selected footage.

5. Select the single-viewport layout.

A composite of a woman in front of a building appears in the viewport. The building layer may look slightly fuzzy. This is because the interlaced fields of the footage are not displayed properly.

- **6.** Change the footage settings to display the interlaced fields properly:
 - a) In the Workspace panel (F3), expand the Building layer.
 - b) Select the Footage operator in the Building layer to view the Footage Controls panel (F8).

Operators | Audio | Tracker | Footage Controls Make Proxy C.\..\Courseware\33 UsingTheDiscreetColorCorrector\Building.png Replace Main Channels & Alpha 3.2 Pulldown Source Layer Field Separation Source Color Upper First Alpha Output LIJT Editor * Color+Alpha Guess Frame Rate 29.97 From File Invert Alpha Pixel Aspect Ratio 0.90 From File Premultiplied with

c) Click Source to view the Source controls.

d) In the Field Separation list, select Upper First.

The fields in the Building layer become less noticeable, making the composite look better.

Adjust the Black and White

The woman looks too dark against the building and lacks contrast. To correct this, apply a Color Corrector operator and remap black and white values in the layer using the histogram.

- 1. Apply a Discreet Color Corrector operator to the Woman layer.
 - a) In the Workspace panel, select the Woman layer.
 - **b)** Choose Operators | Color Correction | Discreet Color Corrector.

Hint: You can also right-click / CONTROL-click the Woman layer, and choose Operators | Color Correction | Discreet Color Corrector.

A Discreet Color Corrector operator is applied to the layer and the Color Correction Controls panel appears.

2. In the Color Correction Controls panel, click Histogram, and then click Master.

- 3. Sample the dark areas of the Woman layer:
 - a) Click the Source color picker to select a color from the source image.

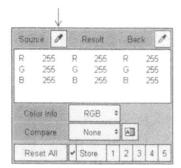

b) Click on the back of the woman's hair in the viewport.

The selected color and its values appear in the Source and Result patches. Notice that the color values are all above zero, indicating that the area you selected is not true black (R=0, G=0, B=0).

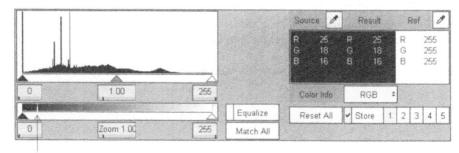

A yellow line appears in the Output Levels bar, below the histogram, to show the position of the sampled color.

4. Drag the black Input slider to the approximate position of the yellow line in the Output Levels bar.

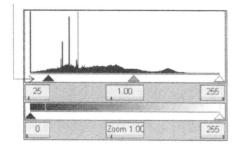

All the colors in the image to the left of the slider are remapped to pure black. As a result, the Woman layer becomes darker.

- Sample the light areas of the image by clicking on the lightest area of the woman's white dress.A yellow line appears in the Output Levels bar, to show the position of the sampled color.
- 6. Drag the white Input slider to the approximate position of the yellow line in the Output Levels bar.

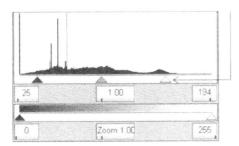

All the colors in the image to the right of the slider are remapped to pure white. The Woman layer is now lightened and has better contrast.

7. Make additional adjustments to the black and white sliders until you are satisfied with the result. Make sure to preserve as much detail as possible, for example, in the woman's hair and in the weave of her dress.

Hint: A good result is achieved with Black set to 11 and White set to 197. You can enter these values manually in the fields.

Add Saturation

Adjust saturation to boost the purity of the colors in the Woman layer so that it matches the background.

- In the Color Correction Controls panel, click Basics to view the Basics controls.
 Master is selected by default. Master makes adjustments to shadows, midtones, and highlights uniformly across the image.
- 2. Set Saturate to 143.

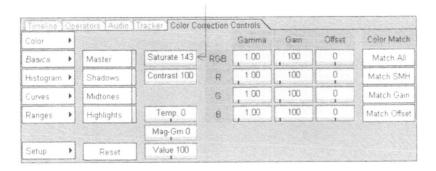

The colors in the Woman layer become more vibrant and better match the background, but should be fine-tuned further.

3. Adjust the overall gamma to make the Woman layer brighter. Set RGB Gamma to 1.12.

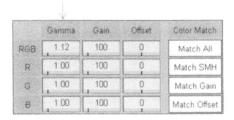

The foreground now appears better lit.

Adjust the Color

The match between the contrast, saturation, and gamma of the layers is improved, but the woman now appears too red. Use the color wheel in the Color controls to adjust the color.

- 1. In the Color Correction Controls panel, click Color.
- 2. Set Strength to 9.0.

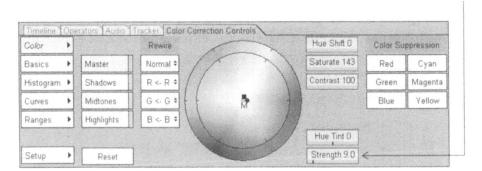

3. Drag the center point of the color wheel slightly towards yellow to offset the red color.

A good result is achieved by dragging the center point to set Hue Tint to 45 and Strength to 9.

Adjust the Shadows

Fine-tune the shadows of the Woman layer to complete the color correction.

- 1. Click Basics to access the Basics controls.
- 2. Click Shadows to access the Gamma, Gain, and Offset controls for the shadows.
- 3. In the RGB channel, set Gamma to 1.11 to increase the gamma of the shadows.

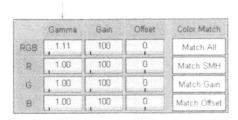

Compare the Color Correction Results

View the results of the color correction by comparing the original footage to the color-corrected Woman layer.

- 1. Enable the Compare tool:
- - a) In the Toolbar (F2), click-drag the Compare tool.
- **b)** From the context menu, select the Compare tool On.

The Toolbar displays the Compare options and the viewport displays a vertical comparison region.

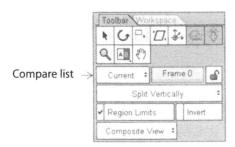

Note: Other Compare tool options are Rectangle and Split Horizontally.

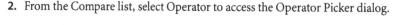

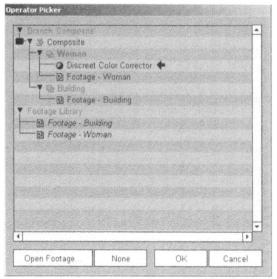

3. Select Footage - Woman and click OK to select the original footage of the woman as the source for comparison.

The screen is split vertically, with the original footage shown to the right. Note the difference between the darker original footage and the color-corrected Woman layer.

4. Click-drag the comparison edge to define the comparison region.

Hint: When Split Horizontally or Split Vertically is selected, you **ALT**-click / **OPTION**-click to toggle between a vertical split and a horizontal split. When Rectangle is selected, you can reposition the default rectangle comparison region and you can draw and position a rectangle comparison region.

- **5.** (Optional) Save the workspace:
 - a) Choose File | Save Workspace (CTRL+S / %+S) to open the Save Workspace dialog.
 - b) Set a filename and directory for the workspace, and then click OK (ENTER / RETURN).
- **6.** Choose File | Close Workspace ($CTRL+W / \Re +W$) to close the workspace.

Using the Diamond Keyer

Lesson 34

In this lesson, create an alpha channel for green screen footage with the Diamond

Keyer and fine tune the key with Color

Suppression and Matte Controls.

Overview

You use the Diamond Keyer to extract a key based on a sampled color or color range and set the tolerance and softness in the Luma Gradient and Hue Cube. The Diamond Keyer affects the alpha of the image. Additional Operators such as Color Suppression and Matte Controls can be added to finish a key.

In this lesson:

- Import a foreground clip and a still background image.
- Use the Diamond Keyer to create an alpha channel on the foreground.
- View the Matte and add tolerance to the key color.
- Adjust the tolerance and softness in the Luma Gradient and Hue Cube.
- Use Color Suppression and Matte Controls to fine-tune the key.

Open the 34_UsingTheDiamondKeyer.mov file in the 34_UsingTheDiamondKeyer folder and preview the result.

Need Help?

If you need help completing this lesson, save and close your workspace, and then open the 34_UsingTheDiamondKeyer.cws file as a reference.

Create a Composite Branch

Create a composite branch and import the footage.

- 1. Check the Combustion preferences. For instructions, see "Setting the Preferences" on page 3.
- 2. Choose File | New or press CTRL+N (Windows) or ૠ+N (Macintosh) and create a branch with the following properties:
 - Type: Composite
 - Name: Diamond Keyer
 - · Format: NTSC DV
 - · Duration: 80 frames
 - Bit Depth: 8 Bit
 - Mode: 2D

- **3.** Select the single-viewport layout.
 - 4. In the Workspace panel (F3), right-click / CONTROL-click the Diamond Keyer composite, and choose Import Footage ($CTRL+I / \Re +I$).
 - 5. From the 34_UsingTheDiamondKeyer folder, click the Ocean.png, double-click the Sheep folder, and doubleclick the *Sheep[####].png* image sequence.

- 6. In the Workspace panel, rename the Sheep0081 layer "Sheep".
- 7. Choose Window | Fit in Window, or right-click / CONTROL-click the viewport and choose Fit in Window.
- 8. Play the clip (SPACEBAR).

The viewport displays an animation of a sheep composed over a green screen.

Create an Alpha Channel for the Foreground

Apply a Diamond Keyer to the Sheep layer and generate an alpha channel to see the Ocean in the background.

- 1. Go to the first frame (HOME).
- 2. Apply the Diamond Keyer operator to the Sheep layer:
 - a) In the Operators panel (F5), click Keying.

b) CTRL-click / % -click Diamond Keyer.

Note: You can also choose Operators | Keying | Diamond Keyer.

The Diamond Keyer Controls panel appears.

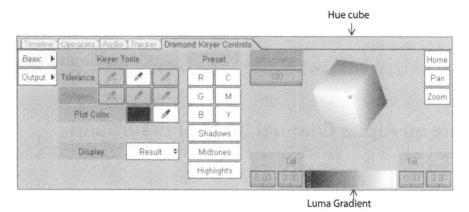

- **3.** Define the color to key out from the front clip:
 - a) Click the Tolerance color picker.

b) In the viewport, click on the green screen under the mouth of the sheep.

The Diamond Keyer keys out much of the green screen.

Hint: CTRL-drag/第-drag the cursor over a region to key out all the pixels inside the selection box. This increases the Tolerance range.

4. Select Matte from the Display list to display the matte and determine areas that need additional Softness or Tolerance.

Note the Matte has areas of gray in the key color around the sheep due to digital video compression and uneven lighting. This area will be added to the Tolerance range. The gray areas in the grass indicate transparency, or Softness, in areas that should have no transparency. This area will be subtracted from the Softness Range.

- 5. Clean up the Matte for a solid key:
 - a) Click the Add Tolerance color picker . .

Tolerance.	0.	1	8
Softness	0.	8	1

b) Click-drag the cursor in the viewport around the sheep in the gray areas. Avoid dragging into the sheep or the grass. This increases the key color range to include a larger range of green.

The cursor samples the actual color in the source regardless of the display settings in the viewport.

The yellow wireframe in the Hue cube defines the Softness range in the color of the image and the red wireframe defines the Tolerance range in the color of the image.

c) In the Hue cube, click-drag the top point of the Softness wirefame down, to reduce the amount of yellow-green in the Softness range.

d) In the Hue cube, click-drag the right point of the Softness wirefame away from center, to reduce the amount of light-green in the Softness range.

Hint: You can pan and zoom the Hue Cube to make very precise adjustments using the Home, Pan and Zoom tools located to the right of the Hue Cube.

e) In the Luma Gradient, click-drag the Softness indicator on the left to 0.00.

This increases the transparency in the shadows of the image by expanding the Softness range. The yellow indicators define the Softness range in the luminance of the image. The red indicators define the Tolerance range in the luminance of the image. Exact values can also be entered into the Softness and Tolerance fields.

The Matte in the viewport should be black for the key color, or 100% transparency. White for 0% transparency, and gray along the edges of the grass and sheep for varying degrees of transparency.

6. Click in the Display list and choose Result from the list to view the effect of the Diamond Keyer on the Composite.

7. Notice the green spill in the contour of the sheep.

Remove the Green Spill Around the Sheep

Use Color Suppression to remove the green spill around the sheep.

- 1. Add a Color Suppression to the Sheep:
 - a) In the Workspace panel (F3), select the Sheep layer.
 - b) Choose Operators | Keying | Color Suppression.

Hint: You can also right-click/**CONTROL**-click the Sheep layer and choose Operators | Keying | Color Suppression.

These controls are used to suppress colors, shift hues and change individual color, saturation and luminance channels.

- 2. Identify the Color Suppression Target:
 - a) Click the Color Suppression Target picker.

b) In the viewport, click on the green spill; the front left leg is a good area.

- 3. Determine the color range that needs to be suppressed:
 - a) Click the Color Plot picker.

b) In the viewport, click on the green spill, near the area that was chosen as the Suppression Target.

A black line appears in the hue spectrum, indicating the plotted color that needs to be suppressed.

Hint: Hint: To have the Plot color match the color in the Color Suppression Target color box, click the Color Suppression Target color box and note the red, green and blue values then, click the Plot color box and enter the same red, green, and blue values.

- **4.** Adjust the Color Suppression curve to remove the green spill.
 - a) Click on the Suppression curve to add a new point where it intersects with the plotted color indicator.

b) Drag the new point down to the first gray horizontal line, so the Suppression value is about 38.00.

Note: The point displays its coordinates when it is selected.

Most of the spill from around the sheep is removed, but removing the green spill created a light fringe around the edges.

- 5. Adjust the Luminance channel to make the edge appear more natural:
 - a) Click the Lum channel to show the Luminance curve.

- b) Click on the Luminance curve to add a new point where it intersects with the plotted color indicator.
- c) Drag the new point down to the first gray horizontal line, so the Luminance value is about 40.00.

The Luminance on the edges of the sheep and grass is reduced.

Improve the Matte

Use Matte Controls to Shrink the Matte edge by 1 pixel.

- 6. Add a Matte Control operator to the sheep layer:
 - a) Ensure the Sheep layer is selected in the Workspace panel.
 - b) In the Operators panel (F5), click Keying, and then CTRL-click / 第-click Matte Controls.
 - c) In the Matte Controls panel, enable Shrink.

d) Make sure the Shrink Width is set to 1 pixel.

Pixels are removed from the edge of the matte, cutting away at the remaining fringe or spill.

- 7. Go to the first frame (HOME), and play the clip (SPACEBAR) to view the result.

 The sheep now appears to be standing on an ocean cliff.
- **8.** (Optional) Save the workspace:
 - a) Choose File | Save Workspace (CTRL+S / ૠ+S) to open the Save Workspace dialog.
 - **b)** Set a filename and directory for the workspace, and then click OK (**ENTER** / **RETURN**).
- 9. Choose File | Close Workspace (CTRL+W / ૠ+W) to close the workspace.

Using the Discreet Keyer

Lesson 35

In this lesson, use the Discreet Keyer to composite an actor onto a tropical sunset.

Overview

In Lesson 2, you made a composite using an image that had a defined alpha channel—a grayscale channel of the image in which white represents opacity and black represents transparency. In this lesson, use the Discreet Keyer to generate a matte to build a composite. A matte, like an alpha channel, is a grayscale version of a clip that defines opacity and transparency, except it is not a channel belonging to the footage used in a layer. Instead, it is an image process stored with the layer.

In this lesson:

- Use the Discreet Keyer to generate a matte for a layer.
- Adjust the tolerance and softness of the key to produce a more realistic composite.
- Use the color suppression tools to eliminate spill while retaining image detail.
- Use the Color Corrector to balance colors in the foreground clip with colors in the background clip.

Open the 35_UsingTheDiscreetKeyer.mov file in the 35_UsingTheDiscreetKeyer folder and preview the result.

Need Help?

If you need help completing this lesson, save and close your workspace, and then open the 35_UsingTheDiscreetKeyer.cws file as a reference.

Create a Composite Branch

Create a composite branch and import the footage.

- 1. Check the Combustion preferences. For instructions, see "Setting the Preferences" on page 3.
- 2. Choose File New or press CTRL+N (Windows) or #+N (Macintosh) and create a branch with the following properties:
 - Type: Composite
 - Format: NTSC D1
 - · Duration: 60 frames
 - Bit Depth: 8 Bit
 - · Mode: 3D

- 3. Select the single-viewport layout.
 - 4. In the Workspace panel (F3), right-click / CONTROL-click the Composite, and choose Import Footage (CTRL+I / **38**+1).
 - 5. From the 35_UsingTheDiscreetKeyer folder, select Sky.png, double-click the Dimitri folder, click the DA[##].png image sequence, and click OK (ENTER / RETURN).

- **6.** In the Workspace panel, rename the Da00 layer "Actor".
- 7. Choose Window | Fit in Window, or right-click / CONTROL-click the viewport and choose Fit in Window.
- 8. Play the clip (SPACEBAR).

The clip features an actor walking across a blue screen. Use the Discreet Keyer to key out the blue screen to see the sky image.

Generate a Matte Using the YUV Mode

Apply a Discreet Keyer to the Actor layer and generate the matte using the YUV Keyer mode. This Keyer mode lets you extract a customized range of colors from the Actor layer, enabling the Sky layer to show through.

- 1. Apply the Discreet Keyer operator:
 - a) In the Workspace panel (F3), make sure the Actor layer is selected.
 - b) In the Operators panel (F5), click Keying, and then CTRL-click / ₩-click Discreet Keyer.

Note: You can also right-click / **CONTROL**-click the Actor layer and choose Operators I Keying I Discreet Keyer.

The Keyer Controls panel appears. In the viewport, you can see some of the sky image. This is because the Discreet Keyer automatically generates a matte by assigning transparency to the most common color in the clip.

Hint: To prevent this default behavior, you can disable Guess Key Color in the Setup controls.

- 2. Reset the Discreet Keyer so you can build the matte:
 - a) In the Keyer Controls panel, click Key to view the Key controls.

b) Click Result to see the result of the Discreet Keyer in the viewport.

c) To reset the Discreet Keyer, click Reset All.

The blue screen reappears in the viewport as the Key Color and other controls are reset.

3. From the Keyer Mode list, select YUV.

Note: YUV is a color model used in broadcast video that is similar to the RGB color model used in computer displays. YUV builds a key using the luminance and chrominance channels of the image. For information on the other available Keyer modes, see the Combustion *User's Guide*.

- 4. Although you can pull a key at any frame, go to frame 25 (/) where the actor is facing the camera.
- 5. Disable Animate, if it is enabled.

Although the Discreet Keyer can be animated, disable Animate to prevent animating the key accidentally.

- **6.** Define the color to key out from the front clip. This is called "setting the tolerance for the key":
 - a) Click the Key Color picker 🕖 .

b) In the viewport, drag the color picker around the blue screen.

The Discreet Keyer calculates an average color from the sampled area, and most of the blue screen is keyed out.

Notice the lines that appear in the Y, B-Y, and R-Y channels in the Key controls. The blue lines represent the tolerance. The yellow lines represent the softness range, which generates gray at the edge of the matte.

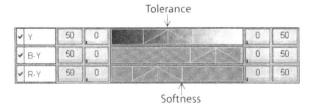

- 7. Increase the tolerance range to increase the range of blue keyed out:
 - a) Click the Add Tolerance color picker.

b) While avoiding the blue spill around the actor's hair, drag the picker over areas in the viewport where the blue screen shows through. You deal with the blue spill later in the lesson.

The tolerance range increases to include the selected colors. All colors in the range are keyed out.

Note: Depending on where you sampled, your values may not match those shown here.

c) When you have keyed out all the blue screen around the actor, click the Add Tolerance color picker again to deselect it.

View the Matte

When using the Discreet Keyer, it is helpful to change the viewport layout so you can view the result composite and the generated matte at the same time. This lets you make subtle changes while viewing the results.

1. Select the four-viewport layout.

The actor appears in four viewports.

2. Set the two left viewports to show a magnified image of the actor's hair:

R

a) In the Toolbar (F2), make sure the Arrow tool is selected, and click the upper left viewport.

Hint: Press [to cycle viewports.

Q

b) In the Toolbar, click the Magnify tool and then click the hair at the top of the actor's head a couple of times to zoom in.

The viewport shows a magnified view of the actor's hair.

Hint: To zoom out, click Magnify and then ALT-click / OPTION-click in the viewport.

c) Repeat steps a) and b) to zoom in on the actor's hair in the lower left viewport.

Note: Use the Pan button to position the image in the viewport, if necessary.

- 3. Set the two right viewports to show the full image:
 - a) In the Toolbar, click the Arrow tool and click the upper right viewport.
 - b) Choose Window | Fit in Window, or right-click / CONTROL-click the viewport and choose Fit in Window.
 - c) Repeat steps a) and b) to fit the image into the lower right viewport.

All four viewports show the result of the composite.

- **4.** Change the display in the upper right viewport to show the result of the Discreet Keyer:
 - a) Click the upper right viewport (or press [to cycle to the right viewport).
 - **b)** In the Workspace panel (**F3**), select the Discreet Keyer operator.

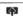

c) Click Send Up.

Clicking Send Up makes the Discreet Keyer operator the current operator for the selected viewport. The result is the keyed front clip as defined by the matte over an empty background.

5. Right-click / CONTROL-click the upper right viewport and choose View Mode | Alpha (CTRL+SHIFT+8 / **%**+SHIFT+8) to show the matte in the selected viewport.

The upper right viewport now shows the Actor layer's matte. The black areas in the matte represent transparent pixels, the white areas represent opaque pixels, and the gray areas at the edge represent semitransparent pixels.

6. Repeat steps 4 and 5 to show the matte in the upper left viewport.

Add Softness to the Matte

Adjust the softness to improve the matte. Softness is the range of semitransparent pixels at the edge of the matte which help to create a more realistic composite. With the four-viewport layout, you can see the effect of adjusting the softness on both the matte and the composite.

- 1. Adjust the softness of the key:
 - a) Click the lower left viewport.

b) Click the Add Softness picker.

c) In the lower left viewport, click the pixels at the edge of the actor's hair and drag slightly towards the center. Only drag by a small amount to stay at the edge of the hair.

As you sample pixels, more gray appears at the edge of the matte (in the upper viewports) and the softness range (the area between the yellow and blue lines) increases.

Y	10	40		19	31		
⊌ B-Y	59	12		0	50		
₹ R-Y	50	0		9	53		

Note: Depending on where you sampled, your values may not match those shown here.

d) Continue sampling until you are satisfied with result.

You use the color suppression curves later in the lesson to suppress the remaining blue spill.

e) Click the Add Softness picker again to disable it.

2. Examine the matte in the upper right viewport.

In this case, a good matte keeps the semitransparent pixels at the edge of the actor. Gray areas away from the edge in the actor's shoulder or face, for example, indicate potential problem areas. If there are no gray areas inside the actor on your matte, you can skip steps 3 and 4.

- 3. Use the Plot picker to sample the color value in the problem area:
 - a) Click the upper right viewport.
 - **b)** Click the Plot picker

c) Click inside the gray areas in the actor.

The red line that appears in each color channel indicating the color of the sampled pixel.

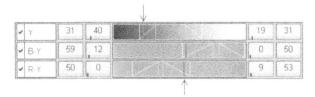

Note: Depending on where you sampled, your values may not match those shown here.

- **4.** Adjust the softness range to exclude the plotted values:
 - a) In each color channel, drag the yellow line that is closest to the red line to match the position of the red line.
 - **b)** Check the result of the adjustment in the viewports.

The matte changes as you adjust the softness range in the color channels. Although the gray areas in the body are gone, the softness at the edge of the matte has also been lost. Because the gray areas do not cause major problems with the key, you can leave them in.

c) Press CTRL+Z / \mathbb{H}+Z to undo the changes you made to the softness range in the color channels.

Hint: You can also use the Remove Softness picker to remove softness from areas of the matte. To remove problem areas without affecting softness, use a mask. For more information, see "Apply a Mask Around the Actress" on page 359.

- 5. Switch to the two-viewport layout:
 - a) Click the lower right viewport that is showing the entire composite.
- =
- b) Select the two-viewport layout.

The left viewport now shows this image. The right viewport shows the layer's matte.

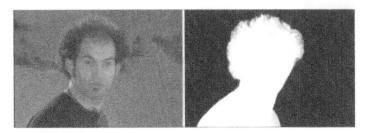

Use the Histogram to Improve the Matte

Using the matte histogram, adjust the luminance of the matte to remove gray areas from regions that should be either black or white. In the exercise, we only reset to black, i.e. make semi-transparent pixels transparent.

1. In the Keyer Controls panel, click Matte to access the Matte controls, including the histogram.

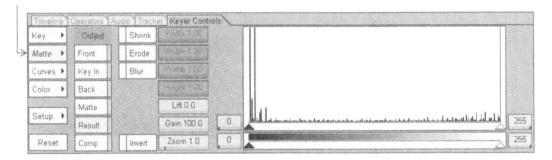

The histogram shows the distribution of luminance values in the matte from black (0) to white (255). Peaks towards the black represent gray in the black regions of the matte.

Depending on your matte, your histogram may not match the one shown here.

This remaps all pixels with luminance values lower than (to the left of) the slider as black (completely transparent).

Hint: To return a little softness at the edge of the matte, you can position the slider just inside the peak's range. Always verify the results of your adjustments in the viewport.

Adjust the Color Suppression Curves

Use the color suppression curves to remove the remaining blue spill around the actor.

- 1. Set the right viewport to show Normal view:
 - a) In the right viewport, right-click / CONTROL-click and choose View Mode | Normal from the menu (CTRL+SHIFT+1 / %+SHIFT+1).
- Q
- b) In the Toolbar (F2), use the Magnify tool to magnify the blue spill in the actor's hair.

The spill is now easier to see over the black background in the right viewport.

2. Click Color to view the Color controls.

You use these controls to apply color suppression and hue shifts, as well as change individual color channels in an image. The histogram here represents the color distribution for the foreground clip.

- 3. Find the color range that needs to be suppressed using the Plot tool:
 - a) Click the Plot picker.

b) In the right viewport, drag the Plot picker through the blue spill in the actor's hair.

A red line appears in the hue spectrum, showing the color of the selected pixel. As you drag the picker through the hair, the red line moves between the blue and magenta areas of the spectrum, indicating the area that needs to be suppressed.

Hint: This range is also indicated by the third peak in the histogram. If you cannot see the histogram clearly, adjust the Histogram Zoom field.

- **4.** Adjust the color suppression curve to remove the blue spill:
 - a) Click Supp to show the color suppression curve. All points are selected by default.
 - b) Click away from the curve in the hue spectrum to deselect the color points.

c) CTRL-click / % -click the magenta and blue color points to select them.

Each point displays its coordinates when you select it. These coordinates show the point's hue value and suppression value, respectively.

d) Drag both points down to the first gray horizontal line, so their suppression values are about 25.

Most of the spill from around the actor's hair is removed, although the outer fringe of hair still has an unnatural tint.

Hint: To reset the selected curve to its original horizontal position, click Reset Selected.

- 5. Adjust the blue channel to make the hair appear more natural:
 - a) Click the Blue channel to show the blue color curve.
 - b) CTRL-click / % -click the magenta and blue color points to select them.

c) Drag these points down until the hair is a more natural shade of brown (about halfway to the first gray horizontal line).

Hint: You can also change the red and green color channels, as well as the image's hue, saturation, and luminance, by adjusting their curves in the hue spectrum.

6. Remove the greenish tinge around the actor's body that remains from the suppression of the other colors:

- a) In the right viewport, scrub the Pan button to show the actor's left shoulder.
- b) With the Plot picker still enabled, drag the picker around the shoulder to plot the colors in the spill.

The colors plotted lie in the dark blue area of the hue spectrum. Adjust the green color curve at this point to remove the green spill.

c) Click the Green channel to show the green color curve.

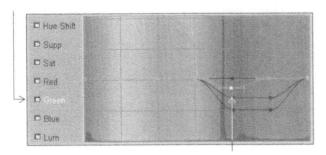

- d) Select the color point in the dark blue area of the spectrum and drag this point down until the greenish tinge is gone.
- 7. Continue adjusting the various color curves until you are satisfied with the result.

Color Correct the Front Clip

Although you removed the spill around the actor, he looks pale in contrast to the red and orange tones of the sunset. Apply the Discreet Color Corrector operator to adjust the actor's colors so they better match the sky image.

- 1. Change the viewport layout:
 - a) Click the left viewport.

- b) Select the single-viewport layout.
- c) Click Home.
- 2. In the Workspace panel (F3), select the Actor layer.
- 3. In the Operators panel (F5), click Color Correction, and then CTRL-click / %-click Discreet CC Basics, or right-click / CONTROL-click the Actor layer and choose Operators | Color Correction | Discreet CC Basics.

Hint: The Discreet CC Basics operator is a subset of the Discreet Color Corrector operator. For more information, see Lesson 33, "Using the Discreet Color Corrector."

4. Set the Basics controls:

a) Click Basics to show the Basics controls.

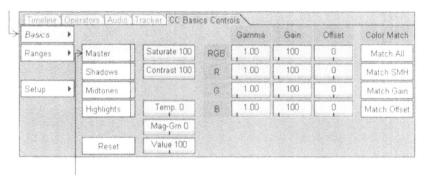

b) Click Master to change the clip's shadows, midtones, and highlights at the same time.

You can quickly change the gamma, gain, and offset for the RGB color channels using the Basics controls. Since the background image contains a lot of red and orange tones, you increase the red and green gain in the image and reduce the blue gain.

- 5. In the Basics controls, change the gain to color correct the image:
 - a) Set the R Gain to 110 to boost the red tones in the image.
 - **b)** Set the G Gain to 108 to boost the green tones in the image.
 - c) Set the B Gain to 85 to reduce the blue tones in the image.
- **6.** Go to the first frame (**HOME**), and play the clip (**SPACEBAR**) to view the result.

The actor now appears naturally lit by the setting sun throughout the clip.

- **7.** (Optional) Save the workspace:
 - a) Choose File | Save Workspace (CTRL+S / 38+S) to open the Save Workspace dialog.
 - b) Set a filename and directory for the workspace, and then click OK (ENTER / RETURN).
- 8. Choose File | Close Workspace (CTRL+W / ℜ+W) to close the workspace.

a State of the

and the second of the second o

e de la completa de la co La completa de la co

The second secon

en de la companya de la co

Nesting Composites

Part IX

36	Basic Nesting	423
37	Creating a Motion Blur	435

Basic Nesting Lesson 36

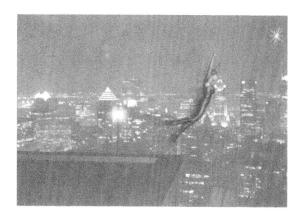

In this lesson, use nesting to apply common or shared operators to various layers of an animation.

Overview

In this lesson, nest a set of selected layers inside a composite, then add an operator as a common operator for the nested layers. The resulting nested layers are still 2D layers arranged in 3D space (if in 3D compositing mode) that you can access within a hierarchy branch. However, in the context of the higher-level composite, the nested layers are regarded as a single 2D layer. You can also nest a composite if you plan to use all of its layers as a single 2D layer.

In this lesson:

- Nest two layers to apply a common Lens Flare operator.
- Animate the lens flare properties.
- Adjust the pivot point of a layer and animate its position and rotation.
- Nest two layers to apply a common Motion Blur operator.
- · Change the properties of the Motion Blur operator.
- Maximize workflow efficiency.

Open the 36_BasicNesting.mov file in the 36_BasicNesting folder and preview the result.

Need Help?

If you need help completing this lesson, save and close your workspace, and then open the 36_BasicNesting.cws file as a reference.

Create a Composite

Create a composite branch and import the footage for the composite.

- 1. Check the Combustion preferences. For instructions, see "Setting the Preferences" on page 3.
- 2. Choose File | New or press CTRL+N (Windows) or ૠ+N (Macintosh) to open the New dialog and create a branch with the following properties:
 - Type: Composite
 - Name: 36_BasicNesting
 - Format: NTSC DV
 - Duration: 60 frames
 - Bit Depth: 8 Bit
 - · Mode: 3D
 - Background: Black

3. Select the single-viewport layout.

- **4.** In the Workspace panel (**F3**), right-click / **CONTROL**-click the 36_BasicNesting composite and choose Import Footage (or press **CTRL+I** / **%+I**).
- 5. In the Import Footage dialog, locate and open the 36_BasicNesting folder.
- **6.** Scrub the 36_BasicNesting.mov thumbnail to preview the result clip.

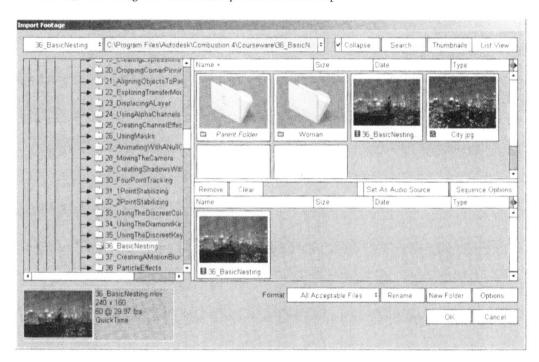

- 7. Import the footage as follows:
 - a) Click the City.jpg image and CTRL-click / ૠ-click the Roof.png image.
 - b) Double-click the Woman folder and click the girl[####].png image sequence.
 - c) Double-click the *Parent* folder and CTRL-click / 第-click the *Crate.png* image and click OK (ENTER / RETURN).
- 8. In the Workspace panel, rename the girl0000 layer "Woman".

Create a Lens Flare Effect for the Lamp

The lamp in the scene is part of the Roof layer. Since the Roof layer has an alpha channel, adding a lens flare to the Roof layer does not allow the flare effect to propagate onto the city background. You need to nest the Roof and City layers into one layer for the lens flare to affect both layers.

- 1. Nest the Roof and City layers:
 - a) In the Workspace panel, select the Roof layer and SHIFT-click the City layer and choose Object | Nesting (CTRL+E / 98+E).
 - **b)** In the Nesting Options dialog, type "Background" as the Composite Name and click Selected Layers to nest the layers into a new composite.

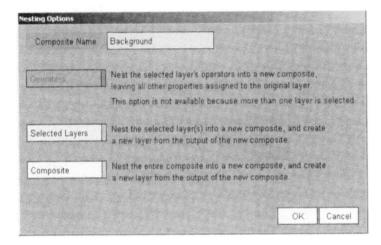

c) Click OK (ENTER / RETURN).

The woman and the crate are no longer visible in the viewport because the new Background layer is the top layer in the workspace. You need to rearrange the layers.

- 2. In the Workspace panel, drag the Background layer below the Woman layer.
- **3.** Add a Lens Flare operator to the Background layer:
 - a) In the Operators panel (F5), select the Stylize category and CTRL-click/ %-click Lens Flare.
 - b) In the Workspace panel, select the Lens Flare operator.
 - c) In the Lens Flare Controls panel, set Strength to 12%.

- d) Click the Color box and set the Red, Green, and Blue values to 70%.
- e) From the Flare Type list, select 105mm Prime.

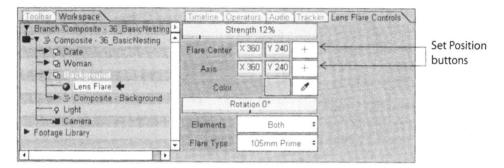

- 4. Animate the Lens Flare axis:
 - a) Click the Flare Center Set Position button and then click on the lamp in the scene.
 - b) Click the Axis Set Position button and click the center left edge of the viewport.
 - c) Enable Animate (A).
 - d) Go to the last frame (END) and click the top of the viewport above the lamp.
 - e) Disable Animate (A).
 - f) Click the Axis Set Position button to deselect it.

Note: If you have time, animate the Strength of the Lens Flare between frames 14 and 19 to dim the effect as the woman runs in front of the lamp.

5. Play the animation (**SPACEBAR**).

Note: If you do not have enough RAM to view the clip in real time, select Medium or Draft from the Display Quality list to the right of the playback controls. This lowers the file resolution in the viewport and allows you to cache more frames.

Animate the Crate

Animate the crate to make the woman kick it and send it tumbling down from the roof as she runs to jump off the building.

1. In the Workspace panel, select the Crate layer.

- 2. Change the pivot point of the Crate layer:
 - a) In the Composite Controls panel, select Transform.
 - b) Set the X Pivot to -80 and the Y Pivot to -125.

By default, the pivot point is placed in the center of the layer. Moving it off the Crate layer creates a "pole" around which the Crate layer rotates.

- 3. Animate the Crate layer:
 - a) Enable Animate (A).
 - b) Go to frame 14.
 - c) In the Composite Controls panel, set the X Position to 80, the Y Position to 30, and the Z Rotation to -30.
- 4. Scrub the animation slider bar.

The crate is animated between frames 1 and 14. You need to adjust the animation so the crates is animated from frame 10 on, when the woman kicks it.

- 5. Adjust the animation of the Crate layer via the Timeline:
 - a) In the Timeline (F4), click Overview and Frame All.
 - **b)** Drag the Transformation key at frame 1 to frame 10.

As you drag, the frame number and value appear in the Timeline graph in parenthesis, making it easy to move the keyframe to the desired position.

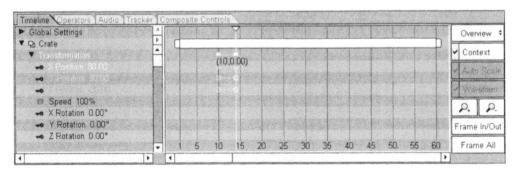

The animation is applied from frame 10 to frame 14.

- 6. Animate the Crate layer from frame 18 to the end of the clip via the Composite Controls panel:
 - a) Show the Composite Controls panel (F8).
 - b) Go to Frame 18 and set the X Position to 140, the Y Position to 17, and the Z Rotation to -77.
 - c) Go to Frame 22 and set the X Position to 171, the Y Position to 24, and the Z Rotation to -126.
 - d) Go to Frame 33 and set the X Position to 217, the Y Position to -7, and the Z Rotation to -293.
 - e) Go to the last frame (END) and set the X Position to 242, the Y Position to -210, and the Z Rotation to -400.
 - f) Disable Animate (A).

Note: Experiment with various values to create the tumbling effect of your choice.

Add a Motion Blur Effect to the Woman and Crate

Create a motion blur effect for the crate and the woman. If you apply a motion blur to the Crate layer at this point, it would have no effect because, even though you animated the Crate layer, the underlying pixels are not animated (remember that this is a still image). On the other hand, if you apply a motion blur to the Woman layer, it would work since the footage of the Woman layer is an image sequence. As for the lens flare effect, you need to nest the Crate and Woman layers first, then add a Motion Blur operator to the nested layer.

- 1. Nest the Crate and Woman layers:
 - a) In the Workspace panel, with the Crate layer still selected, SHIFT-click the Woman layer and choose Object | Nesting (CTRL+E / %+E).
 - **b)** In the Nesting Options dialog, type "Action Sequence" as the Composite Name and click Selected Layers to nest the layers into a new composite, then click OK (ENTER / RETURN).
- 2. Add a Motion Blur operator to the Action Sequence layer:
 - a) In the Workspace panel, select the Action Sequence layer.
 - b) In the Operators panel (F5), select the Blur/Sharpen category and CTRL-click/ %-click Motion Blur.

- 3. Change the Motion Blur settings:
 - a) In the Motion Blur Controls panel, set Samples to 24 to create a softer effect.

The value in the Samples field defines the number of frames or sub-frame instances blended together to blur the frame. Notice that there are 24 vertical green lines. Each line represents one sample. The more samples, the smoother the effect, but the more processing time is required.

- b) Set Phase to -100 to place the motion blur before the current frame.
- c) Set Shutter to 12 to increase the size of the motion blur.

Shutter defines the number of frames over which the samples are taken.

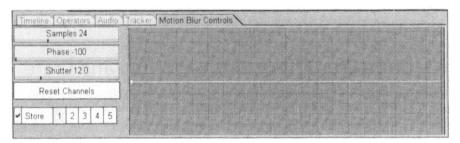

Note: Changing the Shutter value does not affect the appearance of the graph. However, the width of the graph, although unchanged in appearance, now represents 12 frames of the clip.

d) In the Motion Blur graph, click the right end of the white line to add a control point and drag the control point up.

The vertical axis represents the weight (opacity) of the samples and the horizontal axis represents the position of the samples.

e) Click the left end of the white line and drag down.

f) Adjust the Bezier handles as shown in the following figure to give more motion emphasis to the front and create a fading tail effect.

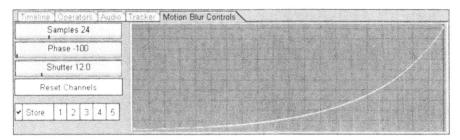

4. Play the animation (**SPACEBAR**).

Notice that the woman and crate become too transparent toward the end of the animation.

- **5.** Make a copy of the Crate and Woman layers so the front of the motion is opaque and the trail of the motion is transparent:
 - a) In the Workspace panel, expand the Action Sequence composite.

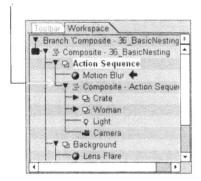

36 Basic Nesting

Note: Notice that you still have access to the original layers, even though you have nested them earlier in the lesson.

- b) Drag a selection box around the Crate and Woman layers to select both layers.
- c) Choose Edit | Copy (CTRL+C / 38+C).
- d) Select the 36_BasicNesting composite.
- e) Choose Edit | Paste (CTRL+V / 第+V).

The copy of the Crate layer and Woman layer are the top layers in the composite.

6. Play the animation (**SPACEBAR**).

Hint: To reduce the processing time required for a motion blur with a high sample value, disable Anti-Aliasing in the Settings controls of the composite in the Composite Controls panel.

Notice that only the motion blur trail is transparent throughout the clip.

Clean up the Composite

Since the Crate layer and Woman layer copies use the same footage as their original layers, you do not need to keep a duplicate of the footage. You can connect the footage of the original layers to the copies of the layers. In this last section, use Schematic view to maximize workflow efficiency.

1. Choose Window | Schematic or click the Schematic View button.

Hint: You can also press either F12 or ~ to show the Schematic view.

The Schematic view is a flowchart style view of the workspace. It displays a series of nodes. Each operator in the Workspace panel is represented by a node in the Schematic view. The arrows (or edges) connect the nodes and show the hierarchy of the composite.

- 2. Delete the Crate footage operator of the Crate layer via the Schematic view:
 - a) Click the edge connecting the Crate layer node to the Crate footage operator node.

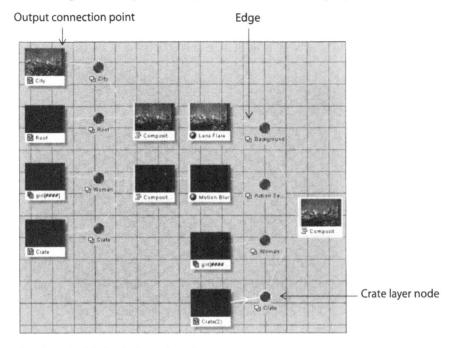

The edge is highlighted when selected.

b) Drag the edge to the output connection point of the Crate footage operator node of the original Crate layer.

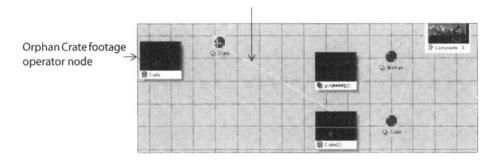

- c) Right-click / CONTROL-click the orphan Crate footage operator node and choose Delete.
 - Hint: To delete a node, you can also click the node and press DELETE.
- d) Click the edge connecting the Woman layer node to the girl[####] footage operator node.
- e) Drag the edge to the output connection point of the girl[####] footage operator node of the original Woman layer.

- f) Right-click / CONTROL-click the orphan girl[####] footage operator node and choose Delete.
- 3. Choose Window | Schematic (F12 or ~) to return to the viewport display.
- 4. Play the clip (SPACEBAR).

Note: If you do not have enough RAM to view the result in real time, render the clip.

- **5.** (Optional) Save the workspace:
 - a) Choose File | Save Workspace (CTRL+S / %+S) to open the Save Workspace dialog.
 - b) Set a filename and directory for the workspace, and then click OK (ENTER / RETURN).
- **6.** Choose File | Close Workspace (**CTRL+W** / **%+W**) to close the workspace.

Creating a Motion Blur

Lesson 37

In this lesson, add a Motion Blur operator to a nested composite to enhance the look of an animation.

Overview

A Motion Blur operator samples frames on either side of the current frame and blends them together. This blending of frames creates the same effect as shooting with a camera that has a slow shutter speed. Depending on where in the composite you add a Motion Blur operator, it can produce different effects. For example, you can blur the motion in a shot or you can blur the motion of a layer as it moves across the frame.

In this lesson:

- Nest a composite via the Schematic view.
- Apply Motion Blur operator to the layer whose source is the nested composite.
- Modify the settings of the Motion Blur operator.
- Apply a Discreet CC Color Wheel operator.

Open the 37_CreatingAMotionBlur.mov file in the 37_CreatingAMotionBlur folder and preview the result.

Need Help?

If you need help completing this lesson, save and close your workspace, and then open the 37_CreatingAMotionBlur.cws file as a reference.

Open the Workspace

Open the workspace file for this lesson and then import an image.

- 1. Check the Combustion preferences. For instructions, see "Setting the Preferences" on page 3.
- 2. Choose File | Open Workspace, or press CTRL+SHIFT+O (Windows) or **%+SHIFT+O** (Macintosh).
- **3.** In the Open Workspace dialog, locate and open the *37_CreatingAMotionBlur* folder.
- **4.** Select the 37_MotionBlur_start.cws from the 37_CreatingAMotionBlur folder and then click OK (ENTER / RETURN).
- 5. Play the clip (SPACEBAR).

Three fish swim at different speeds. To make the scene more believable, apply a color corrector operator and motion blur operator to the clip.

Note: If you do not have enough RAM to view the clip in real time, select Medium from the Display Quality list to the right of the playback controls. With Medium selected, the clip is processed much more quickly. When you examine a single frame, select Best from the Display Quality list.

Nest the Composite

In Combustion, you can nest composites or layers inside other composite operators. Like other typical composites, a nested composite is also made of 2D layers arranged in 2D or 3D space. However, in the context of the higher-level composite, the nested composite is a single 2D layer.

- 1. Show the Schematic view (or press **F12** or ~).
- 2. Right-click / CONTROL-click the viewport and choose Flow Direction Left.

The Schematic shows the six layer nodes (and their footage nodes) that comprise the 37_MotionBlur_start composite.

Hint: You can also choose Window | Schematic, or right-click / **CONTROL**-click an empty area of the viewport and select Schematic from the context menu, to access the Schematic view.

3. Nest the composite:

a) In the Schematic view, right-click / CONTROL-click the composite operator node and choose Nesting.

b) In the Nesting dialog, select Composite and type "37_CreatingAMotionBlur" in the Composite Name field.

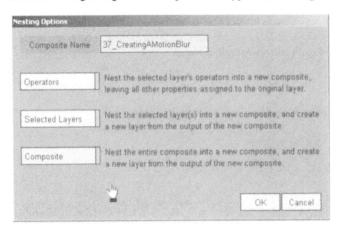

- c) Click OK (ENTER / RETURN).
- 4. Press L to rearrange all the nodes in the Schematic.

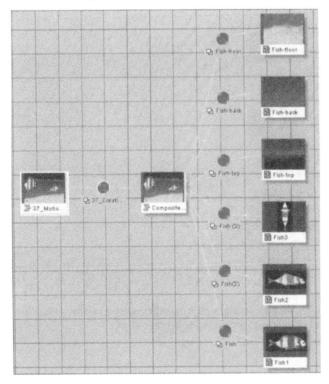

The original composite is nested into a new composite, and a new layer is created from the output of the new composite. The nested composite operator contains all the original layers.

Note: You can also nest layers or a composite using the Workspace panel.

Add a Motion Blur Operator

Once the composite is nested, add a Motion Blur operator to the nested composite. The motion blur is added to all of the layers that comprise the composite.

1. In the Schematic, right-click / CONTROL-click the new 37_MotionBlur_start layer node and choose Operators | Blur/Sharpen | Motion Blur.

A Motion Blur operator is added to the nested composite.

2. Press L to rearrange all the nodes in the Schematic.

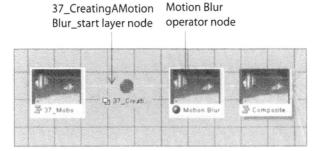

3. In the Workspace panel (**F3**), double-click the 37_MotionBlur_start composite.

The composite is displayed in Camera view.

4. Go to frame (/) 5.

The fish that is mostly affected by the blur is the fish that changes position drastically from frame to frame. The water environment is not blurred because it contains very little movement.

Note: The Motion Blur filter can be process-intensive, and may take a few seconds to render. The system is processing an effect when the Working icon is visible in the lower right corner of the screen.

- 5. Ensure Animate is disabled.
- **6.** In the Workspace panel, select the Motion Blur operator.

7. In the Motion Blur Controls panel (F8), set the Phase to -100.

Phase defines the direction of the blur. A value of -100 takes all samples behind the current frame. A value of 0 centers the samples around the current frame, and a value of 100 takes all samples ahead of the current frame.

The value in the Samples field defines the number of frames or sub-frame instances blended together to blur the frame. The default Samples setting is 16. Notice that there are 16 vertical green lines. Each line represents one sample. In the viewport, the motion blur is much smoother. The more samples, the smoother the effect, but the more processing time is required.

8. Set the Shutter to 2.

The 16 samples are distributed over 2 frames.

Shutter defines the number of frames over which the samples are taken. By default, the samples are evenly distributed throughout this duration. Although the appearance of the graph does not change, it now represents two frames of the clip rather a half a frame.

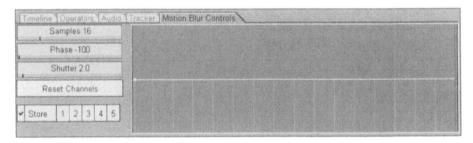

Hint: CTRL-drag / %-drag over the Motion Blur graph to change its scale.

A motion trail is generated behind the position of the Fish at each frame. In the Graph, the vertical red line represents the phase of the motion blur.

Customize the Motion Blur

To further refine the Motion Blur, use the Motion Blur graph to customize the weight of the samples. The graph represents the samples, their relative weight (opacity), and distribution, and position relative to the phase. Adjust the Weight curve so the first sample is heavier than the second sample, which is heavier than the third sample, and so on.

1. Adjust the Weight curve to reduce the weight of the layers from the first sample to the sixteenth:

Note: For the motion blur samples, the right side of the graph is the leading edge of the motion blur.

- a) Position the cursor over the right side of the Weight curve. When the cursor changes to a green cross hair -: , click to add a control point on the top graph line.
- b) Drag the new point to approximately (20, 90).

The first coordinate defines the position of the sample relative to the shutter duration. The second coordinate is the Weight value for the sample at that position.

2. Drag the default point on the left side of the curve to (0,0).

In the viewport, the leading sample is heavier than the trailing samples. On the fish with the most movement, the heaviest motion blur appears.

- 3. Play the clip (SPACEBAR) to preview the result.
- **4.** (Optional) If you do not have enough RAM to view the result in real time, render the clip.

Color Correct the Clip

Apply a Discreet CC Color Wheel to the composite to make the scene more realistic.

- 1. In the Workspace panel (F3), right-click / CONTROL-click the "37_MotionBlur_start" layer and choose Operators | Color Correction | Discreet CC Color Wheel.
- 2. In the CC Color Wheel Controls panel (F8), click and drag the square in the center of the wheel to set the following values:
 - a) Hue Tint: 209.

b) Strength: 68.5.

In the viewport, the color correction is applied to the nested composite (like the Motion Blur operator).

- 3. Play the clip (SPACEBAR).
- **4.** (Optional) If you do not have enough RAM to view the result in real time, render the clip. A greater sense of realism and fluid motion is given to the fish in the clip.
- 5. (Optional) Save the workspace:
 - a) Choose File | Save Workspace (CTRL+S / 38+S) to open the Save Workspace dialog.
 - b) Set a filename and directory for the workspace, and then click OK (ENTER / RETURN).
- 6. Choose File | Close Workspace (CTRL+W / ૠ+W) to close the workspace.

Additional Topics

Part X

38	Applying and Tracking a Particle Emitter	445
39	Creating Particle Effects	453
40	Creating Capsules	467
41	Building G-Buffers	475
42	Morphing	483

o yak turokilakik

Applying and Tracking a Particle Emitter

Lesson 38

In this lesson, apply and track a particle
emitter to video footage. Modify the emitter
and particle appearance and behavior. Add
and modify a particle deflector.

Overview

Use the particles operator on 2D to create random, natural-organic or stylized special effects. Track a smoke emitter to match-move a camera pan in a kitchen scene. Change the emitter and particle behaviors to better integrate with the environment. Add a deflector so the particles interact realistically with the 2D surroundings.

In this lesson:

- Apply an emitter to footage.
- Change the appearance and behavior of a particle.
- Change the appearance and behavior of the emitter.
- · Change the appearance and behavior of a particle.
- Apply a particle deflector to bounce and contain the particles.

Open the 38_ApplyingTrackingEmitter.mov file in the 38_ApplyingTrackingParticleEmitter folder and preview the

Need Help?

If you need help completing this lesson, save and close your workspace, and then open the 38 Applying Tracking Emitter. cws file as a reference.

Open Footage into a Composite

Create a composite branch by opening footage.

- 1. Check the Combustion preferences. For instructions, see "Setting the Preferences" on page 3.
- 2. Choose File | Open or press CTRL+O (Windows) or %+O (Macintosh) and locate and open the 38_ApplyingTrackingParticleEmitter folder.
- 3. In the Open dialog, double-click the Toast folder and double-click the toast[####].png image sequence.
- 4. In the Open Footage dialog, click 2D composite to create a 2D composite with the selected footage and click OK (ENTER / RETURN).

- 5. Select the single-viewport layout to show the clip.
 - **6.** Play the clip (**SPACEBAR**).

The clip shows a camera pan of a toaster on a kitchen counter.

Create a Smoke Effect

Browse the emitter library and choose an emitter that can be used for wispy black smoke. Apply the emitter to the footage.

- 1. Go to frame 1 (HOME).
- 2. Add a Particles operator to the toast layer:
 - a) In the Workspace panel, make sure the toast layer is selected.
 - b) In the Operators panel (F5), CTRL-click / 第-click Particles.
 - A Particles operator is added to the toast layer.

Hint: You can also right-click/ CONTROL-click the toast layer and choose Operators | Particles.

- 3. In the Workspace panel, double-click the Particles operator to make it the current operator and to see its output in the viewport.
- 4. In the Particle Controls panel, click Library.
- 5. Click Load Library.

In the Load Emitter Library dialog, double-click Smoke.elc.

6. In the Particle Library controls, click the right-arrow menu button (▶) and choose Smoke from the list of Libraries.

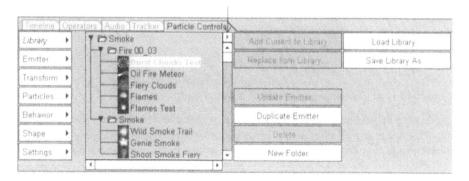

7. Scroll down the Library list to the Wispy smoke 01_09 folder and double-click the Wispy 02 emitter.

Double-clicking an emitter also selects its default Particle tool in the Toolbar.

8. In the viewport, click a point in each end of the right slot of the toaster.

9. Play the clip (SPACEBAR).

The Wispy 02 emitter emits its particle effect but needs to be attached to the toaster.

Track the Smoke to the Toaster

Use the tracker to track a feature of the toaster and apply the tracking data to the emitter.

- 1. Go to the first frame (HOME).
- **2.** In the Toolbar (**F2**), click the Arrow tool (**TAB**) to set the Wispy 02 emitter in edit Object mode.
 - 3. Track the Wispy 02 emitter to the toaster:
 - a) In the Tracker panel (F7), click Position.
 - b) Make sure Mode is set to Relative and Reference is set to Fixed.

With mode set to Relative, the emitter stays where it is; with mode set to Absolute, the emitter snaps to the location of the reference box. With Reference set to Fixed, the reference appears the same on every frame and doesn't change over time. The Tracker does not have to look for a reference match on every frame.

c) In the viewport, click and drag the reference box (the inner box) over the front corner of the right slot of the toaster.

The tracker Preview should show something similar to the following.

- **d)** In the Tracker Panel, click the Analyze Forward button \triangleright to analyze the clip.
 - The Tracker follows the toaster slot throughout the clip.
- e) Click Off when the analysis of the clip is complete to apply the tracking data.
- 4. Play the clip (SPACEBAR).

The Wispy 02 emitter emits its particle effect. The emitter is tracked to the position of the toaster, but the particles behave as if the toaster is moving, not the camera.

Change the Appearance and Behavior of the Smoke

"Attach" the particle to the emitter and adjust the Life Opacity so that the particles appear sooner.

- 1. Go to the last frame (**END**).
- 2. Adjust the properties of the particle:
 - a)) In the Workspace (F3), expand the Wispy 02 emitter and click the particle type New Particle Type.
 - b) In the Particle Controls panel (F8), select Particles.
 - c) Enable Attach to Emitter.

The Particle effect appears over the toaster.

d) In the Particle Controls panel, click and drag the 2nd Opacity tag in the Life Opacity bar to the left to reduce the opacity gradient between the 1st and 2nd tag. The particles appear to be "born" sooner.

Change the Appearance and Behavior of the Emitter

Adjust several properties of the emitter to create a more realistic "burn" smoke.

- 1. Go to the first frame (HOME).
- 2. Adjust several emitter behaviors:
 - a) In the Particle Controls panel, select Emitter.
 - b) Change the Preload Frames to 200.

This starts the emitter 200 frames into emission.

c) Change the Emission Angle to 80 degrees.

This points the emitter straight up.

d) Change the Visibility to 25%.

This reduces the opacity of the emitter.

e) Change the Life to 190%.

This makes the particles last longer, and therefore go higher.

f) Change the Velocity to 130%.

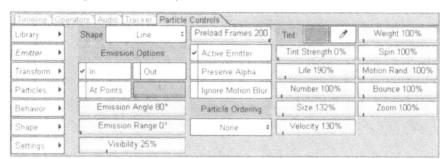

This makes the particles move away from the emitter faster.

- 3. Change the tint of the emitter:
 - a) In the Particle Controls panel, click in the Tint color box.
 - b) In the Color Picker dialog, drag the current color indicator to Black, or Red 0%, Green 0%, Blue 0% and click OK.
 - c) Change the Tint Strength to 60%.
- 4. Play the clip (SPACEBAR).

Now there is a fast, black smoke coming from inside the toaster and going up, out of frame

Add a Deflector to Produce a more Realistic Look

The toaster is partially under an overhanging cupboard. Some of the smoke should be blocked and start to gather under the bottom of the cupboard. Using a particle Deflector to represent objects in the scene can increase realism.

- 1. Go to the first frame (HOME).
- 2. Add a Deflector:
- **≥ a)** In t
 - a) In the Toolbar (F2), click the Deflector tool.
 - b) In the Viewport, click 2 points outside the composite across the bottom of the cupboard.
- c) Click the Arrow tool or press TAB to finish your deflector.

- 3. Change the properties of the Deflector so that not all the smoke gathers under the cupboard:
 - a) In the Deflector panel, change the Bounce to 25%.

The particles hits the Deflector and bounce only slightly appearing to collect under the cupboard.

b) Change the Hits to 95%.

Only 95% of the particles "hits" the Deflector, while 5% goes through the Deflector.

4. Play the clip (SPACEBAR).

The smoke hits the bottom of the cupboard and lingers before billowing out and continuing on up out of frame.

- 5. (Optional) Save the workspace:
 - a) Choose File | Save Workspace (CTRL+S / 第+S) to open the Save Workspace dialog.
 - ${\bf b}$) Set a filename and directory for the workspace, and then click OK (${\bf ENTER}$ / ${\bf RETURN}$).
- **6.** Choose File | Close Workspace (**CTRL+W** / **%+W**) to close the workspace.

Creating Particle Effects

Lesson 39

Apply and track a particle emitter to footage of a moving locomotive. Import an image to create a custom smoke particle shape, and then edit the appearance and behavior of the custom particle types.

Overview

Use the Particles operator to quickly create particles on 2D layers. In this lesson, create and track a particle effect to simulate the smoke of a train's steam engine. First, use a blank emitter library (*.ELC) to create a particle emitter. Next, track the particle emitter to a clip. Customize the appearance of the particles using an imported image.

In this lesson:

- Add a Particle operator to a clip and then track the particle emitter to the clip.
- Import a custom shape for a particle type.
- Animate the size of the particle emitter.
- Edit the behavior and appearance of the particle type.

Open the 39_CreatingParticleEffects.mov file in the 39_CreatingParticleEffects folder and preview the result.

Need Help?

If you need help completing this lesson, save and close your workspace, and then open the 39_CreatingParticleEffects.cws file as a reference.

Open the Workspace

Open the workspace file for this lesson and then import an image.

- 1. Check the Combustion preferences. For instructions, see "Setting the Preferences" on page 3.
- 1. Choose File | Open Workspace, or press CTRL+SHIFT+O / %+SHIFT+O.
- 2. In the Open Workspace dialog, locate and open the 39_CreatingParticleEffects folder.
- 3. Select the starting_point.cws from the Creating Particle Effects folder and then click Open, click OK, or press ENTER / RETURN.

4. Select the single-viewport layout to show the clip.

The footage for this lesson was generated by Autodesk 3ds Max. The artist created a separate rendered item (of a single, white 3D sphere) placed where the smoke should appear out of the engine at any given frame. The rendered element (the TrackMe Footage operator) consists of a white dot on a black background that is ideal for tracking. If you were to track an element on the train (without tracking manually), neither absolute nor relative tracking would produce an ideal track because the perspective in the shot makes the distance between any obvious tracking elements on the train increase over the course of the clip. While this scenario may not be a luxury provided every time to a compositor, it is often a typical workflow to have a 3D rendering application provide frames exclusively to a 2D tracking system in another application such as Combustion.

5. Play the clip (SPACEBAR).

A steam engine behind a fence moves rapidly across a background of mountains and trees.

Note: If you do not have enough RAM to view the clip in real time, select Medium from the Display Quality list to the right of the playback controls. With Medium selected, the clip is processed much more quickly. When you examine a single frame, select Best from the Display Quality list.

Add a Particle Operator

Add a Particle operator to the composite, and then load a blank particle emitter library.

Note: In Combustion, there are several preset smoke particle systems. However, the purpose of this exercise is to show how to create a particle emitter.

1. In the Workspace panel (F3), double-click the TrackMe layer.

The viewport changes to Layer view and displays a black clip with a small white dot in the lower right corner. The dot is the tracking reference point for the lesson.

Note: The white dot was rendered from 3ds Max in a separate pass from the locomotive layer, but originated from the same 3ds Max file. The white dot is timed to the movement of the locomotive.

- 2. Go to the first frame (HOME).
- 3. Make sure Animate is disabled.
- 4. In the Workspace panel, right-click / CONTROL-click the TrackMe layer and choose Operators | Particles.

The Particle Controls panel appears and the operator automatically becomes the current operator. A Particles operator is added to the TrackMe layer in the Workspace panel.

Note: The performance of the particles depends upon the video card installed on your workstation.

Add a Particle Emitter to the Clip

In the previous section you added a Particles operator to the TrackMe layer. However, no particles are added to the clip until you add a library emitter to the Particles operator.

1. In the Particle Controls panel (**F8**), click Library.

The Library contains a list of default emitters.

2. Click Load Library.

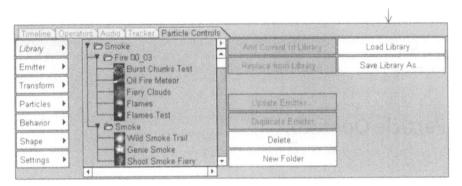

- **3.** In the Load Emitter Library dialog, use the file browser to locate and open the 39_CreatingParticleEffects folder.
- 4. Double-click Blank.elc.

The Blank Emitter library that contains the new emitter is loaded.

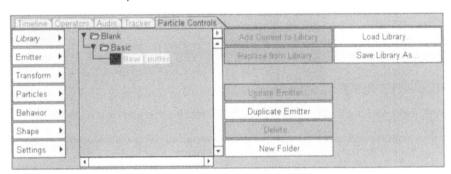

- 5. In the Toolbar (F2), select the Point Emitter.
 - 6. In the viewport, click on the small white dot (tracking reference point).

A single point emitter is added to the clip.

Track the White Dot

1. In the Workspace Panel (F3), select the New Emitter object.

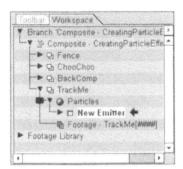

An emitter must be selected in order to activate the tracker.

- **2.** In the Tracker panel (**F7**), click Position to activate the tracker.
 - The Tracker and Reference Boxes appear in the viewport.
- 3. Click Absolute Mode.

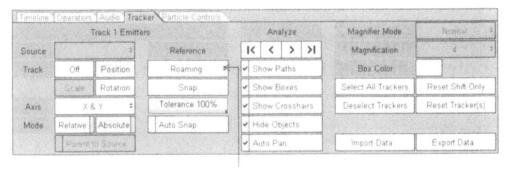

4. Change the Reference type to Roaming.

With the reference set to Roaming, the reference area is resampled at every frame. It is a slower process but it accounts for slight changes to the reference area from frame to frame.

5. Adjust the upper left vertex of the Tracker box (the outer box) using the following screenshot as a guide.

This allows for the movement of the white dot from frame to frame.

- 6. Click the Analyze Forward > button to analyze the clip.
 The Tracker Box follows the white dot until it moves out of the viewport. As the tracker analyzes the clip, the motion path that represents the position of the tracker box appears.
- 7. Turn the Tracker off to apply the tracking data.

Apply the Tracked Emitter to the Train Clip

Copy the tracked particle emitter from the TrackMe layer to the ChooChoo layer.

- 1. In the Workspace panel, right-click / CONTROL-click the Particles operator and choose Copy.
- 2. Right-click / CONTROL-click the ChooChoo layer and choose Paste.
- 3. Expand the ChooChoo layer.

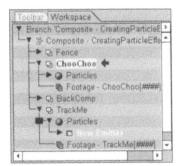

The Particles operator is applied to the layer.

4. Double-click the pasted Particles operator.

The New Emitter object is displayed in the viewport.

5. Play the clip (SPACEBAR) to preview the result.

A few default particles emit from the top front of the locomotive.

- 6. In the Workspace panel, turn off the TrackMe layer.
- 7. (Optional) Delete the TrackMe layer.

Import a Custom Shape for the Smoke Particle

To further enhance the simulated smoke, edit the emitter type and the particle(s). Import an image and adjust the particles properties.

- 1. In the Workspace panel, CTRL-click / ૠ-click the Particles operator to view its contents.
- 2. Rename the New Particle Type "SmokePuff".

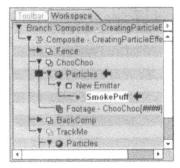

3. Import footage:

a) In the Particle Controls panel (F8), click Shape.

- b) Click Import.
- c) In the Import Particle Shape Image dialog, navigate to the 39_CreatingParticleEffects folder, select the puff8.bmp image, and click OK (ENTER / RETURN).
- d) In the Particle Shape Import Options dialog, from the Shape Type, select Gray.

e) Click OK (ENTER / RETURN).

The imported image is added to the Shape library.

Edit the SmokePuff Particle Type

Adjust the behavior and appearance of the smoke particles by editing the color and opacity of the particles, and by changing the particle Behavior properties.

Note: The SmokePuff particle type must be selected to edit all of the parameters within the Particle operator. When the Emitter is selected, you cannot edit the actual Particles, the Behavior, or the Shape. You are limited to editing only the Emitter parameters. Most Emitter parameters are global scaling properties for all particles that come from that emitter. They scale the overall values of the corresponding particle properties. Since this is the case, start with the basic appearance of the particles, then edit their other properties. You are encouraged to play with the different particle settings and use the Preview.

- 1. In the Workspace panel (F3), select the SmokePuff particle type.
- 2. In the Particle Controls panel (F8), click Particles.
- 3. Set the Life Color gradient:
 - a) In the Life Color gradient, click the lower left corner of the gradient to add a gradient tag.
 - b) Right-click / CONTROL-click the gradient tag to the right and set the color to black.

Note: To delete a gradient tag, select the tag and press DELETE.

- 4. Set the Life Opacity gradient:
 - a) In the Life Opacity gradient, click the lower left corner of the gradient to add a gradient tag.
 - b) Right-click / CONTROL-click the gradient tag to the right and set the color to black.

Note: While most particle properties can be animated, this lesson separates the parameters into those that are constant and those that can be animated over time. The typical workflow for creating and editing custom particles and emitters involves experimentation. You are highly encouraged to "play" and observe how the values change the characteristics of the particles.

- **5.** In the Particle Controls panel, click Emitter.
- **6.** Set the following Emitter values:
 - a) Emission Angle: 90°.
 - b) Emission Range: 180°.
 - c) Visibility: 60%.

- 7. In the Particles Controls panel, click Behavior.
- 8. Set the following Behavior values:

Life	Number	Size	Velocity	Weight	Spin	Motion Rand	Bounce	Visibility
35	20	10	15	-75	0	15	25	100%

9. Set the following Particle Variation values:

Life	Number	Size	Velocity	Weight	Spin	Motion Rand	Bounce
10	5	5	5	5	55	5	10

10. Set the following Behavior over Life values:

a) Size over Life: 180%

b) Velocity over Life: 200%

c) Weight over Life: 100%

d) Spin over Life: 100%

e) Motion Rand Life: 100%

f) Bounce over Life: 100%

Note: You are encouraged to experiment with different Behavior Over Life settings values.

Animate the Values for the Particles

Animate the smoke particles to begin small as it exits the smoke stack of the locomotive and grow as the smoke begins to disseminate. First, animate the size of the particle emitter.

- 1. Go to the first frame (HOME).
- 2. In the Workspace panel (F3), select the SmokePuff particle type.
- 3. In the Particle Controls panel (F8), click Emitter.

- 4. Ensure Size is set to 100%.
- 5. Enable Animate (A).
- **6.** Go to the last frame (**END**).
- 7. Set the Size to 600%.

Since the Emitter values are scaling factors that effect the particles, the Emitter Size value is animated to create the illusion that the source of the smoke is moving closer to the camera (in perspective as this shot requires).

8. Disable Animate (A).

Adjust the Size Over Life Setting

Edit the Behavior Over Life properties. Since the Behavior Over Life properties are special case parameters, use the Timeline graph to see the curves of each property.

- 1. In the Workspace panel (F3), ensure the SmokePuff particle type is selected.
- 2. In the Timeline (F4), enable Graph.
- 3. In the Timeline list, expand the Behavior Over Life category, and select Size Over Life.

The Size Over Life curve is highlighted in the Timeline graph.

In this case, the Timeline does not represent frames. Instead, the Timeline represents the percentage of the life of a particle from 0 to 100 (regardless of the duration of the particle's life setting, or the length of the composite). Therefore, to make a particle begin small and grow over its life span, create a curve in the Size Over Life parameter that begins with a low value and gradually increases.

4. Right-click / **CONTROL**-click the first keyframe and choose Interpolation | Bezier.

Green tangent handles appear on the keyframes.

Note: You can also select a keyframe interpolation method from the Interpolation list in the Timeline Controls panel.

- 5. Click in the background of the Timeline graph to deselect the Size Over Life curve.
- **6.** Double-click the second keyframe (at 100).

7. In the Numerical Input dialog, enter 900 for Size Over Life and then click OK (ENTER / RETURN).

8. Adjust the shape of the Size Over Life curve using the following screenshot as a guide.

Note: You can experiment with the shape of the curve to see its effect on the smoke particles.

- 9. Preview the result:
 - a) In the Workspace panel (F3), double-click the 39_CreatingParticleEffects composite.
 - **b)** Play the clip (**SPACEBAR**).
- 10. (Optional) Save the workspace:
 - a) Choose File | Save Workspace (CTRL+S / ૠ+S) to open the Save Workspace dialog.
 - b) Set a filename and directory for the workspace, and then click OK (ENTER / RETURN).
- 11. Choose File | Close Workspace (CTRL+W / ૠ+W) to close the workspace.

Creating Capsules

Lesson 40

In this lesson, create a Capsule with custom controls for a common keyer setup.

Overview

You use Capsules as compound operators which contain a processing pipeline of multiple operators and inputs, and a single output. A Capsule can be saved to a library and reused to easily apply common processing nodes to your clips.

In this lesson:

- Create a Capsule from a keyer setup.
- Edit the Capsules internal Operators.
- Add notes and create custom controls for the Capsule.
- Save the Capsule to a Capsule library.
- Use the saved Capsule on a new piece of footage to quickly perform a key.

Open the 40_CreatingCapsules.mov file in the 40_CreatingCapsules folder and preview the result.

Need Help?

If you need help completing this lesson, save and close your workspace, and then open the 40_CreatingCapsules.cws file as a reference.

Open the Workspace

Open the starting workspace file for this lesson.

- 1. Check the Combustion preferences. For instructions, see "Setting the Preferences" on page 3.
- Choose File | Open Workspace, or press CTRL+SHIFT+O / ૠ+SHIFT+O.
- **3.** In the Open Workspace dialog, locate and open the 40_CreatingCapsules folder.
- Select the starting_point.cws from the 40_CreatingCapsules folder and then click Open or click OK (ENTER / RETURN).

- **5.** Select the single-viewport layout to show the clip.
 - **6.** Choose Window | Fit in Window or click the Home button.

Examine the Schematic and Encapsulate the Operators

Use the Schematic view to Encapsulate the operators into a Capsule.

1. Choose Window | Schematic or click the Schematic View button.

Hint: You can also press either F12 or ~ to show the Schematic view.

The Schematic view is a flowchart of the workspace. Each operator is represented by a node. The arrows connect the nodes and show the hierarchy of the composite.

Notice that the sheep layer contains nodes for Footage, the Diamond Keyer, Color Suppression and Matte Controls.

2. Create a Capsule:

- a) In the viewport, drag a selection box around the Diamond Keyer node, the Color Suppression node and the Matte Controls node.
- b) Right-click/CONTROL- click on any of the three highlighted nodes and choose Encapsulate.

A Capsule is a compound operator containing the three selected nodes is created.

In the Schematic view, the Capsule node displays a list of the three operators contained within it.

Edit the Capsule

Once a Capsule is created, you can add, remove, or change the parameters of an operator in the process tree. Change the Shrink Width of the Matte Controls to ½ of a pixel and enable the Erode function.

Right-click/click and CONTROL- click on the Capsule in the Schematic and choose Edit Capsule.
 The Capsule is opened for editing and the content of the Capsule appears in the Schematic view.

2. Edit the Shrink Width of the Matte Controls:

The Matte Controls panel appears.

- a) Double-click the Matte Controls node in the Schematic.
- b) In the Matte Controls panel, set Shrink Width to 0.5 and press ENTER / RETURN.
- 3. Right-click/CONTROL-click anywhere in the Schematic view (not on a node) and choose Exit Capsule.

Adding and Creating Controllers

Controllers can be linked to operator channels, or can be created with custom parameters. Controllers determine which channels are exposed for animation. This gives users access to only the subset of channels determined by the author of the capsule, creating a customized operator.

- 1. Add a Controller to the list of channels:
 - a) In the Schematic, double-click the Capsule node to access the Capsule Controls.

b) In the Capsule Controls, click Controllers.

- c) In the ChannelPick panel, select the Shrink Width channel in the Internals Matte Controls.
- d) In the Capsule Controls, click Clone & Link.

A Shrink Width control for the Capsule is added enabling the user of the Capsule to adjust the Shrink Width.

- 2. Add a Controller with custom parameters:
 - a) In the Capsule Controls, click Add.

In the ChannelPick Controls, a New Channel is added.

- b) Click twice on New Channel, pausing slightly between clicks and type Erode Edges and press ENTER / RETURN.
- c) Click Link.
- d) In the ChannelPick, select the Erode Width channel in the Internals Matte Controls.
- e) In the Channel Pararmeters, type .25 in the Min field, and 1 in the Max field.

An Erode Width control for the matte is added enabling the user to erode the edges of the matte.

Note: The matte cannot be eroded less than .25 of a pixel, or more than 1 pixel.

Save the Capsule to the Library

A Capsule can be saved to a library and reused or shared with other artists.

- 1. Save the Capsule:
 - a) Right-click / CONTROL- click the Capsule in the Schematic and choose Save Capsule.
 - **b)** In the browser, navigate to the Capsule Library Folder in the Combustion root directory. Name the file "Sheep Keyer" and click OK.

Reuse the Capsule on New Footage

Apply a Capsule to footage with similar properties to save time.

1. Start a new composite.

Choose File | Open or press CTRL+O (Windows) or %+O (Macintosh) to access the Open Footage dialog.

- 2. CTRL-click / He-Sheep Flip[####].png and Ocean.png (in this order), and then click OK.
- 3. Choose 2D Composite from the Open Footage dialog and then click OK.
- 4. Apply the Capsule Operator:
 - a) In the Workspace panel (F3), make sure the Sheep layer is selected.
 - b) In the Operators panel (F5), click Capsule, and then click Browse Capsules.

Hint: You can also right-click / control- click the Sheep layer and choose Operators | Capsule | Browse Capsules.

c) In the Load Capsule dialog, locate and open the 40_CreatingCapsules folder for this lesson and click the sheep keyer.ccw Capsule and click OK.

The Capsule with the Diamond Keyer, Color Suppressor, and Matte Controls is applied to the new sheep footage, creating the correct key without having to redo all the work.

- **5.** Adjust the Erode Edge of the matte:
 - a) In the Capsule Controls, select Basic.
 - b) Set Erode Edges to 1.

Note: The controller for Erode Edges cannot be set to less than .25 or greater than 1.00, as established in the creation of the Capsule

6. Play the clip to view the result (**SPACEBAR**).

The new sheep footage is quickly keyed and the composite is finished.

7. (Optional) Save the workspace:

- a) Choose File | Save Workspace (CTRL+S / 98+S) to open the Save Workspace dialog.
- **b)** Set a filename and directory for the workspace, and then click OK (**ENTER** / **RETURN**).
- **8.** Choose File | Close Workspace (CTRL+W / $\Re+W$) to close the workspace.

grigateria a la vivi di la tella tella

and the same of same any of first and the same and the sa

Building G-Buffers

Lesson 41

In this lesson, create a Z-Depth channel to apply an animated 3D Fog to ordinary video footage using the G-Buffer Builder.

Overview

The G-Buffer Builder enables you to create additional channels of information to your footage to take advantage of 3D post operators. These channels can be rendered out from 3ds Max files, but for images created outside of 3ds Max (video and film footage) information such as Z-Depth must created with the G-Buffer Builder.

In this lesson:

- Finish a grayscale Paint project to be used as a Z-Depth channel.
- Apply a G-Buffer Builder to use the Paint Operator for z-Depth.
- · Apply a 3D Post Fog Operator.
- Animate the Near Plane of the 3D Fog.

Open the 41 BuildingG-Buffers.mov file in the 41_BuildingG-Buffers folder and preview the result.

Need Help?

If you need help completing this lesson, save and close your workspace, and then open the 41_BuildingG-Buffers.cws file as a reference.

Open the Workspace

Open the workspace file for this lesson and then import an image.

- 1. Check the Combustion preferences. For instructions, see "Setting the Preferences" on page 3.
- 2. Choose File | Open Workspace, or press CTRL+SHIFT+O / %+SHIFT+O.
- 3. In the Open Workspace dialog, locate and open the 41_BuildingG-Buffers folder.
- 4. Select the starting_point.cws from the Creating 41_BuildingG-Buffers folder and then click Open, click OK, or press ENTER / RETURN.

5. Select the two-viewport layout.

Examine the Schematic and open the Paint Operator

Examine the workspace in Schematic view.

1. Choose Window | Schematic or click the Schematic View button.

Hint: You can also press either F12 or ~ to show the Schematic view.

The Schematic view is a flowchart of the workspace. Each operator is represented by a node. There is one footage operator connected to two layers. The Train(2) layer contains a Paint operator named Z Depth Paint.

- 2. Access the Paint Controls and expand the Paint operator in the Workspace:
 - a) In the Schematic view, triple-click the Paint node.
 - b) In the Workspace panel, expand the Train(2) layer, and expand the Z-Depth Paint operator.
 - c) In the Paint Operator, turn on the light and light 2 Paint objects.

Solid and gradient grayscale objects were drawn over the original footage to represent depth. This grayscale information tells the G-Buffer builder what objects appear in front of or behind each other. Objects with a white value correspond to the Near Plane (closer) and objects with a black value correspond to the Far Plane (farther).

Paint the Train Trestle with a Gradient for Z-Depth

The trestle varies greatly in distance from the camera, very near on the left and far on the right, receding to the vanishing point. A gradient polygon is required to make a proper Z-Depth map for the trestle.

- 1. Select the single-viewport layout.
 - 2. Choose Window | Fit In Window, or click the Home button twice.

41 Building G-Buffers

3. In the Paint Controls panel (F8), click Reset to reset the draw modes to their default settings.

4. In the Toolbar, click the Filled Bezier tool (**SHIFT+P**).

Note: If the Filled Bezier tool is not shown in the Toolbar, click-drag the filled tool and choose the Filled Bezier tool from the context menu, or press the tool's hot key.

5. Paint the trestle:

- a) In the viewport, click polygon points to outline the trestle. Where the trestle ends on the left and right sides of the footage, make sure the polygon points are right on the edge.
- **b)**) Click-drag points to make Bezier curves around the 2 foreground bushes. Click the first point (the cursor turns yellow), or press **ENTER** / **RETURN** to close the polygon.

- 6. In the Paint Controls panel (F8), change the polygon to a gradient:
 - a) In the Paint Controls panel, click Modes.
 - b) Click Gradient to change the source of the polygon from a Solid color to a Gradient.

c) Click the Gradient thumbnail preview to access the Gradient controls.

d) Click the Linear Gradient button.

- 7. Create a grayscale gradient for the polygon:
 - a) In the Paint Controls panel, double-click the left side of the Color Gradient bar to add a gradient tag.
 A Color Picker dialog appears.
 - b) In the Color Picker dialog, change each of the Red, Green and Blue percentages to 98% and click OK.
 - c) Double-click the right side of the Color Gradient bar to add a gradient tag.
 - d) In the Color Picker dialog, change each of the Red, Green and Blue percentages to 24% and click OK.

Hint: For the white to gray values to appear correctly in the polygon, you can click and drag the gradient tags to the extreme left and right of the color bar.

Reorder and Enable the Remaining Paint Objects

The remaining contents of the Paint operator must be turned on to be read by the G-Buffer Builder. The trestle also needs to appear behind the 2 lights, but in front of the building.

- 1. Reorganize the Paint objects:
 - a) In the Workspace panel (F3), enable the building, street, and bg objects in the Paint operator.
 - b) Click and drag the Filled Polygon object down underneath light 2.

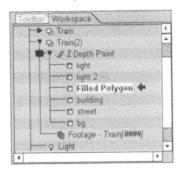

Apply a G-Buffer Builder, Use the Paint Operator for Z-Depth

The finished grayscale image can be used as a Z-Depth input for the G-Buffer Builder defining what is near, far and in-between.

- 1. Apply and the G-Buffer Builder:
 - a) In the Workspace panel (F3), double-click on the top Train layer to view its output in the viewport.
 - b) In the Operators panel (F5), click 3D Post, and then CTRL-click / ૠ-click G-Buffer Builder.

Hint: You can also right-click / CONTROL-click the Train layer and choose Operators | 3D Post | G-Buffer Builder.

- 2. Select an input for the Z Buffer:
 - a) In the G-Buffer Builder Controls (F8), click on Z Buffer "None" in the Operator Input List.
 - b) In the Z Buffer picker dialog, choose the Z Depth Paint operator and click OK.

The G-Buffer Builder's Global Parameters are already set to use the Luma of the painted grayscale and the a Near plane of -100 and a Far plane of -1000.

Apply a 3D Fog Operator and Animate the Near Plane

The 3D Post Operators such as 3D Fog and 3D Depth Of Field access channels from the G-Buffer Builder to create 3D effects. The grayscale Paint Operator in the Z Buffer defines how the 3D Fog is represented in the scene.

- 1. Apply the 3D Post Fog Operator:
 - a) In the Workspace panel (F3), make sure the top Train layer is selected.
 - b) In the Operators panel (F5), click 3D Post, and then CTRL-click / % -click 3D Fog.

Hint: Note: You can also right-click / CONTROL-click the Train layer and choose Operators | 3D Post | 3D Fog.

- c) Click the Send Up button to see the 3D Fog Operator in the viewport.
- 2. Animate the Near Plane of the 3D Fog to "roll" through the scene:
 - a) In the 3D Fog Controls, set the Near Plane to -1000.

- b) Enable Animate (A).
- c) Go to the last frame (END).
- d) In the 3D Fog Controls, set the Near Plane to 0.

- 3. Play the clip to view the result:
 - a) In the Workspace panel, double-click the composite.
 - **b)** Zoom out to 100% view or choose Window | Fit in Window.
 - c) Play the clip (SPACEBAR).

The 3D Fog "rolls" though the scene using the Z Buffer channel from the G-Buffer Builder.

- **4.** (Optional) Save the workspace:
 - a) Choose File | Save Workspace (CTRL+S / 98+S) to open the Save Workspace dialog.
 - **b)** Set a filename and directory for the workspace, and then click OK (${\sf ENTER}$ / ${\sf RETURN}$).
- **5.** Choose File | Close Workspace ($CTRL+W / \Re+W$) to close the workspace.

Morphing Lesson 42

In this lesson, create a morph transition
between 2 objects with the RE:Flex Morph
and control the image with extra points and
boundaries.

Overview

You use AE RE:Flex Morph to gradually transform one still image to another with polygons. The 2 (or more) key images must either occur in the same clip, or exist in the same layer through Nesting or an Edit Operator. Boundaries can be established to control the area affected by the morph polygons.

In this lesson:

- Apply an AE RE:Flex Morph Operator.
- Define 2 key images to transform to one another.
- Change the duration of the AE RE:Flex Morph Operator to return to moving footage.
- · Outline an object in the 1st key image with polygons.
- Animate the polygons to outline another object in the 2nd key image.
- Set a Boundary Polygon to limit the influence of the morph.

Open the 42_Morphing.mov file in the 42_Morphing folder and preview the result.

Need Help?

If you need help completing this lesson, save and close your workspace, and then open the 42_Morphing.cws file as a reference.

Open Footage into a Composite Branch

Create a composite branch by opening footage.

- 1. Check the Combustion preferences. For instructions, see "Setting the Preferences" on page 3.
- 2. Choose File | Open or press CTRL+O (Windows) or ૠ+O (Macintosh) and use the file browser to locate and open the 42_Morphing folder.
- 3. In the Open dialog, double-click the Tools folder and double-click the tools [####].png image sequence.
- **4.** In the Open Footage dialog, select 2D Composite to create a 2D composite with the selected footage and click OK (ENTER / RETURN).

- 5. Select the single-viewport layout.
 - **6.** Choose Window | Fit in Window.
 - 7. Play the clip (SPACEBAR).

A hand reaches into the frame and places an adjustable wrench on the workbench, takes it out of frame, replaces it with a non-adjustable wrench and then takes that wrench out of frame.

Create Picture Keys and In/Out Points for the Morph

Apply an AE RE:Flex Morph to the tools layer and choose the start and end Picture Keys. Change the duration of the morph operator so that moving footage can be seen before and after the morph.

- 1. Go to the first frame (HOME).
- 2. Apply the AE RE:Flex Morph Operator:
 - a) In the Workspace panel (F3), make sure the tools layer is selected.
 - b) In the Operators panel (F5), click RE:Vision Plug-ins, and then CTRL-click/ ℜ-click AE RE:Flex Morph.

Hint: You can also right-click / **CONTROL**-click the tools layer and choose Operators | RE:Vision Plug-ins | AE RE:Flex Morph.

- c) In the Workspace panel (**F3**), double-click the AE RE:Flex Morph operator to make it the current operator and see its output in the viewport.
- 3. Enable Animate (A).
- **4.** Go to frame 34 (/).

This is where the hand leaves the frame.

- 5. Choose Movie | Mark In Point (SHIFT +1) to trim the in point of the Morph operator to the current frame.
- **6.** Choose start and end picture Picture Keys:
 - a) In the AE RE:Flex Morph Controls (**F8**), enable Picture Key? Picture Key?

This sets the current frame as the start image for the morph.

- b) Go to the next frame.
- c) Disable Picture Key? Picture Key?
- d)) Go to frame 125 (/).

This is where the adjustable wrench has been replaced with a non-adjustable wrench.

e) Enable Picture Key? - Picture Key? This sets the current frame as the end image for the morph.

- f) Go to the next frame.
- g) Disable Picture Key? Picture Key?
- h) Choose Movie | Mark Out Point (SHIFT +O) to trim the out point of the Morph operator to the current frame.
- 7. Play the clip (SPACEBAR).

The morph is dissolving from the 1st Picture Key frame to the 2nd Picture Key frame.

Add Control Polygons to Morph Picture Keys

Outline the 1st wrench object with animated polygons at the first Picture Key frame.

- 1. Choose File | Preferences (Windows) or combustion | Preferences (Macintosh) and in the Animation Host category, change the Default Keyframe Interpolation to Linear, and click OK.
- 2. Go to frame 34 (/).

This is the first Picture Key.

3. Draw the morph polygons:

- a) In the Toolbar, select the Bezier tool.
- b) In the viewport, click and drag Bezier points along the border of the adjustable wrench.

Hint: Keep the points to a minimum and remember that each point will have to reference a point on the 2nd wrench in the next Picture Key.

c) Click the first point (the cursor turns yellow) to close the polygon.

d) Manually move each of the polygon points into position and adjust the tangent handles. This sets a keyframe for all the parameters of the individual points.

- e) In the Toolbar (F2), select the Bezier tool.
- f) In the viewport, draw a polygon for the inside of the hole in the wrench handle.
- g) Manually move each of the polygon points into position and adjust the tangent handles.

Animate the Polygons to Morph to the Next Picture Key

Move the polygons to the 2nd wrench in the end Picture Key.

1. Go to frame 125 (/).

This is the second Picture Key.

- 2. Animate the morph polygons:
 - a) In the viewport, select the large outline polygon.
 - b) Click, drag and adjust Bezier points to outline the border of the non-adjustable wrench.

- c) In the viewport, select the small handle hole polygon.
- d) Click and drag and adjust Bezier points to the inside of the hole in the wrench.

3. Play the clip (SPACEBAR).

The morph polygons are pushing and pulling pixels from the 1st Picture Key frame to the 2nd Picture Key frame.

Fine-Tune the Morph

Fix the image edges and set a morph boundary.

- 1.Disable Animate (A).
- 2.Go to (/) frame 80.

The picture edges are being pulled away by the morph polygons.

4. In the AE RE:Flex Morph Controls (F8), enable Hold Edges - Hold Edges.

The edges are stretched back and "held" the edge of the layer. The edges are being "held", but the harddrive and power supply are being affected by the morph polygons.

- 5. Go to (/) frame 34.
- **6.** Create a boundary to limit the influence of the Morph polygons.
 - a) In the Toolbar (F2), select the Bezier tool.
 - b) Draw a simple polygon around the wrench.

c) In the Morph Controls, click on Boundary (none), and choose Polygon (3).

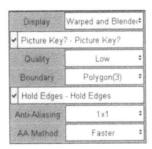

Only the pixels inside the Boundary will be affected by the morph polygons.

Note: Increasing the Quality to Ultra and the Anti-Aliasing to 4x4 greatly improves the quality of the morph. These settings also increase render time.

- 7. Play the clip (SPACEBAR).
- **8.** (Optional) Save the workspace:
 - a) Choose File | Save Workspace (CTRL+S / 38+S) to open the Save Workspace dialog.
 - b) Set a filename and directory for the workspace, and then click OK (ENTER / RETURN).
- 9. Choose File | Close Workspace (CTRL+W / ૠ+W) to close the workspace.

Index

Numerics	view mode 411
3d Post	alpha
operators 481	channel 284
	alpha channel
A	embedded 288
Absolute mode	animating
in Tracker 448	a layer 345
absolute mode	by adding keyframes 218
linking 234	draw modes 131
accessing	layers 33
additional Paint tools 140	Paint object 92
context menus in Paint Toolbar 88	using expressions 228
Paint Selection tools 98, 201	
Action and Title	В
safe zones 151	Balance
Adaptive	Color Correction filter 212
interpolation in Timewarp 57	Bezier Selection
Add	tool 201
transfer mode 325	Bezier tool
add	stroked and filled 88
selection 200	blank emitter
additional Paint tools	library 454
accessing 140	Box Blur
adjusting	filter 226
motion path 248	branch
AE RE Flex Morph	setting duration 302
operator 485	Brightness
align	draw mode 134
option 251	B-Spline
aligning	tool 104
layers and operators to an axis 251	B-Spline tool
aligning layers	stroked and filled 88
to a motion path 248	B-Splines 104
Alpha	vs Bezier curves 102
	Bump Map
	rr

Controls 279	composite in Workspace panel 331		
Burn Shadows	thumbnails 208		
draw mode 133	Collapse option		
	in Import Footage dialog 29		
C	color		
cache	remapping 390		
meter 19	color correction		
Camera	operators 47		
View 329	Color Correction filter		
view 20	Balance 212		
camera	Color Corrector		
parameters 338	operator 389		
stock lenses 338	color picker		
camera motion	in Paint 95		
	Color Plot		
animating 334	picker 401		
Capsule	Color Suppression		
creating 469	curve 402		
edit 470	Target 401		
Library 471	color suppression curves		
operator 468	adjust 415		
saving 471	Plot Picker 416		
changing	Colorize		
default still image duration 45	transfer mode 269		
display quality 46	Compare		
Channel 35	tool 76, 393		
operators 35	compare		
channel	region options 394		
exposing 470	composite		
linking 234	changing output width and height 243		
Speed 5	creating 29		
channel filter	expand and collapse 331		
preset 80	composite operator		
channel filtering	setting duration 302		
in a layer 79	Compound Alpha Arithmetic		
in Timeline 78, 382	Controls 299		
menu in Timeline 79	operator 287		
channels	Compound RGB Arithmetic		
creating using G-Buffer Builder 476	operator 301		
clip	Context in Timeline		
stabilizing 365	enabling 132		
clip duration	control point		
extending 219	grouping 106		
clone	control points		
source mode in Paint 144	active 319		
starting point 145	controller 470		
cloned object	copying a layer		
duration 193	versus duplicating a layer 325		
collapse	versus duplicating a layer 323		

corner-pinning	animating 131
footage 238	drawing
creating	Paint object 98
3D effects 481	duplicating
a layer 123	layers 325
additional channels using G-Buffer Builder 476	objects 96
gradients 96	duration of a clip
cropping	changing 54
footage 238	duration of footage
manually or using the Crop tool 240	stretch 114
Current Time	duration, setting composite 302
indicator 328	
Curve Editor	E
in Timewarp 55	Ease In
cycling viewport display	in Timeline 293
using Home button 128	edges
	in Schematic 297, 331
D	Edit branch
Diamond Keyer	open footage into 61
Controls 398	Edit Gradient
Luma Gradient 400	tool in Paint Toolbar 166
Difference	tool in Toolbar 166
transfer mode 270	Edit operator
Discreet Color Corrector 418	Auto Adjust Duration 62
Discreet Keyer 407	Edit sequence
Displace	navigating 70
Controls 276	rearranging segments 65
Displace operator	editing
adding 276	text 115
displacement source	Ellipse tool
channels 277	stroked and filled 88
setting 276	emitter behavior
displacing	adjusting 450
pixels 274	Emitter Library
display quality	load 447
changing 46	encapsulate 469
displaying	Exclusion
grids, guides, and ruler 89	transfer mode 269
object content in Workspace panel 129	expand
object outlines only 141	composite in Workspace panel 331
outlines only 314	expanding an object
distort	in the Workspace panel 129
a layer 274	Expression
Dodge Midtones	Browser 229
draw mode 133	extending
Dodge Shadows	clip duration 219
draw mode 133	duration of a clip 54
draw modes	extrapolation

before and after 267	preset direction 167 radial 165
F	radial sweep 166
Feedback	setting, using color palette 153
enabled versus disabled 337	spiral 166
field	tag 163
separation 377	text outline 171
filter	types 165
Box Blur 226	vector 167
Filters	gradient tag
Balance 212	removing 165
Fit	gradients
stabilize mode 370	creating 96
Fixed Reference	Graph mode
in Tracker 448	in Timeline 223, 265
Font	grayscale objects
Browser 116	to represent z-depth information 477
footage	green spill
cropping and corner-pinning 238	removing 401
importing 29	Grid
instancing 252	setting preferences 107
loop 114	showing 107
opening in Workspace 35	grid, guides, and ruler
replacing 149	accessing 89
Footage Library	Grouped
showing 21	import option 239
four-point	
tracking 356	Н
Fractal Noise operator	histogram
adding 275	matte 414
animating 279	hold edges
Frame All	when morphing 489
in Timeline 223	Home
frames	button 18
overwriting in Edit Timeline 63	hot keys
Freehand tool	for channel filtering in Timeline 78
stroked and filled 88	for navigating viewports 81
	for navigating Workspace panel 75
G	
G-Buffer Builder	1
operator 476	images
Glow	importing 30
Controls 330	
gradient 162	imported footage order 113
animate 166	
creating 95	importing multi-layer file 239
linear 166	incremental render
micai 100	meremental render

workspaces 82	layer surface
incremental save	blending 267
workspaces 81	layers
instancing	duplicating 252, 325
footage 252	renaming 53
interlaced	scaling and positioning 31
fields 61	Library
interpolation 218	particle 454
Bezier 4	library
Constant 4	emitter 455
Cubic 4	lights
Hermite/Flame 4	Point 346
Linear 4	Spot 347
preferences 4	Linear Keyer 360
interpolation methods	linking channels
in Timewarp 57	using expressions 235
intersect	load
selection 200	particle Library 454
	locating footage
K	using the Import Footage dialog 43
key	locking orientation
extracting 396	layers 342
key icons	loop
in Timeline and Workspace panel 132	footage 114
Keyer mode	looping
YUV 407	footage 219
keyframes	Luma Gradient
adding 221	in Diamond Keyer 400
keying	Luminance
operators 397	draw mode 133
pixels 48	transfer mode 270
setting tolerance 408	
using Linear Keyer 360	M
using the Discreet Keyer 406	Macromedia Flash Player
YUV mode 407	previewing with 197
keying tool	Mask
Linear Keyer 48	operators 313
,	mask
L	drawing 359
layer	masks
converting to four-corner for corner-pinning 241	adding control points to 318
creating 123	deleting control points 318
locking orientation 342	feathering 315
stencil 290	setting properties 315
transfer mode 264	matte
	adjust Luminance 414
layer properties changing 355	adjusting the softness 411
Changing 333	color suppression curves 415
	11

create 285	object outlines		
defined 406	displaying 141		
displaying 398	one-point		
fine-tune 399	stabilizing 364		
generating 406	Open Footage dialog		
histogram 414	options 87		
shrink 403	opening footage		
source 286	to create a Paint branch 86		
view 409	operator		
Merged Image	adding 115		
file import 239	outlines only		
meter	displaying 314		
cache 19	output connection		
mode	in Schematic 332		
Absolute and Relative in Tracker 448	Overlay		
modes	draw mode 133		
transfer 264	transfer mode 244, 269		
morphing 484			
Motion Blur operator	Р		
Phase 430	Paint		
Samples 430	default foreground and background colors 162		
Shutter 430	paint paint		
motion path	draw modes 128		
aligning layers to 248	Paint branch		
multi-layer file	creating 86		
importing options 239	Paint draw mode		
Multiply	descriptions 133		
transfer mode 269	Paint Draw modes		
	examining 129		
N	paint effects		
	Tint 205		
navigating Workspace panel	Paint object		
using hot keys 75	drawing 98		
Nested	Paint Selection tools		
import option 239 node 25	accessing 201		
nodes and edges	Paint tools		
in Schematic 297	context menus 140		
	context-menus 88		
null object 324	stroked and filled tools 88		
creating 327			
•	painting Filled tool mode and Stroked tool mode 88		
0	gradient 95, 162		
object	text gradient 171		
displaying content in Workspace panel 129			
duration 193	panning		
snap to grid 108	in viewport 18 parenting		
object duration	layers and objects 339		
default 90	objects 328		
	Objects 320		

Particle	R
Controls 455	RAM
particle	cache 19
attaching to emitter 450	gauge 19
particle shape	RAM Player
import options 460	playing clip 370
path option	real-time
text 119	playback 18
Perspective	Rectangle
View 328	compare region 394
view 20	rectangle
Zoom tool 328	rounded corner 161
Perspective Rotate	Rectangle tool
tool 337	stroked and filled 88
Picon	rectangles
in Expression Browser 232	with rounded corners 89
Picture Keys	Relative mode
creating 485	in Tracker 448
Ping Pong	relinking
After extrapolation 267	footage 12
pixel	media 12
sampling 408	
play	remapping black and white values 389
modes 18	colors 390
playback controls 18	renaming
playback out point	layers 53
	Render to RAM
setting 221	dialog 370
playing clips	rendering
in RAM Player 370	version of workspaces 82
polygon	replace
closing 202	selection 200
Preferences	replacing
Animation 4	footage 149
Colors 11	Reset
Combustion 4	draw modes 89
Footage 6	Modes in Paint 139
OpenGL 9	resetting
Particles 8	text mode 116
Schematic 10	reveal
preferences	source mode in Paint 142
setting Combustion preferences 3	ripple
preset	mode in Edit Timeline 63
channel filter 80	rounded-corner
preset parameters	rectangle 192
in Expression Browser 233	rectangles 89

S	setting
Safe Zones 369	default object duration 90
safe zones	Shading and Shadows
showing 151	in the Composite Settings controls 347
sampling	Shift
	operator 229
a pixel 95	stabilize mode 370
pixels 408 Saturate	Skip Repeat
transfer mode 270	interpolation in Timewarp 57
	Snap to Grid
saving	menu 108
version of workspaces 81	snapping
Scale	segment in Edit Timeline 63
tool in Toolbar 345	Soft Light
scaling	draw mode 134
using the Scale tool 345	Softness
Schematic	add 412
view 25, 249	softness and tolerance
Schematic view	
flow direction 249	setting 399
rearranging nodes 249	Solid layer
segment	creating 275
head and tail 63	Source
in Edit Timeline 63	color picker 390
navigating the Edit sequence 66	Speed channel 5
trim 63	adjusting 223
segments	in Timeline 265
rearranging in Edit Timeline 63	speed curve
selecting	in Timewarp 55
source to reveal 142	Split Horizontally
Selection	compare region 394
Bezier 98	Split Vertically
selection	compare region 394
Add combination mode 203	stabilize
copy 203	position and rotation 378
drawing 201	Stabilize 1 Point
elliptical 204	operator 366
feathering 209	Stabilize 2 Points
inverting 98	Controls 378
Replace mode 201	operator 376
replace, add, subtract, intersect 200	stabilize point
Subtract combination mode 204	setting 366
Selection tools	Stabilize Point channels
accessing 98	in Timeline 383
selections	stabilizing
context menu 2	a clip 365
menu 2	modes 370
Set Matte	one-point 364
operator 287	two-point 364
operator mor	A CONTRACTOR OF THE PROPERTY O

stacking order	in Text Layout controls 151		
in Workspace panel 34	text object		
of objects in the Workspace panel 98	adding 37		
stencil	Attributes controls 170		
layer 290	Basics controls 169		
still image	Face 170		
default duration 45	Outline controls 171		
stock lenses	Shadow controls 170		
camera 338	text outline		
stretch	using footage 154		
duration of footage 114	text path		
stretching	setting 119		
clip duration 219	texture source		
duration of a clip 54	as text outline 154		
Stylize	timecode		
operator 330	generator 121		
Subtract	Timeline		
transfer mode 270	channel filtering 382		
subtract	Timewarp		
selection 200	Constant 55		
Supersampling	Curve Editor 55		
in the Composite Settings controls 347	interpolation methods 57		
Surface	Variable 55		
controls 325	timing curve		
surface	in Timewarp 55		
properties 350	Tint		
swapping foreground and background colors	color correction effect 205		
in Paint 97	Tolerance		
	add and subtract 408		
Т	tolerance		
	setting 398, 408		
tangent handles	tolerance and softness		
modifying 211	setting 399		
resetting in Timeline controls 225	Toolbar		
technical support 12	Paint tools 140		
text	Тор		
adding 115 attributes 37	View 326		
	Tracker 356		
Attributes controls 116	activating 316, 368		
face, outline, and shadow attributes 118	analyzing a clip 317, 368, 458		
objects 112	applying tracking data 317, 368		
outline 154	box 368		
path offset 120	controls 380		
reset 116	positioning 357		
text gradient	reference box 368		
color and opacity 152	roaming reference 358		
creating 152	Roaming reference type 457		
expanding color 155			
text margins	set to Roaming 380		

Tracker panel 316	workspace
tracking	versions 81, 82
control points 356	Workspace panel
transfer	contents 21
modes 264	customizing 75
Transition controls	expanding 23, 75
in Edit Timeline 63	expanding contents 114
Trim tool	menu 129
head 65	width 23
tail 64	workspaces
	incremental render 82
trimming	incremental save 81
segments 63	Wrap
turn off	stabilize mode 370
a layer 44	stabilize filode 370
two-point	
stabilizing 364	Υ
	YUV
V	color model 408
vary speed of a clip	Keyer mode 407
using a Variable Timewarp 54	
vector graphics 86	Z
Vertical Split	z-depth
defining region limit 77	mapping information 477
view	zooming
Schematic 25, 249	in viewport 18
View list	in viewport 10
Camera 329	
Top 326	
View Mode	
Alpha 411	
-	
viewport display quality 19	
icon in Workspace panel 138	
layouts 17	
panning 18	
zooming 18	
viewports	
cycling 125	
navigating using hot keys 81	
views	
Perspective 336	
W	
wire removal	
using Paint tools 138	
wireframe	
displaying 314	

Acknowledgments

Lesson Development:

Lee Roderick, Miriam Sterle, Alex Udell

Content and illustration:

Lee Roderick, Miriam Sterle, Alex Udell

Review and testing:

Zabelle Côté, Annie Normandin, Miriam Sterle

Technical Support:
Project management:

Stephan Dube Miriam Sterle

Images:

Josée Belhumeur, Alan E. Bell, Handmade Digital, Christopher Byron, Gary

M. Davis, Pam Fernandez, Colin Laski, Lee Roderick "Rod", North Gate, Lee "Rod" Roderick, Runaway Training, Stéphane Tremblay, Alex Udell, Jennifer

van Dijk, Amer Yassine

Additional images:

Academy of Art College - Elisa Stephens, Behaviour Communications,

IMG Worldwide

v.2 Courseware contributors: Josée Belhumeur, Anne Brierly, Christopher Byron, Gary M. Davis, Pam

Fernandez, Pia Maffei, Lee Roderick, Amer Yassine

nijadi (17. je si) nado i superybeni se o Ludžavo i Soba i si sudržadi. V opu 185 os njesu nadi o 1998

gradige — 100 og 4 i mæren og 20 och som og 4 och som og 4

and standy for the second supplies of the sec

dane vo social accessor

Printed and bound by CPI Group (UK) Ltd, Croydon, CR0 4YY 22/10/2024 01777633-0001